D0984605

GIORGIO VASARI

Born at Arezzo in 1511
Died in Florence 1574

EVERYMAN, I will go with thee,

and be thy guide,

In thy most need to go by thy side

GIORGIO VASARI

The Lives of the Painters, Sculptors and Architects

IN FOUR VOLUMES · VOLUME ONE

TRANSLATED BY
A. B. HINDS

EDITED WITH AN INTRODUCTION BY
WILLIAM GAUNT, M.A.

DENT: LONDON
EVERYMAN'S LIBRARY
DUTTON: NEW YORK

© _Introduction and editing, J. M. Dent & Sons Ltd, 1963_
All rights reserved
Made in Great Britain
at the
Aldine Press · Letchworth · Herts
for
J. M. DENT & SONS LTD
Aldine House · Bedford Street · London
First included in Everyman's Library 1927
Revised edition 1963
Last reprinted 1966

NO. 784

INTRODUCTION

GIORGIO VASARI, painter and architect, born at Arezzo, 30th July 1511, was in his thirties when, as he records, the idea of his classic work of art history and biography first took definite shape in his mind. A passage in his autobiography tells how the plan of the work grew out of a conversation at the supper table of Cardinal Farnese at Naples. The connoisseur and collector, Monsignor Giovio, remarked that he 'would dearly like to have a treatise upon all famous artists from Cimabue to our own day' and gave a verbal sketch of how it might be handled. Vasari's opinion was asked. He thought it an admirable scheme, provided that Giovio was 'assisted by someone of the profession to put things straight for him'. After seeing some of the notes on art and artists which Vasari had already made, Giovio urged him to undertake the whole task, and as a result it became his chief labour until it was completed in 1547, though it still had to be revised and was not published until 1550.

If, as seems likely, the discussion at Cardinal Farnese's table took place in 1544, rather than 1546 as Vasari implies, it would none the less be astonishing that this long and pioneer book, surveying the wonderful development of Italian art during some four hundred years, describing a host of painters, sculptors and architects and packed with detail, should have been carried out in so short a space of time. It is quite possible indeed that Vasari, with the project already well formed and work in train, steered the talk he reports in the direction he wanted, in order to enlist the interest and support of his art-loving friends. It is significant that he then refers to 'my notes and papers, which I had made as a pastime from my early youth and because of my regard for artists'. At the age of seventeen he was already collecting the drawings by Giotto and others which were to form part of the 'reference library' of originals, contained in his *Libro di Disegni* (that unique 'Book of Drawings', dispersed in the eighteenth century). One might say that his life since childhood had been a preparation for his great literary work; and many events in his career contributed to its making.

A leaning towards art in some form may have been a family inheritance though he came of a line of unpretentious crafts-men. His great-grandfather, Lazzaro Vasari, to whom he accords the dignity of a *Life*, was a saddler who specialized in

such decorative work as the ornamentation of harness, armour and marriage chests. That Lazzaro was also a fresco painter, comparable with Piero della Francesca, rests on his descendant's assertion, in which there seems a measure of wishful thinking. A number of Giorgio's forbears were potters and their vases probably gave the family its name. His grandfather, also named Giorgio, collected and restored ancient pottery, and his present of Etruscan vases to Lorenzo the Magnificent made the Vasaris known to the House of Medici and may have helped to introduce Giorgio's grandson and namesake to their notice.

The Vasaris numbered among their relations one eminent painter, Luca Signorelli, the son of Lazzaro's sister. One of Giorgio's earliest recollections was of being taken to visit the aged Signorelli, who being told of the boy's fondness for drawing recommended that he should be properly trained. He had lessons accordingly from Guglielmo da Marcilla, a French worker in stained glass and minor painter settled at Arezzo, who is pleasantly described in the *Lives*. A few years later Giorgio's father, Antonio, was able to bring his son to the notice of Cardinal Passerini, tutor to the young Medici princes, who was passing through Arezzo. The cardinal arranged that the boy, already proficient in Latin and promising as a painter, should continue both his general and technical education in Florence and under the protection of the Medicis.

It was a step of great importance, the beginning of a lifelong association with the Florentine dynasty, still powerful and consistent in its patronage of the arts though no longer so securely established as of old. It was the source of many of Vasari's later commissions both as architect and painter, yet it had a value in other respects. At Florence, Vasari studied with the same tutors as the princes Ippolito and Alessandro. He had the benefit of an education which was literary, classical and philosophic, tending to make him as much a man of letters as of the visual arts. This Humanist training enabled him in his adult years to meet the scholars of the various cities he lived in or visited on their own ground, so that they considered him as one of themselves. His letters, autobiography and the *Lives* in general bear witness to his extensive acquaintance with Italian men of learning, historians, antiquarians, philosophers and translators of classical texts, either dignitaries of the Church or lay scholars attached to a court. Their researches into Italian history provided a foundation for his own studies. They were of service to him in other ways. The collections of connoisseurs such as Paolo Giovio were open to him. He gained hints on style from Annibale Caro, distinguished as a scholar, wit and letter-writer, who advised him to be natural and colloquial.

He was helped in the revision of his text by such learned friends as Gian Matteo Faetani of Rimini and Dom Vincenzo Borghini.

From the period of Vasari's tuition at Florence dates his acquaintance with Michelangelo, under whom he studied for a few months until the master was called away to Rome. Vasari had a longer apprenticeship with Baccio Bandinelli yet his brief contact with Michelangelo marks the beginning of a friendship between the two which lasted throughout their lives and made that deep impression on Vasari which is evident in all his works. Not only did he try to imitate the 'grand manner' of Michelangelo, he found in him the supreme justi-fication of his idea of evolution in art. All roads, in Vasari's view, led to the height which Michelangelo attained; it was through him that he took his bearings of the past and measured progress. A feeling that the splendid climax had been reached led him to close the first edition of the *Lives* with his account of Michelangelo, that 'rarest and most divine' of men.

Even the disturbances of Italy in Vasari's time were ulti-mately of profit in his literary task. The independence of Florence as a city state was threatened by the growing domin-ance of Rome and the connections of the Medici with the papal state. Rome, however, was threatened too by invaders from with-out. The turmoil of 1527, when Rome was sacked by the imperial mercenaries of Charles V and the Florentines took the oppor-tunity of rising in revolt and expelling the Medici, caused an upheaval in the lives of artists in both cities. Vasari, in the resultant chaos, and after the death of his father from the plague, was one of those affected.

He relates how during the siege of Florence an arm of Michelangelo's 'David' was broken and that he and his fellow student, Salviati, distinguished themselves by retrieving the pieces while the struggle went on around them. Yet in 1528, deprived of patronage and now the responsible eldest member of a family of six children, otherwise dependent on an uncle, he found it necessary to return to Arezzo. For a while he earned a living by going about the villages painting simple frescoes for the country people, an exercise which he pronounces in his Life of Pontormo to be an excellent training for a young artist. The rural background is often vividly suggested in the *Lives*.

He ventured back to a republican Florence, but when Charles V and the Medici Pope, Clement VII, made up their differences, part of the bargain being the re-establishment of the Medici family in Florence, the threatened recurrence of fighting again compelled him to wander. He left the city before the imperial and papal armies closed in for the siege, going to Pisa, where he worked for a goldsmith. Aiming once more to get back to

Arezzo he was forced to make a wide detour to avoid areas of
conflict and thus came to Bologna at the time of the reconcilia-
tion between the Pope and Charles V (who was then crowned
'King of Lombardy'). Employment offered in the design and
execution of triumphal *décor* for the occasion, though Vasari
did not stay long, being anxious about the state of family affairs.
Reassured that all was well at Arezzo and once again finding
his problem resolved by a visiting dignitary, he was whisked
off to Rome in the train of the Cardinal Ippolito de' Medici.
In Rome he devoted himself with zeal to the study of works by
Michelangelo, Raphael and other masters, in the intervals of
producing paintings of his own for the satisfaction of his patron.

By travel, even enforced, Vasari's view of Italian art was
inevitably much enlarged. He was made more vividly aware
than Florentine artists—or artists Florentine-trained—were
apt to be that the arts had their individual development in other
cities. Circumstances continued to make him something of a
rolling stone with a further benefit to his task. A breakdown in
health due to overwork during the feverish heat of the Roman
summer caused the young man to leave Rome and return to
Arezzo. Thence he went back to Florence where, after the out-
burst of republicanism, the Medicean rule was restored. Yet
all through his life Vasari seems to have been torn between a
liking for the sweets of patronage and a revulsion against its
burdens and the 'perils of the envious court'. He grew prosper-
ous in the service of Alessandro de' Medici, painting his portrait
and those of the duke's half-sister Catherine (afterwards Queen
of France) and the deceased Lorenzo the Magnificent, but he
was aware of being hated by the native Florentine painters as
an interloper and the servant of a now detested rule, imposed
on the city by force of arms. He was the 'blackleg' who in
1536, when the emperor was to be received in state at Florence,
toiled, in despite of the Florentines' strike, to get the decora-
tions ready in time. The assassination of the duke in January
1537 made him realize what enmity he also had incurred and
the dangers to which he was now exposed without protection.
In a thoroughly distressed state he retreated to the hermitage
of Camaldoli above Arezzo, where he regained his mental
balance in the clear mountain air and the serenity of the
monastic existence. It was there he saw among other works
that 'very beautiful little crucifix on a gold ground by Giotto
with his signature' which he mentions in the *Lives*.

The taste of simplicity decided him to give up courtly pre-
tension and take employment where he found it. For the next
few years he led a wandering life, not unprofitably however,
for in 1540 he was able to buy the house in Arezzo which is
now a Vasari museum. His journeys by this time were becoming

a purposeful research. In 1543 he made an extended tour through Italy, visiting not only Rome and Naples but Parma, Mantua, Verona and that furthest outpost of art from his point of view, Venice, which, on general principle, he was inclined at first to regard with no great sympathy though he admitted the city's beauty. There could hardly be a better preparation for an account of an art distributed among so many centres as that of Italy, and the habit he had early formed of noting down particulars of things seen stood him in good stead. The groundwork of the *Lives* was already largely done by the time he came to the Cardinal Farnese's table.

From that date the composition and revision of the book occupied him almost exclusively for five or six years, though after its publication he was again drawn within the orbit of great patrons and was busier than ever before both in painting and architectural design. His friend the Cardinal del Monte, who became Pope as Julius III, employed him in Rome until 1554, when Vasari, with a fresh revulsion of feeling, returned to Florence. He there entered the service of Duke Cosimo, who was eager to revive and increase the glory of the Medicis by his patronage of the arts. Vasari became his chief architectural adviser, his activities including the remodelling of the Palazzo Vecchio as a ducal residence and a series of elaborate and crowded frescoes for its interior; the building of the Uffizi as administrative offices; and the dome of the Umiltà at Pisa. In 1566 the decoration of the Palazzo Vechio was completed; the *Lives* had proved a success and Vasari took a travelling holiday which provided him with additional material for a new edition. Among the many cities he visited were Loreto, Pavia, Milan, Ferrara and Venice, and he kept an eye open for work that had been produced since the time of his earlier investigations. In 1567 he finished the amendments for the second edition which was published in the following year. He had found, he said, 'a thousand and one things to be corrected'. He added accounts of a number of living artists and hurriedly penned his autobiography at the last moment before going to press.

One sees Vasari in the later years of his life as an eminently successful man; a chief magistrate (*gonfaloniere*) of Arezzo; delighting in the prestige given him by the *Lives*; honoured and active still in the arts; married, not unhappily it would seem (to Niccolosa Bacci of Arezzo), though without children. At Florence he was commissioned by the duke to paint the cupola of the Duomo. At Rome, after Michelangelo's death, he was appointed chief architect to St Peter's and in 1571 received the order of knighthood from the Pope. Soon after the Pope employed him to contribute to the decoration of the Sala Regia,

the entrance hall of the Sistine Chapel. He designed, as a final
act of homage to his beloved master, the tomb of Michelangelo
in Santa Croce. Yet his labours and constant journeys had worn
him out. Not quite sixty-three years of age, he died at Florence
on 27th July 1574. His body was later taken to Arezzo to be
buried in the Pieve in the family tomb he had himself prepared.
The altar-piece of the chapel, representing the Vocation of
Peter and Andrew, contains his self-portrait and the portrait
of his wife.

As an artist Vasari was a characteristic representative of the
age of Mannerism, with all the exaggerations of a style derived
from Michelangelo that the word implies. He has often been
described as a 'feeble imitator', though the modern re-estimate
of Mannerist art would suggest a more sympathetic judgment.
He has at all events a respectable place in relation with such
contemporaries as his friend Salviati and Taddeo and Federigo
Zuccari, and beyond doubt was an accomplished and conscien-
tious technician. The accounts of processes and materials used
in architecture, sculpture, painting and such associated arts
as stained glass, which prefaced the first edition of the *Lives*,
valuable to the student as an authentic description of Cinque-
cento craft, bear witness to his all-round technical competence.

It is now usual to regard these technical studies as a separate
treatise and they are not included in the present edition. Their
interest is distinct from that of his great literary undertaking
as a biographical history, and this required qualifications
besides a knowledge of how works of art were produced. As
historian and critic Vasari had the merits of breadth of view,
acuteness of judgment and (within the limits of his criteria)
of impartiality. It is remarkable that a man so conscious of the
splendours of his own century could devote patient attention
to the very different products of earlier periods; that he could
deal with a Margaritone as well as a Michelangelo. He was fair
to artists with whom he might be supposed to have little in
common, to contemporaries whom he had no personal reason
to like. Without minimizing the faults either as artist or man,
of the bullying and pretentious Bandinelli, with whom he had
worked, he studies him objectively and makes an effort to see
his best side. He pays due respect to Benvenuto Cellini's
'Perseus' and refers to him several times without prejudice,
though he was one of the numerous objects of Cellini's hatred
and is maliciously caricatured in Cellini's autobiography.

Vasari was an assiduous inquirer, and the mere statement
that he made notes of what he had seen scarcely does justice
to the extent of his research—or its difficulties. Libraries were
rare, museums did not exist save in the embryonic form of
princely collections, works of art were widely dispersed and

unclassified. As well as making use of historical compilations
and drawing upon such precious documents as the written
notes of Ghirlandaio, Ghiberti and Raphael, he burrowed into
the archives of churches and monasteries, drew up for the first
time lists, which have subsequently proved of immense value,
of the works contained in religious and public buildings and
in the private collections to which he gained access; and con-
stantly sought for any personal recollection of artists or oral
tradition concerning them that he might glean from others.
By correspondence and contact with travelled artists his
researches extended into France and the Netherlands.

He was helped by such collectors as Borghini and Giovio,
who gave him information about works in their possession and
in districts of which they had special knowledge, and by numer-
ous pupils and artist colleagues such as Prospero Fontana
and Bagnacavallo. For particulars of art outside Italy he was
able to refer, for instance, to Niccolò dell' Abbate, who had
worked for Francis I at Fontainebleau, and to his own Flemish
assistant, Giovanni Stradano (Van der Straet). Though Raphael
died when Vasari was a child, no doubt information gained
from Giulio Romano and others accounts for the especially
intimate character of this particular Life. All told he may be
said to have constructed a far-reaching system of fact-finding
in which he enlisted an army of collaborators.

In collating, digesting and presenting the material thus
accumulated it cannot be said that Vasari was 'scientific' in
the modern sense of the word. He committed many errors in
date and transcription and his inaccuracies have been often
remarked on—though what historian covering so long a stretch
of time and dealing with a multitude of artists in the first work
of its kind could avoid error? He made a special point of includ-
ing personal and anecdotal matter but his liking for a good
story, which so often gives an agreeable human warmth to his
narrative, caused him to include a good deal that was apocry-
phal. Too great a credulity, too tolerant an inclusion of 'it is
said that . . .' were among his weaknesses. On the other hand
he tried wherever possible to go to an authentic source; his
estimate of character and description of an artist's 'humours'
are often as illuminating as they are lively, and if he accepted
what others had said or written with too little question, he
was independent in his carefully considered critical evaluations.

Vasari's criterion of judgment was based on the assumption
that art is in the main an imitation of nature and that it is
admirable or otherwise in the degree to which it attains this
end. This (deceptively simple) thesis gained a special signifi-
cance from Vasari's Humanist line of thought (in which Christian
piety and classical philosophy both had their part). He often

uses the words 'God', 'Heaven', 'the Stars' (as celestial influences) and 'Nature' to express the same idea. He speaks of God as the 'divine architect of time and nature' and as being, in a manner of speech, the first and supreme painter and sculptor, having regard to the wonderful diversity of form and colour in His creation. In imitation therefore artists showed respect for a divine attribute; and as they approached imitative perfection, took on *una similitudine di mente divina*. Implicit in this thought is the conception of the Renaissance 'superman', whose genius, a divine gift, in itself approached the divine. As Vasari puts it in the Life of Raphael: 'We may indeed say that those who possess such gifts as Raphael are not mere men but rather mortal gods.' An essential quality of such men was *virtù*—not 'virtue' but an austere compulsion—to be distinguished from the pursuit of 'Glory' (which meant worldly honours and rewards) and rising superior to the untoward combinations of 'Fortune' and the hindrance of the 'humours' which represented human imperfection.

The general plan and theme of the *Lives* developed out of these ideas. Vasari conceived the rise of art on a grand scale rather as Gibbon did the fall of empire. Until the appearance of Cimabue, art, according to his argument, had fallen into decay through the neglect of nature. After Cimabue, and by the efforts of Giotto, it was set on the right path once more, ascending through the centuries to the height of naturalism and the achievement of Michelangelo in the sixteenth century.

From the modern point of view the thesis has its doubtful aspects. Byzantine art no longer appears, as it did to Vasari, the crude product of a uniformly dark age. The flaws of imitation as a criterion have been frequently pointed out and he himself seems, consciously or subconsciously, aware of the difficulties it raised. He was forced to use such terms, proper to art rather than nature, as 'invention' and 'grace' and to make distinctions of style, as, for example, between the 'maniera grande' of Michelangelo and the 'maniera mezzana' of Raphael. He was involved in an evident contradiction in asserting that nature was outdone by these masters—though the statement may be regarded as an admission that the High Renaissance had gone beyond the exercise of merely imitative skill. Yet the idea of continuity, constant development and grand climax tallies with historical fact, and whatever the shortcomings of Vasari's main contention, it enabled him to give a magnificent coherence to his biographical panorama.

His preface deals briefly with the legendary origins of art, the excellence of ancient Greece, the great original model, and the decadence he assumed to have set in from the age of Constantine, resulting in the debased 'Greek' (i.e. Byzantine)

manner of painting from which Italian art broke away in the thirteenth century. The points of departure are represented by Cimabue in painting, Arnolfo di Lapo in architecture and Niccola Pisano in sculpture. Imperfect still, they were worthy of praise to the extent they had extricated themselves from barbarism, Byzantine or Gothic, had revived the classical spirit and turned once more to nature. At this stage Vasari is hampered by his critical system, his lack of knowledge of Byzantine development and perhaps by his Florentine patriotism. The 'Rucellai Madonna' which he speaks of as Cimabue's great achievement is now attributed to Duccio, the founder of the Sienese school, who gets amiable but brief mention. Cimabue, as viewed by modern scholarship, has become a very shadowy figure. Duccio, however, it is now appreciated, was a master whose work was happily inspired by a brilliant Byzantine renaissance of court art, in itself the opposite of a barbarous rigidity. In general Vasari underestimates the art of Siena. He gives a somewhat confused record of dates and persons in the thirteenth and fourteenth centuries yet one that has remained important as a basis and starting-point for research. Giotto rightly stands out as a beacon illuminating the course of early Florentine art which in Part One of his work is the main concern.

The fifteenth century, the Quattrocento, which forms Vasari's Part Two, beginning with the sculptor Jacopo della Quercia, was a less speculative period. Memory and oral tradition were more lively and detailed, source material more abundant, the writer could for the first time refer to an artist he had known personally—Andrea della Robbia, who died in 1525 at the age of ninety. Art had now, he says, 'passed the age of childhood' and arrived at a lusty youth, 'in which a notable improvement may be remarked in everything'. It is a century which Vasari describes with great affection as well as a sensitive appraisal of style and, as was his habit, he dramatically illuminates his key figures. Ghiberti, whose famous bronze doors are described with loving detail, is praised as a creator of the Renaissance. Donatello, whose affinity with classical sculpture is emphasized, is placed among the giants. Vasari gives no general view of evolution in architectural form but represents it as suddenly coming into its own with Brunelleschi —'given by Heaven to invest architecture with new forms'. He admires, among the painters, Paolo Uccello for the closer imitation of nature made possible by his study of perspective, though he criticizes the too theoretical bent which confused art and geometry. He regards Masaccio as the creator of the 'modern style' combining the science of Uccello with a much greater realism in expression and gesture. He seems to have

been unresponsive to the greatness of Piero della Francesca and is more expansive on the piety than the art of Fra Angelico, but on the whole gives a splendid appreciation of the masters of central Italy, while an anxiety to avoid local bias appears in the care he devoted in the second edition to his account of the Venetian painters.

In the third and longest section of the work Vasari deals with the perfection finally attained. Maturity was nearly but not quite reached by the fifteenth century, and his own sixteenth century, the Cinquecento, was the glorious outcome of the long pursuit of naturalism. He does not systematically trace the evolution of styles but again presents a number of masters in magnificent isolation. Thus Bramante in architecture springs suddenly into creative being like Brunelleschi before him. In describing the great figures of the High Renaissance, Vasari himself reaches his highest level as historian and biographer. Always at his best with the greatest men, he writes beautifully about Leonardo da Vinci and indeed creates an image of him which has never been materially amended or improved.

He begins with Leonardo as one of the three principal exponents of the 'modern style' (i.e. the rendering of light and shade), the others being Giorgione and Correggio. One might have expected Vasari to share Michelangelo's prejudice against Leonardo but on the contrary he was exceptionally understanding. He was the first to appreciate his universal range of mind and study and sympathetically explained his small output (scorned by Michelangelo and so different from Vasari's own incessant industry) as the result of a contemplative and perfectionist spirit. His descriptions of such bizarre works as the 'Head of Medusa' wonderfully heighten the impression of the strange and powerful mentality that produced them.

Instinctively Vasari appreciated, as we do today, the mysterious genius of Giorgione, especially praising his *morbidezza* (i.e. lifelike treatment of flesh)—the quality he also admired in Correggio. He is superlative in praise of Raphael, while, as a critic, nicely distinguishing his style from the 'modern manner' of Leonardo and Giorgione or the 'grand manner' of Michelangelo, which utilized only the human figure. Thus in his view Raphael arrived at a balance or mean ('maniera mezzana') between qualities sought by different masters, and widened the scope of composition introducing besides the figure many different objects of interest. The Life of Michelangelo is conceived in an epic spirit as a memorial to a 'genius universal in each art', though the eulogy of technique and mastery leaves unconsidered the complexity of the artist's mind. It has been acutely observed that Vasari, the Florentine academician,

admired the 'Last Judgment' as a sort of academy of design in itself, without remark on the psychology of its creator and the different mood observable in the wall painting as compared with the ceiling of the Sistine Chapel.

Vasari was apt to be critical of the Venetians for their Byzantine associations and want of a true classical tradition. For him Bellini was too 'dry', Tintoretto on the other hand too facile and extravagant; yet in Titian, as in Giorgione, he praises an artist 'whose works will endure as long as the memory of famous men'. Together with the sustained eulogies of greatness and a few somewhat disproportionately long studies of contemporaries such as the Zuccari, Part Three includes such interesting chapters as the short history of engraving contained in the Life of Marcantonio and the references to 'Divers Flemish Artists'. The autobiography with which the work ends gives a modest account of his own productions and an engaging apologia for his lengthy literary task.

In Vasari as a writer there are variations of style which one might expect from the nature of his career. In certain passages, prefatory or valedictory, he has his own (or a borrowed) 'grand manner', using rhetoric and philosophic reflection with all the floweriness of the courtly men of letters with whom he associates. In another mood he is the diligent compiler of catalogues; or again the professional artist discussing the technique of fellow practitioners in studio language. Yet throughout the work is rich in character studies, incident and humour. His artists are flesh and blood as he describes them—whether from acquaintance or imagination—even the dim Cimabue is vividly sketched, after a portrait supposed to represent him, as a thin-faced man with a little, pointed, red beard. Vasari delights in the 'humours' which enliven his narrative, the jests of Buonamico Buffalmaco, for example, or the eccentricities of Piero di Cosimo. Poor or princely, social or solitary, ascetic, amorous, Bohemian, all come vividly to life against the suggested background of aristocratic, monastic, mercantile and peasant Italy. Always pleasant to read and on suitable occasion rising to epic or lyric magnificence, the *Lives* is a great book on a great subject, a classic for the general reader with an interest in art as well as those for whom it still constitutes an essential point of departure in specialist study.

The translation used here is that of the Temple Classics edition published in 1900 and long since out of print. It was revised throughout for the edition in Everyman's Library of 1927 and at that time notes were added, drawn from many sources, including numerous monographs on artists and Italian towns, Milanesi's classic edition of the *Lives*, Professor Venturi's monumental *History of Italian Art* and the

mine of information contained in Messrs Crowe and Caval-
caselle's many volumes. These footnotes remain in the present
reprint with such alterations as were necessary to bring them
up to date and an additional series of notes is appended in
Volume IV. Of the immense number of works mentioned by
Vasari and apart from those still *in situ*, some have disappeared,
others have perished by fire or other accident, others again
have found a permanent home in public galleries. Supplement-
ing references in the notes, a list of works in the last category
is appended in Volume I under the heading of the gallery where
they are now to be found. The reader may be referred to C.
Ragghianti's valuable edition for an exhaustive list of the large
number of works still remaining in their original place. The
index has been revised and modern spelling of names and
modern alternatives of nomenclature added.

1963. WILLIAM GAUNT.

SELECT BIBLIOGRAPHY

LIFE AND BIBLIOGRAPHY. *The Life of Giorgio Vasari: a study of the later
Renaissance in Italy*, by R. W. Carden, illustrated, 1910. *Giorgio Vasari*, by
A. Moschetti (Scrittori Italiani series) (Turin), 1935. A bibliography of
Vasari was compiled by Sidney J. A. Churchill as *Bibliografia Vasariana*
(Florence), 1912.

WORKS. *Le Vite de' più eccellenti Architetti, Pittori, et Scultori Italiani da
Cimabue insino a tempi nostri* (Florence), 1550; 2nd ed., 1568. Later Italian
Editions, Bologna, 1647, 3 vols. in 4to; Rome 1759, 3 vols. in 4to; Florence
1771, 7 vols. in 4to; Siena 1791–4, 11 vols. in 8vo; Milan 1807–11, 16 vols.
in 8vo; Florence 1822, 6 vols. in 12mo, containing other treatises and 55
letters. *Sei Lettere Inedite de Giorgio Vasari* (Lucca), 1868. *Le Opere di Giorgio
Vasari, con nuove annotazioni e commenti di G. Milanesi*, 9 tom. (Florence),
1878–85. *Le Vite*, etc., with annotations and ninety-six illustrations, edited
by Adolfo Venturi (Florence), 1896. Edited by Dr Karl Frey, Parte I, Bd.
I, only (Munich), 1911. Sonzogno edition, 3 vols. in 4to (Milan), 1929;
Salani edition, 7 vols. in 8vo (Florence), 1927, 1932; Rizzoli edition, 4 vols.
in 8vo (Florence), 1942, 1950, with Introduction and notes by C.
Ragghianti.
 Translated into French as *Vie des Peintres, Sculpteurs et Architectes*, by
L. Leclanché, annotated by Leclanché and Jeanron, in 10 vols. (Paris),
1839–42.
 Translated into German as *Die Lebensbeschreibungen des berühmtesten
Architekten, Bildhauer und Maler*, Deutsch von A. Gottschwester, G. Gronau
und E. Jäschke, 4 vols., 8vo. (Strasburg), 1904–16.
 [W. Aglionby]. *Painting Illustrated in Three Diallogues . . . together with
the Lives of the Most Eminent Painters* (eleven lives only, abridged) (London),
1685. Translated into English as *Lives of the Most Eminent Painters,
Sculptors, and Architects*, by Mrs J. Foster, in 5 vols., 1850; a 6th volume
added was a Commentary containing notes and emendations from the
Italian ed. of Milanesi by J. P. Richter (Bohn's Library), 1885. *Lives of

Seventy of the Most Eminent Painters, Sculptors, and Architects, edited and annotated by E. H. and E. W. Blashfield and A. A. Hopkins, in four illustrated vols. (London and New York), 1897. *Lives of the Painters, Sculptors and Architects*, translated by A. B. Hinds (Temple Classics), 1900. *Stories of the Italian Artists from Vasari*, translated by E. L. Seeley (London and New York), 1906. *Lives of the Most Eminent Painters, Sculptors and Architects*, translated by Gaston Du C. De Vere, in 10 vols. with 500 illustrations (London and New York), 1912.

The Maniera of Vasari, translated by Mrs J. Foster and edited by J. G. Freeman (London), 1867; *Vasari on Technique*: being the introduction to the three arts of design, architecture, sculpture and painting, prefixed to the *Lives*, and for the first time translated into English by Louisa S. Maclehose; edited with introduction and notes by Professor G. Baldwin Brown, with illustrations (London), 1907; *I Ragionamenti of Vasari*, 1st edition (Florence), 1588. Included in the editions of Milanesi and Ragghianti. Correspondence; *Der Literarische Nachtlass Giorgio Vasaris*, edited by K. and H. W. Frey, 3 vols. (Munich), 1923–40. *Lo Zibaldone* (collection of projects and notes by Vasari and his helpers), edited by A. del. Vita (Arezzo), 1938.

Studies of Vasari and his work include the *Vasaristudien* of W. Kallab (Vienna), 1908; *Studi Vasariani*, edited by A. del Vita (Arezzo), 1927–43; *Studi Vasariani* (Florence), 1952; G. Vasari's 'Libro dei Disegni' in *Old Master Drawings*, 1937, 1938; 'La Casa del Vasari' in *Arezzo e il suo museo*, by L. Berti (Florence), 1955; *La Renaissance que nous a léguée Vasari*, by J. Rouchette (Paris), 1959.

GALLERIES

(Works mentioned by Vasari, now in Public Galleries)

NOTE. Names of artists and attributions are given in modern fashion, also picture titles. Where name or attribution differs from that of Vasari, his version is added in parentheses.

ENGLAND

London, National Gallery

Follower of Duccio (Cimabue). 'Virgin and Child with Six Angels,' i. 22.

Margarito of Arezzo (Margaritone). 'Virgin and Child Enthroned with Scenes of the Nativity and the Lives of the Saints,' i. 63.

Spinello Aretino (Giotto). Fragments of fresco, i. 68, 175, 183.

Ugolino. Predella panels from altar-piece of Santa Croce, i. 98.

Orcagna. Style of (Andrea di Cione Orcagna). 'Coronation of the Virgin,' i. 143.

Duccio. Predella from altar-piece, i. 166.

Paolo Uccello. 'Battle of San Romano,' i. 237.

Masaccio. 'Virgin and Child,' i. 265.

Masolino. 'A Pope and St Matthias' (part of altar-piece), i. 266.

Piero della Francesca. 'St Michael.' Presumed part of the S. Agostino altar-piece, i. 333.

Fra Angelico. Predella of altar-piece, 'Christ Glorified,' i. 338.

Fra Filippo Lippi. 'St Bernard's Vision of the Virgin,' ii. 3.

Pisanello (Vittore Pisano). 'The Vision of St Eustace,' ii. 19.

Pesellino (Francesco Peselli). 'The Trinity with Saints,' ii. 22.

Benozzo di Lese (Benozzo Gozzoli). 'Virgin and Child Enthroned,' ii. 23.

Francesco Cossa. 'St Vincent Ferrer (?),' ii. 42.

Giovanni Bellini. 'Doge Leonardo Loredan,' ii. 46.

Gentile Bellini (ascribed to). Portrait of Sultan Mehmet II, ii. 50.

Antonio and Piero del Pollaiuolo. 'Martyrdom of St Sebastian,' ii. 81.

Botticini, ascribed to (Botticelli). 'The Assumption of the Virgin,' ii. 86.

Filippino Lippi (Filippo Lippi). 'Virgin and Child with St Jerome and St Dominic,' ii. 109.

Francesco Francia. Pietà, ii. 122.

Pietro Perugino. Three panels of altar-piece, 'Virgin and Child with St Raphael and St Michael,' ii. 129.

Luca Signorelli. 'The Circumcision,' ii. 146.—'The Adoration of the Shepherds' (The Nativity), ii. 146.

Raphael. 'The Ansidei Madonna,' ii. 224.

Baldassare Peruzzi. 'The Adoration of the Kings,' ii. 296, 348.

Girolamo da Treviso (da Trevigi). 'Virgin and Child with Saints,' ii. 348.

Parmigianino (Francesco Mazzuoli). 'Vision of St Jerome,' iii. 9.

Bonsignori (Francesco Monsignori). 'A Venetian Senator,' iii. 39.

Paolo Morando (Paolo Cavazzuola). 'St Roch with the Angel,' iii. 43.

Girolamo dai Libri. 'Virgin and Child with St Anne,' iii. 49.

Domenico Ghirlandaio. 'St. Justus and St Clement,' iii. 77.

Sebastiano del Piombo (Sebastiano Viniziano). 'Raising of Lazarus,' iii. 114.—'A Lady as St Agatha,' iii. 115, 117.

Jacopo da Pontormo. 'Joseph in Egypt,' iii. 242.

Girolamo Genga. 'Coriolanus' (fresco), iii. 263.

Bachiacca (Francesco d'Ubertino). 'The History of Joseph' (two panels), iii. 303.

Andrea del Sarto. 'The Holy Family,' ii. 311.—Charity,' ii. 313.
Giulio Romano. Portrait of Joan of Aragon (head by Raphael), iii. 98.—
'The Nativity,' iii. 107.—'Venus and Vulcan,' iii. 107.
Giuliano Bugiardini. 'Portrait of Michelangelo,' iii. 218.
Jacopo da Pontormo. 'The Holy Family,' iii. 247.
Paolo Veronese (Paulino). 'The Marriage at Cana,' iii. 284.
Correggio. 'The Mystic Marriage of St Catherine,' iii. 309.
Ridolfo Ghirlandaio. 'The Coronation of the Virgin,' iv. 2
Francesco Salviati. 'Christ Showing His Wounds to St Thomas,' iv. 63.
Daniele da Volterra. 'David,' iv. 77.
Michelangelo. Statues of prisoners, iv. 120.
Titian. Portrait of a Lady at her Toilet (? Laura de' Dianti), iv. 202.—
Portrait of Francis I, iv. 203.—'The Supper at Emmaus,' iv. 204.—
Allegorical portrait, iv. 205.—'Christ Mocked,' iv. 209.
Vasari. 'The Annunciation,' iv. 287.

Paris, Musée de Cluny

David Ghirlandaio, 'Virgin and Child with Angels' (mosaic), iv. 2.

Chantilly, Musée Condé

Piero di Cosimo. 'Simonetta Vespucci as Cleopatra,' ii. 183.

GERMANY, AUSTRIA AND HUNGARY

Berlin, National Collection

Ugolino. Panels of altar-piece of Santa Croce, Florence, i. 98.
Duccio. Part of predella for altar-piece formerly in the Duomo, Siena, i. 166.
Andrea del Castagno. 'The Assumption,' ii. 16.
Desiderio da Settignano. Bust of Marietta degli Strozzi, ii. 34.
Sandro Botticelli (Botticello). 'The Virgin between St John the Baptist
and St John the Evangelist,' ii. 85.—Portrait of the wife of Piero de'
Medici, ii. 89.
Andrea Mantegna. Altar-piece of S. Giovanni, Evangelista, Pesaro, ii. 107.
Filippino Lippi (Filippo Lippi). 'The Crucifixion,' ii. 109.
Francesco Francia. 'The Annunciation,' ii. 121.—Altar-piece, ii. 122.
Vincenzo Catena. Portrait of a member of the Fugger family, ii. 141.
Luca Signorelli. 'The Dead Christ,' ii. 146.—'The School of Pan' (now
destroyed), ii, 147.
Giorgione. Portrait of Giovanni Borgherini (?), ii. 169.
Piero di Cosimo. 'Mars and Venus,' ii, 180.
Fra Bartolommeo. Altar-piece, ii. 198.
Raphael. (?) The Colonna Madonna, ii, 226.
Andrea del Sarto. 'Virgin and Child with Saints,' ii. 320.
Gio, Antonio Sogliani. 'Nativity' (after Lorenzo di Credi), ii. 343.
Franciabigio. (?) Portrait of Matteo Sofferoni, ii. 372.
Parmigianino. 'The Baptism of Christ,' iii. 7.
Francesco Granacci. 'The Trinity,' iii. 54.
Giulio Romano. Amorous scene, iii. 107.
Sebastiano del Piombo. Knight in armour, iii. 115.
Bacchiacca. (?) 'Baptism of Christ,' iii. 303.
Benvenuto Garofalo. 'St Peter Martyr,' iii. 307.
Giorgio Vasari. 'Adonis dying in the lap of Venus,' iv. 278.

Cologne Gallery

Titian. 'Bathsheba,' iv. 213.

Dresden Gallery

Ercole de' Roberti (Ercole). Two scenes from the Passion (part of predella),
ii. 43.
Francesco Francia. 'The Baptism,' ii. 121.
Antonio da Correggio. 'Virgin and Child,' ii. 174.

Raphael. 'The Sistine Madonna,' ii. 241.
Andrea del Sarto. 'The Sacrifice of Abraham,' ii. 321.
Franciabigio. 'David and Bathsheba,' ii. 371.
Parmigianino (Francesco Mazzuoli). 'The Madonna della Rosa,' iii. 10.—
'The Virgin with St John and St Stephen,' iii. 12.
Benvenuto Garofalo. 'The Nativity,' iii. 307.—'Triumph of Bacchus,' iii. 308.
Girolamo da Carpi. 'Virgin and Child with St Peter Martyr' (after Correggio), iii. 309.
Titian. 'The Tribute Money,' iv. 202.

Munich, Pinakothek

Domenico Ghirlandaio. 'Herodias Dancing before Herod,' ii. 75.
Sandro Botticelli (Botticello). Pietà, ii. 85.
Filippino Lippi (Filippo Lippi). Christ Appearing to the Virgin,' ii. 110.
Marco Basaiti (Basarini). 'The Deposition,' ii, 141.
Raffaellino del Garbo. Pietà, ii. 205.
Raphael. 'The Holy Family,' ii. 225.
Raphael (?). Portrait of the artist as a young man, ii. 236.
Andrea del Sarto. 'The Holy Family' (?), ii. 310.

Vienna, Kunsthistorischesmuseum

Taddeo Bartoli. 'Virgin and Saints,' i. 193.
Fra Bartolommeo. 'The Purification,' ii. 198.
Raphael. 'The Madonna del Giardino,' ii. 223.
Parmigianino (Francesco Mazzuoli). Portrait in a Mirror, iii. 8.—'Virgin and Sleeping Child,' iii. 12.
Giuliano Bugiardini. 'The Rape of Dina' (after Fra Bartolommeo), iii. 217.
S. Anguiscola. Self-portrait, iii. 319.
Cesare da Sesto. 'Salome,' iii. 325.
Daniele da Volterra. 'St John in Penitence,' iv. 77.
Titian. 'Ecce Homo,' iv. 200.

Budapest Gallery

Gentile Bellini. Caterina Cornaro, Queen of Cyprus, ii. 45.
Andrea Verrocchio. Altar-piece, ii. 98.

ITALY

Arezzo, Accademia Petrarca

Giorgio Vasari. 'Wedding of Esther and Ahasuerus,' iii. 155.

Arezzo, Pinacoteca

Pietro Dei (?) (Don Bartolommeo). 'St Roch Interceding with the Virgin on Behalf of the People of Arezzo,' ii. 61.
Domenico Pecori. 'The Madonna of Arezzo,' ii. 64.—Altar-piece, ii. 65.

Bologna, Academy

Raphael. 'St Cecilia,' ii. 235.

Bologna, Pinacoteca

Francesco Francia. 'Virgin and Child,' ii. 119.—'The Nativity,' ii. 120.—
'Virgin and Child with Saints,' ii. 122.
Pietro Perugino. 'The Assumption of the Virgin,' ii. 130.
Timoteo Viti. 'St Mary Magdalene,' ii. 273.
Girolamo da Cotignuola. 'Lo Sposalizio di Maria,' ii. 367.
Parmigianino. 'Virgin and Saints,' iii. 11.
Giuliano Bugiardini. 'Virgin and Saints,' iii. 217.
Giorgio Vasari. 'St Gregory,' iii. 265.

Borgo Sansepolcro, Palazzo Communale

Piero della Francesca. 'Madonna della Misericordia,' i. 333.

Florence, Uffizi Gallery

Cimabue. 'Virgin and Child with Angels,' i. 22.
Master of St Cecilia (Cimabue). 'Scenes from the Life of St Cecilia,' i. 22.
Giotto. The 'Ognissanti Madonna,' i. 79.
Pietro Lorenzetti (Pietro Laurati). 'Virgin and Child with Angels,' i. 99.
Ambrogio Lorenzetti (Ambruogio Lorenzetti). 'Presentation in the Temple,' i. 123.
Simone Martini. 'Annunciation,' i. 129.
Lorenzo Monaco (Don Lorenzo). 'Coronation of the Virgin,' i. 189.
Paolo Uccello. 'Battle of San Romano,' i. 237.
Lorenzo Ghiberti. 'The Sacrifice of Isaac,' i. 241.
Masaccio. 'Virgin and Child and St Anne,' i. 260.
Fra Angelico. 'Virgin and Child with Angels,' i. 339.—'Virgin with St John the Baptist and Saints,' i. 340.
Fra Filippo Lippi. Coronation of the Virgin,' ii. 2.—'Virgin and Child,' ii. 2.
Domenico Veneziano (Viniziano). 'Virgin and Child,' ii. 17.
Gentile da Fabriano. 'Adoration of the Magi,' ii. 18.—'St Mary Magdalen and St Nicholas of Bari, St John and St George,' ii. 18.
Giuliano Pesello. 'Adoration of the Magi,' ii. 21.
Francesco Pesellino (Peselli). 'Annunciation,' ii. 22.—Predella of altar-piece, ii. 22.
Domenico Ghirlandaio. 'Virgin and Child with Angels,' ii. 70.—'Adoration of the Magi,' ii. 70.—Altar-piece for S. Giusto, ii. 77.
Piero Pollaiuolo. 'St Eustace, St James and St Vincent,' ii. 80.—Series of six panels: 'Justice', 'Prudence', 'Temperance', 'Faith', Hope' and 'Charity'. ii. 81.
Antonio Pollaiuolo. Panels of 'Hercules and Antaeus' and 'Hercules and the Hydra', ii. 82.
Sandro Botticelli. 'Fortitude,' ii. 85.—'The Virgin Enthroned,' ii. 85.—'Coronation of the Virgin,' ii. 85.—'Pallas and the Centaur,' ii. 85.—'Birth of Venus,' ii. 85.—'Allegory of Spring,' ii. 85.—'Adoration of the Magi,' ii. 86.—'Calumny of Apelles,' ii. 90.
Andrea Verrocchio. 'Baptism of Christ,' ii. 98.
Andrea Mantegna. 'Adoration of the Magi,' ii. 105.—'Madonna of the Grotto,' ii. 106.
Filippino Lippi (Filippo Lippi). 'Adoration of the Magi,' ii. 112.—'The Virgin Enthroned' (panel from the Palazzo della Signoria), ii. 112.—'The Deposition,' ii. 113.
Pietro Perugino. 'Christ in the Garden,' ii. 127.—Pietà, ii. 128.—'The Crucifixion,' ii. 128.—'The Assumption' (from the church of Vallambrosa), ii. 129.—'Virgin with St John the Baptist and St Sebastian, ii. 131.—'The Deposition,' ii. 132.
Luca Signorelli. 'Virgin and Child,' ii. 147.
Leonardo da Vinci (Lionardo). 'Adoration of the Magi,' ii. 160.
Piero di Cosimo. 'Perseus and Andromeda,' ii. 180.—'The Immaculate Conception,' ii. 181.
Fra Bartolommeo. 'The Circumcision and the Nativity' ('Annunciation' on reverse), ii. 191.—'The Last Judgment,' ii. 192.—'Virgin and Child with Saints,' ii. 198.
Mariotto Albertinelli. 'Visitation,' ii. 202.
Raffaellino del Garbo. 'The Resurrection,' ii. 205.
Raphael. 'Madonna del Cardellino' (of the Goldfish), ii. 224.—Portrait of Pope Julius II, ii. 230.—'St John in the Desert,' ii. 243.
Lorenzo di Credi. 'The Adoration of the Magi,' ii. 288.
Andrea del Sarto. 'Christ Appearing to the Magdalen,' ii. 305.—'Madonna delle Arpie' (of the Harpies), ii. 309.—'Archangel Michael with St Giovanni Gualberto, St John the Baptist and St Bernardo degli Uberti,' ii. 319.—Self-portrait, ii. 320.
Rosso Fiorentino. 'Moses Defending the Daughters of Jethro,' ii. 357.
Franciabigio. 'Virgin and Child with St John,' ii. 369.—'Madonna del Pozzo' (of the Well), ii. 369.

Francesco Granacci. 'Scenes from the Life of Joseph,' iii. 54.—'Virgin and Child with St Zenobius and St Francis,' iii. 54.
Valerio Belli. Crystal casket, iii. 65.
Pierino da Vinci. 'Virgin and Child with St John' (bas-relief), iii. 186.
Baccio Bandinelli. 'Laocoon,' iii. 194.
Jacopo da Pontormo. Portrait of Cosimo de' Medici, iii. 243.—'Christ at Emmaus,' iii. 246.—'The Martyrdom of St Maurice' (replica of subject in the Pitti Gallery), iii. 248.
Sodoma. 'St Sebastian,' iii. 289.
Ridolfo Ghirlandaio. 'St Zenobius Restoring Life to a Child,' iv. 3.— 'Translation of the Body of St Zenobius,' iv. 3.
Mariano da Pescia. 'Virgin and Child with St Elizabeth and St John,' iv. 5.
Daniele da Volterra (Daniello Ricciarelli). 'Massacre of the Innocents,' iv. 78.
Michelangelo. 'The Holy Family,' iv. 117.
Titian. Portrait of Giovanni de' Medici, iv. 206.
Giulio Clovio. 'Crucifixion,' iv. 248.
Giorgio Vasari. Portrait of Lorenzo de' Medici, iv. 261.

Forlì Gallery

Francesco Francia. 'Nativity,' ii. 122.

Milan, Ambrosiana

Bernardino Zenale (da Trevio). Fragment of tomb of Gaston de Foix, iii. 324.

Milan, Brera Gallery

Andrea Mantegna. Altar-piece of S. Justina, ii. 105.
Raphael. 'Lo Sposalizio' (Marriage of the Virgin), ii. 223.
Pordenone. 'Doctors of the Church,' ii. 336.
Palma Vecchio (Jacopo Palma). 'Adoration of the Magi,' iii. 15.
Niccolò Rondinello. 'St John Consecrating the Church of S. Giovanni, Ravenna,' iii. 18.
Francesco Bonsignori (Monsignori). 'St Louis and St Bernardino,' iii. 36.
Girolamo Genga. 'The Annunciation,' iii. 263.
Tintoretto. 'Scene from the Life of St Mark,' iv. 25.

Modena Gallery

Francesco Ferrari. 'Assumption of the Virgin,' ii. 121.

Naples, National Museum

Donatello (Donato). Sculptured horse's head, i. 307.
Pinturicchio. 'The Assumption,' ii. 117.
Giovanni delle Corniole. 'Cassetta Farnese,' iii. 62.
Fra Bartolommeo. 'The Assumption,' iii. 197.
Raphael. Predella of altar-piece, ii. 225.
Polidoro da Caravaggio. 'Christ Bearing the Cross,' ii. 354.
Marco Cardisco (Marco Calavrese). 'Scenes from the Life of Christ,' iii. 5.
Giulio Romano. 'Virgin and Child' (the 'Madonna of the Cat'), iii. 101.
Sebastiano del Piombo (Sebastiano Viniziano). Portrait of Cardinal Enckenvoort (?), iii. 115.
Titian. Portrait of Pope Paul III, iv. 205.—Portrait of Cardinal Farnese, iv. 206.
Giulio Clovio. 'The Tower of Babel,' iv. 247.

Naples, Pinacoteca

Parmigianino. 'Lucretia,' iii. 12.

Parma Gallery

Francesco Francia. Pietà, ii. 121.
Correggio. 'Virgin and Child,' ii. 173.—'Virgin and St Mary Magdalene,' ii. 173.

Pisa, Accademia
Buonamico Buffalmacco. 'St Ursula Entreated for Aid by Pisa' (allegory), i. 117.

Pisa, Museo Civico
Domenico Ghirlandaio. 'St Roche and St Sebastian, ii. 76.
Sodoma. 'Virgin and Child with Saints,' iii. 292.

Perugia, Pinacoteca
Piero della Francesca. Virgin and Child with Saints, i. 335.
Benedetto Buonfiglio. 'Scenes from the Life of St Ercolano' and other works, ii. 117.
Pietro Perugino. 'Adoration of the Magi' and other works, ii. 130, 131.
Lattanzio. Panel, iii. 226.

Ravenna Gallery
Niccolo Rondinello. 'The Virgin Between St Catherine and St John, iii. 18.
Giorgio Vasari. 'The Deposition,' iv. 316.

Rome, Borghese Gallery
Correggio. 'Leda,' ii. 174.
Raphael. 'The Entombment,' ii. 226.

Rome, Chigi Gallery
Benvenuto Garofalo. 'The Ascension,' iii. 307.

Rome, Colonna Gallery
Salviati. 'Adam and Eve,' iii. 65.

Rome, Corsini Gallery
Fra Bartolommeo. 'The Holy Family,' ii. 194.
Parmigianino (Francesco Mazzuoli). 'Virgin and Child,' iii. 10.

Rome, Doria Gallery
Sebastiano del Piombo (Sebastiano Viniziano). Portrait of Andrea Doria, iii. 116.

Siena Gallery
Beccafumi. 'St Catherine of Siena Receiving the Stigmata, iii. 142.—'The Visitation,' iii. 142.—'Christ's Descent into Hell,' iii. 147.—'Scenes from the Life of the Virgin,' iii. 148.
Girolamo Genga. Frescoes, iii. 262.
Sodoma. 'The Deposition,' iii. 288.

Turin Gallery
Antonio and Piero Pollaiuolo. 'The Angel Raphael with Tobias,' ii. 81.
Franciabigio. 'The Annunciation,' ii. 369.
Paolo Veronese (Paulino). 'The Banquet of Simon,' iii. 283.

Venice, Accademia
Gentile Bellini. 'The Miracle of the Cross,' ii. 45.—' Procession in the Piazza S. Marco,' ii. 47.
Giovanni Bellini. Altar-piece of San Giobbe, ii. 46.
Carpaccio (Vittore Scarpaccia). 'The Legend of St Ursula,' ii, 140.—'The Story of the Martyrs,' ii. 140.—'The Presentation in the Temple,' ii. 140.
Pordenone. Altar-piece, ii. 339.
Palma Vecchio (Jacopo Palma). The 'Tempestà di Mare' (legendary salvation of Venice from storm), iii. 15.
Lorenzo Lotto. 'The Nativity,' iii. 17.
Tintoretto. 'The Miracle of St Mark,' iv. 25.
Titian. 'St John the Baptist in the Wilderness,' iv. 203.—'St John the Almoner,' iv. 204.
Paris Bordone. Altar-piece, iv. 212.—'The Doge receiving the Ring,' iv. 213.

Verona Gallery
Francesco Morone. 'Christ Washing the Disciples' Feet,' iii. 41.—'Madonna with Saints,' iii. 42.
Paolo Morando (Cavazzuola). 'Deposition from the Cross,' iii. 43.—'Madonna Among Clouds with Saints,' iii. 44.
Girolamo dai Libri. 'The Nativity,' iii. 49.

Verona, Museo Civico
Liberale da Verona. 'St Jerome with St Francis and St Paul,' iii. 26.
Giovanni Francesco Caroto. 'St Raphael, St Gabriel and St Michael,' iii. 27.

SPAIN

Madrid, Prado
Fra Angelico. 'The Annunciation' and five smaller panels of altar-piece, i. 338.
Correggio. 'Noli me Tangere,' ii. 174.
Raphael. 'The Madonna del Pesce' ('of the Fish'), ii. 235, 368.—'The Way to Calvary' ('Lo Spasimo di Sicilia'), ii. 238.
Sebastiano del Piombo (Sebastiano Viniziano). 'Christ Bearing the Cross,' iii. 117.
Daniele da Volterra. Pieta, iv. 77.
Titian. 'Bacchanal,' iv. 202.—'The Worship of Venus,' iv. 202.—Portrait of Charles V in armour, iv. 204.—Other portraits of Charles V, iv. 207.—'The Trinity,' iv. 208.—'Prometheus,' iv. 208.—'Sisyphus,' iv. 208.—'Venus and Adonis,' iv. 208.—'Adoration of the Magi,' iv. 209.

Seville Museum
Torrigiano. 'St Jerome,' ii. 210.

UNITED STATES

Boston, Gardner Museum
Titian. 'The Rape of Europa,' iv. 208.

Cambridge, The Fogg Museum.
Spinello Aretino. Part of altar-piece, i. 180.

New York, Frick Collection
Piero della Francesca. 'A Saint.' Presumed part of the S. Agostino altar-piece, i. 333.

New York, Metropolitan Museum
Fra Filippo Lippi. 'St Lawrence and other saints,' ii. 6.
Antonio and Piero Pollaiuolo. 'St Christopher,' ii. 82.
Girolamo dai Libri. The Cartieri altar-piece, iii. 49.
Giovanni delle Corniole. Carved crystal, iii. 62.
Benvenuto Garofalo. 'St Nicholas of Tolentino reviving a child,' iii. 307.

New York, Morgan Library
Girolamo dai Libri. Miniatures, iii. 49.

Washington, National Gallery
Duccio. Panels from altar-piece, i. 166.
Fra Filippo Lippi. The Annunciation, ii. 3.

GLOSSARY

Arricciato. The second of three coats of mortar put on a wall or surface to be painted in fresco. A special mixture of ground marble, brick dust, etc., put on a surface to be painted in oils.

Bargello. An officer of police, a sheriff.

Braccia. A measure of length, roughly two feet, more exactly twenty-three inches.

Calimala, Calimara. The name of the Florentine Art or Guild of the dressers of foreign cloth; probably derived from the name of the street in which the headquarters of the Guild was situated.

Campanile. Bell tower; in Italy often a distinct building from the church to which it belongs.

Canna. A measure, roughly an ell.

Chiaroscuro. A picture in monochrome, in which the effects are obtained by the use of light and shade.

Ciborium. An ornamental tabernacle or vessel, usually on the high altar to receive the consecrated Host.

Corporale. The white linen cloth placed on the altar at the consecration of the Host.

Duomo. Cathedral church.

Eliotropia. A precious stone, emerald-green with red spots.

Fresco, Painting in. Done with variously coloured earths, mixed with pure water on a freshly prepared surface of lime or gypsum.

Friars minor. Franciscans.

Friars Preachers. Dominicans.

Gesso. Material similar to lime, used for making reliefs, or for forming moulds to cast things in relief.

Gonfaloniere. Literally a standard-bearer. The name given to the chiefs of the Florentine guilds, and to the most important magistrate of the city. In 1502 Piero Soderini was made gonfaloniere for life and became thereby the chief man in the state, a position he held until 1512.

Graffito, Sgraffito. A design in outline, scratched on a wall or façade.

Grisaille. Method of painting in grey monotone to represent solid bodies, such as friezes, mouldings, etc., in relief, by means of grey tints.

Julius. A silver coin originally introduced by Pope Julius II.; worth about sixpence.

Macigno. A hard grey stone used for the corners of buildings or for grindstones.

Mandorla. An almond-shaped glory or frame, surrounding the whole figure. Originally this shape represented the vesica piscis or fish shape, because ἰχθύς, the Greek word for fish is made up of the initial letters of the Greek words meaning " Jesus Christ, Son of God, Saviour."

Monte. A bank for advancing money at interest. At Florence pawnbroking was a state monopoly, and the office was known as the Monte di Pietà.

Niello. The filling of an incised design on gold or silver with a black composition.

Noli mi tangere. "Touch me not." The appearance of the risen Christ to Mary Magdalene—John xx. 17.

Opera. Office with the charge of the fabric of a church.

Palm. One-tenth of a *canna.* About five inches.

Pavonazzo di sale. A crimson colouring material obtained from copper mines, mixed with some alkali or salt.

Peperigno. A black volcanic tufa, i.e. rough rock; so called from its colour (*pepe*=pepper).

Piazza. An open space; a public square.

Pietà. Lamentation over the dead Christ. Usually the group of the Virgin Mary with the body across her knees.

Pieve. Parochial church, with priories and rectories under it. Derived from Latin *plebs.*

Piscopio. See *Vescovado.*

Podestà. The principal executive officer of an Italian city state; it was usually necessary that he should be of noble birth, and it was often a condition that he should not be a native of the city where he exercised his functions. Latin *potestas.*

Ponte. A bridge. Ponte Vecchio, the old bridge (at Florence).

Porta. A gate; a door.

Pozzolana. A sand found about Baia and Cuma near Naples, used for making mortar and for stucco-work.

Predella. The step at the top of the altar, forming the base of the altar-piece, on which it was customary to paint miniature scenes related to the subject of the large picture above.

Presepio. The manger. A representation of the scene of the Nativity with figures. A chapel was often set aside for this and so called.

Proveditore. Literally a provider. An official charged to supervise and direct certain functions.

Rio, rivo. Name given to the canals at Venice.

Secco, a. To retouch *a secco* is to paint over a fresco in distemper, when the colours are put on a dry surface, instead of a wet one, as is the case when painting in fresco.

Sgraffito. See *Graffito.*

Stigmata. The marks of the five wounds of Christ in feet, hands and side.

Tazza. A shallow vase, or basin, for receiving water.

Tempera. White and yolk of an egg and water, used for mixing with the colours, for painting; or chalk or clay diluted with weak glue for the same purpose. To paint in tempera was to paint on a dry surface.

Terra verde, terretta verde. A natural green earth, used for painting. Obtained from Monte Baldo near Verona or from Cyprus.

Travertine. A calcareous stone, of white or yellow tint, found near Tivoli.

Tufa. Rock of volcanic origin, of rough or cellular texture.

Verdaccio. A green pigment used to form a groundwork for painting in fresco.

Vescovado, Piscopio. Cathedral church.

CONTENTS

CONTENTS

PART II

GIOTTO

PREFACE TO THE LIVES

I AM aware that it is commonly held as a fact by most writers that sculpture, as well as painting, was naturally discovered originally by the people of Egypt, and also that there are others who attribute to the Chaldeans the first rough carvings of statues and the first reliefs. In like manner there are those who credit the Greeks with the invention of the brush and of colouring. But it is my opinion that design, which is the foundation of both arts, and the very soul which conceives and nourishes in itself every part of the intelligence, came into full existence at the time of the origin of all things, when the Most High, after creating the world and adorning the heavens with shining lights, descended through the limpid air to the solid earth, and by shaping man, disclosed the first form of sculpture and painting in the charming invention of things. Who will deny that from this man, as from a living example, the ideas of statues and sculpture, and the questions of pose and of outline, first took form; and from the first pictures, whatever they may have been, arose the first ideas of grace, unity, and the discordant concords made by the play of lights and shadows? Thus the first model from which the first image of man arose was a clod of earth, and not without reason, for the Divine Architect of time and of nature, being all perfection, wished to demonstrate, in the imperfection of His materials, what could be done to improve them, just as good sculptors and painters are in the habit of doing, when, by adding additional touches and removing blemishes, they bring their imperfect sketches to such a state of completion and of perfection as they desire. God also endowed man with a bright flesh colour, and the same shades may be drawn from the earth, which supplies materials to counterfeit everything which occurs in painting. It is indeed true that it is impossible to feel absolutely certain as to what steps men took for the imitation of the beautiful works of Nature in these arts before the flood, although it appears most probable that even then they practised all manner of painting and sculpture; for Belus, son of

the proud Nimrod, about 200 years after the flood, had a
statue made, from which idolatry afterwards arose; and his
celebrated daughter-in-law, Semiramis, queen of Babylon, in
the building of that city, introduced among the ornaments
there coloured representations from life of divers kinds of
animals, as well as of herself and of her husband Ninus, with
bronze statues of her father, her mother-in-law, and her
grandmother, as Diodorus relates, calling them Jove, Juno, and
Ops, Greek names, which did not then exist. It was, perhaps,
from these statues that the Chaldeans learned to make the
images of their gods. It is recorded in Genesis how 150 years
later, when Rachel was fleeing from Mesopotamia with her
husband Jacob, she stole the idols of her father Laban. Nor
were the Chaldeans singular in making statues and paintings,
for the Egyptians also had theirs, devoting great pains to those
arts, as is shown by the marvellous tomb of that king of remote
antiquity, Osymandyas, described at length by Diodorus, and,
as the severe command of Moses proves, when, on leaving
Egypt, he gave orders that no images should be made to God,
upon pain of death. Moses also, after having ascended the
Mount, and having found a golden calf manufactured and
adored by his people, was greatly troubled at seeing divine
honours accorded to the image of a beast; so that he not only
broke it to powder, but, in the punishment of so great a fault,
caused the Levites to put to death many thousands of the
false Israelites who had committed this idolatry. But as the
sin consisted in adoring idols and not in making them, it is
written in Exodus that the art of design and of making statues,
not only in marble but in all kinds of metal, was given by the
mouth of God himself to Bezaleel, of the tribe of Judah, and to
Aholiab, of the tribe of Dan, who made the two cherubim of
gold, the candlesticks, the veil, and the borders of the sacer-
dotal vestments, together with a number of other beautiful
things in the tabernacle, for no other purpose than to induce
people to contemplate and adore them. From the things seen
before the flood, the pride of man found the means to make
statues of those whose fame they desired to remain immortal
in the world; and the Greeks, who assign a different origin to
this, say that the Ethiopians invented the first statues, according
to Diodorus, the Egyptians imitated these, while the Greeks
followed the Egyptians. From this time until Homer's day it
is clear that sculpture and painting were perfect, as we may
see from the description of Achilles' shield by that divine poet,

who represents it with such skill that the image of it is presented to our minds as clearly as if we had seen the thing itself. Lactantius Firmianus attributes the credit of the invention to Prometheus, who like God fashioned the human form out of clay. But according to Pliny this art was introduced into Egypt by Gyges of Lydia, who, on seeing his shadow cast by the fire, at once drew an outline of himself on the wall with a piece of coal. For some time after that it was the custom to draw in outline only, without any colouring, Pliny again being our authority. Colour was afterwards introduced by Philocles of Egypt with considerable pains, and also by Cleanthes and Ardices of Corinth and by Telephanes of Sicyon. Cleophantes of Corinth was the first of the Greeks to use colours, and Apollodorus was the first to introduce the brush. Polygnotus of Thasos, Zeuxis and Timagoras of Chalcis, Pytheus and Aglaophon followed them, all most celebrated, and after them came the renowned Apelles who was so highly esteemed and honoured for his skill by Alexander the Great, for his wonderful delineation of Calumny and Favour, as Lucian relates. Almost all the painters and sculptors were of high excellence, being frequently endowed by heaven, not only with the additional gift of poetry, as we read in Pacuvius, but also with that of philosophy. Metrodorus is an instance in point, for he was equally skilled as a philosopher and as a painter, and when Apelles was sent by the Athenians to Paulus Æmilius to adorn his triumph he remained to teach philosophy to the general's sons. Sculpture was thus generally practised in Greece, where there flourished a number of excellent artists, among them being Phidias of Athens, Praxiteles and Polycletus, very great masters, Lysippus and Pyrgoteles who were of considerable skill in engraving, and Pygmalion in ivory carving in relief, it being recorded of him that he obtained life by his prayers for the figure of a maid carved by him. The ancient Greeks and Romans also honoured and rewarded painting, since they granted the citizenship and very great honours to those who excelled in this art. Painting flourished in Rome to such an extent that Fabius gave a name to his family, subscribing himself in the beautiful things he did in the Temple of Safety as Fabius the Painter. By public decree slaves were prohibited from practising painting, and so much honour was continually accorded by the people to the art and to artists that rare works were sent to Rome among the spoils to appear in their triumphs; excellent artists who were slaves obtained their liberty and received notable rewards from the

republic. The Romans bore such a reverence for the art, that
when the city of Syracuse was sacked Marcellus gave orders
that his men should treat with respect a famous artist there,
and also that they should be careful not to set fire to a quarter
in which there was a very fine picture. This was afterwards
carried to Rome to adorn his triumph. To that city in the
course of time almost all the spoils of the world were brought,
and the artists themselves gathered there beside their excellent
works. By such means Rome became an exceedingly beautiful
city, more richly adorned by the statues of foreign artists than
by those made by natives. It is known that in the little island
city of Rhodes there were more than 30,000 statues, in bronze
and marble, nor did the Athenians possess less, while those of
Olympus and Delphi were even more numerous, and those of
Corinth were without number, all being most beautiful and of
great price. Does not every one know how Nicomedes, king of
Lycia, expended almost all the wealth of his people owing to
his passion for a Venus by the hand of Praxiteles? Did not
Attalus do the same? who without an afterthought expended
more than 6000 sesterces to have a picture of Bacchus painted
by Aristides. This picture was placed by Lucius Mummius,
with great pomp in the temple of Ceres, as an ornament to Rome.
But although the nobility of this art was so highly valued, it is
uncertain to whom it owes its origin. As I have already said,
it is found in very ancient times among the Chaldeans, some
attribute the honour to the Ethiopians, while the Greeks claim
it for themselves. Besides this there is good reason for supposing
that the Tuscans may have had it earlier, as our own Leon
Battista Alberti asserts, and weighty evidence in favour of this
view is supplied by the marvellous tomb of Porsena at Chiusi,
where not long ago some tiles of terracotta were found under
the ground, between the walls of the Labyrinth, containing
some figures in half-relief, so excellent and so delicately
fashioned that it is easy to see that art was not in its infancy
at that time, for to judge by the perfection of these specimens
it was nearer its zenith than its origin. Evidence to the same
purport is supplied every day by the quantity of pieces of red
and black Aretine vases, made about the same time, to judge
by the style, with light carvings and small figures and scenes
in bas-relief, and a quantity of small round masks, cleverly
made by the masters of that age, and which prove the men of
the time to have been most skilful and accomplished in that
art. Further evidence is afforded by the statues found at Viterbo

at the beginning of the pontificate of Alexander VI., showing that sculpture was valued and had advanced to no small state of perfection in Tuscany. Although the time when they were made is not exactly known, yet from the style of the figures and from the manner of the tombs and of the buildings, no less than by the inscriptions in Tuscan letters, it may be conjectured with great reason that they are of great antiquity, and that they were made at a time when such things were highly valued. But what clearer evidence can be desired than the discovery made in our own day in the year 1554 of a bronze figure representing the Chimera of Bellerophon, during the excavation for the fortifications and walls of Arezzo.[1] This figure shows to what perfection the art had arrived among the Tuscans, in this Etruscan style. Some small letters carved on a paw are presumed, in the absence of a knowledge of the Etruscan language, to give the master's name, and perhaps the date. This figure, on account of its beauty and antiquity, has been placed by Duke Cosimo in a chamber in his palace in the new suite of rooms where I painted the deeds of Pope Leo X. The Duke also possesses a number of small bronze figures of similar character which were found in the same place. But as the antiquity of the works of the Greeks, Ethiopians, Chaldeans, and Tuscans is equally doubtful, like our own or even more so, and because it is necessary in such matters to base one's opinions on conjectures, although these are not so ill founded that one is in danger of going very far astray, yet I think that anyone who will take the trouble to consider the matter carefully will arrive at the same conclusion as I have, that art owes its origin to Nature herself, that this beautiful creation the world supplied the first model, while the original teacher was that divine intelligence which has not only made us superior to the other animals, but like God Himself, if I may venture to say it. In our own time it has been seen, as I hope to show quite shortly, that simple children, roughly brought up in the wilderness, have begun to draw by themselves, impelled by their own natural genius, instructed solely by the example of these beautiful paintings and sculptures of Nature. Much more then is it probable that the first men, being less removed from their divine origin, were more perfect, possessing a brighter intelligence, and that with Nature as a guide, a pure intellect for master, and the lovely world as a model, they originated these noble arts, and by gradually improving them brought them at length,

[1] Now in the Museo Archeologico Florence.

from small beginnings, to perfection. I do not deny that there must have been an originator, since I know quite well that there must have been a beginning at some time, due to some individual. Neither will I deny that it is possible for one person to help another, and to teach and open the way to design, colour, and relief, because I know that our art consists entirely of imitation, first of Nature, and then, as it cannot rise so high of itself, of those things which are produced from the masters with the greatest reputation. But I will say that to declare absolutely it was one man or another is a very dangerous and perhaps unnecessary task, since we have seen the true and original root of all. The works which constitute the life and fame of artists decay one after the other by the ravages of time. Thus the artists themselves are unknown, as there was no one to write about them and could not be, so that this source of knowledge was not granted to posterity. But when writers began to commemorate things made before their time, they were unable to speak of those of which they had seen no notice, so that those who came nearest to these were the last of whom no memorial remains. Thus Homer is by common consent admitted to be the first of the poets, not because there were none before him, for there were, although they were not so excellent, and in his own works this is clearly shown, but because all knowledge of these, such as they were, had been lost two thousand years before.

But we will now pass over these matters, which are too vague on account of their antiquity, and we will proceed to deal with clearer questions, namely, the rise of the arts to perfection, their decline and their restoration or rather renaissance, and here we stand on much firmer ground. The practice of the arts began late in Rome, if the first figures were, as reported, the image of Ceres made of the metal of the possessions of Spurius Cassius, who was condemned to death without remorse by his own father, because he was plotting to make himself king. But although the arts of painting and sculpture continued to flourish until the death of the last of the twelve Cæsars, yet they did not maintain that perfection and excellence which had characterised them before, as we see by the buildings of the time under successive emperors. The arts declined steadily from day to day, until at length by a gradual process they entirely lost all perfection of design. Clear testimony to this is afforded by the works in sculpture and architecture produced in Rome in the time of Constantine, notably in the triumphal arch made

for him by the Roman people at the Colosseum, where we see, that for lack of good masters not only did they make use of marble reliefs carved in the time of Trajan, but also of spoils brought to Rome from various places, Those who recognise the excellence of these bas-reliefs, statues, the columns, the cornices and other ornaments which belong to another epoch will perceive how rude are the portions done to fill up gaps by sculptors of the day. Very rude also are some scenes of small figures in marble below the reliefs and the pediment, representing victories, while between the side arches there are some rivers, also very crude, and so poor that they leave one firmly under the impression that the art of sculpture had begun to decline even before the coming of the Goths and other barbarous and foreign nations who combined to destroy all the superior arts as well as Italy. It is true that architecture suffered less at that time than the other arts of design. The bath erected by Constantine at the entrance of the principal portico of the Lateran contains, in addition to its porphyry columns, capitals carved in marble and beautifully carved double bases taken from elsewhere, the whole composition of the building being very well conceived. On the other hand, the stucco, the mosaic and some incrustations of the walls made by the masters of the time are not equal to those which had been taken away for the most part from the temples of the gods of the heathen, and which Constantine caused to be placed in the same building. Constantine observed the same methods, according to report, with the garden of Æquitius in building the temple which he afterwards endowed and gave to Christian priests. In like manner the magnificent church of S. Giovanni Lateran, built by the same emperor, may serve as evidence of the same fact, namely, that sculpture had already greatly declined in his time, because the figures of the Saviour and of the twelve apostles in silver, which he caused to be made, were very base works, executed without art and with very little design. In addition to this, it is only necessary to examine the medals of this emperor, and other statues made by the sculptors of his day, which are now at the capitol, to perceive clearly how far removed they are from the perfection of the medals and statues of the other emperors there. All these things prove that sculpture had greatly declined long before the coming of the Goths to Italy. Architecture, as I have said, maintained its excellence at a higher though not at the highest level. Nor is this a matter for surprise, since large buildings were almost entirely constructed of spoils, so that

it was easy for the architects in great measure to imitate the old in making the new, since they had the former continually before their eyes. This was an easier task for them than for the sculptors, as the art of imitating the good figures of the ancients had declined. A good illustration of the truth of this statement is afforded by the church of the chief of the apostles in the Vatican, which is rich in columns, bases, capitals, architraves, cornices, doors and other incrustations and ornaments which were all taken from various places and buildings, erected before that time in very magnificent style. The same remarks apply to S. Croce at Jerusalem, which Constantine erected at the entreaty of his mother, Helena; to S. Lorenzo outside the walls, and to S. Agnesa, built by the same emperor at the request of his daughter Constance. Who also is not aware that the font which served for the baptism of the latter and of one of her sisters, was ornamented with fragments of much greater antiquity? such as the porphyry pillar carved with beautiful figures and some marble candelabra exquisitely carved with leaves, and children in bas-relief of extraordinary beauty? In short, by these and many other signs, it is clear to what an extent sculpture had declined in the time of Constantine, and with it the other superior arts. If anything was required to complete their ruin it was supplied by the departure of Constantine from Rome when he transferred the seat of government to Byzantium, as he took with him to Greece not only all the best sculptors and other artists of the age, such as they were, but also a quantity of statues and other beautiful works of sculpture.

After the departure of Constantine, the Cæsars whom he left in Italy were continually building in Rome and elsewhere, endeavouring to make their works as good as possible, but as we see, sculpture, painting and architecture were steadily going from bad to worse. This arose perhaps from the fact that when human affairs begin to decline, they grow steadily worse until the time comes when they can no longer deteriorate any further. In the time of Pope Liberius the architects of the day took considerable pains to produce a masterpiece when they built S. Maria Maggiore, but they were not very happy in the result, because although the building, which is also mostly constructed of spoils, is of very fair proportions, it cannot be denied that, not to speak of other defects, the spaces running round the church above the columns, decorated with stucco and painting, are of very poor design, and that many other things to be seen there leave no doubt as to the imperfection of the arts. Many

years later, when the Christians were suffering persecution under Julian the Apostate, a church was erected on the Celian Hill to SS. John and Paul, the martyrs, in so inferior a style to the others mentioned above that it is quite clear that at that time, art had all but entirely disappeared. The edifices erected in Tuscany at the same time bear out this view to the fullest extent. To take one example among many: the church outside the walls of Arezzo, built to St. Donato, bishop of that city, who suffered martyrdom with Hilarion the monk, under the same Julian the Apostate, is in no way superior to those mentioned above. It cannot be contended that such a state of affairs was due to anything but the lack of good architects, since the church in question, which is still standing,[1] has eight sides, and was built of the spoils of the theatre, colosseum and other buildings erected in Arezzo before it was converted to the Christian faith. No expense was spared, and it was adorned with columns of granite, porphyry and variegated marble taken from ancient buildings. For my own part, I have no doubt, seeing the expense incurred, that if the Aretines had possessed better architects they would have produced something marvellous, since what they actually accomplished proves that they spared nothing in order to make this building as magnificent and complete as possible. But as architecture had lost less of its excellence than the other arts, as I have so often said before, some good things may be seen there. At the same period the church of S. Maria in Grado[2] was enlarged in honour of St. Hilarion, who had lived in the city a long time before he accompanied Donato to receive the palm of martyrdom. But as Fortune, when she has brought men to the top of the wheel, either for amusement or because she repents, usually turns them to the bottom, it came to pass after these things that almost all the barbarian nations rose in divers parts of the world against the Romans, the result being the speedy fall of that great empire, and the destruction of everything, notably of Rome herself. That fall involved the complete destruction of the most excellent artists, sculptors, painters and architects, burying them and their arts under the débris and ruins of that most celebrated city. The first to go were painting and sculpture, as being arts which served rather for pleasure than for utility, the other art, namely architecture, being necessary and useful for the welfare of the

[1] The church was built in the eleventh century. It was fortified by Filippo Strozzi in 1554 against the Emperor Charles V., and was destroyed in 1561 by order of Duke Cosimo to make way for new fortifications.
[2] More usually known as the Pieve.

*B 784

body, continued in use, but not in its perfection and purity. The very memory of painting and sculpture would have speedily disappeared had they not represented before the eyes of the rising generations, the distinguished men of another age who had been honoured thereby. Some of these were commemorated by effigies and by inscriptions placed on public and private buildings, such as amphitheatres, theatres, baths, aqueducts, temples, obelisks, colosseums, pyramids, arches, reservoirs and treasuries, yes, and even on the very tombs. The majority of these were destroyed and obliterated by the savage barbarians, who had nothing human about them but their shape and name. Among others there were the Visigoths, who having made Alaric their king, invaded Italy and twice sacked Rome without respecting anything. The Vandals who came from Africa with Genseric, their king, did the like. But he, not content with his plunder and booty and the cruelties he inflicted, led into servitude the people there, to their infinite woe, and with them Eudoxia the wife of the Emperor Valentinian, who had only recently been assassinated by his own soldiers. These men had greatly degenerated from the ancient Roman valour, because a great while before, the best of them had all gone to Constantinople with the Emperor Constantine, and those left behind were dissolute and abandoned. Thus true men and every sort of virtue perished at the same time; laws, habits, names and tongues suffered change, and these varied misfortunes, collectively and singly, debased and degraded every fine spirit and every lofty soul. But the most harmful and destructive force which operated against these fine arts was the fervent zeal of the new Christian religion, which, after long and sanguinary strife, had at length vanquished and abolished the old faith of the heathen, by means of a number of miracles and by the sincerity of its acts. Every effort was put forth to remove and utterly extirpate the smallest things from which errors might arise, and thus not only were the marvellous statues, sculptures, paintings, mosaics and ornaments of the false pagan gods destroyed and thrown down, but also the memorials and honours of countless excellent persons, to whose distinguished merits statues and other memorials had been set up in public by a most virtuous antiquity. Besides all this, in order to build churches for the use of the Christians, not only were the most honoured temples of the idols destroyed, but in order to ennoble and decorate S. Pietro [1] with more ornaments than it then possessed, they took away the stone columns from the mole

[1] This should be S. Paolo.

of Hadrian, now the castle of S. Angelo, as well as many other things which we now see in ruins.

Now, although the Christian religion did not act thus from any hatred for talent, but only in order to condemn and overthrow the heathen gods, yet the utter ruin of these honourable professions, which entirely lost their form, was none the less entirely due to this burning zeal. That nothing might be wanting to these grave disasters there followed the rage of Totila against Rome, who destroyed the walls, ruined all the most magnificent and noble buildings with fire and sword, burned it from one end to another, and having stripped it of every living creature left it a prey to the flames, so that for the space of eighteen days not a living soul could be found there. He utterly destroyed the marvellous statues, paintings, mosaics and stuccos, so that he left Rome not only stripped of every trace of her former majesty, but destitute of shape and life. The ground floors of the palaces and other buildings had been adorned with paintings, stuccos and statues, and these were buried under the débris, so that many good things have come to light in our own day. Those who came after, judging everything to be ruined, planted vineyards over them so that these ruined chambers remained entirely underground, and the moderns have called them grottos and the paintings found there grotesques. The Ostrogoths being exterminated by Narses, the ruins of Rome were inhabited in a wretched fashion when after an interval of a hundred years there came the Emperor Constans II. of Constantinople, who was received in a friendly manner by the Romans. However, he dissipated, plundered and carried away everything that had been left in the wretched city of Rome, abandoned rather by chance than by the deliberate purpose of those who had laid it waste. It is true that he was not able to enjoy this booty, for being driven to Sicily by a storm at sea, he was killed by his followers, a fate he richly deserved, and thus lost his spoils, his kingdom and his life. But as if the troubles of Rome had not been sufficient, for the things which had been taken away could never return, there came an army of Saracens to ravage that island, who carried away the property of the Sicilians and the spoils of Rome to Alexandria, to the infinite shame and loss of Italy and of all Christendom. Thus what the popes had not destroyed, notably St. Gregory, who is said to have put under the ban all that remained of the statues and of the spoils of the buildings, perished finally through the instrumentality of this traitorous Greek. Not a trace or a vestige of any good thing

remained, so that the generations which followed being rude and coarse, particularly in painting and sculpture, yet feeling themselves impelled by nature and inspired by the atmosphere of the place, set themselves to produce things, not indeed according to the rules of art, for they had none, but as they were instructed by their own intelligence.

The arts of design having arrived at this pitch, both before and during the time that the Lombards ruled Italy, they subsequently grew gradually worse and worse, until at length they reached the lowest depths of baseness. An instance of their utter tastelessness and crudity may be seen in some figures in the Byzantine style over the door in the portico of S. Pietro at Rome, in memory of some holy fathers who had disputed for Holy Church in certain councils. Further evidence is supplied by a number of examples in the same style in the city and in the whole of the Exarchate of Ravenna, notably some in S. Maria Rotonda outside that city,[1] which were made shortly after the Lombards were driven from Italy. I will not deny that there is one very notable and marvellous thing in this church, and that is the vaulting or cupola which covers it, which is ten braccia[2] across and serves as the roof of the building, and yet is of a single piece and so large that it appears impossible that a stone of this description, weighing more than 200,000 pounds, could be placed so high up. But to return to our point, the masters of that day produced nothing but shapeless and clumsy things which may still be seen to-day. It was the same with architecture, for it was necessary to build, and as form and good methods were lost by the death of good artists and the destruction of good buildings, those who devoted themselves to this profession built erections devoid of order or measure, and totally deficient in grace, proportion or principle. Then new architects arose who created that style of building, for their barbarous nations, which we call Gothic, and produced some works which are ridiculous to our modern eyes, but appeared admirable to theirs. This lasted until a better form somewhat similar to the good antique manner was discovered by better artists, as is shown by the oldest churches in Italy which are not antique, which were built by them, and by the palaces erected for Theoderic, King of Italy, at Ravenna, Pavia, and Modena, though the style is barbarous and rather

[1] Known to-day as the Mausoleum of Theoderic.
[2] May be considered roughly to represent about two feet; literally translated it means an arm.

rich and grand than well-conceived or really good. The same may be said of S. Stefano at Rimini and of S. Martino at Ravenna, of the church of S. Giovanni Evangelista in the same city built by Galla Placidia about the year of grace 438, of S. Vitale which was built in the year 547, and of the abbey of Classi di fuori, and indeed of many other monasteries and churches built after the time of the Lombards. All these buildings, as I have said, are great and magnificent, but the architecture is very rude. Among them are many abbeys in France built to St. Benedict and the church and monastery of Monte Cassino, the church of S. Giovanni Battista at Monza built by that Theodelinda, Queen of the Goths, to whom St. Gregory the Pope wrote his dialogues. In this place that queen caused the history of the Lombards to be painted. We thus see that they shaved the backs of their heads, wore their hair thick in front, and were dyed to the chin. Their clothes were of linen, like those worn by the Angles and Saxons, and they wore a mantle of divers colours; their shoes were open to the toes and bound above with small leather straps. Similar to the churches enumerated above were the church of S. Giovanni, Pavia, built by Gundeberga, daughter of Theodelinda, and the church of S. Salvatore in the same city, built by Aribert, the brother of the same queen, who succeeded Rodoald, husband of Gundeberga, in the government; the church of S. Ambruogio at Pavia, built by Grimoald, King of the Lombards, who drove from the kingdom Aripert's son Pentharit. This Pentharit being restored to his throne after Grimoald's death built a nunnery at Pavia called the Monasterio Nuovo, in honour of Our Lady and of St. Agatha, and the queen built another dedicated to the Virgin Mary in Pertica outside the walls. Cunipert, Pentharit's son, likewise built a monastery and church to St. George called di Coronate in a similar style, on the spot where he had won a great victory over Alachis. Not unlike these was the church which the Lombard king Luitprand, who lived in the time of King Pepin, the father of Charlemagne, built at Pavia, called S. Piero, in Cieldauro, or that which Desiderius, who succeeded Astolf, built to S. Piero Clivate in the diocese of Milan; or the monastery of S. Vincenzo at Milan, or that of S. Giulia at Brescia, because all of them were exceedingly costly, but in a most ugly and characterless style. In Florence the style of architecture improved slightly somewhat later, the church of S. Apostolo built by Charlemagne, although small, being very beautiful, because the shafts of the columns, although

made up of pieces, are very graceful and beautifully formed, and the capitals and the arches for the vaulting of the side aisles show that some good architect was left in Tuscany, or had arisen there. In fine the architecture of this church is such that Pippo di Ser Brunellesco did not disdain to make use of it as his model in designing the churches of S. Spirito and S. Lorenzo in the same city. The same progress may be noticed in the church of S. Marco at Venice, not to speak of that of S. Giorgio Maggiore erected by Giovanni Morosini in the year 978. S. Marco's was begun under the Doge Giustiniano and Giovanni Particiaco near to S. Teodosio, when the body of the Evangelist was brought from Alexandria to Venice. After the Doge's palace and the church had suffered severely from a series of fires, it was rebuilt upon the same foundations in the Byzantine style as it stands to-day, at a great cost and with the assistance of many architects, in the time of the Doge Domenico Selvo, in the year 973, the columns being brought from the places where they could be obtained.[1] The construction was continued until the year 1140, M. Piero Polani being then Doge, from the plans of several masters who were all Greeks, as I have said. Erected at the same time, and also in the Byzantine style, were the seven abbeys built in Tuscany by Count Hugh, Marquis of Brandenburg, such as the Badia of Florence, the abbey of Settimo, and the others. All these structures and the vestiges of others which are not standing bear witness to the fact that architecture maintained its footing though in a very bastard form far removed from the good antique style. Further evidence is afforded by a number of old palaces erected in Florence of Tuscan work after the destruction of Fiesole, but the measurements of the very elongated doors and the windows and the sharp-pointed arches after the manner of the foreign architects of the day, denote some amount of barbarism. Subsequently, in 1013, the art appears to have received an access of vigour in the rebuilding of the beautiful church of S. Miniato on the Mount in the time of M. Alibrando,[2] citizen and bishop of Florence, for, in addition to the marble ornamentation both within and without, the façade shows that the Tuscan architects were making efforts to imitate, so far as they were able, the good ancient order in the doors, windows, columns, arches and cornices, which they perceived in part in

[1] S. Marco was begun under Pietro Orseolo in 976. Selvo did not become Doge until 1071.
[2] Ildebrando.

the very ancient church of S. Giovanni in their city. At the same period, pictorial art, which had all but disappeared, seems to have made some progress, as is shown by a mosaic in the principal chapel of the same church of S. Miniato.[1]

From such beginnings design and a general improvement in the arts began to make headway in Tuscany, as in the year 1016 when the Pisans began to erect their Duomo.[2] For at that time it was a considerable undertaking to build such a church, with its five aisles and almost entirely constructed of marble both inside and out. This church, built from the plans and under the direction of Buschetto, a Greek from Dulichium and a most remarkable architect for his time, was erected and adorned by the Pisans when at the zenith of their power with an endless quantity of spoils brought by sea from various distant parts, as the columns, bases, capitals, cornices and other stones there of every description, amply demonstrate. Now since all these things were of all sizes, great, medium, and small, Buschetto displayed great judgment and skill in adapting them to their places, so that the whole building is excellently devised in every part, both within and without. Amongst other things he devised the façade very cleverly, which is made up of a series of stages, gradually diminishing toward the top and consisting of a great number of columns, adorning it with other carved columns and antique statues. He carried out the principal doors of that façade in the same style, beside one of which, that of the Carroccio, he afterwards received honourable burial, with three epitaphs, one being in Latin verse, not unlike other things of the time:

> *Quod vix mille boum possent juga juncta movere,*
> *Et quod vix potuit per mare ferre ratis*
> *Buschetti nisu, quod erat mirabile visu,*
> *Dena puellarum turba levavit onus.*

As I have mentioned the church of S. Apostolo at Florence above, I will here give an inscription which may be read on a marble slab on one of the sides of the high altar, which runs:

VIII. v. Die vi. Aprilis in resurrectione Domini Karolus Francorum Rex a Roma revertens, ingressus Florentiam cum magno gaudio et tripudio succeptus, civium copiam torqueis aureis decoravit. Ecclesia Sanctorum Apostolorum in altari inclusa est lamina plumbea, in qua descripta apparet praefata fundatio et consecratio facta per Archiepiscopum Turpinum, testibus Rolando et Uliverio.

The edifice of the Duomo at Pisa gave a new impulse to the minds of many men in all Italy, and especially in Tuscany, and

[1] The date of the mosaic is 1297. [2] It was begun in 1063.

led to the foundation in the city of Pistoia in 1032 of the church of S. Paolo, in the presence of St. Atto, the bishop there, as a contemporary deed relates,[1] and indeed of many other buildings, a mere mention of which would occupy too much space.

I must not forget to mention either, how in the course of time the round church of S. Giovanni was erected at Pisa in the year 1060, opposite the Duomo and on the same piazza.[2] A marvellous and almost incredible statement in connection with this church is that of an ancient record in a book of the Opera of the Duomo, that the columns, pillars and vaulting were erected and completed in fifteen days and no more. The same book, which may be examined by anyone, relates that an impost of a penny a hearth was exacted for the building of the temple, but it does not state whether this was to be of gold or of base metal. The same book states that there were 34,000 hearths in Pisa at that time. It is certain that the work was very costly and presented formidable difficulties, especially the vaulting of the tribune, which is pear-shaped and covered outside with lead. The exterior is full of columns, carving, scenes, and the middle part of the frieze of the doorway contains figures of Christ and the twelve apostles[3] in half-relief and in the Byzantine style.

About the same time, namely in 1061, the Lucchese, in emulation of the Pisans, began the church of S. Martino at Lucca, from the designs of some pupils of Buschetto, there being no other artists then in Tuscany. The façade[4] has a marble portico in front of it containing many ornaments and carvings in honour of Pope Alexander II., who had been bishop of the city just before he was raised to the pontificate. Nine lines in Latin relate the whole history of the building and of the Pope, repeated in some antique letters carved in marble between the doors of the portico. The façade also contains some figures and a number of scenes in half-relief under the portico relating to the life of St. Martin executed in marble and in the Byzantine style. But the best things there, over one of these doors, were done by Niccola Pisano, 170 years later, and completed in 1233, as will be related in the proper place, Abellenato and Aliprando being the craftsmen at the beginning, as some letters carved in marble in the same place fully relate. The

[1] Atto was not consecrated bishop until 1133, and the land for the church was bought in 1136.
[2] The Baptistery was begun in 1153 by Diotisalvi.
[3] They represent eleven saints.
[4] The façade is of 1204.

figures by Niccola Pisano show to what an extent sculpture was improved by him. Most of the buildings erected in Italy from this time until the year 1250 were similar in character to these, for architecture made little or no apparent progress in all these years, but remained stationary, the same rude style being retained. Many examples of this may be seen to-day, but I will not now enumerate them, because I shall refer to them again as the occasion presents itself.

The admirable sculptures and paintings buried in the ruins of Italy remained hidden or unknown to the men of this time who were engrossed in the rude productions of their own age, in which they used no sculptures or paintings except such as were produced by the old artists of Greece, who still survived, making images of clay or stone, or painting grotesque figures and only colouring the general outline. These artists were invited to Italy for they were the best and indeed the only representatives of their profession. With them they brought the mosaic, sculpture, and painting as they understood them, and thus they taught their own rough and clumsy style to the Italians, who practised the art in this fashion up to a certain time, as I shall relate.

As the men of the age were not accustomed to see any excellence or greater perfection than the things thus produced, they greatly admired them, and considered them to be the type of perfection, barbarous as they were. Yet some rising spirits, aided by some quality in the air of certain places, so far purged themselves of this crude style that in 1250 Heaven took compassion on the fine minds that the Tuscan soil was producing every day, and directed them to the original forms. For although the preceding generations had before them the remains of arches, colossi, statues, pillars or carved stone columns which were left after the plunder, ruin and fire which Rome had passed through, yet they could never make use of them or derive any profit from them until the period named. Those who came after were able to distinguish the good from the bad, and abandoning the old style they began to copy the ancients with all ardour and industry. That the distinction I have made between old and ancient may be better understood, I will explain that I call ancient the things produced before Constantine at Corinth, Athens, Rome and other renowned cities, until the days of Nero, Vespasian, Trajan, Hadrian and Antoninus; the old works are those which are due to the surviving Greeks from the days of S. Silvester, whose art consisted rather of tinting than

of painting. For the original artists of excellence had perished
in the wars, as I have said, and the surviving Greeks, of the
old and not the ancient manner, could only trace profiles on a
ground of colour. Countless mosaics done by these Greeks in
every part of Italy bear testimony to this, and every old church
of Italy possesses examples, notably the Duomo of Pisa, S.
Marco at Venice and yet other places. Thus they produced a
constant stream of figures in this style, with frightened eyes,
outstretched hands and on the tips of their toes, as in S. Miniato
outside Florence between the door of the sacristy and that of
the convent, and in S. Spirito in the same city, all the side of
the cloister towards the church, and in Arezzo in S. Giuliano
and S. Bartolommeo and other churches, and at Rome in old
S. Pietro in the scenes about the windows, all of which are
more like monsters than the representation of anything existing.

They also produced countless sculptures, such as those in
bas-relief still over the door of S. Michele on the piazza Padella
at Florence, and in Ognissanti, and in many places, in tombs
and ornaments for the doors of churches, where there are some
figures acting as corbels to carry the roof, so rude and coarse,
so grossly made, and in such a rough style, that it is impossible
to imagine worse.

Up to the present, I have discoursed upon the origin of
sculpture and painting, perhaps more at length than was neces-
sary at this stage. I have done so, not so much because I have
been carried away by my love for the arts, as because I wish
to be of service to the artists of our own day, by showing them
how a small beginning leads to the highest elevation, and how
from so noble a situation it is possible to fall to utterest ruin,
and consequently, how these arts resemble nature as shown

in our human bodies; and have their birth, growth, age
and death, and I hope by this means they will be enabled
more easily to recognise the progress of the renaissance of
the arts, and the perfection to which they have attained in
our own time. And again, if ever it happens, which God forbid,
that the arts should once more fall to a like ruin and disorder,
through the negligence of man, the malignity of the age, or the
decree of Heaven, which does not appear to wish that the things
of this world should remain stationary, these labours of mine,
such as they are (if they are worthy of a happier fate), by
means of the things discussed before, and by those which
remain to be said, may maintain the arts in life, or, at any
rate, encourage the better spirits to provide them with every

assistance, so that, by my good will and the labours of such men, they may have an abundance of those aids and embellishments which, if I may speak the truth freely, they have lacked until now.

But it is now time to come to the life of Giovanni Cimabue, who originated the new method of design and painting, so that it is right that his should be the first of the Lives. And here I may remark that I shall follow the schools rather than a chronological order. And in describing the appearance and the features of the artists, I shall be brief, because their portraits, which I have collected at great expense, and with much labour and diligence, will show what manner of men they were to look at much better than any description could ever do. If some portraits are missing, that is not my fault, but because they are not to be found anywhere. If it chance that some of the portraits do not appear to be exactly like others which are extant, it is necessary to reflect that a portrait of a man of eighteen or twenty years can never be like one made fifteen or twenty years later, and, in addition to this, portraits in black and white are never so good as those which are coloured, besides which the engravers, who do not know design, always take something from the form, because they are never able to reproduce those small details which constitute the excellence of a work, or to copy that perfection which is rarely, if ever, to be found in wood engravings. To conclude, the reader will be able to appreciate the amount of labour, expense, and care which I have bestowed upon this matter when he sees that I have got the best that I could.

VASARI'S LIVES

PART I

CIMABUE, Painter of Florence [1]
(1240–1302)

THE endless flood of misfortunes which overwhelmed unhappy
Italy not only ruined everything worthy of the name of a
building, but, what is more serious, completely extinguished
the race of artists. Then, as it pleased God, there was born in
the year 1240 in the city of Florence, Giovanni, surnamed
Cimabue, of the noble family of the Cimabui, to shed the first
light on the art of painting. As he grew up he appeared to his
father and others to be a boy of quick intelligence, and
accordingly he was sent to receive instruction in letters to a
relation, a master at S. Maria Novella, who then taught grammar
to the novices of that convent. Instead of paying attention to
his lessons, Cimabue spent the whole day in drawing men,
horses, houses, and various other fancies on his books and odd
sheets, like one who felt himself compelled to do so by nature.
Fortune proved favourable to this natural inclination, for some
Greek artists were summoned to Florence by the government
of the city for no other purpose than the revival of painting in
their midst, since that art was not so much debased as altogether
lost. Among the other works which they began in the city, they
undertook the chapel of the Gondi, the vaulting and walls of
which are to-day all but destroyed by the ravages of time. It
is situated in S. Maria Novella, next the principal chapel. In
this way Cimabue made a beginning in the art which attracted
him, for he often played the truant and spent the whole day
in watching the masters work. Thus it came about that his
father and the artists considered him so fitted to be a painter
that, if he devoted himself to the profession, he might look for
honourable success in it, and to his great satisfaction his father
procured him employment with the painters. Then, by dint of

[1] Modern criticism has deprived Cimabue of practically every work
ascribed to him, and the statements in this life must therefore be accepted
with reserve.

continual practice and with the assistance of his natural talent, he far surpassed the manner of his teachers both in design and in colour. For they had never cared to make any progress, and had executed their works, as we see to-day, not in the good manner of ancient Greece, but in the rude style of that time. Although Cimabue imitated the Greeks he introduced many improvements in the art and in a great measure emancipated himself from their stiff manner, bringing honour to his country by his name and by the works which he produced. The pictures which he executed in Florence bear testimony to this, such as the reredos of the altar of St. Cecilia,[1] and a Madonna on a panel in S. Croce, which was then and still is fastened to a pillar on the right hand side of the choir.[2] Subsequently he painted on a panel a S. Francis, on a gold ground.[3] He drew this from nature, to the best of his powers, although it was a novelty to do so in those days, and about it he represented the whole of the saint's life in twenty small pictures full of little figures, on a gold ground. He afterwards undertook a large picture for the monks of Vallombrosa in their abbey of S. Trinità at Florence. This was a Madonna with the Child in her arms, surrounded by many adoring angels, on a gold ground. To justify the high opinion in which he was already held, he worked at it with great industry, showing improved powers of invention and exhibiting Our Lady in a pleasing attitude. The painting when finished was placed by the monks over the high altar of the church, whence it was afterwards removed to make way for the picture of Alesso Baldovinetti, which is there to-day.[4] It was afterwards placed in a minor chapel of the left aisle in that church. Cimabue next worked in fresco at the hospital of the Porcellana, at the corner of the via Nuova which leads to the Borgo Ognissanti. On one side of the façade, in the middle of which is the principal door, he represented an Annunciation, and on the other side, Jesus Christ with Cleophas and Luke, life-size figures. In this work he abandoned the old manner, making the draperies, garments, and other things somewhat more lifelike, natural and soft than the style of the Greeks, full as that was of lines and profiles as well in mosaics as in painting. The painters of those times had taught one another that rough, awkward and commonplace style for a

[1] Now in the Uffizi Gallery, Florence; considered to belong to the school of Giotto.
[2] This seems to be the picture now in the National Gallery, London.
[3] Still in S. Croce, but attributed to Margaritone.
[4] Now in the Uffizi, Florence.

great number of years, not by means of study but as a matter of custom, without ever dreaming of improving their designs by beauty of colouring or by any invention of worth.

After this was finished Cimabue again received a commission from the same superior for whom he had done the work at S. Croce. He now made him a large crucifix of wood, which may still be seen in the church. The work caused the superior, who was well pleased with it, to take him to their convent of S. Francesco at Pisa, to paint a picture of St. Francis there. When completed it was considered most remarkable by the people there, since they recognised a certain quality of excellence in the turn of the heads and in the fall of the drapery which was not to be found in the Byzantine style in any work executed up to that time either in Pisa or throughout Italy.[1]

For the same church Cimabue afterwards painted a large picture of Our Lady with the Child in her arms, surrounded by several angels, on a gold ground.[2] In order to make room for the marble altar which is now there it was soon afterwards removed from its original situation and placed inside the church, near the door on the left hand. For this work he was much praised and rewarded by the Pisans. In Pisa also he painted a small panel of S. Agnes surrounded by a number of little figures representing scenes from her life, at the request of the Abbot of S. Paolo in Ripa d'Arno. The panel is to-day over the altar of the Virgin in that church.

The name of Cimabue having become famous through these works, he was taken to Assisi, a city of Umbria, where, in conjunction with some Greek masters, he painted a part of the vaulting of the lower church of S. Francesco, and on the walls, the life of Jesus Christ and that of St. Francis. In these paintings he far surpassed the Greek masters, and encouraged by this, he began unaided to paint the upper church in fresco,[3] and in four sections of the principal tribune above the choir, he painted some subjects from the history of Our Lady, that is to say, her death, when her soul is carried to heaven by Christ on a throne of clouds, and when He crowns her in the midst of a choir of angels, with a number of saints beneath. These are now destroyed by time and dust. He then painted several things at the intersections of the vaulting of that church, which are five in number.

[1] This work is at present attributed to Margaritone.

[2] Now in the Louvre, Paris.

[3] Painting *al fresco*, upon fresh or wet ground, is executed with mineral and earthy pigments upon a freshly laid stucco ground of lime or gypsum.—*Fairholt*.

In the first one over the choir he represented the four Evangelists, larger than life-size, and so well done, that even to-day they are acknowledged to possess some merit; and the freshness of the flesh colouring shows that, by his efforts, fresco-painting was beginning to make great progress. The second intersection he filled with gold stars on an ultramarine field. In the third he represented Jesus Christ, the Virgin his mother, St. John the Baptist and St. Francis in medallions, that is to say, a figure in each medallion and a medallion in each of the four divisions of the vaulting. The fourth intersection like the second he painted with gold stars on ultramarine. In the fifth he represented the four Doctors of the Church, and beside each of them a member of the four principal religious orders. This laborious undertaking was carried out with infinite diligence. When he had finished the vaulting he painted the upper part of the walls on the left side of the church from one end to the other, also in fresco. Near the high altar between the windows and right up to the vaulting he represented eight subjects from the Old Testament, starting from the beginning of Genesis and selecting the most noteworthy incidents. In the space flanking the windows to the point where they terminate at the gallery which runs round the inside of the church, he painted the remainder of the Old Testament history in eight other scenes. Opposite these and corresponding to them he painted sixteen subjects representing the deeds of Our Lady and of Jesus Christ, while on the end wall over the principal entrance and about the rose window above it, he painted the Ascension and the descent of the Holy Spirit upon the apostles. This truly great work, so richly and finely executed, must, in my opinion, have astounded the people of those times, especially as painting had been in such blindness for so long a space. When I saw it again in the year 1563 it seemed most beautiful, as I reflected how marvellous it was that Cimabue should see so much light in the midst of so great darkness. But it is worthy of note that of all these paintings those of the vaulting are much the best preserved since they are less injured by the dust and other accidents.[1] When these works were finished Giovanni set about painting the walls beneath, namely those beneath the windows, and he did some things there, but as he was summoned to Florence on some affairs of his own, he did not pursue the task, which was finished by Giotto many years after, as will be related when the time comes.

[1] Modern criticism denies the handiwork of Cimabue in these frescoes, and attributes them to painters of the Roman School.

Cimabue having thus returned to Florence painted in the cloister of S. Spirito, where the whole length of wall over against the church is done in the Byzantine style by other masters, events from the life of Christ, in three small arches, with considerable excellence of design. At the same time, he sent to Empoli some things executed by him in Florence, which are held in great reverence to this day in the Pieve of that town. He next painted a picture of Our Lady for the church of S. Maria Novella, where it hangs high up between the chapel of the Rucellai and that of the Bardi of Vernio. The figure was of a larger size than any which had been executed up to that time, and the angels about it show that, although he still had the Byzantine style, he was approaching in some respects the treatment and methods of modern times. The people of that day, who had never seen anything better, considered this work so marvellous, that they carried it to the church from Cimabue's house in a stately procession with great rejoicing and blowing of trumpets, while Cimabue himself was highly rewarded and honoured. It is reported, and some records of the old painters relate that while Cimabue was painting this picture in some gardens near the gate of S. Piero, the old King Charles of Anjou[1] passed through Florence. Among the many entertainments prepared for him by the men of the city, they brought him to see the picture of Cimabue. As it had not then been seen by anyone, all the men and women of Florence flocked thither in a crowd, with the greatest rejoicings, so that those who lived in the neighbourhood called the place Borgo Allegri (Joyful Quarter), because of the rejoicing there.[2] This name it has ever afterwards retained, being in the course of time enclosed within the walls of the city.

At S. Francesco, at Pisa, where Cimabue executed some other works which have been mentioned, there is a small picture in tempera[3] by his hand above, in the cloister, at a corner beside the doorway leading into the church, representing Christ on the cross, surrounded by some angels who are weeping, and holding in their hands certain words written about the head of Christ,

[1] The brother of St. Louis, crowned king of Sicily in 1266.

[2] The Rucellai Madonna is now confidently attributed to the Sienese master Duccio, both from the style of the painting and because Duccio is shown to have been commissioned to paint a picture for S. Maria Novella. There is difficulty about accepting Vasari's story, because when the old King Charles of Anjou, brother of St. Louis, was in Florence, S. Maria Novella had not been begun.

[3] A method in which the pigments are mixed with chalk or clay and diluted with size.

which they are directing towards the ears of our Lady, who is standing weeping on the right-hand side; and on the other side to St. John the Evangelist, who stands plunged in grief. The words to the Virgin are: "*Mulier, ecce filius tuus*," and those to St. John: "*Ecce mater tua.*" Another angel, separated from these, holds in its hands the sentence: "*Ex illa hora accepit eam discipulus in suam.*" In this we perceive how Cimabue began to shed light and open the way to inventions, bringing words, as he does here, to the help of his art in order to express his meaning—a curious device, certainly, and an innovation.

By means of these works Cimabue had now acquired a great name and much profit, so that he was associated with Arnolfo Lapi, an excellent architect of that time, in the building of S. Maria del Fiore, at Florence. But at length, when he had lived sixty years, he passed to the other life in the year 1300, having achieved hardly less than the resurrection of painting from the dead.

He left behind a number of disciples, and among others Giotto, who was afterwards an excellent painter. Giotto dwelt in his master's old house in the via del Cocomero after Cimabue's death. Cimabue was buried in S. Maria del Fiore, with this epitaph made for him by one of the Nini:

> Credidit ut Cimabos picturæ castra tenere;
> Sic tenuit vivens, nunc tenet astra poli.

I must not omit to say that if the greatness of Giotto, his pupil, had not obscured the glory of Cimabue, the fame of the latter would have been more considerable, as Dante points out in his *Commedia* in the eleventh canto of the *Purgatorio*, with an allusion to the inscription on the tomb, where he says:

> Credette Cimabue nella pintura
> Tener lo campo, ed ora ha Giotto il grido,
> Si che la fama di colui oscura.[1]

A commentator on Dante,[2] who wrote during Giotto's life-time, about 1334, some ten or twelve years after the poet's death, in his explanation of these lines, says the following words in speaking of Cimabue: "Cimabue was a painter of Florence in the time of our author, a man of unusual eminence and so arrogant and haughty withal, that if any one pointed out a

[1] "Cimabue thought
 To lord it over painting's field; and now
 The cry is Giotto's, and his name eclips'd."—*Cary.*
[2] Known as the *Anonimo*, first published at Pisa, 1827-30.

fault or defect in his work, or if he discovered any himself, since it frequently happens that an artist makes mistakes through a defect in the materials which he employs, or because of some fault in the instrument with which he works, he immediately destroyed that work, however important it might be. Giotto was, and is, the most eminent among the painters of the same city of Florence, as his works testify, at Rome, Naples, Avignon, Florence, Padua, and many parts of the world," etc. This commentary is now in the possession of the Very Rev. Vincenzio Borghini, prior of the Innocents, a man distinguished for his noble nature, piety and learning, but also for his love and knowledge in all the fine arts, so that he has well deserved his judicious selection by Duke Cosimo to be his representative in our academy of design.

Returning to Cimabue, Giotto certainly overshadowed his renown, just as a great light eclipses a much smaller one, and although Cimabue was, as it were, the first cause of the revival of the art of painting, yet Giotto, his disciple, moved by a praiseworthy ambition, and aided by Heaven and by Nature, penetrated deeper in thought, and threw open the gates of Truth to those who afterwards brought art to that perfection and grandeur which we see in our own age. In fact the marvels, miracles, and impossibilities daily executed at the present time by those who practise this art, have brought things to such a pitch, that no one marvels at them although they are rather divine than human, and those who make the most praiseworthy efforts may consider themselves fortunate, if, instead of being praised and admired, they escape censure, and even disgrace. The portrait of Cimabue by the hand of Simone of Siena may be seen in the chapter-house of S. Maria Novella,[1] executed in profile in the picture of the Faith. The face is thin, the small beard is somewhat red and pointed, and he wears a hood after the fashion of the day, bound gracefully round his head and throat. The one beside him is Simone himself, the author of the work, who drew himself with the aid of two mirrors placed opposite each other, to enable him to draw his head in profile. The soldier in armour in the group is said to be Count Guido Novello, lord of Poppi. I need only add that I have some small things by Cimabue's hand in the beginning of a book in which I have collected drawings by the hand of every artist, from

[1] The identity is disputed. The figure is in French costume, and it has been conjectured that it represents the Duke of Athens, captain and protector of Florence, expelled by a popular rising in 1343.

Cimabue onwards.[1] These little things of Cimabue are done like miniatures, and although they may appear rather crude than otherwise to modern eyes, yet they serve to show to what an extent the art of design profited by his labours.

ARNOLFO DI LAPO, Florentine Architect

(1232–1302)

IN the preface to these lives I have spoken of some edifices in the old but not antique style, and I was silent respecting the names of the architects who executed the work, because I did not know them. In the introduction to the present life I propose to mention some other buildings made in Arnolfo's time, or shortly before, the authors of which are equally unknown, and then to speak of those which were erected during his lifetime, the architects of which are known, either because they may be easily recognised through the style of the buildings, or because there is some notice of them in the writings and memorials left by them in the works done. This will not be beside the point, for although the buildings are neither beautiful nor in good style, but only very large and magnificent, yet they are none the less worthy of some consideration.

In the time of Lapo, and of Arnolfo his son,[2] many buildings of importance were erected in Italy and outside, of which I have not been able to find the names of the architects. Among these are the abbey of Monreale in Sicily, the Bishop's palace of Naples, the Certosa of Pavia, the Duomo of Milan, S. Pietro and S. Petronio of Bologna, and many others, which may be seen in all parts of Italy, erected at incredible cost. I have seen and examined all these buildings, as well as many sculptures of those times, particularly at Ravenna, but I have never found any memorial of the masters, and frequently not even the date when they were erected, so that I cannot but marvel at the simplicity and indifference to fame exhibited by the men of that age. But to return to our subject. After the buildings just

[1] It is stated that the knight Gaddi sold five volumes of drawings to some merchants for several thousands of scudi, which composed Vasari's famous book, so often referred to by him. Card. Leopold de' Medici collected several of those by the most famous artists. This collection was sent to the Uffizi Gallery in 1700, where they are merged with the other drawings.

[2] Arnolfo was not the son of Lapo, but of Cambio of Colle di Val d'Elsa. He was a fellow-pupil of Lapo under Niccola Pisano.

enumerated there arose some persons of a more exalted temper, who, if they did not succeed in lighting upon the good, at least made the attempt.

The first was Buono,[1] of whom I know neither the country nor the surname, since he himself has put nothing beyond his simple name to the works which he has signed. He was both a sculptor and architect, and he worked at first in Ravenna, building many palaces and churches, and executing some sculptures, in the year of grace 1152. Becoming known by these things, he was summoned to Naples, where he began the Castel Capoano and the Castel dell' Uovo, although they were afterwards finished by others, as will be related. Subsequently, in the time of the Doge Domenico Morosini, he began the campanile of S. Marco at Venice,[2] with much prudence and good judgment, and so well did he drive the piles and lay the foundations of that tower, that it has never moved a hair's breadth, as many buildings erected in that city before his time may be seen to have done. Perhaps it was from him that the Venetians learned their present method of laying the foundations of the rich and beautiful edifices which are erected every day to adorn that most noble city. At the same time it must be admitted that the tower has no other excellence of its own, either in style or decoration, or indeed anything which is worthy of much praise. It was finished under the Popes Anastasius IV. and Adrian IV. in the year 1154. Buono was also the architect of the church of S. Andrea at Pistoia,[3] and a marble architrave over the door, full of figures executed in the Gothic style, is his work. On this architrave his name is carved, as well as the date at which the work was done by him, which was in the year 1166. Being afterwards summoned to Florence, he prepared the design for enlarging the church of S. Maria Maggiore,[4] which was carried out. The church was then outside the city, and was held in veneration, because Pope Pelagius had consecrated it many years before, and because it was in size and style a building of considerable merit.

Buono was next invited by the Aretines to their city, where he built the old residence of the lords of Arezzo, a palace in the Gothic style,[5] and near it a tower for a bell. This building, which

[1] Vasari has confused more than one architect under this name.

[2] Bartolommeo Buono of Bergamo was architect of the Campanile, but it was begun long before his time.

[3] The architect was Gruamonte.

[4] By Buono of Florence.

[5] The Palazzo dei Signori was built in 1232.

was very tolerable for that style, was pulled down in 1533 because it was opposite and too near the citadel.

The art now began to receive some amount of improvement through the works of a certain Guglielmo, a German by race, as I believe, and some buildings were erected at a great expense and in a slightly better style. In the year 1174 this Guglielmo, in conjunction with Bonanno, a sculptor, is said to have founded the campanile of the Duomo at Pisa,[1] where the following words are carved:

A.D. M.C. 74 *campanile hoc fuit fundatum mense Aug.*

But these two architects had not much experience in laying foundations in Pisa, and since they did not drive in piles as they should have done, before they were half through the work, there was a subsidence on one side, and the building leant over on its weaker side, so that the campanile hangs 6½ braccia out of the straight where the foundations have given way, and although this appears slight from below, it is very apparent above, so that one is filled with amazement that the tower can stand thus without falling and without cracks starting. The reason is that the building is round both within and without, hollow like a well, and the stones are so joined and bound together, that its fall is all but impossible, and it is supported moreover by foundations raised three braccia above the ground level, which were made to maintain it after the subsidence had taken place, as may be seen. Had it been square, I am convinced that it would not be standing to-day, as in that case it would have bulged at the angles and so fallen, a thing which we see happen frequently. And if the Carisenda tower at Bologna, which is square, leans without falling, that is because it is slighter and does not hang over so much, nor is it nearly so heavy a structure as this campanile, which is praised, not because of its design or good style, but simple by reason of its remarkable character, since to a spectator it does not appear possible that it can remain standing. The Bonanno mentioned above, while he was engaged on the campanile, also executed in 1180 the principal door of the Duomo of Pisa in bronze.[2] On it may be seen these words:

Ego Bonannus Pis. mea arte hanc portam uno anno perfeci
tempore Benedicti operarii.

That the art was making steady progress may be seen by

[1] Bonanno only did the lower part. William of Innsbruck took over the work in 1234 and completed the three upper galleries.
[2] Destroyed by fire in 1596.

the walls of S. Giovanni Lateran at Rome, which were con-
structed of the spoils of antiquity under Popes Lucius III. and
Urban III., when the Emperor Frederick was crowned by the
latter, because certain small temples and chapels there, made
with these spoils, possess considerable merit of design and
contain some things which are worth notice, and this, among
others, that the vaulting was made of small nerves filled in
with stucco, so as not to overload the side walls of the buildings,
a very praiseworthy contrivance for those times. The cornices
and other parts show that the artists were helping one another
to find the good.

Innocent III. afterwards caused two palaces to be erected
on the Vatican hill, and so far as can be ascertained they appear
to have been in a fairly good style, but since they were destroyed
by other popes, and especially by Nicholas V., who pulled down
and rebuilt the greater part of the palace, I will say no more
about them, except that a part of them may be seen in the
great round tower, and a part in the old sacristy of S. Pietro.
This Innocent III., who occupied St. Peter's chair for nineteen
years, took great delight in architecture, and erected many
buildings in Rome, notably the tower of the Conti, so called
after the name of his family, from designs by Marchionne, an
architect and sculptor of Arezzo. In the year that Innocent died
this artist completed the Pieve of Arezzo, as well as the cam-
panile. He adorned the front of the church with three rows of
columns, one above the other, in great variety, not only in the
shape of the capitals and bases, but even in the shafts, some
being heavy, others slender, some bound together in pairs,
others in fours.[1] In like manner some are twisted in the manner
of vine stems, while others are made to become supporting
figures, variously carved. He further introduced many animals
of different kinds, which carry the weight of the columns on
their backs, the whole exhibiting the strangest and most ex-
travagant fantasies imaginable, not only altogether removed
from the excellent antique order, but opposed to all good and
reasonable proportion. Yet in spite of all this, anyone who will
justly consider the matter will see that he was making strenuous
efforts to do well, and possibly he imagined that he had dis-
covered the way in this manner of work and in this wondrous
variety. The same artist carved a God the Father, with certain
angels of great size in half-relief in the arch over the door of

[1] The original façade was of the eleventh century. Marchionne merely
restored this, adding the colonnading and sculpture work.

that church in a rude style, together with the twelve months
of the year, adding underneath his name, cut in round letters,
as was customary, and the date, 1216. It is said that Marchionne
also erected for Pope Innocent the old building and church of
the hospital of S. Spirito in Sassia, in the Borgo Vecchio at
Rome, where some part of the old work may still be seen.
Indeed the old church remained standing to our own day, when
it was restored in the modern style, with more ornament and
design, by Pope Paul III. of the house of the Farnesi. In
S. Maria Maggiore, also in Rome, he made the marble chapel,
which contains the manger of Jesus Christ, in which he placed
a portrait of Pope Honorius III., drawn from life.[1] He also made
that Pope's tomb, decorating it with ornaments which were
somewhat better than, and very different from, the style then
prevalent throughout Italy. At the same time also Marchionne
made the lateral door of S. Pietro at Bologna, which truly was
a very great work for those times, because of the number of
sculptures which are seen in it, such as lions in relief, which
sustain columns, with men like porters and other animals, also
bearing burdens. In the arch above he made the twelve months
in relief, with varied fancies, each month with its zodiacal sign,
a work which must have been considered marvellous in those
times.[2]

About the same time the order of the friars minors of St.
Francis being established and confirmed by Pope Innocent III.
in 1206 (*rectius* 1216), religious feeling and the number of
friars increased, not only in Italy, but in every part of the
world, to such an extent, that there was scarcely a city of note
which did not build churches and convents for them at very
great cost, each one according to its ability. Thus brother Elias,
acting as superior of that order at Assisi, founded a church,
dedicated to Our Lady in that place, two years before the death
of St. Francis, while the saint, as general of the order, was away
preaching. After the death of St. Francis all Christendom crowded
to visit the body of a man, who, both in life and in death, was
known to have been so much beloved of God. As every man
did alms to the saint according to his ability, it was determined
that the church begun by friar Elias should be made much
larger and more magnificent. But since there was a scarcity of
good architects, and as the work demanded an excellent one,
it being necessary to erect the building on a very high hill,

[1] See note added at end of life. Probably Honorius IV.
[2] The months are anterior to Marchionne, but the lunette is his.

round the base of which runs a torrent called Tescio, a German master named Jacopo was brought to Assisi after much deliberation, as being the best man who was then to be found. After he had examined the site and understood the wishes of the friars, who held a chapter general at Assisi for the purpose, he designed a most beautiful church and convent,[1] making a model for it in three stories. One of these was underground, while the two others served as churches, the lower one for perambulating, with a portico of considerable size before it, the other as the church proper. The ascent from the first to the second was managed by means of a very convenient arrangement of steps, which encircled the principal chapel and which were divided into two flights to enable the second church to be reached with more ease. He made this in the form of the letter T, the length being five times the breadth, dividing one nave from the other by great stone pillars, uniting them with stout arches, with cross vaulting between. This truly monumental work then was carried out from the model in every detail, except the buttresses on either side of the choir and the principal chapel, as they did not put up the cross vaulting as designed, but employed barrel vaulting for the sake of greater strength. He afterwards placed the altar before the principal chapel of the lower church, and when this was finished he deposited the body of St. Francis beneath, after a most solemn translation. And because the tomb of the glorious saint is in the first, or lower, church, where no one ever goes, and which has its doors walled up, there is a magnificent iron railing about the altar, richly adorned with marble and mosaic, which permits the tomb to be seen. On one side of the building were erected two sacristies and a lofty campanile, five times as high as it is broad. Above it there was originally a lofty octagonal spire, but it was removed because it threatened to fall down. The work was brought to completion in the space of four years and no more by the skill of Master Jacopo the German, and by the industry of Friar Elias. After the friar's death, twelve strong towers were erected about the lower church in order that the vast erection should never be destroyed; in each of these is a spiral staircase ascending from the ground to the summit. In the course of time, moreover, several chapels were added and other rich ornaments, of which it is not necessary to speak further, as enough has been said about the matter for the present, especially as it is in the power of everyone to see

[1] Begun in 1228.

how much that is useful, ornamental and beautiful has been added to this beginning of Master Jacopo by popes, cardinals, princes, and many other great persons of all Europe.

And now to return to Master Jacopo. By means of this work he acquired such renown throughout Italy that he was invited to Florence by the government of the city, and was afterwards received there with the utmost goodwill. But the Florentines, in accordance with a custom of abbreviating names which they practised then as they do now, called him not Jacopo, but Lapo, all his life, for he settled permanently in that city with all his family. And although at divers times he went away to erect a number of buildings in Tuscany, his residence was always at Florence. For example, he built the palace of the Poppi at Casentino for the count there, who had married the beautiful Gualdrada, with the Casentino as her dower; the Vescovado[1] for the Aretines, and the Palazzo Vecchio of the lords of Pietramela. It was at Florence that he laid the piles of the alla Carraia bridge, then called the new bridge, in 1218, and finished them in two years. A short while afterwards the bridge was completed in wood, as was then the custom. In the year 1221 he prepared plans for the church of S. Salvadore del Vescovado, which was begun under his direction, as was the church of S. Michele on the piazza Padella, where there are some sculptures in the style of those days. He next planned a system of drainage for the city, raised the level of the piazza S. Giovanni, and in the time of M. Rubaconte da Mandella of Milan,[2] constructed the bridge which still bears that official's name. It was he who invented the useful method of paving the streets with stone, when they had previously been paved only with bricks. He designed the existing Podestà palace, which was originally built for the *anziani*,[3] and finally, after he had designed the tomb of the Emperor Frederick for the abbey of Monreale in Sicily, by the order of Manfred, he died, leaving Arnolfo, his son, heir to his ability, no less than to his fortune.

Arnolfo, by whose talents architecture was no less improved than painting had been by Cimabue, was born in the year 1232, and was thirty years of age at his father's death. He was at that time held in very great esteem, because, not only had he learned all that his father had to teach, but had studied

[1] Begun 1218 by Lapo, continued by Margaritone 1274, and finished 1289.
[2] M. Rubaconte was podestà of Florence in 1237, and in addition to laying the foundation-stone of this bridge, he also caused the city to be paved. *Villani*, vi. 26. The bridge is now known as the Ponte alle Grazie.
[3] i.e. Elders, members of the governing body.

design under Cimabue in order to make use of it in sculpture, so that he was reputed the best architect in Tuscany. Thus not only did the Florentines, under his direction, begin the outer circuit of the walls of their city in the year 1284, but they also built, after his design, the loggia and pillars of Or San Michele, where grain was sold, constructing it of brick with merely a roof above. It was also in conformity with his advice that, when the cliff of the Magnoli fell, on the slope of S. Giorgio above S. Lucia in the via dei Bardi,[1] a public decree was issued the same year that no walls or edifices should ever more be erected in that place, seeing that they would always be in danger owing to the undermining of the rock by water. That they were right has been seen in our own day when many buildings and fine houses of the aristocracy have been destroyed. The year after, 1285, Arnolfo began the loggia and piazza of the priors, and in the Badia of Florence he constructed the principal chapel and those on either side of it, restoring both the church and choir, which had originally been built on a much smaller scale by Count Ugo, the founder. For the Cardinal Giovanni degli Orsini, papal legate in Tuscany, he built the campanile of that church, which won great praise among the works of those times, but it did not receive its stone finishing until after the year 1330. His next work was the foundation, in 1294, of the church of S. Croce, where the friars minor are. Arnolfo designed the nave and side aisles of this church on such a large scale that he was unable to vault the space under the roof owing to the great distances, so with much judgment he made arches from pillar to pillar, and over these he placed the roof, with stone gutters along the top of the arches to carry off the water, inclined at such an angle that the roof should be safe, as it is, from the danger of damp. This thing was so novel and ingenious that it well deserves the consideration of our day. He next prepared plans for the first cloisters of the old convent of that church, and shortly after he removed from the outside of the church of S. Giovanni all the sarcophagi and tombs of marble and stone which were there, and put a part of them behind the campanile in front of the Canonical Palace, beside the oratory of St. Zanobius, when he proceeded to incrust all the eight sides of the exterior of the church with black Prato marble, removing the rough stone which was originally used along with the antique marbles.

In the meantime the Florentines were desirous of erecting

[1] This landslip occurred on 2 April, 1284, after heavy rain and floods, destroying over fifty houses. Villani, *Croniche*, lib. vii. cap. 97.

buildings at S. Giovanni and Castelfranco in the upper Valdarno
for the convenience of the city and for the supply of victuals to
their markets. Arnolfo prepared the plan for this in the year
1295, and gave such general satisfaction, as indeed he had in his
other works, that he was awarded the citizenship of Florence.

After these things the Florentines took counsel together, as
Giovanni Villani relates in his History,[1] to build a principal
church for their city, and to make it so grand and magnificent
that nothing larger or finer could be desired by the industry
and power of man; and thus Arnolfo prepared the plans for the
church of S. Maria del Fiore, a building which it is impossible
to praise too highly. He provided that the exterior should be
entirely incrusted with polished marble, with all the cornices,
pillars, columns, carvings of leaves, figures, and other things
which may be seen to-day, and which were brought very near
completion, although not quite. But the most marvellous cir-
cumstance of all in this undertaking was the care and judgment
with which he laid the foundations, for in clearing the site,
which is a very fine one, other small churches and houses about
S. Reparata were involved beside that edifice itself. He made
the foundations of this great structure both broad and deep,
filling them with good materials, such as gravel and lime, with
large stones at the bottom, so that they have been able without
difficulty to bear the weight of the huge dome with which
Filippo di Ser Brunellesco vaulted the church, as may be seen
to-day. The excellence of this initial work was such that the
place is still called Lungo i Fondamenti (beside the foundations).
The laying of the foundations and the initiation of so great a
church was celebrated with much ceremony. The first stone
was laid on the day of the Nativity of Our Lady, 1298,[2] by the
cardinal legate of the Pope, in the presence not only of many
bishops and of all the clergy, but also of the podestà, captains,
priors and other magistrates of the city, and indeed of all the
people of Florence, the church being called S. Maria del Fiore.
Now, as it was estimated that the expenses of this work would
be very heavy, as they afterwards proved to be, a tax of four
deniers the pound was imposed at the chamber of the commune
on everything exported from the city, as well as a tax of two
soldi per head yearly. In addition to this, the Pope and the
legate offered the most liberal indulgences to those who would
contribute alms towards the work. I must not omit to mention,
however, that besides the broad foundations of fifteen braccia

[1] *Croniche*, lib. viii. cap. 9.　　　　[2] Villani gives the date as 1294.

deep, buttresses were, with great foresight, placed at each angle
of the eight sides, and it was the presence of these which en-
couraged Brunellesco to impose a much greater weight there
than Arnolfo is likely to have contemplated.

It is said that, when Arnolfo began the two first lateral doors
of S. Maria del Fiore, he caused some fig-leaves to be carved
in a frieze, which were the armorial bearings of himself and his
father Lapo, from which it may be inferred that the family of
the Lapi, now among the nobility of Florence, derives its origin
from him. Others say that Filippo di Ser Brunellesco was also
among the descendants of Arnolfo. But I let this pass for what
it may be worth, for there are some who say that the Lapi
originally came from Figaruolo, a place situated at the mouth
of the Po. Returning to Arnolfo, I say that for this magnificent
achievement he deserved unstinted praise and an immortal
renown, since he caused the exterior of the building to be
incrusted with marble of various colours, and the interior with
hard stone, making even the most unobtrusive corners of the
building of the same stone. But, in order that everyone may
know the proportions of this marvellous edifice, I will add that
from the doorway to the far end of the chapel of St. Zanobius the
length is 260 braccia, the breadth at the transepts is 166 braccia,
that of nave and aisles 66. The nave is 72 braccia high, and the
aisles 48. The external circumference of the entire church is
1280 braccia; the cupola, from the ground to the base of the
lantern, is 154 braccia; the lantern, without the ball, is 36
braccia high, the ball 4 braccia high, and the cross 8 braccia;
the entire cupola, from the ground to the top of the cross, is
202 braccia. But to return to Arnolfo, I say that he was con-
sidered so excellent, and so much confidence was felt in him,
that nothing of importance was discussed without first asking
his advice. Thus the foundation of the final circuit of the city
walls having been finished that same year by the community
of Florence, the commencement of which was referred to above,
and also the gate towers, and the work being well forward, he
began the palace of the Signori,[1] making it similar in design
to that which his father Lapo had erected in Casentino for the
counts of Poppi. But he was unable to realise the grand and
magnificent conception which he had formed in that perfection
which his art and judgment required, because a piazza had been
made by the dismantling and throwing down of the house of
the Uberti, rebels against the Florentine people and Ghibellines,

[1] In 1298.

and the blind prejudice of certain persons prevailed against all the arguments brought forward by Arnolfo to such an extent that he could not even obtain permission to make the palace square, because the rulers of the city absolutely refused to allow the building to have its foundations in the land of the rebel Uberti, and they would rather suffer the destruction of the south nave of S. Piero Scheraggio than give Arnolfo free scope in the space designated. They were also desirous that he should include and adapt to the palace the tower of the Fieraboschi, called the Torre della Vacca (Cow Tower), 50 braccia in height, to hold the great bell, together with some houses bought by the commune for such a building. For these reasons it is no marvel if the foundations of the palace are awry and out of the square, as, in order to get the tower in the middle and to make it stronger, he was obliged to surround it with the walls of the palace. These were found to be in excellent condition in the year 1561 by Giorgio Vasari, painter and architect, when he restored the palace in the time of Duke Cosimo. Thus, as Arnolfo left the tower full of good materials, it was easy for other masters to erect upon it the lofty campanile which we see to-day, since he himself finished no more than the palace in the space of two years. It was in later years that the building received those improvements to which it owes its present grandeur and majesty.

After all these things, and many others not less useful than beautiful, Arnolfo died, at the age of seventy, in the year 1300,[1] about the time when Giovanni Villani began to write the general history of his times. And since he left S. Maria del Fiore not only with its foundations laid, but saw three principal apses under the cupola vaulted in, to his great praise, he deserves the memorial set up to him in the church on the side opposite the campanile, with these lines carved in the marble in Roman characters:

> Anno millenis centum bis octo nogenis
> Venit legatus Roma bonitate donatus
> Qui lapidem fixit fundo, simul et benedixit
> Praesule Francisco, gestante pontificatum.
> Istud ab Arnolpho templum fuit aedificatum.
> Hoc opus insigne decorans Florentia digne
> Reginæ cœli construxit mente fideli,
> Quam tu, Virgo pia, semper defende, Maria.

I have written the life of Arnolfo with the greatest possible brevity because, although his works do not nearly approach

[1] He died on 8 March, 1302.

the perfection of those of the present time, yet he none the less deserves to be remembered with affection, since, in the midst of so great darkness, he pointed out the road to perfection to those who came after him. The portrait of Arnolfo, by the hand of Giotto, may be seen in S. Croce, next to the principal chapel, where the friars are mourning the death of St. Francis. He is represented at the beginning of the scene as one of the two men who are talking together. A representation of the exterior of the church of S. Maria del Fiore, with the dome, by the hand of Simon of Siena, may be seen in the chapter-house of S. Maria Novella. It was taken from the actual model of wood which Arnolfo made. From this representation it is clear that Arnolfo proposed to begin to vault his space, starting immediately above the first cornice, whilst Filippo di Ser Brunellesco, desiring to lighten the weight and make the appearance of the structure more graceful, added above this the whole of the space which contains the round windows before he began his vaulting. This matter would be even more obvious than it is had not the negligence and carelessness of those who had charge of the works of S. Maria del Fiore in past years allowed Arnolfo's own model, as well as those of Brunellesco and others, to be lost.

NOTE.

In S. Maria Maggiore at Rome Arnolfo began the tomb of Pope Honorius III. of the Savella house. He left this unfinished with the Pope's portrait. This was afterwards placed in the principal chapel in S. Paolo, Rome, in mosaic from his design, with the portrait of Giovanni Gaetano, abbot of that monastery.

The marble chapel containing the manger of Jesus Christ was one of the last pieces of sculpture Arnolfo ever did. He made it at the instance of Pandolfo Ipotecorvo in the year twelve, according to an inscription on the wall near the chapel. He also made the chapel and tomb of Pope Boniface VIII. in S. Pietro at Rome, where the name of Arnolfo is carved.

NICCOLA and GIOVANNI PISANI, Sculptors and Architects
(? 1205 – 1278; 1250 – 1328)

HAVING discussed the arts of design and painting in dealing with Cimabue, and that of architecture in the life of Arnolfo Lapo, we now propose to treat of sculpture, and of the very important architectural works of Niccola and Giovanni Pisani.

Their achievements in both sculpture and architecture are alike remarkable for the manner in which they have been conceived as well as for the style in which they are executed, since to a great extent they emancipated themselves from the clumsy and ill-proportioned Byzantine style in both arts, showing more originality in the treatment of their subjects and arranging their figures in better postures.

Niccola Pisano was originally associated with some Greek sculptors who were engaged upon the figures and other ornaments in relief for the Duomo at Pisa and the church of S. Giovanni there.[1] Among the marble remains brought home by the Pisan fleet were some ancient sarcophagi now in the Campo Santo of that city, including a very fine one on which was an admirable representation of the chase of Meleager, hunting the Calydonian boar.[2] Both the nude and the draped figures of this composition are executed with much skill, while the design is perfect. This sarcophagus, on account of its beauty, was afterwards placed by the Pisans on the façade of the Duomo opposite S. Rocco, against the principal door on that side. It originally served as a tombstone for the mother of the Countess Matilda, if we may credit the inscription cut in the marble:

Anno Domini MCXVI. Kal. Aug. obiit D. Matilda felicis memoriae comitissa, quae pro anima genetricis suae D. Beatricis comitissae venerabilis in hac tumba honorabili quiescentis in multis partibus mirifice hanc dotavit ecclesiam, quarum animae requiescant in pace.

And then follows:

Anno Domini MCCCIII. sub dignissimo operario Burgundio Tadi occasione graduum fiendorum per ipsum circa ecclesiam supradictam tumba superius notata bis translata fuit, nunc de sedibus primis in ecclesiam, nunc de ecclesia in hunc locum, ut cernitis excellentem.

Niccola, considering the excellence of this work, which greatly delighted him, applied such diligence in imitating that style, and other excellent sculptures on the other antique sarcophagi, that before long he was considered the best sculptor of his time. There was indeed, after Arnolfo, no other sculptor of repute in Tuscany except Fuccio, a Florentine architect and sculptor, who designed S. Maria sopra Arno at Florence in 1229, putting his name over the door. The marble tomb of the Queen of Cyprus

[1] Niccola appears to have come from Apulia. Modern criticism considers that the Pisani, father and son, derived their inspiration from French sources.

[2] This scene, now in the Campo Santo at Pisa, represents Hippolytus and Phædra.

in the church of St. Francis of Assisi is also his work. It contains a number of figures, the principal one being the queen herself, seated on a lion, as emblematical of her fortitude. She had bequeathed a large sum of money for the completion of these works.

Niccola, having proved himself a much greater master than Fuccio, was summoned to Bologna in 1225 to make a marble tomb for St. Dominic Calagora, founder of the order of the Friars Preachers, then recently deceased.[1] Having arranged with those who had charge of the work, he designed a tomb full of figures, as may be seen at this day. The task was completed in 1231, and the finished tomb was greatly praised, it being considered a remarkable work, and the best piece of sculpture executed up to that time. He further made plans for the church there and for a great part of the convent. On returning to Tuscany, he learned that Fuccio had set out from Florence and was gone to Rome, at the time when the Emperor Frederick was crowned there by Honorius.[2] From Rome Fuccio accompanied Frederick to Naples, where he finished the castle of Capoana, now called "la Vicheria," where all the courts of that kingdom are held.[3] He also completed the Castel dell' Uovo,[4] beginning the towers, made the gates on the side of the River Volturno at Capua, constructed a park near Gravina for fowling, enclosing it by a wall, and made another at Amalfi for winter hunting, besides many other things which are omitted for the sake of brevity.

Meanwhile Niccola was staying at Florence, engaged not only in sculpture but also in architecture, for building was going on throughout Italy, but especially in Tuscany, with some amount of good design. Thus he contributed not a little to the abbey of Settimo, left unfinished by the executors of Count Hugh of Brandenburg, as the other six had been, as we have noticed above. For although an inscription on the campanile of the abbey reads: "*Gugliel. me fecit*," yet it is clear from the style of the work that it was carried out under the advice of Niccola. At the same time he was building the old palace of the *anziani* at Pisa. This building has been dismantled at the present time by Duke Cosimo, who has used a part of the old edifice for the

[1] St. Dominic died in 1221 and was not canonised until 1234. Fuccio appears to have been a patron and not an artist. It is known that Frà Guglielmo d'Agnello of Pisa was engaged upon this tomb in 1266, and it was probably begun about that time.

[2] Frederick II. by Honorius III. on 22 November, 1220.

[3] Begun 1231. [4] Finished 1221.

erection of the magnificent palace and convent of the new order of the Knights of S. Stephen, after the designs of Giorgio Vasari, Aretine painter and architect, who has done his best with the old walls to adapt them to the modern style. Niccola designed many other palaces and churches at Pisa, and he was the first, after the loss of good methods of construction, who introduced at Pisa the practice of making the foundations of buildings upon pillars connected by arches, first driving piles in under the pillars. This method renders the building absolutely secure, as is shown by experience, whereas without the piles the foundations are liable to give way, causing the walls to fall down. The church of S. Michele in Borgo of the monks of Camaldoli was also built after his plans.[1] But the most beautiful, ingenious and whimsical piece of architecture that Niccola ever constructed was the campanile of S. Niccola at Pisa, where the friars of St. Augustine are. Outside it is octagonal, but the interior is round with a spiral staircase rising to the top leaving the middle space void like a well, while on every fourth step there are columns with arches of unequal sides, which follow the curve of the building. The spring of the vaulting rests upon these arches, and the ascent is of such sort that anyone on the ground always sees those who are going up, those who are mounting see those who are on the ground, while those who are in the middle see both those who are above and those below. This whimsical invention was afterwards adopted by Bramante in a better style, with more correct proportions and richer ornamentation, for Pope Julius II. in the Belvedere at Rome, and by Antonio da Sangallo for Pope Clement VII. in the well at Orvieto, as will be said when the time comes.

To return to Niccola, who excelled no less as a sculptor than as an architect. For the church of S. Martino at Lucca he did a Deposition from the Cross, which is under the portico above the minor doorway on the left-hand as one enters the church.[2] It is executed in marble, and is full of figures in half-relief, carried out with great care, the marble being pierced through, and the whole finished in such style as to give rise to hopes in those who first practised this art with the most severe labour, that one would soon come who would give them more assistance with greater ease. It was Niccola also who in the year 1240 designed the church of S. Jacopo at Pistoia, and set some Tuscan

[1] Founded 1018, enlarged in 1219, and again in 1262 and 1304, by Frà Guglielmo of Pisa.
[2] Done after 1260.

masters to work there in mosaic, who did the vaulting of the apse. But although it was considered a difficult and costly thing at that time, it rather moves one to laughter and compassion to-day, and not to admiration, on account of the poorness of the design, a defect which was prevalent not only in Tuscany, but throughout Italy, where the number of buildings and other things erected without method and without design betray the poverty of their minds no less than the bountiful riches wasted on them by the men of their day; because there were no masters capable of executing in a good style anything which they did for them. Now Niccola was steadily increasing his renown in both sculpture and architecture, and was of greater account than the sculptors and architects who were then at work in the Romagna, as one may see in S. Ippolito and S. Giovanni at Faenza, in the Duomo of Ravenna, in S. Francesco, in the houses of the Traversari, and in the church of Porto, and at Rimini, in the public palace, in the houses of the Malatesti, and in other buildings which are much worse than the old buildings erected in Tuscany at the same time; and what is here said of the Romagna may be repeated with even more truth of a part of Lombardy. It is only necessary to see the Duomo of Ferrara and the other buildings erected for the Marquis Azzo, to perceive at once how different they are from the Santo of Padua, built from Niccola's model, and from the church of the friars minor at Venice,[1] both of them magnificent and famous buildings.

In Niccola's day there were many moved by a laudable spirit of emulation, who applied themselves more diligently to sculpture than they had done before, especially in Milan, where many Lombards and Germans were gathered for the building of the Duomo. These were afterwards scattered throughout Italy by the dissensions which arose between the Milanese and the Emperor Frederick. They then began to compete among themselves, both in carving marble and in erecting buildings, and attained to some measure of excellence. The same thing happened in Florence after the works of Arnolfo and Niccola had appeared. The latter, while the little church of the Misericordia on the piazza S. Giovanni was being built after his designs, carved a marble statue of Our Lady, with St. Dominic and another saint on either side, which may still be seen on the façade of that church.[2]

[1] The Frari.
[2] It was built much later, in 1352-8, by Alberto Arnoldi, who also did the statuary.

It was also in Niccola's time that the Florentines began to demolish many towers, erected previously in a rude style all over the city, in order that the people should suffer less by their means in the frequent collisions between the Guelphs and Ghibellines, or for the greater security of the commonweal. One of these, the tower of Guardamorto, situated on the piazza S. Giovanni, presented unusual difficulty to those who wished to destroy it because the walls were so well knit that the stones could not be removed with the pickaxe, and also because the tower was a very high one. Niccola, however, caused a piece to be cut out of the base on one side of the tower and closed the gap with short wooden supports, a braccia and a half long, to which he then set fire, and so soon as these were consumed the tower fell of itself.[1] The idea seemed so ingenious and so well adapted for such emergencies, that it afterwards came into general use, so that, whenever it was necessary to destroy a building, the task was speedily accomplished in this most facile manner.

Niccola was present when the foundations of the Duomo of Siena were laid, and he designed the church of S. Giovanni in that city. He went back to Florence in the year of the return of the Guelphs,[2] and designed the church of S. Trinità, and the nunnery at Faenza, pulled down in recent years to make the citadel. Being subsequently summoned to Naples, and not wishing to abandon his enterprises in Tuscany, he sent thither his pupil Maglione, sculptor and architect, who in the time of Conrad afterwards built the church of S. Lorenzo at Naples,[3] finished a part of the Vescovado, and made some tombs there, in which he closely imitated the manner of his master, Niccola. In the meantime Niccola went to Volterra, in the year that the people of that place came under the dominion of the Florentines (1254), in response to a summons, because they wished him to enlarge their Duomo, which was small; and although it was very irregular, he improved its appearance, and made it more magnificent than it was originally. Then at length he returned to Pisa and made the marble pulpit of S. Giovanni,[4] devoting all his skill to it, so that he might leave a memory of himself in his native place. Among other things in it he carved the Last Judgment, filling it with a number of figures, and if they are not perfectly designed they are at any rate executed with infinite patience and diligence, as may be seen; and because he rightly considered that he had completed a work

[1] In 1249. [2] 1266. [3] In 1266. [4] 1260.

which was worthy of praise, he carved the following lines at
the foot:

> Anno milleno bis centum bisque trideno,
> Hoc opus insigne sculpsit Nicola Pisanus.

The people of Siena, moved by the fame of this work, which
greatly delighted not only the Pisans, but whoever saw it,
assigned to Niccola the task of making for their Duomo the
pulpit from which the Gospel is sung, at the time when Guglielmo
Mariscotti was praetor.[1] In this Niccola introduced a number
of scenes from the life of Jesus Christ, especially remarkable
for the figures which they contain, which stand out in full
relief, a work of great difficulty. He likewise designed the church
and convent of S. Domenico at Arezzo, for the lords of Pietra-
mala who built it, and at the request of the Bishop Ubertini he
restored the Pieve of Cortona, and began the church of S.
Margherita for the friars of St. Francis, on the highest ground in
that city. The fame of Niccola was continually on the increase,
owing to these works, so that in 1267 he was invited by Pope
Clement IV. to Viterbo, where, among many other things, he
restored the church and convent of the Friars Preachers. From
Viterbo he went to Naples to King Charles I., who, having
defeated and slain Curradino on the plain of Tagliacozzo,[2]
founded a wealthy church and abbey on the spot, for the burial-
place of the large number of men who had fallen on that day,
ordaining that prayers should be offered for their souls both
day and night by many monks. King Charles was so delighted
with the work of Niccola in this building that he loaded him
with honours and rewards. On the way back from Naples to
Tuscany Niccola stayed to take part in the building of S. Maria
at Orvieto,[3] where he worked in the company of some Germans,
making figures in high relief in marble for the front of that
church, and more particularly a Last Judgment in two scenes,
comprising both Paradise and Hell; and as he took the greatest
pains to render the souls of the blessed in Paradise as beautifully
as he possibly could, so he introduced into his Hell the most
fantastic shapes of devils imaginable, all intent on tormenting
the souls of the damned. In this work not only did he surpass
the Germans who were working there, but even himself, to his
great glory, and because he introduced a great number of figures

[1] 1266–8, assisted by Arnolfo di Cambio.

[2] 23 August, 1268.

[3] The church was not begun until about 1290, when Niccola had been
dead for many years. The principal architect, up to his death in 1330,
was Lorenzo Maitani.

and spared no pains, it has been praised even to our own day for no other reason by those whose judgment of sculpture does not amount to much.

Among other children Niccola had a son called Giovanni, who was always with his father, and under his care learned both sculpture and architecture, so that in the course of a few years he became not only the equal of his father, but his superior in some things. Thus, as Niccola was already old, he withdrew to Pisa and lived quietly there, leaving the control of everything to his son.[1] At the death in Perugia of Pope Urban IV., Giovanni was sent for to make the tomb, which he executed in marble; but it was afterwards thrown down, together with that of Pope Martin IV., when the Perugians enlarged their Vescovado, so that only a few remains may be seen to-day dispersed about the church. At the same time the Perugians, thanks to the skill and industry of a friar of the Silvestrini, had brought to their city from the hill of Pacciano, two miles away, an abundance of water by leaden conduits.[2] The ornamentation of the fountain in both bronze and marble was entrusted to Giovanni, so that he thereupon set his hand to the work, making three basins, one above the other, two in marble and one in bronze. The first is placed at the top of a flight of twelve steps with twelve sides, the second rests on pillars which rise from the floor of the first basin, while the third, which is of bronze, is supported by three figures; and in the middle are griffins, also of bronze, which throw out water on every side. And as Giovanni considered that he had executed an excellent piece of work, he put his name to it. The arches and conduits of this fountain, which cost 160,000 gold ducats, were found to be very much worn and broken about the year 1560, but Vincenzio Danti, sculptor of Perugia, contrived a means, to his great glory, of bringing water to the fountain in the original way, without rebuilding the arches, which would have been very costly. When the work was finished Giovanni felt anxious to return to see his old father, who was sick, and he set out from Perugia intending to return to Pisa; but on his way through Florence he was compelled to stay there, to assist with others at the mills of the Arno, which were being made at S. Gregorio, near the piazza dei Mozzi. But at length receiving word that his father Niccola was dead, he departed for Pisa, where he was

[1] Niccola helped his son with the fountain at Perugia from 1273 to 1277, when he probably withdrew. He died in the following year.
[2] The decree for this is dated 1254.

received with great honour by all the city, on account of his
worth, since everyone rejoiced that although Niccola was lost
to them, yet they still possessed Giovanni, who inherited his
father's ability as well as his property. Nor were they deceived
in him when the time of testing arrived, for when it was neces-
sary to do some few things for the tiny but highly ornate church
of S. Maria della Spina, the task was entrusted to Giovanni.[1]
He therefore put his hand to the work and, with the help of some
of his young men, brought much of the ornamentation of that
oratory to the state of perfection which it possesses to-day.
In those days it must have appeared a miracle, the more so as
he introduced the portrait of Niccola, taken from life, executed
to the best of his ability. When the Pisans had seen this they
decided to entrust to him the construction of the Campo Santo,
adjoining the piazza del Duomo towards the walls, as they had
long desired and talked of having a place for the burial of all
their dead, both gentle and simple, so that the Duomo should
not be filled with tombs, or for other reasons. Thus Giovanni
with good designs and great judgment erected the building as
we now see it, in style, size, and marble ornamentation, and as
no expense was spared, it was roofed with lead. On the outside
of the principal entrance may be read these words, carved in
the marble:

A.D. MCCLXXVIII. tempore Domini Federigi archiepiscopi Pisani,
et Domini Terlati potestatis, operario Orlando Sardella, Johanne
magistro aedificante.

In the year of the completion of this work, 1283, Giovanni
went to Naples, where he erected the Castel Nuovo for King
Charles; and in order to enlarge it and add to its strength, he
was compelled to pull down a number of houses and churches,
among them a convent of the friars of St. Francis, which was
afterwards rebuilt on a larger and grander scale at some distance
from the castle, with the title of S. Maria della Nuova. After
these buildings had been set on foot and were well advanced,
Giovanni left Naples to return to Tuscany, but when he reached
Siena he was not allowed to go farther, but was induced to
design the façade of the Duomo of that city, which was sub-
sequently erected from his plans in a very rich and magnificent
style. In the following year, 1286, while the Vescovado at Arezzo
was being built from the design of Margaritone, architect of

[1] The church was originally an open shrine, and was not converted into
a chapel until 1333, when Giovanni had been dead five years.

Arezzo, Giovanni was fetched from Siena to that city by Guglielmo Ubertini, then bishop. He there executed in marble the panel of the high altar, full of figures cut in relief, foliage and other ornaments, distributing about it some delicate mosaic work and *appliqué* enamels on silver plates, fixed into the marble with great care. In the midst is Our Lady with the Child in her arms, and on one side of her is St. Gregory the Pope (a portrait of Pope Honorius IV. drawn from life), and on the other side St. Donato, the bishop and protector of that city, whose body, with those of St. Antilia and other saints, rests under that same altar. And as the altar stands out by itself, the sides are decorated with small representations in bas-relief from the life of St. Donato, and the work is crowned with a series of niches, full of marble figures in relief, of exquisite workmanship. On the Madonna's breast is an ornament shaped like a gold casket, containing, if report be true, jewels of great value, although it is believed that they, as well as some other small figures on the top and about the work, were taken away in time of war by soldiers, who often do not respect even the most Holy Sacrament.[1] On all these works the Aretines expended 30,000 gold florins, as is found in some records. Nor does this appear impossible, because at that time it was considered to be a thing of the most precious and rare description, so that when Frederick Barbarossa [2] returned from his coronation at Rome, and was passing through Arezzo many years after its completion, he praised and admired it infinitely, and indeed with good cause, since the joints are constructed of countless pieces so excellently welded together that, to an inexperienced eye, the whole work seems to be made in one piece. In the same church Giovanni made the chapel of the Ubertini, a most noble family, and lords of a town, as they still are, though they were formerly of greater estate. He adorned this with many marble ornaments, which are to-day covered over by many large ornaments of stone, placed there in the year 1535, after plans by Giorgio Vasari, for the support of an organ of extraordinary excellence and beauty which rests upon them. Giovanni Pisano also designed the church of S. Maria dei Servi, which has been destroyed in our day, together with many palaces of the noblest families of the city, for the reasons mentioned above. I must not omit to

[1] Ubertini was Bishop of Arezzo 1249–89. The monument is much later, being executed in 1369–75 by Giovanni di Francesco of Arezzo and Bettino di Francesco of Florence. The Pope represented is Gregory X.

[2] Impossible, for Barbarossa died two centuries before. Perhaps Vasari means the Emperor Frederick III.

note that in the construction of the marble altar Giovanni was
assisted by some Germans, who associated with him, rather
for the sake of learning the art than for gain, and who profited
so much by his instruction that, when they went to Rome,
after the completion of that work, they served Pope Boniface
VIII. in many works of sculpture executed for S. Pietro, and
also in architecture, when he made Città Castellana. They
were, moreover, sent by that Pope to S. Maria at Orvieto,
where they made a number of marble figures for the façade of
the church, which were very tolerable for those times. But
among the others who assisted Giovanni in his undertakings
for the Vescovado at Arezzo were Agostino and Agnolo, sculp-
tors and architects of Siena, who in the course of time far sur-
passed all the others, as will be said in the proper place. But
to return to Giovanni. When he left Orvieto, he came to Florence
to see Arnolfo's building of S. Maria del Fiore, and also to see
Giotto, of whom he had heard a great deal elsewhere; but no
sooner had he arrived in Florence than he was appointed by
the intendants of the fabric of S. Maria del Fiore to make the
Madonna, which stands between two small angels above the
door of that church, which leads into the canons' quarters, a
work much praised at the time. He next made the small font
for S. Giovanni, containing representations from the life of
that saint in half-relief.[1] Proceeding thence to Bologna, he
directed the construction of the principal chapel of the church
of S. Domenico, in which he was also commissioned to make
the marble altar by Teodorico Borgognoni of Lucca, then
bishop, a friar of that order. Later on (1298), in the same place,
he made the marble panel in which are Our Lady and eight
other figures, all of very tolerable workmanship. In the year
1300, when Niccola da Prato was at Florence as cardinal legate
of the Pope, for the purpose of settling the discords among the
Florentines, he caused Giovanni to build a nunnery for him at
Prato, which was called S. Niccola after him, and in the same
district he employed him to restore the convent of S. Domenico, as
well as that of Pistoia, in both of which the arms of that cardinal
may still be seen. And since the Pistoiese held the name of
Niccola, Giovanni's father, in great respect, because of what his
genius had accomplished in their city, they commissioned Gio-
vanni to make a marble pulpit for the church of S. Andrea,[2]

[1] Made in 1370 for the Art of Calimala, by a sculptor of the Venetian
school, according to Professor Venturi.
[2] Commissioned in 1298 and finished in 1301.

similar to that which he had made for the Duomo of Siena, and in competition with one which had been made shortly before for the church of S. Giovanni Evangelista by a German,[1] which had been much praised. Giovanni finished his task in four years, dividing the work into four scenes from the life of Jesus Christ, and further introducing a Last Judgment, working with the utmost diligence in order to equal, and perhaps surpass, the one at Orvieto then so renowned. About the pulpit above some columns which support it and on the architrave he carved the following lines, since he thought that he had completed a great and beautiful work, as indeed he had, considering the attainments of the age:

> Hoc opus sculpsit Johannes, qui res non egit inanes,
> Nicoli natus . . . meliora beatus
> Quem genuit Pisa, doctum super omnia visa.

At the same time Giovanni made the holy-water vessel in marble for the same church of S. Giovanni Evangelista,[2] borne by three figures, Temperance, Prudence and Justice, and as it was then considered a work of great beauty, it was placed in the middle of the church as a remarkable object. Before he left Pistoia he made the model for the campanile of S. Jacopo, the principal church of the city, although the work was not then begun. The tower is situated beside the church in the piazza of S. Jacopo, and bears the date A.D. 1301. On the death of Pope Benedict IX.,[3] at Perugia, Giovanni was sent for to make his tomb, which he executed in marble in the old church of S. Domenico of the Friars Preachers, placing the Pope's effigy, taken from life, and in his pontifical habit, upon the sarcophagus with two angels holding a curtain, one on either side, and Our Lady above, between two saints, executed in relief, as well as many other ornaments carved on the tomb. Similarly, in the new church of the same order, he made the tomb of M. Niccolo Guidalotti of Perugia, Bishop of Recanati, founder of the new University of Perugia. In this same new church, which had been begun previously by others, he directed the construction of the central nave, and this part of the building was on much safer foundations than the rest, which cants over on one side, and threatens to fall down, owing to the faulty laying of the foundations. And, in truth, he who undertakes to build or perform any things of importance ought always

[1] By Guglielmo da Pisa in 1270. [2] Done in 1273.
[3] It should be Benedict XI., who died in 1304.

to take the advice, not of those who know little, but of those most competent, so that he may not afterwards have to repent with loss and shame that he was ill-directed when he was in most need of assistance.

When he had completed his labours in Perugia, Giovanni wished to go to Rome to learn from the few antique things there, as his father had done, but sufficient reasons prevented him from ever realising this desire, the main one being that he heard that the court had just gone to Avignon.[1] So he returned to Pisa, where Nello di Giovanni Falconi, craftsman, entrusted to him the great pulpit of the Duomo, which is set up in the choir on the right-hand side as one approaches the high altar. He set to work on this,[2] and on a number of figures in full relief, three braccia high, which he intended to use for it, and little by little he brought it to its present form, resting in part on the said figures and in part upon columns supported by lions, while on the sides he represented scenes from the life of Jesus Christ. It is truly a sin that so much money, such diligence and labour should not be accompanied by good design, and that it should lack that perfection, invention, grace and good style which any work of our own day would possess, even were it executed at much less cost and with less difficulty. Yet it must have excited no small admiration among the men of the time, who had only been accustomed to see the rudest productions. It was finished in the year 1302, as appears in certain lines which run round the pulpit and read thus:

> Laudo Deum verum, per quem sunt optima rerum,
> Qui dedit has puras homini formare figuras;
> Hoc opus, his annis Domini sculpsere Johannis
> Arte manus sole quondam, natique Nicole,
> Cursis undenis tercentum milleque plenis.

There are thirteen other lines, which I do not quote here, because I do not wish to weary the reader, and because these are sufficient to show not only that the pulpit is by the hand of Giovanni, but that the men of that time were like this in everything. A marble Madonna between St. John the Baptist and another saint over the principal door of the Duomo is by the hand of Giovanni, and the figure kneeling at her feet is said to be Piero Gambacorti, the warden.[3] However this may be,

[1] In 1309.
[2] About 1301. The pulpit was destroyed by fire on 24 October, 1595. It has recently been restored from the fragments that survived.
[3] He was killed in 1392, and would be too young for Giovanni Pisano.

the following words are cut in the pedestal, on which the image
of Our Lady stands:

> Sub Petri cura haec pia fuit sculpta figura
> Nicoli nato sculptore Johanne vocato.

Moreover, there is another marble Madonna, by Giovanni,
over the side door opposite the campanile, while on one side
of her kneel a lady and two children, representing Pisa, and
on the other side the Emperor Henry. On the base are these
words:

> Ave gratia plena, Dominus tecum,

and then—

> Nobilis arte manus sculpsit Johannes Pisanus.
> Sculpsit sub Burgundio Tadi benigno.

And about the base of Pisa:

> Virginis ancilla sum Pisa quieta sub illa,

and about the base of Henry:

> Imperat Henricus qui Christo fertur amicus.

In the old Pieve at Prato, beneath the altar of the principal
chapel, was preserved for many years the girdle of Our Lady,
which Michele da Prato had brought back with him from the
Holy Land in the year 1141, and had deposited it with Uberto,
provost of the church, who laid it in the said place, where it
was always held in great veneration. In the year 1312 an attempt
to steal it was made by a native of Prato, a man of a most evil
life, another Ser Ciappelletto,[1] but he was discovered and put
to death for sacrilege. Moved by this deed, the people of Prato
proposed to make a strong and suitable receptacle in which
the girdle should be kept with greater security, and sent for
Giovanni, who was now an old man. Acting upon his advice, they
constructed the chapel in the principal church, where Our
Lady's girdle now reposes.[2] They then greatly enlarged their
church also from his plans, and incrusted both the church and
the campanile with white and black marble on the outside, as
may be seen. At length Giovanni died at a ripe old age in the
year 1320,[3] after having completed many works in sculpture
and architecture besides those which are mentioned here. And
in truth a great debt is due to him and to Niccola his father,

[1] The hero of the first story in Boccaccio's *Decameron*: forger, murderer,
blasphemer, fornicator, drunkard and gambler, "he was probably the
worst man who was ever born"; to crown all, he so deceived the priest to
whom he confessed that he was canonised.

[2] In 1317.

[3] He seems, from the Scrovegni altar at Padua, to have been alive in
1328.

since, in an age which lacked every element of good design, in the midst of all the darkness they threw so much light on those arts in which they were really excellent.

Giovanni was honourably buried in the Campo Santo, in the same tomb in which his father Niccola was laid. Many disciples of his flourished after him, but especially Lino,[1] sculptor and architect of Siena, who made the chapel which contains the body of St. Ranieri in the Duomo of Pisa, richly decorated with marble; and also the baptismal font of that cathedral which bears his name. Let no one marvel that Niccola and Giovanni executed so many works, for, besides the fact that they lived to a good age, they were the foremost masters in Europe of their time, so that nothing of importance was undertaken without their having a share in it, as may be seen in many inscriptions besides those which have been quoted. Whilst speaking of these two sculptors and architects, I have often referred to Pisa, so that I do not hesitate at this stage to quote some words written on the pedestal of a vase mounted on a column of porphyry and supported by a lion, which is situated at the top of the steps leading to the new hospital there. They are as follows:

"This is the talent which the Emperor Cæsar gave to Pisa, to the intent that the tribute which they rendered to him should be regulated thereby. The talent was set upon this column and lion in the time of Giovanni Rosso, master of the work of S. Maria Maggiore, Pisa, A.D. MCCCXIII., the second Indiction, in March."

Andrea Tafi, Florentine Painter
(? 1213–1294)

JUST as the works of Cimabue excited no small amount of wonder in the men of that time, since he introduced a better design and form into the art of painting, whereas they had only been accustomed to see things executed in the Byzantine style, so the mosaics of Andrea Tafi, who was a contemporary, were much admired and even considered divine, for the people of that day, who had not been used to see anything different, did not think that it was possible to produce better works in

[1] Probably Tino da Camaino is meant, conjectured to have been the sculptor of the Madonna and the Emperor Henry mentioned above. The altar of St. Ranieri is in the Campo Santo.

that art. But in truth, as he was not the most capable man in the world, and as he reflected that work in mosaic was more valued than other pictorial representation on account of its greater durability, he left Florence for Venice, where some Greek painters were working in mosaic at S. Marco. There he formed a close intimacy with them, and by dint of persuasion, money and promises he at length contrived to bring to Florence Master Apollonio, a Greek painter, who taught him how to bake the glass of the mosaic, and how to make the cement in which to fix it. With him Andrea worked at the vaulting of S. Giovanni, doing the upper part which contains the Dominions, Principalities and Powers. Afterwards, when he had gained more experience, he did the Christ which is in the same church above the principal chapel, as will be related below. But as I have mentioned S. Giovanni, I will take this opportunity of saying that that ancient sanctuary is incrusted both within and without with marbles of the Corinthian order, and not only is it perfectly proportioned and finished in all its parts, but most beautifully adorned with doors and windows. Each face is supplied with two columns of granite, 11 braccia high, forming three compartments, above which are the architraves, which rest on the columns, to carry the whole weight of the double roof, which is praised by modern architects as a remarkable thing, and justly, because this church helped to demonstrate to Filippo di Ser Brunellesco, Donatello, and the other masters of their time, what possibilities lay in that art. They all studied architecture from this building and from the church of S. Apostolo at Florence, a work of such a good style that it approaches the true antique, since, as I have said before, all the columns are proportioned and arranged with such care that much may be learned from a careful examination of the entire structure. But I will refrain from saying more about the good architecture of this church, though much might be added to what precedes, and I will content myself by saying that those who rebuilt in marble the façade of the church of S. Miniato del Monte deviated widely from this model and from this excellent style. This work was carried out in honour of the conversion of the blessed Giovanni Gualberto, citizen of Florence and founder of the congregation of the monks of Vallombrosa, because these and many other works erected afterwards are not to be compared for excellence with those two buildings. The art of sculpture experienced a similar fate because all the things produced by the masters of the time in Italy, as has been said in the Preface

to the Lives, were very rude. This may be seen in many places, but especially in S. Bartolommeo of the regular canons at Pistoia, where there is a pulpit very rudely executed by Guido da Como, containing the early part of the life of Jesus Christ, with these words inscribed there by the artist himself in the year 1199:

> Sculptor laudatur, quod doctus in arte probatur,
> Guido de Como me cunctis carmine promo.

But to return to S. Giovanni, I pass by the history of its foundation because that has been written by Giovanni Villani [1] and other authors, and, as I have already remarked that the good architecture in use to-day is derived from that building, I will now add that, to judge by appearances, the vaulting is of a later date. At the time when Alesso Baldovinetti, succeeding the Florentine painter Lippo, repaired the mosaics it appeared as if it had anciently been painted in red, the designs being executed on the stucco. Now Andrea Tafi and Apollonius the Greek, in their scheme for the decoration of the vaulting, divided it into compartments. Starting from the top of the vault next to the lantern, these became gradually larger until they reached the cornice below. The upper part is divided into circles containing various subjects. The first contains all the ministers and performers of the Divine will, such as the Angels, Archangels, Cherubim, Seraphim, Dominions, Principalities, Powers. The second, in which the mosaics are executed in the Byzantine style, are the principal acts of God from the creation of light to the Flood. The next circle has more space for its eight faces and contains the history of Joseph and his twelve brethren. These are followed by an equal number of spaces of the same size and in a like situation containing the life of Jesus Christ in mosaic from the Conception of Mary to the Ascension. Next, following the same order, under the three friezes, is the life of St. John the Baptist, beginning with the apparition of the angel to Zacharias the priest and continuing to John's beheading and the burial by his disciples. All these things are rude, without design and without art, and they are no advance upon the Byzantine style of the time, so that I cannot praise them absolutely, though they merit some commendation, when one considers the methods in use at the time and the imperfect state in which pictorial art then was. Besides, the work is sound and

[1] Book i. cap. 42. Villani states that it was originally built by the Romans in the time of Octavian as a temple to Mars.

the pieces of mosaic are very well set. In short, the latter part of the work is much better or rather less bad than is the beginning, although the whole, when compared with the works of to-day, rather excites laughter than pleasure or admiration. Ultimately Andrea made the Christ, 7 braccia high, for the vaulting over the wall of the principal chapel, which may be seen there to-day, and this he did by himself without the aid of Apollonius, to his great glory. Having become famous throughout Italy by these works and being reputed excellent in his own land, he merited the richest honours and rewards. It was certainly a great good fortune for Andrea to be born at a time when only rude works were produced, so that things which should have been considered of very slight account or even worthless were held in high repute. The same thing happened to Frà Jacopo da Turrita, of the order of St. Francis, who received extraordinary rewards for the mosaics which he executed for the small choir behind the altar of S. Giovanni, although they deserved little praise, and he was afterwards invited to Rome as a great master, where he was employed on some works in the chapel of the high altar of S. Giovanni Lateran and in that of S. Maria Maggiore.[1] He was next invited to Pisa, where he did the Evangelists and other things which are in the principal vault of the Duomo, in the same style as the other things which he executed, although he was assisted by Andrea Tafi and Gaddo Gaddi. These were finished by Vicino, for Jacopo left them in a very imperfect state. The works of these masters obtained credit for some time, but when the productions of Andrea, Cimabue and the rest had to bear comparison with those of Giotto, as will be said when the time comes, people came to recognise to some extent where perfection in art lay, for they saw how great a difference there was between the early manner of Cimabue and that of Giotto in the delineation of figures, a difference equally strongly marked in the case of their pupils and imitators. From this time others gradually sought to follow in the footsteps of the better masters, surpassing each other more and more every day, so that art rose from these humble beginnings to that summit of perfection to which it has attained to-day. Andrea lived eighty-one years and died before Cimabue, in 1294. The reputation and honour which he won by his mosaics, because it was he who first introduced the

[1] The Jacobus Torriti who did the mosaics of the Baptistery has here been confounded by Vasari with Jacopo Torriti, the author of the mosaics at Rome, and a much more skilful master.

better methods and taught them to the men of Tuscany, paved the way for the excellent works in that art by Gaddo Gaddi, Giotto and the rest, which have brought them fame and immortality. After Andrea's death his merits were magnified in the following inscription:

> Here lies Andrea, who produced graceful and beautiful works
> In all Tuscany. Now he has gone
> To adorn the realm of the stars.

Buonamico Buffalmacco was a pupil of Andrea, and played many pranks on him when a youth. From his master Buonamico had the portraits of Pope Celestine IV. of Milan and Innocent IV., both of which he afterwards introduced in the paintings which he made in S. Paolo a Ripa d'Arno at Pisa. Another pupil was Antonio di Andrea Tafi, who may possibly have been his son. He was a fair painter, but I have not been able to find any works by his hand, and there is nothing beyond a bare mention of him in the old book of the company of artists of design.

But Andrea Tafi deserves a high place among the old masters, because, although he learned the principles of mosaic from the craftsman whom he brought from Venice to Florence, yet he introduced great improvements into the art, uniting the pieces with great care, and making his surfaces as smooth as a table (a most important thing in mosaics), so that he prepared the way for Giotto among others, as will be said in that artist's life; and not for Giotto alone, but for all those who have since practised this branch of pictorial art to our own day. Thus it may be asserted with perfect truth that the works now being carried out which render S. Marco, at Venice, and other places, a marvel in mosaic, owe their origin to Andrea Tafi.

GADDO GADDI, Florentine Painter [1]
(1259 – c. 1333)

GADDO, painter of Florence, who flourished at this same time, showed more design in the works which he produced in the Byzantine style, and which he executed with great care, than did Andrea Tafi and the other painters who preceded him.

[1] The particulars contained in this life are not considered to be of much worth, as no documentary evidence has been found to support the statements made.

This was possibly due to his close friendship and intercourse with Cimabue, for, whether it was through congeniality of disposition or from the goodness of their hearts, they became very much attached to each other, and their frequent conversations together, and their friendly discussions upon the difficulties of the arts, gave rise to many great and beautiful ideas in their minds. This came to pass the more readily, because they were aided by the quality of the air of Florence, which usually produces ingenious and subtle spirits, and which is constantly removing any little ruggedness and coarseness, a thing which Nature cannot achieve as a rule of herself, by the advantage of emulation and by the precepts laid down by good craftsmen in every age. It is, indeed, abundantly clear that, when things have been talked over in a friendly way, without any reserve of convention, although this rarely happens, they may be brought to a great state of perfection. The same remark applies to those who study the sciences; for, by discussing difficulties among themselves when they arise, men remove them, rendering the path so clear and easy, that the greatest glory may be won thereby. But, on the other hand, there are some who, with devilish arts and led by envy and malice, while making profession of friendship under the guise of truth and affection, give the most pernicious advice, so that the arts do not attain to excellence so soon as they do where the minds of noble spirits are united by such a bond of love as that which drew together Gaddo and Cimabue, and, in like manner, Andrea Tafi and Gaddo. It was Andrea who took Gaddo into partnership to finish the mosaics of S. Giovanni. Here Gaddo learned so much, that he was able, without assistance, to make the prophets, which may be seen round the walls of that sanctuary, in the squares under the windows; and, as he executed these unaided and in a much improved style, they brought him great renown. Encouraged by this, he prepared himself to work alone, and devoted himself constantly to the study of the Byzantine style, combined with that of Cimabue. By such means it was not long before he became an excellent artist; so that the wardens of S. Maria del Fiore entrusted to him the semicircular space within the building above the principal entrance, where he introduced a Coronation of the Virgin in mosaic. Upon its completion, it was pronounced by all the foreign and native masters to be the finest work of its kind that had yet been seen in Italy, for they recognised that it possessed more design and more judgment, and displayed the

results of more study, than were to be found in all the remaining works in mosaic then in existence in the peninsula. Thus, his fame being spread abroad by this work, he was summoned to Rome by Clement V. in the year 1308, that is to say, in the year following the great fire in which the church and palaces of the Lateran were destroyed. There he completed for the Pope some works in mosaic which had been left unfinished by Jacopo da Turrita.

His next work, also in mosaic, was in the church of S. Pietro, where he executed some things in the principal chapel and for other parts of the church; but especially a God the Father, of large size, with many figures, which he did for the façade. He also assisted in the completion of some mosaics on the façade of S. Maria Maggiore, somewhat improving the style, and departing slightly from the Byzantine manner, which was entirely devoid of merit. On his return to Tuscany he did some work in mosaic for the Tarlati, lords of Pietramala, in the old Duomo, outside Arezzo, in some vaulting entirely constructed of spungite. He covered the middle part of this building with mosaics; but the church fell down in the time of Bishop Gentile Urbinate,[1] because the old stone vaulting was too heavy for it, and it was afterwards rebuilt in brick by that bishop. On his departure from Arezzo, Gaddo went to Pisa, where he made, for a niche in the chapel of the Incoronata in the Duomo, the Ascension of Our Lady into Heaven, where Jesus Christ is awaiting her, with a richly prepared throne for her seat. This work was executed so well and so carefully for the time, that it is in an excellent state of preservation to-day. After this Gaddo returned to Florence, intending to rest. Accordingly he amused himself in making some small mosaics, some of which are composed of egg-shells, with incredible diligence and patience, and a few of them, which are in the church of S. Giovanni at Florence, may still be seen. It is related that he made two of these for King Robert,[2] but nothing more is known of the matter. This much must suffice for the mosaics of Gaddo Gaddi. Of pictures he painted a great number, among them that which is on the screen of the chapel of the Minerbetti in S. Maria Novella, and many others sent to different places in Tuscany. Thus, by producing now mosaics and now paintings, he executed many very tolerable works in both mediums, which have always assured him good credit and reputation. There is a great deal

[1] Gentile de' Becchi da Urbino, Bishop of Arezzo 1473–97.
[2] Robert, King of Naples 1309–43.

more which I might say about Gaddo, but I will pass it over
in silence, because the manner of the painters of those days
cannot be of great assistance to artists; and I shall dwell at
greater length upon the lives of those who may be of some help,
because they introduced improvements into the art.

Gaddo lived seventy-three years, and died in 1312. He was
honourably buried in S. Croce by his son Taddeo. This Taddeo,
who had Giotto for his godfather, was the only one of all
Gaddo's children who became a painter, learning the rudiments
of the art from his father and the rest from Giotto. Besides
Taddeo, a Pisan painter already referred to, named Vicino,
was also a pupil of Gaddo. He did some excellent work in
mosaic for the great tribune of the Duomo of Pisa, where the
following words still testify to his authorship:

Tempore Domini Johannis Rossi operarii istius ecclesiae, Vicinus
pictor incepit et perfecit hanc imaginem B. Mariae, sed Majestatis,
et Evangelistae per alios inceptae, ipse complevit et perfecit. Anno
Domini 1321. De mense Septembris. Benedictum sit nomen Domini
Dei nostri Jesu Christi. Amen.

The portrait of Gaddo, by the hand of Taddeo his son, may be
seen in the Baroncelli chapel in the church of S. Croce, where
he stands by the side of Andrea Tafi, in the marriage of the
Virgin. In the book which I have mentioned above there is
a miniature by Gaddo, like that of Cimabue, which serves to
show his ability as a draughtsman.

Now, because an old book from which I have extracted these
few notices about Gaddo Gaddi speaks of the building of the
church of S. Maria Novella in Florence for the Friars Preachers,
a truly magnificent and imposing structure, I will take this
opportunity of relating the circumstances of its erection. While
St. Dominic was at Bologna, the place of Ripoli outside Florence[1]
was granted to him. Accordingly he sent twelve friars thither
under the care of the Blessed Giovanni da Salerno. Not many
years after they came to Florence, to the church and place of
S. Pancrazio, and established themselves there. When Dominic
himself came to Florence they left it, and went to stay in the
church of S. Paolo, as he wished them to do. Subsequently,
when the place of S. Maria Novella and all its possessions were
granted to the Blessed Giovanni by the papal legate and by the
bishop of the city, they entered into possession and began to
live in that place on the last day of October 1221. But as this

[1] Three miles beyond the gate of S. Niccolo.

church was rather small, with a western aspect, and the entrance on the old piazza, the friars, who had increased in numbers and who were in great credit in the city, began to think of enlarging their church and convent. So, having collected a great sum of money, and many people of the city having promised every assistance, they began the construction of a new church on St. Luke's day, 1278, when the first stone was laid with great ceremony by the Cardinal Latino degli Orsini, legate of Pope Nicholas III. to the Florentines. The architects of the church were Frà Giovanni of Florence, and Frà Ristoro da Campi, lay brethren of the order, who had restored the alla Carraia bridge, and that of S. Trinità, after their destruction by the flood of the 1st of October, 1264.[1] The greater part of the land covered by the church and convent was given to the friars by the heirs of M. Jacopo de' Tornaquinci, knight. The cost, as has been said, was defrayed partly by alms, partly by the money of various persons who gave assistance readily, but especially by the good offices of Friar Aldobrandino Cavalcanti, who was afterwards Bishop of Arezzo, and who is buried over the gate of the Virgin. Besides other things, this friar is said to have collected by his industry all the labour and materials required for the church. It was completed when Frà Jacopo Passavanti was prior of the convent, who thus deserved his marble tomb, which is on the left-hand side in front of the principal chapel. The church was consecrated by Pope Martin V. in the year 1420, as appears by an inscription on marble on a pillar on the right of the principal chapel, which runs:

Anno Domini 1420 die septima Septembris, Dominus Martinus divina providentia Papa V personaliter hanc ecclesiam consecravit, et magnas indulgentias contulit visitantibus eamdem.

All these things and many more are related in a chronicle of the building of this church, which is in the possession of the fathers of S. Maria Novella, as well as in the history of Giovanni Villani. I did not wish to omit these few particulars, because the church is one of the finest and most important in Florence, and also because it contains many excellent works of the most famous artists of a later time, as will be related hereafter.

[1] 1269. Villani's *Croniche*, lib. vii. cap. 24.

Margaritone, Painter, Sculptor and Architect of Arezzo
(? 1216 – ? 1293)

Among the other painters of old time, in whom the well-deserved praise accorded to Cimabue and his pupil Giotto aroused a great deal of fear, for their good workmanship in painting was hailed throughout Italy, was one Margaritone, painter of Arezzo, who recognised equally well with the others who previously occupied the foremost positions in painting in that unhappy age, that the work of these two men would probably all but obliterate his own reputation. Margaritone was considered excellent among the painters of the age who worked in the Byzantine style, and he did a number of pictures in tempera at Arezzo. He worked in fresco also, painting almost the whole of the church of S. Clemente, an abbey of the order of Camaldoli, but these occupied him a long time and cost him much trouble. The church is entirely destroyed to-day,[1] together with many other buildings, including a strong fortress called S. Chimenti, because the Duke Cosimo de' Medici not only here, but round the whole circuit of the city, pulled down many buildings with the old walls which had been restored by Guido Petramalesco, a former bishop and lord of the city, in order to reconstruct them with curtains and bastions of much greater strength and less circuit than the former ones had been, and consequently more easy to defend with a smaller number of men. Margaritone's pictures in this church contained many figures both small and great, and although they were executed in the Byzantine style, yet it was recognised that he had done them with good judgment and with love of art, as may be inferred from the works of this painter which are still extant in that city. Of these the principal is a picture, now in the chapel of the Conception in S. Francesco, with modern ornamentation representing a Madonna, which is held in great veneration by the friars there. In the same church he did a large crucifix, also in the Byzantine style, which is now placed in the chapel near the quarters of the wardens. The Saviour is delineated upon the axis of the cross, which is outlined, and Margaritone made many such crucifixes in that city. For the nuns of S. Margherita he painted a work which is now placed in the transept of their church. This is canvas stretched on a panel, containing subjects from the life of Our Lady and of St. John the Baptist in small figures, executed in a

[1] In 1547.

much better style and with more diligence and grace than the large ones.[1] This work is noteworthy, not only because the little figures in it are so carefully finished that they resemble the work of an illuminator, but because it is a wonderful thing that a picture on canvas should have lasted three hundred years. He did an extraordinary number of pictures for all the city, and a St. Francis drawn from life at Sargiano, a convent of the barefooted friars. To this he placed his name, because he considered that he had done it better than usual. He afterwards made a large crucifix in wood, painted in the Byzantine manner, and sent it to Florence to M. Farinata degli Uberti, a most famous citizen who, in addition to many other notable exploits, had saved his native city from imminent danger and ruin.[2] This crucifix is now in S. Croce, between the chapel of the Peruzzi and that of the Giugni. In S. Domenico, at Arezzo, a church and convent built by the lords of Pietramala in the year 1275, as their device still shows, he did many things before returning to Rome, where he had already given great satisfaction to Pope Urban IV. by doing some things in fresco for him in the portico of S. Pietro; for, although in the Byzantine style, they were not without merit for the time. After he had finished a St. Francis at Ganghereto, a place above Terranuova in the Valdarno, he devoted himself to sculpture, as he was of an ambitious spirit, and he studied with such diligence that he succeeded much better than he had done in painting; for, although his first sculptures were in the Byzantine style, as may be seen in four figures in wood of a Deposition from the Cross in the Pieve, and some other figures in relief which are in the chapel of St. Francis above the baptismal font, yet he adopted a much better manner after he had visited Florence and had seen the works of Arnolfo, and of the other more celebrated sculptors of the time. In the year 1275 he returned to Arezzo in the suite of Pope Gregory, who passed through Florence on his journey from Avignon to Rome. Here an opportunity occurred of making himself better known, for the Pope died at Arezzo after having given 30,000 crowns to the commune wherewith to finish the building of the Vescovado which had been begun by Master Lapo, and had made but little progress. The Aretines therefore ordained that the chapel of St. Gregory should be made in memory of the Pope in the Vescovado, in which Margaritone afterwards placed

[1] Now in the National Gallery, London; but incorrectly described here.
[2] In 1260, when the Ghibellines wished to destroy it after their victory at Montaperti. Farinata died in 1266.

a picture, and in addition that Margaritone should make a
marble tomb for the Pope in the Vescovado.[1] He set to work
upon the task and brought it to such a successful completion,
introducing the Pope's portrait from life both in marble and in
painting, that it was considered to be the best work he had
ever produced.

Margaritone then set to work to complete the Vescovado,
following the design of Lapo, and he made great progress; but
he did not complete it, for a few years later, in 1289, war broke
out again between the Florentines and Aretines, through the
fault of Guglielmo Ubertini, Bishop and lord of Arezzo, aided
by the Tarlari of Pietramela and by the Pazzi of Val d' Arno,
when all the money left by the Pope for the building of the
Vescovado was expended upon the war, while evil befell the
leaders, who were routed and slain at Campaldino. The Aretines
then ordained that the tolls paid by the surrounding country,
called a *dazio*, should be set aside for the use of the building,
and this toll has lasted to our own day.

To return to Margaritone; he seems to have been the first,
so far as one can judge by his works, who thought it necessary
to take precautions, when painting on wood, that the joints
should be secure, so that no cracks or fissures should appear
after the completion of the painting, and it was his practice to
cover the panel completely with canvas, fastened on by a strong
glue made of shreds of parchment and boiled in the fire; he then
treated the surface with gypsum, as may be seen in many of his
own pictures and in those of others. Over the gypsum thus
mixed with the glue, he made borders and diadems and other
rounded ornaments in relief; and it was he who invented the
method of introducing bosses on which he laid gold-leaf
which he afterwards burnished. All these things, which had
never been seen before, may be noticed in his works, especially
in a reredos in the Pieve of Arezzo, which contains scenes from
the life of St. Donato, and also in S. Agnesa and S. Niccolo in
the same city.

Margaritone produced many works in his own country which
were sent out of it, part of which are at Rome in S. Giovanni
and in S. Pietro, and some at S. Caterina at Pisa, where there
is a St. Catherine of his over an altar in the transept, containing
many small figures in a representation of her life, and also a
small panel of St. Francis with many subjects from his life, on a
gold ground. In the upper church of S. Francesco at Assisi is a

[1] The tomb is the work of Agostino and Agnolo.

crucifix by his hand, painted in the Byzantine style, on a beam which spans the church. All these works were greatly prized by the people of the time, although they are not valued to-day, except on account of their age; indeed, they could only be considered good in an age when art was not at its zenith, as it is to-day. Margaritone also paid some attention to architecture, although I have not mentioned any things made from his designs because they have no importance. However, I must not forget to say that he designed the palace of the governors of the city of Ancona, as I have found, in 1270, in the Byzantine style; and what is more, he carved in sculpture eight windows for the façade, each of which has two columns in the middle, which support two arches. In each window is a representation in half-relief, occupying the space between the arches and the top of the window, of an Old Testament subject, carved in a species of stone found in the country. Under the windows and on the façade are some letters, the purport of which must be conjectured, so badly are they done, which give the date and time at which the work was executed. The design of the church of S. Ciriaco at Ancona was also by his hand. Margaritone died at the age of seventy-seven, regretting, it is said, that he had lived long enough to see the changes of the age and the honours accorded to the new artists. He was buried in the old Duomo outside Arezzo, in a tomb of travertine, which has perished in our own time by the demolition of that church. The following epitaph was written for him:

> Hic jacet ille bonus pictura Margaritonus
> Cui requiem Dominus tradat ubique pius.

Margaritone's portrait was in the old Duomo by the hand of Spinello, in the Adoration of the Magi, and was copied by me before the church was pulled down.

GIOTTO, Painter, Sculptor and Architect of Florence
(1266 – 1337)

THE debt owed by painters to Nature, which serves them continually as an example, that from her they may select the best and finest parts for reproduction and imitation, is due also, in my opinion, to the Florentine painter Giotto; because, when the methods and outlines of good painting had been buried for so many years under the ruins caused by war, he alone, although

born in the midst of unskilful artists, through God's gift in him,
revived what had fallen into such an evil plight and raised it to a
condition which one might call good. Certainly it was nothing
short of a miracle, in so gross and unskilful an age, that Giotto
should have worked to such purpose that design, of which the
men of the time had little or no conception, was revived to a
vigorous life by his means. The birth of this great man took
place in the year 1276, fourteen miles from Florence, in the
town of Vespignano, his father, who was a simple field labourer,
being named Bondone. He brought up Giotto well for his
position in life. When the boy had attained the age of ten
years he exhibited, in all his childish ways, an extraordinary
quickness and readiness of mind, which made him a favourite
not only with his father, but with all who knew him, both in
the village and beyond it. Bondone then set him to watch a few
sheep, and while he was following these from place to place to
find pasture, he was always drawing something from Nature
or representing the fancies which came into his head, on flat
stones on the ground or on sand, so much was he attracted to
the art of design by his natural inclination. Thus one day, when
Cimabue was going on some business from Florence to Ves-
pignano, he came upon Giotto, who, while his sheep were grazing,
was drawing one of them from life with a roughly pointed piece
of stone upon a smooth surface of rock, although he had never
had any master but Nature. Cimabue stopped in amazement
and asked the boy if he would like to come and stay with him.
Giotto replied he would go willingly if his father would consent.
Accordingly Cimabue asked Bondone, who gladly consented,
and allowed him to take his son with him to Florence. After his
arrival there, assisted by his natural talent and taught by
Cimabue, the boy not only equalled his master's style in a short
time, but became such a good imitator of Nature that he entirely
abandoned the rude Byzantine manner and revived the modern
and good style of painting, introducing the practice of making
good portraits of living persons, a thing which had not been in
use for more than two hundred years. And although some had
made the attempt, as has been said above, yet they had not
been very successful, nor were their efforts nearly so well executed
as those of Giotto. Among other portraits which he made, the
chapel of the Podestá palace at Florence still contains that of
Dante Aligheri, his close companion and friend, no less famous
as a poet than Giotto then was as a painter. The latter has been
warmly praised by M. Giovanni Boccaccio in the introduction

to the story about M. Forese da Rabatta and Giotto.[1] In this same chapel Giotto has also painted his own portrait as well as those of Ser Brunetto Latini, Dante's master, and M. Corso Donati, a famous citizen of the time. Giotto's first paintings were in the chapel of the high altar of the Badia at Florence, in which he made a number of things which were considered beautiful, but especially an Annunciation.[2] In this he has represented with extraordinary truth the fear and astonishment of the Virgin Mary at the salutation of Gabriel, who, in her terror, seems ready to run away. The picture of the high altar in the same chapel is also by Giotto's hand, and it has retained its position there to this day, rather because of a certain reverence which is felt for the work of such a man than for any other reason. In S. Croce four chapels are decorated by his hand, three between the sacristy and the principal chapel, and one on the other side.[3] In the first of these, that of M. Ridolfo de Bardi, in which the bell-ropes hang, is the life of St. Francis, at whose death a number of friars display very faithfully the emotion of weeping. In the second, which is that of the family of the Peruzzi, are two scenes from the life of St. John the Baptist, to whom the chapel is dedicated. Here is a very life-like representation of the dancing of Herodias,[4] and of the deftness with which some servants are performing the service of the table. In the same chapel are two miracles of St. John the Evangelist, the one representing the raising of Drusiana, the other his being caught up into heaven. The third chapel, that of the Giugni and dedicated to the Apostles, contains representations by Giotto of the martyrdom of many of them. In the fourth, that of the Tosinghi and Spinelli, which is on the north side of the church and is dedicated to the Assumption of Our Lady, Giotto painted the Nativity of the Virgin, her marriage, the Annunciation, the Adoration of the Magi, and the Presentation of the Christ-child to Simeon. This last is a most beautiful thing, for not only is the warmest love depicted in the face of the old man as he receives the Christ, but the action of the child, who is afraid of him and stretches out his arms to return to his mother, could not be represented with more tenderness or greater beauty. In the Death of Our Lady, the Apostles are represented with a number of very beautiful angels holding torches. The Baroncelli

[1] *Decameron*, 6th Day, Novella 5.
[2] The work of Lorenzo Monaco.
[3] Probably done after 1317, because St. Louis of Toulouse, who was canonised in that year, is represented.
[4] Her daughter; Vasari habitually makes this mistake.

chapel in the same church contains a painting in tempera by Giotto's hand, in which he has represented with great care the Coronation of Our Lady; it contains a very large number of small figures and a choir of angels and saints, very carefully finished. On this work he has written his name and the date in gold letters. Artists who reflect that at this time Giotto was laying the foundations of the proper method of design and of colouring, unaided by the advantages of seeing the light of the good style, will be compelled to hold him in the highest veneration. In the same church of S. Croce there are in addition a crucifix above the marble tomb of Carlo Marzuppini of Arezzo, Our Lady with St. John and the Magdalene at the foot of the cross, and opposite, on the other side of the building, an Annunciation towards the high altar over the tomb of Lionardo Aretino, which has been restored by modern artists with great lack of judgment. In the refectory he has done the history of St. Louis, a Last Supper, and a Tree of the Cross, while the presses of the sacristy are decorated with some scenes from the lives of Christ and of St. Francis in small figures. At the church of the Carmine, in the chapel of St. John the Baptist he represented the whole of that saint's life in several pictures[1]; and in the Palazzo della parte Guelfa at Florence there is the history of the Christian faith painted admirably by him in fresco, and containing the portrait of Pope Clement IV., who founded that magistracy to which he gave his arms, retained by them ever since.[2]

After these works, Giotto set out from Florence for Assisi in order to finish what Cimabue had begun there.[3] On his way through Arezzo he painted the chapel of St. Francis, which is above the baptistery in the Pieve there, and a St. Francis and a St. Dominic, portraits from life, on a round pillar near to a most beautiful antique Corinthian capital. In the Duomo outside Arezzo he decorated the interior of a large chapel with the stoning of St. Stephen, an admirable composition of figures. On completing these things he proceeded to Assisi, a city of Umbria, whither he was summoned by Frà Giovanni di Muro della Marca, at that time general of the friars of St. Francis. In the upper church of this town he painted a series of thirty-two scenes in fresco of the life of St. Francis, under the course which runs round the church, below the windows, sixteen on

[1] These frescoes were painted by Spinello Aretino. Two heads of Apostles from them are in the National Gallery, London.
[2] Founded after the defeat of the Ghibellines in 1267.
[3] Probably in 1296.

each side, with such perfection that he acquired the highest reputation thereby. In truth the work exhibits great variety, not only in the gestures and postures of the different figures, but in the composition of each subject, besides which it is very interesting to see the various costumes of those times and certain imitations and observations of Nature. One of the most beautiful of these represents a thirsty man, whose desire for water is represented in the most lively manner as he kneels on the ground to drink from a spring, with such wonderful reality that one might imagine him to be a real person. There are many other things most worthy of notice into which I will not enter now, because I do not wish to be tedious. Let it suffice to say that by these works Giotto acquired the highest reputation for the excellence of his figures, for his arrangement, sense of proportion, truth to Nature, and his innate facility which he had greatly increased by study, while he never failed to express his meaning clearly. Giotto indeed was not so much the pupil of any human master as of Nature herself, for, in addition to his splendid natural gifts, he studied Nature diligently, and was always contriving new things and borrowing ideas from her.

When these works were completed Giotto, painted in the lower church of the same place the upper part of the walls beside the high altar, and all four sections of the vaulting over the spot where the body of St. Francis lies, the whole displaying his beautiful and inventive imagination. The first contains St. Francis glorified in heaven, surrounded by those Virtues which are required of those who wish to be perfect in the sight of God. On the one side Obedience puts a yoke on the neck of a friar who kneels before her, the bands of which are drawn by hands to heaven. With one finger on her mouth she signifies silence, and her eyes are turned towards Jesus Christ, who is shedding blood from His side. Beside her are Prudence and Humility to show that, where true obedience exists, there also will be humility and prudence, causing everything to prosper. In the second section is Chastity, in a strong castle, who will not allow herself to be won by the kingdoms, crowns or palms which are being offered to her. At her feet is Purity, who is washing the naked, while Fortitude is bringing others to be washed and cleansed. On one side of Chastity is Penitence, chasing a winged Love with the cord of discipline and putting to flight Uncleanness. Poverty occupies the third space, treading on thorns with her bare feet; behind her barks a dog, while a boy is throwing stones at her and another is pushing thorns into her legs with a stick.

Poverty here is espoused by St. Francis, while Jesus Christ holds her hand in the mystical presence of Hope and Chastity. In the fourth and last of these sections is a St. Francis in glory, clothed in the white tunic of a deacon, in triumph and surrounded by a multitude of angels who form a choir about him and hold a banner on which are a cross and seven stars, while over all is the Holy Spirit. In each of these sections are some Latin words explanatory of the subject. Besides these four sections, the paintings on the side walls are most beautiful, and deserve to be highly valued both for the perfection which they exhibit and because they were produced with such skill that they are in an excellent state of preservation to-day. These paintings contain an excellent portrait of Giotto himself, and over the door of the sacristy is a fresco by his hand of St. Francis receiving the stigmata, so full of tenderness and devotion that it seems to me to be the most excellent painting that Giotto has produced here, though all are really beautiful and worthy of praise.

When S. Francesco was at length finished Giotto returned to Florence, where he painted with extraordinary care a picture of St. Francis in the fearful desert of Vernia, to be sent to Pisa.[1] Besides a landscape full of trees and rocks, a new thing in those days, the attitude of the saint, who is receiving the stigmata, on his knees, with great eagerness, exhibits an ardent desire to receive them and an infinite love towards Jesus Christ, who is in the air surrounded by seraphim granting them to him, the varied emotions being all represented in the most telling manner imaginable. The predella of the picture contains three finely executed subjects from the life of the same saint. The work may now be seen in S. Francesco at Pisa, on a pillar beside the high altar, where it is held in high veneration in memory of so great a man. It led the Pisans, on the completion of their Campo Santo from the plan of Giovanni di Niccola Pisano, as already related, to entrust to Giotto the painting of a part of the walls. For, as the outside of the walls was incrusted with marble and sculptures at a great cost, the roof being of lead, and the interior filled with antique sarcophagi and tombs of Pagan times, gathered together in that city from all parts of the world, the Pisans wished the walls to be decorated with a series of noble paintings. Accordingly Giotto went to Pisa, and beginning at the end of one of the walls of the Campo Santo, he depicted the life of the patient Job in six large scenes in

[1] Now in the Louvre.

fresco.[1] Now it occurred to him that the marbles of the part
of the building in which he was at work were turned towards
the sea, and, being exposed to the south-east wind, they are
always moist and throw out a certain saltness, as do nearly all
the bricks of Pisa, and because the colours and paintings are
eaten away by these causes, and as he wished to protect his work
from destruction as far as possible, Giotto judiciously prepared
a coating for the whole of the surface, what we call intonaco
or incrustation, on which he proposed to paint his frescoes,
consisting of a mixture of lime, chalk and brick-dust. This
device has proved so successful, that the paintings which he
subsequently executed on this surface have endured to this
day, and they would have stood better had not the neglect of
those who should have taken care of them allowed them to be
much injured by the damp. The want of attention to this
detail, which would have involved little trouble, has caused
the pictures to suffer a great deal in some places where the
damp has converted the crimsons into black and caused the
plaster to fall off. Besides this, it is the nature of chalk when
mixed with lime to become corroded and to peel, whence it
happens that the colours are destroyed, although they may
originally appear to take well. These frescoes contain the portrait
of M. Farinata degli Uberti, besides many fine figures, among
which one may remark some rustics bringing the sad news to
Job, whose sorrow for the lost animals and the other mis-
fortunes could not be better felt or depicted. There is also
remarkable grace in the figure of a servant, who with a fan of
branches stands near the afflicted Job, abandoned by everyone
else, for, in addition to the figure being well executed in every
particular, his attitude is wonderful, as with one hand he drives
away the flies from his leprous and noisome master, and holds
his nose with the other with disgust, to escape the smell. Very
fine also are the other figures of these pictures and the heads
of both men and women, and the delicate treatment of the
drapery, so that it is small wonder that the work brought
Giotto such renown in that city and elsewhere, that Pope
Benedict IX., who was proposing to decorate St. Peter's with
some paintings, sent a courtier from Trevisi to Tuscany, to see
what manner of man Giotto was, and the nature of his work.[2]

[1] It used to be stated that these frescoes were done by Francesco Neri
of Volterra in 1371, but now it appears that they were only restored by
him at that date, probably not by Giotto, however. Now destroyed.
[2] Impossible, as Benedict occupied the chair of St. Peter 1033-45. The Pope
who sent for Giotto was Boniface VIII. (1295-1303), probably about 1298.

On the way the courtier learned that there were other excellent masters in painting and mosaic in Florence, and he interviewed a number of artists at Siena. When he had received designs from these, he proceeded to Florence. Entering Giotto's shop one morning, as he was at work, the envoy explained to him the Pope's intention, and the manner in which he wished to make use of his work, and finally asked Giotto for some small drawing to send to His Holiness. Giotto, who was always courteous, took a sheet of paper and a red pencil, pressed his arm to his side to make a compass of it, and then, with a turn of his hand, produced a circle so perfect in every particular that it was a marvel to see. This done, he turned smiling to the courtier and said: "Here is the drawing." The latter, who thought he was being mocked, said: "Am I to have no other design but this?" "It is enough and more than enough," replied Giotto; "send it in with the others and you will see if it obtains recognition." The messenger perceived that he would get nothing else, and left in a state of considerable dissatisfaction imagining that he had been laughed at. However, when he sent in the other designs with the names of their authors, he included that of Giotto, and related how the artist had executed it without moving his arm and without compasses. From this the Pope and many of the well-informed courtiers recognised to what an extent Giotto surpassed all the other painters of the time in excellence. When the story became public it gave rise to a saying which is still used for people of dull wits: "You are more simple (tondo) than Giotto's O." This proverb deserves to be considered a good one, not only from the circumstances out of which it arose, but much more for its meaning, which is due to the twofold significance of the word tondo in Tuscany, that of a perfect circle, and slowness and heaviness of mind. Accordingly the Pope sent for Giotto to Rome, where he received him with great honour, and recognised his worth. He caused him to paint for the choir of St. Peter's five subjects from the life of Christ, and the principal picture for the sacristy, all of which were executed with great care, and no more finished work in tempera ever left his hands; thus he richly deserved the reward of 600 gold ducats which the delighted Pope gave to him, bestowing many other favours upon him, so that it became the talk of all Italy.

As I do not wish to omit a memorable circumstance concerning art, I will notice here that there happened to be in Rome at this time a great friend of Giotto named Oderigi

d'Agobbio, an excellent illuminator of the day, who adorned many books for the Pope for the palace library, though they are now mostly destroyed by time. In my own book of old designs there are some remnants by his hand, and he certainly was a clever artist. But a much better master than he was Franco, an illuminator of Bologna, who did a number of excellent things for the Pope for the same library at that very time, in a like style, as may be seen in my book, where I have some designs by his hand, both for painting and illuminations, among them an eagle, excellently done, and a fine lion tearing up a tree. These two excellent illuminators are referred to by Dante in the passage on the vainglorious in the eleventh canto of the *Purgatorio*, in these lines:

> Oh, dissi lui, non se' tu Oderisi
> L'onor d'Agobbio e l'onor di quell' arte
> Ch' alluminare è chimata in Parisi?
> Frate, diss' egli, più ridon le carte,
> Che pennelleggia Franco Bolognese
> L'onor è tutto or suo, e mio in parte.[1]

When the Pope had seen these works he was so enchanted by Giotto's style that he commissioned him to surround the walls of St. Peter's with scenes from the Old and New Testaments. Giotto therefore began these, and painted in fresco the angel, seven braccia high, which is above the organ, and many other paintings, of which some have been restored by other artists in our own day, and some have been either destroyed or carried away from the old fabric of St. Peter's during the building of the new walls, and set under the organ. Among these was a representation of Our Lady on a wall. In order that it might not be thrown down with the rest, it was cut out, supported by beams and iron, and so taken away. On account of its great beauty, it was afterwards built into a place selected by the devotion of M. Niccolo Acciaiuoli, a Florentine doctor enthusiastic over the excellent things of art, who has richly adorned this work of Giotto with stucco and other modern paintings. Giotto is also the author of the mosaic known as the Navicella, which is over the three doors of the portico in the courtyard

[1] "Oh," I exclaimed,
"Art thou not Oderigi, art not thou
Agobbio's glory, glory of that art
Which they of Paris call the limner's skill?"
"Brother," said he, " with tints that gayer smile,
Bolognian Franco's pencil lines the leaves.
His all the honour now; mine borrowed light."—*Cary.*

of St. Peter's.[1] This is a truly marvellous work, well deserving
its high reputation among all persons of taste. In addition to
its excellent design, the Apostles are admirably represented,
toiling in different ways in the midst of the tempest, while
the winds fill the sail, which bellies out exactly like a real one;
and yet it is a difficult task so to unite those pieces of glass to
form the light and shade of so real a sail, which, even with
the brush, could only be equalled by a great effort. Besides all
this, there is a fisherman who is standing on a rock and fishing
with a line, whose attitude is expressive of the extreme patience
proper to that art, while his face betrays his hope and desire
to catch something. Beneath this work are three small arches
painted in fresco, but as they are almost entirely effaced, I will
say no more about them. All artists, however, unite in praise of
this work.

At last, when Giotto had painted a large crucifix in tempera
on a panel in the Minerva, a church of the Friars Preachers,
which was then much admired, he returned to his own country,
after an absence of six years. But soon after Pope Clement V.
was elected at Perugia, on the death of Pope Benedict IX., and
Giotto was obliged to accompany the new pontiff to his court
at Avignon to execute some works there.[2] Thus, not only in
Avignon, but in several other places of France, he painted many
very beautiful frescoes and pictures, which greatly delighted
the Pope and all his court. When he at length received his
dismissal, he was sent away kindly with many gifts, so that he
returned home no less rich than honoured and famous. Among
other things which he brought away with him was the Pope's
portrait, which he afterwards gave to Taddeo Gaddi, his pupil.
The date of this return to Florence was the year 1316. But he
was not long permitted to remain in Florence, as he was invited
to Padua to do some work for the lords della Scala, for whom
he painted a beautiful chapel in the Santo, a church built in
those times. He thence proceeded to Verona, where he did some
pictures for the palace of Messer Cane, particularly the portrait
of that lord, and a picture for the friars of S. Francesco. On the
completion of these things he was detained at Ferrara, on his
way back to Tuscany, to paint for the lords of Este in their

[1] This was done in 1298 to the order of Cardinal Stefaneschi. Later
restorations have entirely altered its character, but there is a drawing
of it in its early form at Chatsworth.

[2] Clement V. succeeded Benedict XI. in 1305. It is now doubted whether
Giotto ever went to Avignon, though he was summoned thither by
Benedict XII. in 1334. Benedict IX. is an obvious mistake.

palace and S. Agostino some things which may be seen there to this day. When the news of Giotto's presence at Ferrara reached the Florentine poet Dante, he succeeded in inducing his friend to visit Ravenna, where the poet was exiled, and caused him to paint some frescoes about the church of S. Francesco for the lords of Polenta, which are of reasonable merit. From Ravenna Giotto proceeded to Urbino, and did a few things there. Afterwards he happened to be passing through Arezzo, and being unable to refuse a favour to Piero Saccone, who had been very kind to him, he executed in fresco, on a pillar of the principal chapel of the Vescovado, a St. Martin, who is cutting his mantle in two and giving part of it to a beggar who is all but naked. Then, when he had painted in tempera a large crucifix on wood for the abbey of S. Fiore, which is now in the middle of that church, he at length reached Florence. Here, among many other things, he painted some pictures in fresco and tempera for the nunnery of Faenza, which no longer exist owing to the destruction of that house.

In 1321 occurred the death of Giotto's dearest friend Dante, to his great grief; and in the following year he went to Lucca, where, at the request of Castruccio, then lord of that city, his birthplace, he made a picture of St. Martin, with Christ above in the air, and the four patron saints of the city, St. Peter, St. Regulus, St. Martin and St. Paulinus, who seem to be presenting a pope and an emperor, believed by many to be Frederick of Bavaria and the anti-Pope Nicholas V.[1] There are also some who believe that Giotto designed the impregnable fortress of the Giusta at S. Fridiano at Lucca. When Giotto had returned to Florence, King Robert of Naples wrote to his eldest son Charles, King of Calabria, who was then in that city,[2] to use every means to induce the painter to go to Naples, where the king had just completed the building of the nunnery of S. Chiara and the royal church, which he wished to have decorated with noble paintings. When Giotto learned that he was wanted by so popular and famous a king, he departed to serve him with the greatest alacrity,[3] and on his arrival he painted many scenes from the Old and New Testaments in some chapels of the monastery. It is said that the scenes from the Apocalypse which he made in one of those chapels were suggested by Dante, as also perchance were some of the much-admired works

[1] Vasari probably means Louis of Bavaria, the Emperor. Nicholas V. was created Pope in 1327, but the dates do not seem to tally very well.
[2] Charles was in Florence from July 1326 to December 1327.
[3] January 1330.

King often came to talk to —: p.

at Assisi, of which I have already spoken at length; and although Dante was dead at this time, it is possible that they had talked over these things, as friends frequently do. To return to Naples, Giotto did many works in the Castel dell' Uovo,[1] especially in the chapel, which greatly delighted the king, who became so fond of him that he often came to talk with the artist while he was at work, and took delight in seeing him at work and in listening to his conversation. Giotto, who always had a jest ready or some sharp retort, entertained the king with his hand in painting and with his tongue by his pleasant discourse. Thus it once happened that the king told him it was his intention to make him the first man in Naples, to which Giotto replied: "No doubt that is why I am lodged at the Porta Reale to be the first man *in* Naples." Another day the king said to him: "Giotto, if I were you, this hot day, I would leave off painting for a while." He answered: "So I should certainly, if I were you." Being thus on very friendly terms with the king, he painted a good number of pictures for him in the chamber which King Alfonso I. pulled down to make the castle, and also in the Incoronata, and among those in the chamber were the portraits of many famous men, Giotto among the number.[2] One day, by some caprice, the king asked Giotto to paint his kingdom. It is said that Giotto painted for him a saddled ass, with another new saddle at its feet at which it was sniffing, as if he wished for it in place of the one he had on. On each saddle were the royal crown and the sceptre of power. When the king asked Giotto for the meaning of this picture, he replied: "Such are your subjects and such is the kingdom, where every day they are wanting to change their master."

On his departure from Naples for Rome Giotto stayed at Gaeta, where he was constrained to paint some subjects from the New Testament in the Nunziata, which have suffered from the ravages of time, but not to such an extent that it is not possible to distinguish a portrait of Giotto himself near a large crucifix of great beauty. This done, he remained a few days at Rome, in the service of the Signor Malatesta, whom he could not refuse this favour, and then he went on to Rimini, of which city Malatesta was lord, and there in the church of S. Francesco he painted a large number of pictures[3] which were afterwards destroyed by Gismondo, son of Pandolfo Malatesta, who rebuilt

[1] This should be the Castel Nuovo, which was the royal palace.
[2] It is now suggested that these frescoes are by Simone Memmi, or his school.
[3] Before 1313.

the whole of that church. In the cloister of the same church,
opposite the façade, he painted in fresco the life of the
Blessed Michelina,[1] which ranks with the best things which he
ever did, on account of the many fine things which he took
into consideration in executing it, for, quite apart from the
beauty of the drapery and the grace and vigour of the heads,
which are truly marvellous, there is a young woman of the
most exquisite beauty who, in order to free herself from an
accusation of adultery, takes a most solemn oath upon a book,
keeping her eyes fixed on those of her husband, who has made
her swear because his suspicions had been aroused by her giving
birth to a black son, whom he could not be persuaded to acknow-
ledge as his own. Just as the husband shows his anger and
mistrust in his face, so his wife betrays, to those who look
carefully, her innocence and simplicity, by the trouble in
her face and eyes, and the wrong which is done to her in
making her swear and in unjustly proclaiming her publicly as
an adulteress. Giotto has also expressed with great realism a
man afflicted with sores, as all the women who are about him,
disgusted by the stench, turn away with various contortions in
the most graceful manner imaginable. Then again the fore-
shortening in a picture containing a number of deformed beggars
is highly praiseworthy, and should be much prized by artists,
since it is from these works that the origin of foreshortening is
derived; and when it is remembered that they are the first,
they must be considered very tolerable achievements. But the
most remarkable thing of all in this series is the action of the
saint with regard to certain usurers who are paying her the
money realised by the sale of her possessions, which she intends
to give to the poor. Her face displays contempt for money and
other earthly things, which she seems to abhor, while the usurers
are the very picture of human avarice and greed. Similarly the
face of one who is counting the money, and appears to be
informing the notary, who is writing, is very fine; for al-
though his eyes are turned towards the notary, yet he keeps
his hand over the money, thus betraying his greed, avarice
and mistrust. Also the three figures in the air representing
Obedience, Patience and Poverty, who are holding up the habit
of St. Francis, are worthy of the highest praise, chiefly on account
of the natural folds of the drapery, showing that Giotto was
born to throw light on the art of painting. Finally he has intro-
duced into this work a portrait of the Signor Malatesta in a ship,

[1] As she died in 1356 the work cannot be Giotto's.

which is most life-like; and his excellence is also displayed in
the vigour, disposition and posture of the sailors and other
people, particularly of one figure who is speaking with others
and, putting his hand to his face, spits into the sea. Certainly
this may be classed among the very best works in painting
produced by the master, because, in spite of the large number
of figures, there is not one which is not produced with the most
consummate art, being at the same time exhibited in an attrac-
tive posture. Accordingly there is small need for wonder that
the Signor Malatesta loaded him with rewards and praise.
When Giotto had completed his works for this Signor, he did
a St. Thomas Aquinas reading to his brethren for the outside of
the church door of S. Cataldo at Rimini at the request of the
prior, who was a Florentine. Having set out thence, he returned
to Ravenna, where he executed a much-admired painting in
fresco in a chapel of S. Giovanni Evangelista. When he next
returned to Florence, laden with honours and riches, he made
a large wooden crucifix in tempera for S. Marco, of more than
life-size, with a gold ground, and it was put on the right-hand
side of the church. He made another like it for S. Maria Novella,
in which his pupil Puccio Capanna collaborated with him. This
is now over the principal entrance to the church, on the right-
hand side, above the tomb of the Gaddi. Upon the screen of the
same church he made a St. Louis, for Paolo di Lotto Ardinghelli,
with portraits of the donor and his wife at the saint's feet.

In the following year, 1327, occurred the death of Guido
Tarlati da Pietramala, bishop and lord of Arezzo, at Massa di
Maremma, on his return from Lucca, where he had been visiting
the Emperor. His body was brought to Arezzo, where it received
the honour of a stately funeral, and Pietro Saccone and Dolfo
da Pietramala, the bishop's brother, determined to erect a
marble tomb which should be worthy of the greatness of such
a man, who had been both spiritual and temporal lord and the
leader of the Ghibelline party in Tuscany. Accordingly they
wrote to Giotto, desiring him to design a very rich tomb, as
noble as possible; and when they had supplied him with the
necessary measurements, they asked him to send them at once
the man who was, in his opinion, the most excellent sculptor
then living in Italy, for they relied entirely upon his judgment.
Giotto, who was very courteous, prepared the design and sent
it to them, and from it the tomb was made, as will be said in
the proper place. Now Pietro Saccone was a great admirer of
Giotto's worth, and when, not long after, he took the Borgo

a S. Sepolero, he brought from that place to Arezzo a picture by the artist's hand of small figures, which was afterwards broken into fragments; but Baccio Gondi, a Florentine of gentle birth, a lover of the noble arts and of every kind of virtue, made a diligent search for the pieces of this picture when he was commissioner at Arezzo, and succeeded in finding some. He brought them to Florence, where he holds them in great veneration, as well as some other things in his possession, also by Giotto, who produced so much that an enumeration of all his works would excite incredulity. It is not many years since that I happened to be at the hermitage of Camaldoli, where I have done a number of things for the fathers, and in a cell to which I was taken by the Very Rev. Don Antonio da Pisa, then general of the congregation of Camaldoli, I saw a very beautiful little crucifix, on a gold ground, by Giotto, with his signature. I am informed by the Rev. Don Silvano Razza, a Camaldolian monk, that this crucifix is now in the cell of the principal at the monastery of the Angeli, Florence, where it is treasured for its author's sake as a most precious thing, together with a very beautiful little picture by the hand of Raphael of Urbino.

For the Umiliati brethren of Ognissanti at Florence Giotto painted a chapel and four pictures, one of them representing Our Lady surrounded by a number of angels, with the Child in her arms, and a large crucifix of wood,[1] the design of which was subsequently copied by Puccio Capanna, and reproduced in every part of Italy, for he closely followed Giotto's style. When this work of the Lives was printed for the first time, the screen of that church contained a small panel painted in tempera by Giotto, representing the Death of Our Lady, surrounded by the Apostles, while Christ receives her soul into His arms.[2] The work has been much praised by artists, and especially by Michelagnolo Buonarotti, who declared, as is related elsewhere, that it was not possible to represent this scene in a more realistic manner. This picture, being as I say held in great esteem, has been carried away since the publication of the first edition of this work, by one who may possibly have acted from love of art and reverence for the work, which may have seemed then to be too little valued, and who thus from motives of pity showed himself pitiless, as our poet says. It is certainly a marvel that Giotto should have produced such beautiful paintings in those times, especially when it is considered that he

[1] Now in the Uffizi, Florence. [2] Now at Chantilly.

may in a certain sense be said to have learned the art without a master.

After these things, in the year 1334, on the ninth day of July, he began work on the campanile of S. Maria del Fiore, the foundations of which were laid on a surface of large stones, after the ground had been dug out to a depth of 20 braccia, the materials excavated being water and gravel. On this surface he laid 12 braccia of concrete, the remaining 8 braccia being filled up with masonry. In the inauguration of this work the bishop of the city took part, laying the first stone with great ceremonial in the presence of all the clergy and magistrates. While the work was proceeding on its original plan, which was in the German style in use at the time, Giotto designed all the subjects comprised in the ornamentation, and marked out with great care the distribution of the black, white and red colours in the arrangement of the stones and friezes. The circuit of the tower at the base was 100 braccia, or 25 braccia on each side, and the height 144 braccia. If what Lorenzo di Cione Giberti has written be true, and I most firmly believe it, Giotto not only made the model of this campanile, but also executed some of the marble sculptures in relief, which represent the origin of all the arts. Lorenzo asserts that he had seen models in relief by the hand of Giotto, and particularly those of these works, and this may readily be credited, since design and invention are the father and mother of all the fine arts, and not of one only. According to Giotto's model, the campanile should have received a pointed top or quadrangular pyramid over the existing structure, 50 braccia in height, but because it was a German thing, and in an old-fashioned style, modern architects have always discountenanced its construction, considering the building to be better as it is. For all these things Giotto received the citizenship of Florence, in addition to a pension of one hundred gold florins yearly from the commune of Florence, a great thing in those days. He was also appointed director of the work, which was carried on after him by Taddeo Gaddi, as he did not live long enough to see its completion.

While the campanile was in progress, Giotto made a picture for the nuns of S. Giorgio, and three half-length figures in the Badia of Florence, in an arch over the doorway inside, now whitewashed over to lighten the church. In the great hall of the podestà at Florence, he painted a representation of the commune, plundered by many. The figure is represented as a judge, seated with a sceptre in his hand, over whose head are

the scales, equally poised to indicate the just measures meted out by him, while he is assisted by four Virtues: Fortitude with the soul, Prudence with the laws, Justice with arms, and Temperance with words; a fine painting, and an appropriate and plausible idea.

Giotto then made a second visit to Padua, where, besides painting a number of chapels and other things, he executed a famous series of pictures in the place of the Arena, which brought him much honour and profit.[1] In Milan also he left a few things which are scattered about the city, and which are considered very beautiful to this day. At length, shortly after his return from Milan, he rendered his soul to God in the year 1336, to the great grief of all his fellow-citizens, and of all those who had known him or even heard his name, for he had produced so many beautiful works in his life, and was as good a Christian as he was an excellent painter. He was buried with honour, as his worth deserved, for in his life he was beloved by everyone, and especially by distinguished men of every profession. Besides Dante, of whom we have spoken above, he and his works were highly esteemed by Petrarch, who in his will left to Signor Francesco da Carrara, lord of Padua, among other things which were held in the greatest veneration, a Madonna by Giotto's hand, as a rare thing, and a most acceptable gift. The words of this part of the will run thus:— *Transeo ad dispositionem aliarum rerum; et predicto igitur domino meo Paduano, quia et ipse per Dei gratiam non eget, et ego nihil aliud habeo dignum se, mitto tabulam meam sive historiam Beatæ Virginis Mariae, operis Jocti pictoris egregii, quæ mihi ab amico meo Michaele Vannis de Florentia missa est, in cujus pulchritudinem ignorantes non intelligunt, magistri autem artis stupent: hanc iconem ipsi domino lego, ut ipsa Virgo benedicta sibi sit propitia apud filium suum Jesum Christum*, etc. It was Petrarch also who said the following words in the fifth book of his *Letters* written to his intimate friends: *Atque (ut a veteribus ad nova, ab externis ad nostra transgrediar) duos ego novi pictores egregios, nec formosos, Jottum Florentinorum civem, cujus inter modernos fama ingens est, et Simonem Sanensem. Novi scultores aliquot*, etc. Giotto was buried in S. Maria del Fiore, on the left-hand as one enters the church, where a white marble slab is set up to the memory of this great man. As I remarked in the life of Cimabue, a contemporary commentator of Dante said: "Giotto was, and is, the chief among the painters in that same city of Florence

[1] 1303-5.

as his works in Rome, Naples, Avignon, Florence, Padua and
many other parts of the world testify."

Giotto's pupils were Taddeo Gaddi, his godson as I have
already said, and Puccio Capanna, a Florentine,[1] who painted
for the Dominican church of S. Cataldo at Rimini a most perfect
fresco representing a ship apparently about to sink, while the
men are throwing their goods into the water. Puccio has here
portrayed himself among a number of sailors. After Giotto's
death, the same artist painted a number of things in the church
of S. Francesco at Assisi, and for the Chapel of the Strozzi,
beside the door on the river-front of the church of S. Trinità,
he did in fresco a Coronation of the Virgin with a choir of angels,
in which he followed Giotto's style very closely, while on the
side walls are some very well-executed scenes from the life of
St. Lucy. In the Badia of Florence he painted the chapel of
S. Giovanni Evangelista of the family of the Covoni, which is
next to the sacristy. At Pistoia he painted in fresco the principal
chapel of S. Francesco, and the chapel of S. Ludovico, with
scenes from the lives of the patron saints, which are very toler-
able productions.[2] In the middle of the church of S. Domenico
in the same city is a crucifix with a Madonna and St. John,
executed with much softness, and at the feet an entire human
skeleton, an unusual thing at that time, which shows that
Puccio had made efforts to understand the principles of his art.
This work contains his name, written after this fashion: *Puccio
di Fiorenza me Fece*. In the same church, in the tympanum
above the door of S. Maria Nuova are three half-length figures,
Our Lady, with the Child in her arms, St. Peter on the one side
and St. Francis on the other, by the same artist. In the lower
church of S. Francesco at Assisi he further painted in fresco
some scenes from the Passion of Jesus Christ, with considerable
skill and much vigour, and in the chapel of S. Maria degli Angeli
he executed in fresco a Christ in glory, with the Virgin, who is
interceding with Him for Christian people, a work of consider-
able merit, but much smoked by the lamps and candles which
are always burning there in great quantity. In truth, so far as
one can judge, Puccio adopted the style and methods of his
master Giotto, and knew full well how to make use of them in
his works, although, as some assert, he did not live long, but
sickened and died through working too much in fresco. His

[1] A mistake, owing to his patronymic di Ser Fiorenza. He probably
belonged to Assisi.
[2] In 1386.

hand may also be recognised in the chapel of St. Martin in the
same church, in the history of the saint, done in fresco for the
Cardinal Gentile.[1] In the middle of a street called Portica may
also be seen a Christ at the Column, and a picture of Our Lady
between St. Catherine and St. Clare. His works are scattered about
in many other places, such as Bologna, where there is a picture
of the Passion of Christ in the transept of the church, and scenes
from the life of St. Francis, besides other things which I omit
for the sake of brevity. But at Assisi, where the majority of his
works are, and where I believe he helped Giotto to paint, I
found that they consider him to be a fellow-citizen, and there
are some members of the family of the Capanni in that city to
this day. From this we may gather that he was born in Florence,
since he himself wrote as much, and that he was a pupil of Giotto,
but that he took his wife from Assisi, and had children there,
whose descendants still inhabit the town. But this matter is
of very slight importance, and it is enough to know that he was
a skilful master. Another pupil of Giotto, and a very clever
painter, was Ottaviano da Faenza, who painted many things
in S. Giorgio at Ferrara, a convent of the monks of Monte
Oliveto. In Faenza, where he lived and died, he painted in the
tympanum above the door of S. Francesco, Our Lady and
St. Peter and St. Paul, and many other things in his own country
and at Bologna.

Another pupil was Pace di Faenza, who was often with his
master, and helped him in many things. At Bologna there are
some scenes in fresco by his hand on the outside front of
S. Giovanni Decollato. This Pace was a clever artist, especially
in painting small figures, as may be seen to-day in the church
of S. Francesco at Forli, in a Tree of the Cross and in a small
panel in tempera containing the life of Christ, and four small
subjects from the life of Our Lady, which are all very well
executed. It is said that he executed in fresco, for the chapel
of St. Anthony at Assisi, some scenes from the life of that saint
for a duke of Spoleto, who is buried there with a son. These two
princes had been killed while fighting in the suburbs of Assisi,
as may be seen by a long inscription on the sarcophagus of their
tomb. The old book of the company of painters records that one
Francesco, called "of Master Giotto," was another pupil of the
master, but I know nothing more about him.

Yet another pupil of Giotto was Guglielmo da Forli, who,
besides many other works, painted the chapel of the high altar

[1] These frescoes are the work of Simone Martini.

for S. Domenico at Forli, his native place. Other pupils were
Pietro Laureati, Simone Memmi of Siena, Stefano of Florence,
and Pietro Cavallini of Rome. But as I intend to deal fully with
these in their lives, I shall content myself here with simply
saying that they were pupils of Giotto. That the master drew
extremely well for his day may be seen on a number of parch-
ments containing some water-colours, pen-and-ink drawings,
chiaroscuros with the lights in white, by his hand, in our book
of designs, which are truly marvellous when compared with
those of the masters who preceded him, and afford a good
example of his style.

As has been said, Giotto was a very witty and merry person,
very ready in speech, many of his sayings being still fresh in
the memory of his fellow-citizens. Besides the one related by
M. Giovanni Boccaccio, several very good stories are told by
Franco Sacchetti in his *Three Hundred Tales*.[1] I give one in the
author's own words, because it contains many expressions and
phrases characteristic of the time. The rubric of this one runs:
"Giotto, the great painter, is requested by a person of low
birth to paint his buckler. Making a jest of the matter, he
paints it so as to cover the applicant with confusion."

TALE LXIII

Everyone must have heard of Giotto, and how as a painter
he surpassed all others. His fame came to the ears of a rude
artizan, who wanted his buckler painted possibly because he had
to go to render his feudal service. Accordingly he presented himself
abruptly at Giotto's workshop, with a man to carry the buckler be-
hind him. He found Giotto in, and began: "God save thee, Master,
I want to have my arms painted on this buckler." Giotto took
stock of the man and his manners, but he said nothing except
"When do you want it?" and the man told him. "Leave it to
me," said Giotto, and the man departed. When Giotto was
alone he reflected: "What is the meaning of this? Has someone
sent him here to play a trick on me? At all events, no one
has ever before brought me a buckler to paint. And the fellow
who brought it is a simple creature, and asks me to paint his
arms as if he was of the royal house of France. Decidedly I shall
have to make him some new arms." Reflecting thus with him-

[1] Born at Florence in 1335. His Novelle were considered the best after
those of Boccaccio. They were in MS. in Vasari's time.

self he sat down before the buckler, and having designed what he thought proper, he called a pupil and told him to complete the painting of it, which was accordingly done. The painting represented a light helmet, a gorget, a pair of arm pieces, a pair of iron gauntlets, a pair of cuirasses, a pair of cuisses and gambadoes, a sword, a knife, and a lance. When the worthy man returned, who knew nothing of all this, he came up and said: "Master, is the buckler finished?" "Oh yes," said Giotto, "go you and bring it here." When it arrived this gentleman by proxy looked hard at it and said to Giotto: "What rubbish have you painted here?" "Will you think it rubbish to pay for it?" said Giotto. "I won't pay you four deniers," said the man. "What did you ask me to paint?" asked Giotto. "My arms," replied the man. "Well," said Giotto, "are they not here, are any wanting?" "That is so," said the man. "A plague on you," said Giotto, "you must needs be very simple. If anyone asked you who you were you would be at a loss to tell him, and yet you come here and say, 'Paint me my arms.' If you had been one of the Bardi, well and good, but what arms do you bear? Where do you come from? Who were your ancestors? Are you not ashamed of yourself? Begin at least by coming into the world before you talk of arms as if you were the Duke of Bavaria. I have represented all your arms on the buckler, and if you have any more tell me, and I will have them painted." "You have given me rough words," said the man, "and spoilt my buckler." He then departed to the justice, and procured a summons against Giotto. The latter appeared, and on his side issued a summons against the man for two florins, as the price of the painting. When the magistrates had heard the arguments, which were much better advanced on Giotto's side, they adjudged that the man should take away his buckler, and give six lire to Giotto, because he was in the right. Accordingly the rustic took his buckler, paid the money, and was allowed to go. Thus this man, who did not know his place, had it pointed out to him, and may this befall all such fellows who wish to have arms and found houses, and whose antecedents have often been picked up at the foundling hospitals!

It is said that while Giotto was still a boy, and with Cimabue, he once painted a fly on the nose of a figure which Cimabue had made so naturally that, when his master turned round to go on with his work, he more than once attempted to drive the fly

away with his hand, believing it to be real, before he became aware of his mistake. I could tell many more of Giotto's practical jokes, and relate many of his sharp retorts, but I wish to confine myself to the things which concern the arts, and I must leave the rest to Franco and others.

In conclusion, in order that Giotto should not be without a memorial, in addition to the works which came from his hand, and to the notices left by the writers of his day, since it was he who found once again the true method of painting, which had been lost many years before his time, it was decreed by public order that his bust in marble, executed by Benedetto da Maiano, an excellent sculptor, should be placed in S. Maria del Fiore. This was due to the activity and zeal displayed by Lorenzo dei Medici the Magnificent, the elder, who greatly admired Giotto's talents. The following verses by that divine man Messer Angelo Poliziano were inscribed on the monument, so that all men who excelled in any profession whatever might hope to earn such a memorial, which Giotto, for his part, had most richly deserved and earned:

> Ille ego sum, per quem pictura extincta revixit,
> Cui quam recta manus, tam fuit et facilis.
> Naturae deerat nostrae, quod defuit arti:
> Plus licuit nulli pingere, nec melius.
> Miraris turrim egregiam sacro aere sonantem?
> Haec quoque de modulo crevit ad astra meo.
> Denique sum Jottus, quid opus fuit illa referre?
> Hoc nomen longi carminis instar erit.

And in order that those who come after may see by Giotto's own designs the nature of the excellence of this great man, there are some magnificent specimens in my book, which I have collected with great care as well as with much trouble and expense.

AGOSTINO and AGNOLO, Sculptors and Architects of Siena
(ob. 1350; ob. ?1348)

AMONG the others who worked in the school of the sculptors Giovanni and Niccola Pisani were Agostino and Agnolo,[1] sculptors of Siena, whose lives we are now writing, and who achieved great excellence according to the standard of the time. I have discovered that their father and mother were both Sienese, and their antecedents were architects, for the Fontebranda was completed by them in the year 1190, under the

[1] Agostino di Giovanni, Agnolo di Ventura.

government of the three Consuls, and in the following year they did the Custom House and other buildings of Siena, under the same consulship. Indeed, it is often seen that where the seeds of talent have existed for a long time, they germinate and put forth shoots so that they afterwards produce greater and better fruit than the first plants had done. Thus Agostino and Agnolo added many improvements to the style of Giovanni and Niccola Pisani, and enriched art with better designs and inventions, as their works clearly show. It is said that, when Giovanni Pisano returned to Pisa from Naples in the year 1284, he stopped at Siena to design and begin the façade of the Duomo, where the three principal doors are, so that it should be entirely adorned with marble.[1] It was then that Agostino, who was not more than fifteen years of age at the time, associated with him in order to study sculpture, of which he had learned the first principles, being no less attracted by that art than by architecture. Under Giovanni's instruction and by means of unremitting study he surpassed all his fellow-pupils in design, grace and style, so that everyone remarked that he was his master's right eye. And because it is natural to desire for those whom one loves beyond all other gifts of nature, mind or fortune that quality of worth which alone renders men great and noble in this life and blessed in the next, Agostino took advantage of Giovanni's presence to secure the same advantages for his younger brother Agnolo; nor was it very difficult to do so, for the practice already enjoyed by Agnolo with Agostino and the other sculptors, and the honour and benefits which he perceived could be gained from this art, had so inflamed him with a desire to take up the study of sculpture, that he had already made a few things in secret before the idea had occurred to Agostino. The elder brother was engaged with Giovanni in making the marble reliefs for the high altar of the Vescovado of Arezzo, which has been mentioned above, and he succeeded in securing the co-operation of Agnolo in that work, who did so well that, when it was completed, it was found that he had caught up with Agostino in excellence. When this became known to Giovanni, he employed both brothers in many other works undertaken by him subsequently in Pistoia, Pisa and other places. And because Agostino practised architecture as well as sculpture, it was not long before he designed a palace in Malborghetto for the Nine who then ruled in Siena, that is to say in the year 1308. The execution of this work won the brothers such a

[1] Giovanni was architect-in-chief of the Duomo, 1284-98.

reputation in their native place that, when they returned
to Siena after the death of Giovanni, they were both appointed
architects of the State, so that in the year 1317 the north
front of the Duomo was made under their direction,[1] and in
1321 the building of the walls of the Romana gate, then
known as the S. Martino gate, was begun from their plans in its
present style, being finished in 1326. They restored the Tufi
gate, originally called the gate of S. Agata all Arco, and in
the same year the church and convent of S. Francesco were
begun from their design, in the presence of the cardinal of
Gaeta, the papal legate.[2] Not long afterwards Agostino and
Agnolo were invited by means of some of the Tolomei, who
were staying in exile at Orvieto, to make some sculptures for
the opera of S. Maria in that city.[3] Going thither they made in
sculpture some prophets which are now on the façade, and are
the finest and best-proportioned parts of that celebrated work.
Now in the year 1326 it chanced that Giotto was summoned
to Naples through Charles, Duke of Calabria, who was then
staying in Florence, to do some things in S. Chiara and other
places there for King Robert, as has been related in that master's
life.[4] On his way to Naples, Giotto stopped at Orvieto to see the
work which had been executed there and which was still being
carried on by so many men, wishing to examine everything
minutely. But the prophets of Agostino and Agnolo of Siena
pleased him more than all the other sculptures, from which cir-
cumstance it arose that Giotto not only commended them, but
counted them among the number of his friends, to their great
delight, and further recommended them to Piero Saccone of
Pietramala as the best sculptors of the day, and the best fitted
to make the tomb of Guido, the lord and bishop of Arezzo, as
mentioned in the Life of Giotto. Thus the fact that Giotto had
seen the work of many sculptors at Orvieto, and had considered
that of Agostino and Agnolo of Siena to be the best, gave rise
to their being commissioned to make this tomb after his designs
and in accordance with the model which he had sent to Piero
Saccone. They finished the tomb in the space of three years,
conducting the work with great care, and they set it up in the
chapel of the Sacrament in the church of the Vescovado of

[1] This is doubtful, as Camaino di Crescenzio was master until 1318.
[2] In 1325. The legate was Cardinal Giovanni Gaetano degli Orsini.
[3] Agostino is first mentioned in connection with the work at Orvieto in
1339, and Agnolo not at all.
[4] Giotto went in 1330. Charles was at Florence from July 1326 to
December 1327.

Arezzo.[1] Above the sarcophagus, which rests on brackets carved in a really admirable manner, is stretched the form of the bishop, in marble, while at the side are some angels drawing curtains, done with considerable skill. Twelve square panels contain scenes of the life and acts of the bishop in an infinite number of small figures carved in half-relief. I do not think it too much trouble to relate the subjects of these scenes, so that it may appear with what patience they were executed, and how these sculptors endeavoured to discover the good style by study.

The first shows how the bishop, aided by the Ghibelline party of Milan, who sent him 400 masons and money, entirely rebuilt the walls of Arezzo, increasing their length so that they took the shape of a galley. The second is the taking of Lucignano di Valdichiana; the third, that of Chiusi; the fourth, that of Fronzoli, a strong place of that time above Poppi, held by the sons of the Count of Battifolle. The fifth contains the final surrender to the bishop of the town of Rondine, after it had been besieged by the Aretines for many months. The sixth is the capture of the town del Bucine in Valdarno. The seventh contains the storming of the Rocca di Caprese, which belonged to the Count of Romena, after it had been besieged for several months. In the eighth the bishop is dismantling the castle of Laterino, and causing the hill which rises above it to be cut in the form of a cross, so that it should not be possible to make another fortress there. The ninth represents the destruction and burning of Monte Sansavino and the driving out of all the inhabitants. The eleventh contains the bishop's coronation, with a number of richly dressed soldiers, both horse and foot, and of other people. The twelfth and last represents the bishop being carried by his men from Montenero, where he fell sick, to Massa, and thence, after his death, to Arezzo. In many places about the tomb are the Ghibelline insignia and the bishop's arms, which are six squared stones *or* on a field *azure*, disposed in the same manner as the six balls in the arms of the Medici. These arms of the bishop's house were described by Friar Guittone, knight and poet of Arezzo, when he wrote of the site of the castle of Pietramala, whence the family derived its origin, in the lines:

> Dove si scontra il Giglion con la Chiassa
> Ivi furon i miei antecessori,
> Che in campo azzurro d'or portan sei sassa.[2]

[1] Completed in 1330. The heads were restored in stucco in 1783.

[2] Where the Giglion joins the Chiassa
 There did my ancestors flourish
 Who bear six golden stones on azure ground.

Agostino and Agnolo displayed more art, invention and diligence in this work than had ever been employed on anything before their time. And indeed they deserve the highest praise, having introduced into it so many figures, such a variety of landscapes, places, towers, horses, men and other things, that it is a veritable marvel. And although the tomb has been almost entirely destroyed by the French of the Duke of Anjou, who sacked the greater part of the city in revenge for some injuries received by them from their enemies, yet it is still clear that it was executed with the most excellent judgment by Agnostino and Agnolo, who carved on it in large letters: *Hoc opus fecit magister Augustinus et magister Angelus de Senis.* In 1329 they did a marble bas-relief for the church of S. Francesco at Bologna which is in a very fair manner, and besides the carved ornamentation, which is very rich, they introduced figures a braccia and a half high of Christ crowning Our Lady, with three similar figures on either side, St. Francis, St. James, St. Dominic, St. Anthony of Padua, St. Petronius, and St. John the Evangelist, and under each of these figures is carved in bas-relief a scene from the life of the saint above.[1] All these scenes contain a great number of figures in half-relief, which make a rich and beautiful ornamentation after the manner of those times. It is very apparent that Agostino and Agnolo threw an immense amount of labour into this work, and that they applied all their care and knowledge to make it worthy of praise, as it truly was, and even now when it is half destroyed, it is possible to read their names and the date, by means of which, and of a knowledge of the time when they began it, one may see that they spent eight whole years upon it, although it is true that at the same time they made many other small things in different places for various persons.

Now while they were at work at Bologna, that city gave itself freely to the Church, through the mediation of the papal legate,[2] and the Pope in return promised that he and his court would go to live at Bologna, but that for his security he wished to build a castle or fortress there. This was granted by the Bolognese, and the castle was quickly built under the direction and from the design of Agostino and Agnolo; but it had a very short life, for, when the Bolognese discovered that all the promises made by the Pope were vain, they dismantled and destroyed it much more quickly than it had been made.[3]

[1] This work was done by Jacobello and Pier Paolo delle Massegne in 1388.
[2] The legate entered Bologna on 5 February, 1328. [3] In 1333.

It is said that, while these two sculptors were staying at Bologna, the Po impetuously burst its banks, doing incredible damage to the territories of Mantua and Ferrara, causing the death of more than ten thousand persons, and wasting the country for miles around.[1] The assistance of Agostino and Agnolo, as clever and worthy men, was requested, and they succeeded in finding means of reducing that terrible river to its bed, and of confining it there with embankments and other effective remedies. This brought them much praise and benefit, for, besides the fame which they acquired thereby, their services were acknowledged by the lords of Mantua and by the house of Este with most liberal rewards.

When they next returned to Siena in the year 1338, the new church of S. Maria, near the old Duomo, towards the piazza Manetti, was made under their direction from their design, and not long after the Sienese, who were greatly pleased with all the works which they executed for them, decided to seize this excellent opportunity of carrying into effect a plan which they had long discussed, but till then without any result, namely, the erection of a public fountain on the principal piazza opposite the palace of the Signoria. The charge of this undertaking was entrusted to Agostino and Agnolo, and, although it was a matter of great difficulty, they brought water to the fountain by pipes made of lead and clay, and the first jet of water was thrown up on 1st June, 1343, to the great delight and contentment of all the city, which on this account was under a great obligation to the talent of these two citizens. At the same time the hall of the greater council was made in the Palazzo del Pubblico, and the same artists directed and designed the building of the tower of that palace, which they completed in the year 1344, hanging two great bells in it, one of which came from Grosseto, while the other was made at Siena. In the course of time Agnolo arrived at Assisi, where he made a chapel in the lower church of S. Francesco, and a marble tomb for a brother of Napoleone Orsini, a cardinal and a Franciscan friar, who had died in that place.[2] Agostino, who had remained at Siena in the service of the State, died while he was engaged upon the designs for the ornamentation of the piazza fountain, mentioned above, and was buried in the Duomo with honour. I have not been able to

[1] In October 1331.
[2] The tomb is attributed by Professor Venturi to Giovanni di Cosma. Giovanni Gaetano degli Orsini, brother of Napoleone, died at Avignon in 1339.

discover how or when Agnolo died, so that I can say nothing about it, nor do I know of any other works of importance by his hand, and so this is the end of their lives. It would, however, be an error, as I am following a chronological order, not to make mention of some who, although they have not done things which would justify a full account of their lives, have nevertheless in some measure added things of utility and beauty to art and to the world. Therefore, in connection with the mention made above of the Vescovado and Pieve of Arezzo, let me here relate that Pietro and Paolo, goldsmiths of Arezzo, who learned design from Agnolo and Agostino of Siena, were the first who executed great works of any excellence with the chisel; for they made for the head priest of the Pieve of Arezzo a silver head of life-size, in which was put the head of St. Donato, bishop and protector of that city, a work which was certainly praiseworthy, if only because they introduced into it some figures in enamel of great beauty and other ornaments, and because, as I have said, it was among the first things executed with the chisel.

About the same time, or shortly before, the art of the Calimara at Florence entrusted to Master Cione, an excellent goldsmith, the greater part, if not the whole, of the silver altar of S. Giovanni Battista, which contains many scenes from the life of that saint, represented in a very creditable manner in half-relief on a silver plate. This work, on account of its dimensions, and the novelty of its execution, was considered marvellous by everyone who saw it. The same Master Cione, in 1330, when the body of St. Zenobius was found under the vaults of St. Reparata, placed in a silver head of life-size the piece of the head of that saint which is still preserved therein, and is carried in procession. This head was considered a most beautiful thing at the time, and brought much reputation to the artist, who died soon after, a wealthy man, and held in high esteem.[1]

Master Cione left many pupils, and among others Forzore di Spinello of Arezzo, who did all manner of engraving excellently, but was especially good in making scenes in enamel on silver, such as may be seen in the Vescovado at Arezzo, for which he made a mitre with a beautiful border of enamel, and a fine pastoral staff in silver. He also executed many things in silver for the Cardinal Galeotto da Pietramala, who bequeathed them to the friars of la Vernia, where he wished to be buried, and where, beyond the wall which the Count Orlando, lord of Chiusi, a small place below la Vernia, had caused to be set up, he built

[1] The work of Andrea Arditi.

the church and many rooms in the convent, and all this without leaving any notice or other memorial of himself in any part of that place. Another pupil of Master Cione was Lionardo di Ser Giovanni of Florence, who executed a number of works with the chisel and by welding, with a better design than those who preceded him, especially the altar and silver bas-reliefs of S. Jacopo at Pistoia, where, beside a large number of subjects, the figure of St. James in the middle in full relief, more than a braccia high, is much admired. It is finished with such elaboration, that it looks like a cast rather than a work of the chisel. The figure is placed in the midst of the scenes of the altar panel, about which runs a border in letters of enamel:

Ad honorem Dei et S. Jacobi Apostoli, hoc opus factum fuit tempore Domini Franc. Pagni dictae operae operarii sub anno 1371 per me Leonardum Ser Jo. de Floren. aurific.

Now to return to Agostino and Agnolo; they had many pupils who produced many works after them in architecture and sculpture in Lombardy and other places in Italy. Among them was Jacopo Lanfrani of Venice, who began S. Francesco of Imola, and executed the sculptures for the principal door, where he carved his name and the date, 1343; for the church of S. Domenico at Bologna the same Master Jacopo made a marble tomb for Gio. Andrea Calduino, doctor of law and secretary of Pope Clement VI., and another very well executed also in marble and in the same church for Taddeo Peppoli, protector of the people and of justice at Bologna.[1] In the same year, that is to say in 1347, after the completion of this tomb, or shortly before, Master Jacopo returned to his native Venice and there began the church of S. Antonio, which was originally of wood, at the request of a Florentine abbot of the ancient family of the Abati, M. Andrea Dandolo, being doge at the time. This church was completed in the year 1349.

Then again Jacobello and Pietro Paolo, Venetians, who were pupils of Agostino and Agnolo, erected in S. Domenico at Bologna a marble tomb for M. Giovanni da Lignano, doctor of laws, in the year 1383. All these and many other sculptors continued for a long space of time to employ the same manner, so that they filled all Italy with examples of it. It is further believed that the native of Pesaro, who besides many other

[1] It should be Giovanni d' Andrea Calderini. The tomb was made in 1348. Peppoli was lord of Bologna 1337–47. Professor Venturi asserts that these tombs cannot possibly be by the same hand. The former is now in the Museo Civico at Bologna.

things did the door of the church of S. Domenico in his native town, with the three marble figures of God the Father, St. John the Baptist and St. Mark, was a pupil of Agostino and Agnolo, and the style of the work gives colour to the supposition. This work was completed in the year 1385. But since it would take much too long to enter into particulars of the works made in this style by many masters of the time, I will let what I have said, in this general way, suffice, chiefly because our arts can derive no real benefit from such works. Yet I thought it good to mention these men, because even if they do not deserve a long notice, they are not so insignificant as to be altogether passed over in silence.

STEFANO, Painter of Florence, and UGOLINO of Siena (1301–1350; 1260–1339)

STEFANO, painter of Florence and pupil of Giotto, was so excellent that, not only did he surpass all the artists who had studied the arts before him, but he so far surpassed his master himself that he was deservedly considered the best of the painters up to that time, as his works clearly prove.[1] He painted the Madonna in fresco for the Campo Santo at Pisa, and it is somewhat superior in design and colouring to the work of Giotto. In the cloister of S. Spirito at Florence he painted three arches in fresco, in the first of which, containing the Transfiguration with Moses and Elias, he represented the three disciples in fine and striking attitudes. He has formed a fine conception of the dazzling splendour which astonished them, their clothes being in disorder, and falling in new folds, a thing first seen in this picture, as he tried to base his work upon the nude figures, an idea which had not occurred to anyone before, no, not even to Giotto himself. Under the arch, in which he made a Christ healing a demoniac, he drew an edifice in perspective, perfectly, in a style then little known, displaying improved form and more science. He further executed it in the modern manner with great judgment, and displayed such art and such invention and proportion in the columns, doors, windows and cornices, and such different methods from the other masters, that it seemed as if he had begun to see some glimpses of the

[1] This artist, so famous in his own day, is now a mere name, and nothing survives that can with confidence be attributed to him.

good and perfect manner of the moderns. Among other ingenious things he contrived a very difficult flight of steps, which are shown both in painting and in relief, and possess such design, variety and invention, and are so useful and convenient, that Lorenzo de' Medici the Magnificent, the elder, adopted the design for the steps outside the palace of Poggio a Caiano, now the principal villa of the Most Illustrious Duke. In the other arch is a representation of Christ saving St. Peter from drowning, so well done that one seems to hear the voice of Peter saying: *Domine, salva nos, perimus.* This work is considered much finer than the other, because, besides the grace of the draperies, there is a sweetness in the bearing of the heads and a fear of the fortunes of the sea, while the terror of the Apostles at various motions and appearances of the water is represented in very suitable attitudes and with great beauty. And although time has partly destroyed the labour expended by Stefano on this work, one may still discern confusedly that the Apostles are defending themselves with spirit from the fury of the winds and waves. This work, which has been highly praised by the moderns, must certainly have appeared a miracle in all Tuscany in the time of its author. Stefano then painted in the first cloister of S. Maria Novella a St. Thomas Aquinas, next a door, where he also made a crucifix which has since been much damaged by other painters in restoring it. He also left unfinished a chapel in the church which he began, now much damaged by time. In it may be seen the fall of the angels through the pride of Lucifer, in divers forms. Here it is noteworthy that the foreshortening of the arms, busts and legs of the figures is much better done than ever before, and this shows us that Stefano began to recognise and had partially overcome the difficulties which stand in the way of the highest excellence, the mastery of which by his successors, by means of unremitting study, has rendered their works so remarkable. For this cause the artists nicknamed him the Ape of Nature.

Some time after Stefano was invited to Milan, where he began many things for Matteo Visconti, but was not able to complete them because, having fallen sick owing to the change of air, he was compelled to return to Florence. There he regained his strength, and executed in fresco in the chapel of the Asini in S. Croce the story of the martyrdom of St. Mark by being drawn asunder, with many figures which possess merit. As a pupil of Giotto he was then invited to Rome, where he did in fresco for the principal chapel of St. Peter's, which contains the altar of

that saint, some scenes from the life of Christ between the windows of the large apse, with such care that he approaches very closely to the modern style and far surpasses his master Giotto in design and other things. After this he executed in fresco, at Araceli, on a pillar beside the principal chapel on the left, a St. Louis, which is much admired because it possesses a vivacity which had not been apparent in any works up to that time, not even in those of Giotto. Indeed, Stefano had great facility in design, as may be seen in a drawing by his hand in our book, in which the Transfiguration is represented which he made for the cloister of S. Spirito, and indeed in my opinion he designed much better than Giotto. He next went to Assisi, and in the apse of the principal chapel of the lower church, where the choir is, he began a representation in fresco of the Heavenly Glory; and although he did not finish it, what he did perform shows that he used the utmost diligence. In this work he began a series of saints with such beautiful variety in the faces of the youths, the men of middle age and the old men, that nothing better could be desired, and those blessed spirits exhibit so sweet and so harmonious a style that it appears all but impossible that they could have been done by Stefano at that time. He however did execute them, although no more than the heads of the figures are finished. Above them is a choir of angels rejoicing, in various attitudes, appropriately carrying theological symbols in their hands. All are turned towards a crucified Christ, who is in the midst of the work immediately above a St. Francis, who is surrounded by a multitude of saints. Besides this he made some angels as a border for the work, each of them holding one of those churches of which St. John the Evangelist writes in the Apocalypse. These angels are represented with such grace that I am amazed to find a man of that age capable of producing them. Stefano began this work with the intention of thoroughly completing it, and he would have succeeded had he not been forced to leave it imperfect and to return to Florence on some important private affairs. During this stay at Florence, and in order to lose no time, he painted for the Granfigliazzi lung' Arno, between their houses and the alle Carraia bridge, in a small tabernacle on one side, Our Lady seated sewing, to whom a clothed child, who is seated, is offering a bird, done with such care that, although it is small, it merits no less praise than the more ambitious efforts of the master.

On the completion of this work and the settling of his affairs, Stefano was summoned to Pistoia by the lords there, and was

set by them to paint the chapel of S. Jacopo in the year 1346.[1]
In the vaulting he did a God the Father with some Apostles,
and on the side walls the life of the saint, notably the scene where
his mother, the wife of Zebedee, asks Jesus Christ to permit that
her two sons shall sit, one on His right hand and the other on
His left in the kingdom of His Father. Near this is a fine presen-
tation of the beheading of the saint. It is thought that Maso,
called Giottino, of whom I shall speak afterwards, was the son
of this Stefano, and although, on account of his name, many
believe him to be the son of Giotto, I consider it all but certain
that he was rather the son of Stefano, both because of certain
documents which I have seen, and also because of some trust-
worthy notices written by Lorenzo Ghiberti and by Domenico
del Grillandaio. However this may be, and to return to Stefano,
to him is due the credit of the greatest improvement in painting
since the days of Giotto; because, besides being more varied in
his inventions, he obtained more harmony and better blending
in his colouring than all the others, and, above all, in finish he
had no rival. And although the foreshortenings which he made
exhibit, as I have said, a bad manner owing to the difficulties
of execution, yet as the first investigator of these difficulties he
deserves a much higher place than those who follow after the
path has been made plain for them. Thus a great debt is due to
Stefano, because he who presses on through the darkness and
shows the way heartens the others, enabling them to overcome
the difficulties of the way, so that in time they arrive at the
desired haven. In Perugia also, in the church of S. Domenico,
Stefano began in fresco the chapel of St. Catherine which was
left unfinished.[2]

At the same time there lived a Sienese painter called Ugolino,
of considerable repute, and a great friend of Stefano. He did
many pictures and chapels in all parts of Italy. But he kept in
great part to the Byzantine style, to which he had become
attached by habit, and always preferred, from a species of
obstinacy, to follow the manner of Cimabue rather than that
of Giotto, which was held in such esteem. His works consist of
a picture for the high altar of S. Croce, on a gold ground, and
another picture which stood for many years on the high altar of
S. Maria Novella, and which is now in the chapter-house, where

[1] The work was done by Alesso d' Andrea and Bonaccorso di Maestro
Cino in 1347.
[2] This mediocre work belongs to the fifteenth century. Vasari ascribes
this work in another place to Buffalmacco, see page 121 below.

every year the Spanish nation celebrates with a solemn feast the festival of St. James and its other offices and burial services.[1] Besides these he did many other things in a good style, but without in the least departing from the manner of his master. It was he who painted on a brick pier of the loggia, which Lapo had built on the piazza of Orsanmichele, that Madonna which, not many years after, worked so many miracles that the loggia was for a great time full of votive offerings, and to this day is held in the highest veneration. Finally, in the chapel of M. Ridolfo de' Bardi, in S. Croce, where Giotto painted the life of St. Francis, he did a Crucifixion in tempera with the Magdalene and St. John weeping, and two friars on either side. Ugolino died at an advanced age in the year 1349, and was honourably buried at Siena, his native place.

But to return to Stefano, who, they say, was also a good architect, and what has been said above makes this likely; he died, it is said, at the beginning of the Jubilee of 1350, at the age of forty-nine, and was buried in S. Spirito in the tomb of his ancestors with this epitaph:

Stephano Florentino pictori, faciundis imaginibus ac colorandis figuris nulli unquam inferiori; Affines moestiss. pos. vix. an. XXXXIX.

PIETRO LAURATI, Painter of Siena
(ob. 1350)

PIETRO LAURATI,[2] an excellent painter of Siena, proved by his life how great may be the contentment of men of undoubted talent, who realise that their works are valued, both at home and abroad, and who see themselves in request by all men; for in the course of his life he was employed and caressed by all Tuscany. The first works which brought him into notice were the scenes which he painted in fresco in la Scala, a hospital of Siena,[3] in which he imitated so successfully the style of Giotto, which had become known throughout Tuscany, that men thought that he would become a better master than Cimabue, Giotto and the others, as he actually did. In these scenes he represented the

[1] Three panels of the high altar-piece of Santa Croce, Florence, with a portion of the predella are now in the Berlin Museum. Other portions of this predella are in the National Gallery, London, and in private collections. The S. Maria Novella altar-piece, now in the Accademia, Florence, is not now accepted as a work of Ugolino.

[2] Pietro di Lorenzo or Lorenzetti, brother of Ambrogio Lorenzetti.

[3] Painted in 1335, ruined in 1720.

Virgin mounting the steps of the Temple, accompanied by Joachim and Anna, and received by the priest; then her marriage, both remarkable for good ornamentation, well-draped figures with simple folds of the clothes, and a majesty in the carriage of the heads, while the disposition of the figures is in the finest style. During the progress of this work, which introduced the good style of painting to Siena, being the first gleam of light for the many fine spirits who have flourished in that land in every age, Pietro was summoned to Monte Oliveto di Chiusuri, where he painted a picture in tempera which is now placed in the paradiso under the church. He next painted a tabernacle at Florence, opposite the left door of the church of S. Spirito, on the side where a butcher's shop now stands, which merits the highest praise from every artist of knowledge, on account of the grace of the heads and the sweetness which it exhibits. Proceeding from Florence to Pisa, he did for the Campo Santo, on the wall next the principal door, all the lives of the Holy Fathers, with such striking reality and in such fine attitudes that they rival Giotto. For this work he won the highest praise, having expressed in some heads, in drawing and colour, all the vivacity of which the manner of the time was capable. From Pisa he passed to Pistoia, and in S. Francesco did a picture of Our Lady in tempera, surrounded by some angels, very well arranged, the predella beneath containing some scenes with small figures presented with a vigour and life remarkable for those times.[1] This work satisfied him as much as it delighted others, and accordingly he put his name to it in these words: *Petrus Laurati de Senis.* Afterwards, in the year 1355, Pietro was summoned to Arezzo by M. Guglielmo, head priest, and by Margarito Boschi and the other wardens of the Pieve of Arezzo. This church had been brought to an advanced stage in a better style and manner than had been practised in Tuscany up to that time, being ornamented with squared stones and carvings by the hand of Margaritone, as has been said. There Pietro painted in fresco the tribune and all the great apse of the chapel of the high altar, representing twelve scenes from the life of Our Lady, with life-size figures, from the chasing of Joachim out of the Temple, to the birth of Jesus Christ. In these works in fresco one meets with the ideas, lineaments, carriage of the heads and attitudes of the figures characteristic of Giotto, his master. And although the whole of this work is beautiful, yet the paintings in the vaulting of the apse are certainly much better than the rest, because, in

[1] Now in the Uffizi, Florence.

the place where he represented the ascent of Our Lady to heaven, besides making the Apostles four braccia high each, in which he showed his greatness of mind, being the first artist who attempted to aggrandise his style, he gave such a beautiful turn to the heads and such grace to the vestments that more could not have been desired in those days. In like manner in the vaulting he depicted a truly angelic and divine joy in a choir of angels flying in the air about a Madonna. As they gracefully dance they appear to be singing, and whilst they are playing various instruments they keep their eyes fixed and intent on another choir of angels, sustained by a cloud of almond shape bearing the Madonna to heaven, arranged in beautiful attitudes and surrounded by rainbows. This work, which was deservedly popular, procured him a commission to paint in tempera the picture of the high altar of that Pieve, where in five panels of life-size figures, represented to the knees, he made Our Lady with the Child on her arm, with St. John the Baptist and St. Matthew on one side of her, and on the other the Evangelist and St. Donato. In the predella are many small figures, as well as in the frame of the picture above, all really fine and executed in the best style. I have entirely restored this altar at my own expense and with my own hands, so that this picture has been placed above the altar of St. Christopher, at the bottom of the church. I may take this opportunity, without appearing to be impertinent, of saying in this place that I have myself restored this ancient collegiate church, moved by Christian piety and by the affection which I bear to the venerable building, because it was my first instructress in my early childhood and contains the remains of my forefathers. This I did also because it appeared to me to be as it were abandoned, and it may now be said to have been called back to life from the dead. Besides increasing the light, for it was very dark, by enlarging the original windows and making new ones, I also took away the choir, which used to occupy a great part of the church, and put it behind the high altar, to the great satisfaction of the canons there. The new altar stands isolated, and has on the front panel a Christ calling Peter and Andrew from their nets, and on the side next the choir is another picture of St. George killing the serpent. On the sides are four panels, each of which contains two saints of life-size. Above and below in the predella are numerous other figures, which are omitted for the sake of brevity. The ornamentation of the altar is 13 braccia high, and the predella 2 braccia. The interior is hollow and is approached by a staircase through a

small iron aperture, very well arranged. Many valuable relics are preserved there, which may be seen from the outside through two iron gratings in the front. Among others is the head of St. Donato, bishop and protector of Arezzo. In a sarcophagus of variegated stone, 3 braccia high, which I have caused to be newly made, are the bones of four saints. The predella of the altar, which goes all round it, to scale, has in front of it the tabernacle or *ciborium* of the Sacrament, in carved wood, all gilt, about 3 braccia high. It is round and may be seen from the choir side as well as from the front. As I have spared neither pains nor expense, since I considered myself bound to do my best to honour God, I may venture to affirm that, so far as my ability would allow, this work lacks nothing in the way of ornament, whether of gold, carving, painting, marble, trevertine, variegated, porphyry, or other stones.

Now to return to Pietro Laurati. When he had completed the picture mentioned above, he did many things for St. Peter's at Rome, which were afterwards destroyed in building the new church. He also executed some works at Cortona and at Arezzo, besides those already mentioned, and some others in the church of S. Fiore e Lucilla, a monastery of black monks, notably a representation in a chapel of St. Thomas putting his hand into the wound in Christ's side.

A pupil of Pietro was Bartolommeo Bologhini [1] of Siena, who executed many pictures at Siena and other places in Italy. There is one by his hand at Florence, on the altar of the chapel of St. Silvester in S. Croce. The paintings of this man were executed about the year 1350. In my book, which I have so often referred to, may be seen a drawing by Pietro, representing a shoemaker sewing in a simple but most natural manner with an admirable expression. It affords a good example of Pietro's peculiar style. His portrait by the hand of Bartolommeo Bologhini was in a picture at Siena, where not many years ago I copied it, in the manner seen above.

Andrea Pisano, Sculptor and Architect
(1270–1348)

While the art of painting has flourished, sculptors have never been lacking who could produce excellent work. To the observant mind, the works of every age bear testimony to this fact, for the two arts are really sisters, born at the same time and

[1] Bolgarini, fl. 1337–78.

nourished and animated by the same spirit. This is seen in Andrea Pisano,[1] who practised sculpture in the time of Giotto, and made so much improvement in that art, both by practice and study, that he was considered the best exponent of the profession who had until then appeared in Tuscany, especially in casting bronze. For this reason his works were so honoured and prized by those who knew him, and especially by the Florentines, that he was able without a pang to change his country, relations, property and friends. It was a great advantage to him that the masters who had preceded him in sculpture had experienced so much difficulty in the art that their works were rude and commonplace, so that those who saw his productions judged him a miracle by comparison. That these first works were rude may be credited, as has been said elsewhere upon an examination of some which are over the principal door of S. Paolo at Florence, and some stone ones in the church of Ognissanti, which are so executed as to move to laughter those who regard them, rather than to excite in them any admiration or pleasure. It is certain that it was much more easy to recover the art of sculpture when the statues had been lost, as a man is a round figure by nature, and is so represented by that art, whereas in painting, on the other hand, it is not so easy to find the right shapes and the best manner of portraying them, which are essential to the majesty, beauty, grace and ornament of a picture. In one circumstance fortune favoured the labours of Andrea, because, as has been said elsewhere, by means of the numerous victories won by the Pisans at sea, many antiquities and sarcophagi were brought to Pisa, which are still about the Duomo and Campo Santo. These gave him great assistance and much light, advantages which could not be enjoyed by Giotto, because the ancient paintings which have been preserved are not so numerous as the sculptures. And although statues have frequently been destroyed by fire, devastation and the fury of war, or buried or transported to various places, yet it is easy for a connoisseur to recognise the productions of all the different countries by their various styles. For example, the Egyptian is slender, with long figures; the Greek is cunning, and much care is displayed on the nude, while the heads nearly always have the same turn; and the ancient Tuscan is hard in the treatment of hair and somewhat rude. As regards the Romans, and I call Roman for the most part those things which were brought to Rome after the subjection of Greece, as all that

[1] Andrea da Pontedera.

was good and beautiful in the world was carried thither; this Roman work, I say, is so beautiful in expression, attitudes, movements both in nude figures and in draperies, that the Romans may be said to have plucked what is beautiful from all other parts of the world and gathered it into a single style, making it the best and the most divine of all.

At the time of Andrea all these good methods and arts were lost, and the only style in use was that which had been brought to Tuscany by the Goths and the rude Greeks. So, after observing the new style of Giotto and such few antiquities as were known to him, he somewhat refined a great part of the grossness of that wretched manner by his own judgment, so that he began to work in better style, and endow his works with far more beauty than had been seen in any sculptor before his time. When his intelligence, skill and dexterity had become known he was assisted by many of his compatriots, and while he was still a young man he was commissioned to make some small figures in marble for S. Maria a Ponte.[1] These brought him such a good name that he was most earnestly desired to come to work at Florence by those in charge of the building of S. Maria del Fiore, as, after the façade of the three doors had been begun, there was a lack of masters to execute the subjects which Giotto had designed for the beginning of that structure. Accordingly Andrea went to Florence in order to undertake that work, and because at that time the Florentines were desirous of making themselves agreeable and friendly to Pope Boniface VIII., who was then the head of the Church of God, they wished Andrea, before everything else, to make his statue in marble. Andrea therefore set to work, and did not rest until he had finished the Pope's effigy placed between St. Peter and St. Paul, the three figures being set up on the façade of S. Maria del Fiore, where they still are. Afterwards Andrea made some small figures of prophets for the middle door of that church, set in tabernacles or niches. These showed that he had made great improvements in the art, and that in excellence and design he surpassed all those who had laboured for that structure up to that time. Hence it was decided that all works of importance should be entrusted to him and not to others. Soon after he was commissioned to make four statues of the principal doctors of the Church—St. Jerome, St. Ambrose, St. Augustine and St. Gregory.[2]

[1] Now known as S. Maria della Spina.

[2] These figures were made by Niccolo di Piero Lamberti and Piero di Giovanni Tedesco. They are now on the highway of Poggio Imperiale.

When these were finished they brought him favour and renown with the craftsmen and throughout the city, and he was commissioned to make two other figures in marble of the same size. These were St. Stephen and St. Laurence, which are on the front of S. Maria del Fiore at the extreme ends. By Andrea's hand also is the marble Madonna, three and a half braccia high with the Child in her arms, which is over the altar of the little church and company of the Misericordia on the piazza of S. Giovanni at Florence.[1] This was much praised in those times, especially as on either side of the Madonna he put an angel two and a half braccia high. A setting of very finely carved wood has been made for this in our own day by Maestro Antonio called " Il Carota," with a predella beneath, full of most beautiful figures coloured in oil by Ridolfo, son of Domenico Grillandai. In like manner the half-length Madonna in marble which is over the side-door of the Misericordia, on the façade of the Cialdonai, is by Andrea's hand,[2] and was highly praised, because in it he had imitated the good antique manner, contrary to his habit, which was always remote from it, as shown by some designs of his which are in our book, representing all the scenes from the Apocalypse.

Now Andrea had studied architecture in his youth, and an opportunity occurred for his employment in this art by the commune of Florence, for, as Arnolfo was dead and Giotto absent, he was entrusted with the preparation of plans for the castle of Scarperia, which is in Mugello at the foot of the Alps. Some say, though I will not vouch for the truth of it, that Andrea stayed a year at Venice, and there executed some small marble figures which are on the façade of S. Marco, and that in the time of M. Piero Gradenigo, doge of that republic,[3] he planned the Arsenal. But as I know nothing of this beyond the bare mention of it which occurs in some writers, I must leave the matter to the judgment of my readers. From Venice he returned to Florence, where the city, fearing the coming of the Emperor,[4] with Andrea's co-operation hastily added eight braccia to part of the wall between S. Gallo and the Prato gate, and in other places he made bastions, palisades and other very strong works in earth and wood. Now some three years before, he had shown his skill in casting bronze in a much-admired cross which he had sent to the Pope at Avignon, by means of his close friend

[1] This was the work of Alberto Arnoldi in 1359.
[2] Also by Arnoldi. [3] 1289–1311.
[4] Henry VII. The walls were strengthened in 1310.

Giotto, then staying at that court; accordingly he was commissioned to make in bronze one of the doors of the church of S. Giovanni,[1] for which Giotto had already made a very fine design. This, as I say, was given to him to finish, because he was considered the most talented, skilful and judicious master of all those who had worked until then, not only in Tuscany, but in all Italy. He set to work, resolved to spare neither time, pains nor diligence upon the completion of a task of such importance. Fate was propitious to him in his casting, at a time when men were ignorant of the secrets known to-day, so that in the space of twenty-two years he brought the door to its present stage of perfection; and what is more, at the same time he made not only the tabernacle of the high altar of S. Giovanni, with an angel on either side which were considered most beautiful, but also the small marble figures to complete the decoration of the door of the campanile of S. Maria del Fiore, after Giotto's design, and about that campanile, in certain mandorle, the seven planets, the seven virtues, and the seven works of mercy in small figures in half-relief, which were then much admired. At the same time he made the three figures of four braccia high which were placed in niches in that campanile, under the windows on the side towards the place where the Pupilli now are, that is towards the south, figures which were considered at the time to be of considerable merit. But to return to my starting point, I say that the bronze door contains scenes in bas-relief from the life of St. John the Baptist, from his birth to his death, happily conceived and executed with great care. And although many are of opinion that these scenes do not exhibit that fine design nor that high art which should be put into figures, yet Andrea merits the highest praise, because he was the first who undertook to complete a work which rendered it possible for those who came after him to produce what is beautiful, difficult and good in the other two doors, and in the exterior ornaments now to be seen. This work was set in the middle door of the church, and remained there until Lorenzo Ghiberti made the present one, when it was removed and set up opposite the Misericordia, where it is at the present time. I must not omit to say that in making this door Andrea was assisted by his son Nino, who afterwards became a much better master than his father had been, and that it was finished in the year 1339; that is to say, not only polished and cleaned, but gilt at the fire. It is thought that the metal was cast by some

[1] In 1330; the door was finished and set up in 1336.

Venetian masters very skilful in founding; and a record of this
is in the library of the art of the Calimara, wardens of the
opera of S. Giovanni. Whilst the door was being made, Andrea
not only made the works aforesaid, but many others, and in
particular the model of the church of S. Giovanni at Pistoia,
which was begun in the year 1337. In this same year, on the
25th day of January, they found the body of St. Atto, bishop
of that city, in excavating the foundations of the church. The
body had been buried in that place for 137 years. The archi-
tecture of that temple, which is round, was meritorious for the
time. Also by the hand of Andrea is a marble tomb in the prin-
cipal church of Pistoia, the body of the sarcophagus of which
is full of small figures, with some larger ones above. In this
tomb rests the body of M. Cino d'Angibolgi,[1] doctor of laws,
and a very famous man of letters in his day, as M. Francesco
Petrarca testifies in the sonnet:

> Piangette donne, e con voi pianga Amore;

and in the fourth capitolo of the *Trionfo d'Amore,* where he says:

> Ecco Cin da Pistoia; Guitton d'Arezzo,
> Che di non esser primo per ch' ira aggia.

This marble tomb of Andrea's contains the portrait of M. Cino,
who is represented as teaching a number of his scholars, who
are about him, with such a fine attitude and style that it must
have been considered a marvellous thing in those days, although
it would not be valued now.

Walter, Duke of Athens and tyrant of Florence,[2] also employed
Andrea to enlarge the piazza, and to fortify his palace by barring
the bottom of all the windows on the first floor, where the hall
of the Two Hundred now is, with very strong square iron bars.
The same duke also added, opposite S. Piero Scheraggio, the
rough stone walls which are beside the palace to augment it,
and in the thickness of the wall he made a secret staircase,
to mount and descend unperceived. Through this same wall
he made a great door, which now serves for the Customs,
and over this he set his arms, the whole after the designs and
with the advice of Andrea. Although the arms were defaced
by the magistracy of the Twelve, who took pains to obliterate
every memorial of that duke, yet on the square shield there

[1] Cino Sinibaldi. Professor Venturi attributes this work to Agostino
and Agnolo.
[2] Walter of Brienne, who ruled Florence for twelve months from July
1342.

remained the form of the lion rampant with two tails, as any
attentive observer may see. For the same duke Andrea made
many towers about the city walls, and not only began the gate
of S. Friano in fine style, leaving it in its present form,[1] but
also made the walls of the portals for all the gates of the city,
and the smaller gates for the convenience of the people. And,
because the duke purposed to make a fortress on the hill of
S. Giorgio, Andrea prepared a model for it, which was never
used, as the work was not begun, the duke being driven out in
the year 1343. The duke's plan to convert the palace into a
strong castle was in great measure effected, for a considerable
addition was made to the original building, as may be seen
to-day, the circuit comprising the houses of the Filipetri, the
tower and houses of the Amidei, and Mancini, and those of the
Bellaberti. And because, after this great undertaking was begun,
all the materials required for it and for the great walls and
barbicans were not ready, he kept back the building of the
Ponte Vecchio, which was being hurried forward as a necessary
thing, and made use of the dressed stones and timber designed
for this without any consideration. Although Taddeo Gaddi
was probably not inferior to Andrea Pisano as an architect,
the duke would not employ him on these works because he was
a Florentine, but made use of Andrea. The same Duke Walter
wished to pull down S. Cicilia, in order to obtain a view of the
Strada Romana and the Mercato Nuovo from his palace, and
would also have destroyed S. Piero Scheraggio for his con-
venience, but the Pope would not grant him licence. At length,
as has been said above, he was driven out by the fury of
the people.

For his honoured labours of so many years Andrea not only
deserved the highest rewards, but also civil honours. Accordingly
he was made a Florentine citizen by the Signoria, offices and
magistracies in the city were given to him, and his works were
valued during his life and after his death, as no one was found
to surpass him in workmanship until the advent of Niccolo of
Arezzo, Jacopo della Quercia of Siena, Donatello, Filippo di
Ser Brunellesco and Lorenzo Ghiberti, whose sculptures and
other works were such that people recognised in what error
they had been living up till then, as these men had again dis-
covered the true excellence which had been hidden for so great
a number of years. The works of Andrea were executed about
the year of grace 1340.

[1] In 1332.

Andrea left many pupils, among others Tommaso, architect and sculptor, of Pisa, who finished the chapel of the Campo Santo, and brought the campanile of the Duomo to completion, that is to say the last part, where the bells are.[1] This Tommaso was Andrea's son, if we may believe an inscription on the high altar of S. Francesco at Pisa, on which a Madonna and other saints are carved by him in half-relief, with his name and that of his father beneath. Andrea left a son Nino, who devoted himself to sculpture, his first work being in S. Maria Novella at Florence, where he finished a marble Madonna, begun by his father, which is within the side door, near the chapel of the Minerbetti. Going afterwards to Pisa, he made for the Spina a half-length marble Madonna suckling the Infant Jesus Christ, clothed in delicate draperies. In the year 1522 a marble orna-ment for this Madonna was made for M. Jacopo Corbini, who had a much larger and finer one made for another full-length marble Madonna of Nino, representing with great grace the Mother offering a rose to the Child, who takes it in childish fashion, and so prettily that one may say that Nino had made some steps to subduing the roughness of the stone, endowing it with the attributes of living flesh and finishing it with great polish. The figure is between a St. John and a St. Peter in marble, the head of the latter being a portrait of Andrea. Nino also made two marble statues for an altar of S. Caterina at Pisa, that is to say the Madonna and an angel in an Annunciation executed, like his other works, with such care that they may be considered as the best productions of those times. On the base beneath this Madonna Nino carved the following words: "On the first day of February 1370"; and beneath the angel: "Nino, son of Andrea Pisano, made these figures."

He produced yet other works in that city and at Naples which it is not necessary to mention here. Andrea died at the age of seventy-five, in the year 1345, and was buried by Nino in S. Maria del Fiore with the following epitaph:

Ingenti Andreas jacet hic Pisanus in urna,
Marmore qui potuit spirantes ducere vultus
Et simulacra Deum mediis imponere templis
Ex aere, ex auro, candenti et pulcro elephanto.

[1] This completion seems to have been the work of Francesco Talenti, who succeeded Andrea as architect-in-chief.

BUONAMICO BUFFALMACCO, Painter of Florence
(alive 1351)

BUONAMICO DI CRISTOFANO, called Buffalmacco, painter of Florence, who was a pupil of Andrea Tafi, celebrated for his jests by M. Giovanni Boccaccio in his *Decameron*, is well known to have been the close companion of Bruno and Calandrino, painters, and themselves jocular and merry men. He possessed a very fair judgment in the art of painting, as may be seen by his works, which are scattered throughout Tuscany. Franco Sacchetti related in his *Three Hundred Tales* (to begin with the deeds of this artist while he was still young) that, while Buffalmacco was a boy with Andrea, it was his master's custom, when the nights were long, to rise to work before dawn and to call the boys. This thing displeased Buonamico, who had to rise out of his beauty sleep, and he tried to devise a plan that should induce Andrea to leave off calling them to work so much before daylight. He soon discovered one, for in an ill-swept loft he happened to find thirty great beetles or cockroaches. With some thin needles and corks he fixed a small candle on the back of each beetle, and when the hour came for Andrea to rise he lighted the candles and put the beetles one by one through a chink in the door of Andrea's room. When the master awoke, just about the hour when he was accustomed to call Buffalmacco, and saw these lights, he began to tremble with fear, being an old man and timid, and to recommend himself to God, repeating his prayers and psalms. Finally he put his head under the clothes and did not call Buffalmacco that night, but remained trembling in the same posture until the day. The following morning when he arose he asked Buonamico if he, like himself, had seen more than a thousand devils. Buonamico said no, because he had kept his eyes shut, and had wondered why he had not been called. "What!" said Tafi; "I had something else to think of besides painting, and I am resolved to go and live in another house." The following night, although Buonamico only put three beetles into Tafi's chamber, yet the poor man did not sleep a jot, owing to his fear of the past night and to those devils which he saw. No sooner was day come than he left the house, declaring he would never return to it, and they had much ado to make him change his mind. Moreover, Buonamico brought him the priest of the parish, who consoled him as best he could. When Tafi and Buonamico were

talking over the matter afterwards, the latter said: "I have always heard tell that the devils are the greatest enemies of God, and consequently they must also be the chief adversaries of painters, because, besides the fact that we always make them very ugly, we do nothing else but represent saints on walls and panels, in order to render men more devout or better in despite of the devils. For this cause the devils are enraged with us, and as they have more power at night than during the day, they come and play these pranks, and will do worse if this practice of early rising is not entirely abandoned." With these words, and many others, Buffalmacco succeeded in settling the matter, as the priest supported his arguments, so that Tafi left off his early rising and the devils ceased to go through the house at night with lights. But not many months afterwards, when Tafi, induced by desire of gain, and forgetting all his fear, began once more to rise and work at night and to call Buffalmacco, the beetles also began to make their rounds, so that the master was compelled by fear to give it up entirely, being strongly advised to this by the priest.

When this thing became known through the city, it for a while prevented other painters as well as Tafi from rising to work at night. When, shortly afterwards, Buffalmacco himself became a fairly good master he left Tafi, as the same Franco relates, and began to work by himself, and he never lacked employment. Accordingly he took a house to serve equally as a workshop and a dwelling-house, next door to a worker of wool in easy circumstances who, being a raw simpleton, was called Goosehead. This man's wife rose early, at the very moment when Buffalmacco, who had worked up to that time, was going to rest, and setting herself at her spinning-wheel, which she unfortunately placed over against Buffalmacco's bed, she spent all the night in spinning yarn. Buonamico was unable to sleep a moment, and began to devise a means whereby to rid himself of this nuisance. It was not long before he perceived that, behind the brick wall which separated him from Goosehead, was the fire of his objectionable neighbour, and by means of a crack he could see everything that she did at the fire. Accordingly he devised a new trick, and bored a hole through the wall with a long augur. When he found that the wife of Goosehead was not at the fire, he every now and again put through that hole in the wall into his neighbour's pot as much salt as he wished. When Goosehead returned either to dine or to sup he could, as a rule, neither eat nor drink or taste either soup or

meat, as everything was made bitter by too much salt. For a
little while he had patience, and only made a slight to-do; but
when he found that words did not suffice, he frequently gave
blows to the poor woman, who was in despair, because she
thought she had been more than cautious in salting the dish.
As her husband beat her from time to time, she tried to excuse
herself, which only increased the anger of Goosehead, so that
he began to strike her again, and as she cried out at the top of
her voice, the whole neighbourhood ran to see what was the
matter, Buffalmacco among the rest. When he heard of what
Goosehead accused his wife and how she excused herself, he
said to Goosehead: "By my troth, good friend, you should be
reasonable; you complain that your morning and evening dishes
are too salt, but I only wonder that your wife makes them so
well as she does. I cannot understand how she is able to keep
going all day, considering that she is sitting up the whole night
over her spinning, and does not, I believe, sleep an hour. Let
her give up rising at midnight, and you will see, when she has
enough sleep, her brain will not wander during the day, and she
will not fall into such serious mistakes." Then he turned to the
other neighbours, and succeeded so well in convincing them
that he had found the true explanation, that they all told
Goosehead that Buonamico was right, and that he should
follow this advice. Goosehead, believing what he was told,
ordered his wife not to rise so soon, and the dishes were after-
wards reasonably salted, except sometimes when the goodwife
happened to rise early, because then Buffalmacco had recourse
to his remedy, a fact which induced Goosehead to cause his
wife to give up early rising altogether.

One of the earliest works Buffalmacco did was the decoration
of the entire church of the nunnery of Faenza at Florence,
where the citadel del Prato now is. Here he represented scenes
from the life of Christ among other things, everything in which
is in good style, and among others the massacre of the In-
nocents by Herod's order. In this he displays with considerable
vigour the expressions of the murderers as well as of the other
figures, because some nurses and mothers, who are snatching
the children from the hands of the murderers, are using their
hands, nails, teeth and every bodily agent to help them as much
as possible, the sentiment of grief as well as rage and fury being
expressed by such outward emotion. As the nunnery is de-
stroyed to-day, nothing more of this work is to be seen than
a coloured drawing in our book of designs, which contains the

sketch for this by Buonamico's own hand. In executing this work for the nuns of Faenza, Buffalmacco, who was as negligent and casual in his dress as his habits, did not always happen to wear the hood and cloak customary in those days, and the nuns, who sometimes looked at him through the screen which he had caused to be made, began to say to the custodian that they objected to seeing him always in his doublet. After he had reassured them, they remained quiescent for a while. At length, as they always saw him attired after the same fashion, they thought he must be the boy to mix the colours, and accordingly they induced the abbess to tell him that they should like to see the master himself at work and not this other one always. Buonamico, who ever loved his joke, told them that so soon as the master arrived he would let them know, for he was sensible of the small amount of confidence which they placed in him. Then he took a chair and put another on the top of it, setting a water-jug or pitcher on this, over the handle of which he put a hood and then covered the rest of the pitcher in a civilian's cloak, fastening it firmly about the chairs. After this he dexterously inserted a brush in the spout from which the water flows, and there left it. When the nuns returned to see the work through an opening where he had torn the canvas, they saw the supposed master in full canonicals. They believed that he was working there to the utmost of his power, and would do much better than the mere untidy boy had done; so several days passed without their thinking any more about it. At last they were anxious to see what beautiful things the master had done. Fifteen days had passed since Buonamico had set foot in the place, and one night they went to see the paintings, thinking that the master could no longer be there. They were covered with confusion and blushes when one bolder than the rest discovered the nature of the solemn master, who had not done a stroke in the fortnight. When they learned that Buonamico had treated them according to their deserts, and that the works which he had made were excellent, they sent their steward for him and he returned with much laughter and joking to take up the work, making them see that there is a difference between men and dummies, and that a man's work must not always be judged by his clothes. After a few days he finished one subject there, with which they were very delighted, since it appeared to them to be satisfactory in all its parts, except that the flesh-colouring of the figures seemed to them to be rather too pale. When Buonamito heard this, and knowing

that the abbess had the best vernaccia wine in Florence, which
served for the sacrifice of the Mass, he told them that, in order
to remedy such a defect, nothing would be serviceable except
to temper the colours with a good vernaccia, for if the cheeks
and other flesh parts of the figures were touched with this,
they would become red and very freshly coloured. When the
good sisters heard this they believed it completely, and after-
wards kept him supplied with the best vernaccia so long as the
work lasted, while he on his part made merry and thence-
forward with his ordinary colours rendered his figures more
fresh and brilliant.

On the completion of this work Buffalmacco painted in the
abbey of Settimo some scenes from the life of St. James in the
chapel dedicated to that saint which is in the cloister, on the
vaulting of which he did the four Patriarchs and the four
Evangelists, among whom the attitude of Luke is noteworthy
for the natural way in which he is blowing his pen to make the
ink flow. In the subjects for the walls, which are five, the figures
are represented in fine attitudes and everything is carried out
with originality and judgment. In order to make his flesh-
colouring easier to paint Buonamico used a ground of *pavonazzo
di sale*, as is seen in this work, which in the course of time has
caused a saltness by which the white and other colours are
corroded and consumed, so that it is no marvel that the work
is damaged and destroyed, while many that were made long
before have been excellently preserved. I formerly considered
that the injury was caused by the damp, but afterwards, by an
examination of his other works, I have proved by experience
that it is not the damp, but this peculiar practice of Buffalmacco
which has caused them to be so damaged that it is not possible
to see the design or anything else, and where the flesh-colour
should be there remains nothing but the *pavonazzo*. This method
of working should not be practised by anyone who desires a
long life for his paintings.

After the two pictures mentioned above, Buonamico did two
others in tempera for the monks of the Certosa at Florence, one
of which is in the place where the singing books for the choir
rest, and the other is below in the old chapels. In the Badia at
Florence he painted in fresco the chapel of the Giochi and
Bastari, beside the principal chapel, which was afterwards
granted to the family of the Boscoli, and still retains these
paintings of Buffalmacco. Here he did the Passion of Christ,
with fine and original expressions, showing in Christ, when He

washes the disciples' feet, the greatest humility and benignity, and cruelty and fierceness in the Jews who lead Him to Herod. But he displayed especial originality and facility in a Pilate whom he painted in prison and in Judas, hung to a tree, from which we may readily believe what is related of this merry painter that, when he wished to be diligent and take pains, which rarely happened, he was not inferior to any other artist of his time. That this is true is proved by his works in fresco in Ognissanti, where the cemetery now is, produced with such diligence and with such precautions that the water which has rained upon them for many years has not injured them or caused any harm except by preventing a recognition of their excellence. They are so well preserved because they were done simply upon fresh lime. On the walls are the Nativity of Jesus Christ and the Adoration of the Magi, that is to say, over the tomb of the Aliotti. After these works Buonamico went to Bologna, where he painted some scenes in fresco on the vaulting of the chapel of the Bolognini in S. Petronio, but did not finish them, for some reason unknown to me.[1] It is said that in the year 1302 he was summoned to Assisi, and in the chapel of St. Catherine in the church of S. Francesco he painted the history of the former saint's life in fresco, works which are very well preserved, and which contain some figures well worthy of praise. When he had completed the chapel and was on his way through Arezzo, the Bishop Guido, who had heard that Buonamico was a merry fellow and a skilful painter, wished him to stay in the city and paint for him the chapel in the Vescovado containing the Baptism of Christ. Buonamico put his hand to the work and had already done a considerable part of it when a very strange adventure happened to him, related by Franco Sacchetti in his *Three Hundred Tales*. The bishop possessed an ape, the most mischievous and malignant creature that ever was seen. This animal was one day standing on the scaffolding and watching Buonamico work, carefully observing everything and never taking his eyes off him as he mixed the colours, used the gallipots, broke the eggs to make the tempera, or did any other thing, no matter what. One Saturday evening Buonamico left the work, and on Sunday morning this ape, although he had a great log of wood attached to his legs, which the bishop made him carry so that he should not leap everywhere, notwithstanding this heavy weight, leapt on to the scaffolding where Buonamico used

[1] It is impossible that he should have done this work, as the church was not begun until 1390. The chapel was painted about 1410.

to stand to work, and there took up the gallipots and emptied
them one by one, made the mixtures, broke as many eggs as
were there, and began to daub all the figures with the brush,
never resting until he had repainted everything himself. That
done, he made a fresh mixture of all the colours which were left
over, although they happened to be few, and then descended
from the scaffolding and departed. When Buonamico came back
to his work on Monday morning and saw his figures spoiled, his
gallipots emptied and everything upside down, he was filled
with amazement and confusion. After turning the matter over
in his mind for some time he concluded that some Aretine had
done this from envy or for some other reason. Accordingly he
went to the bishop and told him what had happened and what
he suspected, at which the bishop was much troubled, yet he
encouraged Buonamico to return to the work, and to repaint
the part which had been spoiled. As he concurred in Buonamico's
opinion, which seemed likely, he gave the artist six armed men
of his infantry, who should stand concealed, with falchions,
when he was not working, and cut to pieces without mercy
anyone who should come. Accordingly the figures were repainted
a second time, and one day while the soldiers were on the watch
they heard a curious rolling noise in the church, and soon after
the ape appeared, jumped upon the seat, made the mixtures
in an instant, and they saw him set to work upon the saints of
Buonamico. The guard then called the master, and showed him
the criminal, and as they stood together and watched the animal
work, they burst into laughter, and Buonamico himself, though
grieved at the damage, could not help laughing till he cried. At
length he dismissed the soldiers who had been on guard with
their falchions, and went to the bishop and said to him: "My
lord, you like my manner of painting, but your ape prefers
another." He then related the matter, adding: "It was not
necessary for you to send away for painters since you had a
master in the house, although perhaps he did not know how to
mix his colours properly. Now that he knows, let him work by
himself, for I am of no further use here, and as his worth is now
recognised, I shall be contented with no other wages for my
work except permission to return to Florence." Although much
displeased, the bishop could not refrain from laughing when he
heard this, especially when he considered that a beast had made
a jest of the most jest-loving man in the world. After they had
laughed and talked over this new adventure, the bishop pre-
vailed so far, that Buonamico set himself a third time to do the

work, and he finished it. The ape, as a punishment and penance for his fault, was shut up in a large wooden cage, and kept there while Buonamico worked, until the painting was quite finished. It is not possible to imagine the antics which the great beast played in the cage with his mouth, his body and his hands, at seeing others work while he was not able to imitate them. When the decoration of the chapel was completed the bishop directed, for a jest or for some other reason, that Buffalmacco should paint for him on a wall of his palace an eagle on the back of a lion which it had killed. The cunning painter promised to do as the bishop desired, and made a big screen of boards, saying that he did not wish anyone to see a thing of that sort being painted. This done, and while shut up all alone inside, he painted the contrary to what the bishop wished, a lion crushing an eagle.[1] When the work was completed, he asked licence from the bishop to go to Florence to procure some colours which he needed. Accordingly, having locked up his picture, he went to Florence intending never to return. The bishop, after waiting some time and seeing that the painter did not return, caused the screen to be opened, and found that Buonamico was wiser than himself. Furious at the trick which had been played upon him he threatened to take the artist's life. When Buonamico heard this, he sent to tell him to do his worst, wherefore the bishop menaced him with a malediction. But at length he reflected that the artist had only been jesting, and that he should take the jest in good part, whereupon he pardoned Buonamico the insult, and acknowledged his pains most liberally. What is more, he induced him to come again to Arezzo not long after, and caused him to paint many things in the old Duomo which have been pulled down to-day, treating him always as his friend and most faithful servant. The same artist also painted in Arezzo the apse of the principal chapel of S. Giustino. Some write that when Buonamico was in Florence he was often in the workshop of Maso del Saggio with his friends and companions. He was also present with many others in arranging the regatta which the men of the borgo S. Friano on Arno celebrate on the calends of May; and when the alla Carraia bridge, which was then of wood, broke down because it was too crowded with people, who had run thither to see the spectacle,[2] he did not perish like many others,

[1] The bishop was a prominent Ghibelline, whose figure was the imperial eagle, while the lion signified the opposing Guelph party. Buffalmacco as a Florentine would belong to the latter faction.
[2] On the Kalends of May 1304. Villani's *Croniche*, lib. viii. cap. 70.

because when the bridge fell right on a contrivance representing Hell upon boats on the Arno, he had gone to hunt up some things that were wanted for the feast.

Not long after these things Buonamico was invited to Pisa, and painted a series of subjects from the Old Testament, from the Creation of Man to the building of the Tower of Nimrod, for the abbey of S. Paolo a ripa d'Arno, which then belonged to the monks of Vallombrosa, on the whole of the crossing of that church, on three sides, from the roof to the ground. This work, which is now almost entirely destroyed, is remarkable for the vigour of the figures, the skill and beauty of the colouring and artist's faculty of expressing his ideas, although he was not very good in design. On the wall of this crossing opposite that which contains the side door, there are some scenes of the life of St. Anastasia, where some women, painted in a graceful manner, exhibit certain antique habits and gestures very prettily and well. No less fine are some figures in a barque, arranged in well-designed attitudes, among them being the portrait of Pope Alexander IV., which it is said Buonamico had from his master Tafi, who had represented that pontiff in mosaic in St. Peter's. Similarly in the last subject, which represents the martyrdom of the saint and of others, Buonamico finely expresses in the faces the fear of death, the grief and dread of those who are standing by to see her tormented and put to death, while she stands bound to a tree, and above the fire. Bruno di Giovanni, a painter, assisted Buonamico in this work. He is called painter in the old book of the company. This Bruno, also celebrated as a joke-loving man by Boccaccio, after the scenes for the walls were done, painted the altar of St. Ursula for the same church, with her company of virgins. In one hand the saint holds a standard with the arms of Pisa, which are a white cross on a red ground, while she places the other on a woman who is rising between two mountains, and touches the sea with one foot and places her hands together in an act of entreaty. This woman represents Pisa, her head being circled with a gold crown, while she wears a garment full of circles and eagles, and being in much trouble at sea she asks help of the saint.[1] But because Bruno complained when he executed those figures that they were not life-like as those of Buonamico were, the latter in jest, to teach him to make figures which, if not life-like, should at least converse, made him put some words issuing from the mouth of the woman who is entreating the saint, and also the saint's reply

[1] Now in the Accademia, Pisa.

to her, a device which Buonamico had seen in the works executed
by Cimabue in the same town. This thing pleased Bruno and
other foolish men of the time, just as to-day it pleases certain
clumsy fellows who have thus employed vulgar devices worthy
of themselves. It is certainly curious that in this way advice
intended simply as a jest has been generally followed, so much
so that a great part of the Campo Santo done by masters of
repute is full of this clumsiness.

The works of Buonamico having greatly pleased the Pisans,
those in charge of the fabric of the Campo Santo commissioned
him to do four scenes in fresco from the beginning of the world
until the building of Noah's ark, surrounding them with an
ornamentation, in which he drew his own portrait from life, that
is to say, in a border in the middle and at the corners of which
are some heads, among which, as I have said, is his own.[1]
He wears a hood, just like the one that may be seen above.
This work contains a God who holds in His arms the heavens
and the elements, and all the apparatus of the universe, so that
Buonamico, explaining his scene with verses, like the paintings
of the age, wrote at the foot in capital letters with his own hand
the following sonnet, as may be seen, which for its antiquity and
simplicity of diction peculiar to the time, has seemed to me to
be worth insertion in this place, so that if it does not perchance
give much pleasure, yet it is a matter which will perhaps bear
testimony to the amount of the knowledge of the men of
that age:

> Voi che avvisate questa dipintura
> Di Dio pietoso sommo creatore,
> Lo qual fe' tutte cose con amore
> Pesate, numerate ed in misura.
> In nove gradi angelica natura
> In ello empirio ciel pien di splendore,
> Colui che non si muove et è motore,
> Ciascuna cosa fecie buona e pura.
> Levate gli occhi del vostro intelletto
> Considerate quanto è ordinato
> Lo mondo universale; e con affetto
> Lodate lui che l' ha si ben creato:
> Pensate di passare a tal diletto
> Tra gli angeli, dove a ciascun beato.
> Per questo mondo si vede la gloria,
> Lo basso, e il mezzo, e l'alto in questa storia.[2]

[1] The work is by Pietro di Puccio of Orvieto, done about 1390.

[2] Ye who behold this painting
> Think, weigh and consider
> Upon the merciful God, supreme creator,
> Who made all things in love.
> He fashioned that angelic nature in new orders,

It was indeed bold of Buonamico to set himself to make a God the Father five braccia high, the hierarchy, the heavens, the angels, the zodiac, and all the things above to the sky of the moon, and then the element of fire, the air, the earth, and finally the centre. For the two lower corners he did a St. Augustine and a St. Thomas Aquinas. At the top of this Campo Santo, where the marble tomb of the Corte now is, Buonamico painted the Passion of Christ, with a great number of figures on foot and on horse, all in varied and beautiful attitudes. Continuing the story, he also did the Resurrection and the Apparition of Christ to the Apostles very satisfactorily. When he had completed these labours, and had at the same time spent everything that he had earned at Pisa, which was not a little, he returned to Florence as poor as he had left it, and there he did many pictures and works in fresco, which it is not necessary to describe further. When his close friend Bruno, with whom he had returned from Pisa after squandering everything, was employed to do some works in S. Maria Novella, because he had not much skill in design or invention, Buonamico designed for him all that he afterwards did for a wall of that church opposite the pulpit, filling the space between column and column. This was the story of St. Maurice and his companions, who were beheaded for the faith of Jesus Christ. Bruno executed this work for Guido Campese, then constable of the Florentines. The artist took his portrait before his death, in the year 1312, and afterwards put it in this work, as an armed man, after the fashion of those days, and behind him he made an array of warriors, all armed in the antique style, forming a fine spectacle, while Guido himself kneels before Our Lady, who has the Child Jesus in her arms while St. Dominic and St. Agnes, who are on either side of him, intercede for him. Although this painting is not very beautiful, yet, when one considers Buonamico's design and invention, it is worthy of some amount of praise, chiefly on account of the variety of clothing, and of the barbed and other armour of the time. I

In that resplendent empire of heaven.
Motionless Himself yet the source of all motion
He made everything good and pure.
Raise the eyes of your mind,
Reflect upon the ordering
Of the entire globe and reverently
Praise Him who has created so well.
Think that you also may taste the delight
Of living among the angels, where all are blessed.
In this scene also we see the glory of the world
The base, the mean, and the lofty.

myself made use of it in some scenes which I did for Duke
Cosimo, in which it was necessary to represent an armed man
in the antique style and other similar things of that age. This
thing greatly pleased His Most Illustrious Excellency and others
who have seen it. From this it may be seen what an advantage
it is to draw materials from inventions and works made by these
ancients, for, although they are not perfect, yet it is useful to
know in what manner they can be made of service, since they
opened the way to the marvels which have since been produced
and are still appearing. Whilst Bruno was engaged upon these
works, a rustic desired him to do a St. Christopher, and they
made an agreement at Florence, the terms being that the price
should be eight florins, and the figure should be twelve braccia
high. Accordingly Buonamico went to the church where he was to
do the St. Christopher, and found that, as its length and breadth
did not exceed nine braccia, he could not manage to get the
figure in, so he determined, in order to fulfil the agreement, to
make the figure lying down, but as even then it would not
entirely come in, he was compelled to turn it from the knees
downwards on to another wall. When the work was completed
the rustic refused to pay for it, exclaiming that he had been
cheated. The matter thus came before the officials of the Grascia,
who judged that Buonamico was justified by the terms of the
contract.

At S. Giovanni fra l'Arcore there was a very fine Passion of
Jesus Christ by Buonamico's hand, and among other much
admired things it contained a Judas hanging from a tree, done
with much judgment and in good style. There was also an old
man blowing his nose very naturally, and the Maries are repre-
sented so dishevelled and sad with weeping that they merit
high praise for a time when men had not acquired such facility
in expressing the emotions of the soul with the brush. On the
same wall is a St. Ivo of Brittany with many widows and orphans
at his feet, a good figure, and two angels in the air who crown
him, executed in the sweetest style. This building, together
with the paintings, was pulled down in the year of the war
of 1529. Again Buonamico painted many things in the Ves-
covado of Cortona for M. Aldebrando, bishop of that city,
especially the chapel and the picture of the high altar; but as
during the restoration of the palace and church it was all
pulled down, it is not worth while to say more about them.
In S. Francesco and in S. Margherita of the same city, there are
still some pictures by the hand of Buonamico. From Cortona he

went once more to Assisi, where in the lower church of S. Fran-
cesco he painted in fresco all the chapel of the Cardinal Egidio
Alvaro of Spain, and because he did very well he was liberally re-
cognised by the cardinal. Finally, after Buonamico had done many
pictures in every part of la Marca, he stayed at Perugia on his
way back to Florence, and there painted the chapel of the
Buontempi in fresco in the church of S. Domenico, representing
scenes from the life of St. Catherine, virgin and martyr. In the
old church of S. Domenico he painted also in fresco on the wall
the scene where St. Catherine, daughter of King Costa, disputes
with, convinces and converts certain philosophers to the faith
of Christ.[1] As this scene is the finest that Buonamico ever pro-
duced, it may be said with truth that he has surpassed himself,
and moved by this, as Franco Sacchetti writes, the Perugians
directed that he should paint in the piazza S. Ercolano, bishop
and protector of that city. Accordingly, when the terms had
been settled, a screen of boards and wicker-work was made in
the place where he was to paint, so that the master should not
be seen at work, and this done he set himself to the task. But
before ten days had passed everyone who went by asked when
the picture would be finished, as if such things were cast in
moulds. This disgusted Buonamico, who was angered by such
importunity, and when the work was finished he resolved to be
quietly avenged on the people for their impatience. An idea
came to him, and before he uncovered his work he showed it
to the people, who were delighted. But when the Perugians
wanted to remove the screen, Buonamico said that they must
let it remain for two days longer, because he wished to retouch
some things *a secco*, and this was done. Buonamico then climbed
up to where he had made a great diadem of gold for the saint,
done in relief with the lime, as was customary in those days,
and replaced it by a crown or garland of roach. That done,
he went away to Florence after settling with his landlord. When
two days had passed, the Perugians, not seeing the painter about
as usual, asked the landlord what had become of him, and
learned that he had returned to Florence. Accordingly they at
once went to uncover the work, and found their S. Ercolano
solemnly crowned with fishes. They immediately informed their
magistrates, and horsemen were sent off in haste to find Buona-
mico. But all was in vain, since he had returned with great
speed to Florence. They therefore agreed to get one of their
own painters to remove the crown of fishes and to repaint the

[1] See note at page 97 above.

saint's diadem, saying all the evil things imaginable of Buona-
mico and of the other Florentines. Thus Buonamico returned
to Florence, caring little for what the Perugians said, and de-
voted himself to many works which I must not mention for
fear of being too tedious. I will only remark that once, after he
had painted a Madonna and Child in fresco at Calcinaia, the
man who had commissioned him to paint it gave him promises
instead of gold. Buonamico, who had not reckoned upon being
used and cheated in this way, determined to be even with him.
Accordingly he went one morning to Calcinaia and converted
the child which he had painted in the Virgin's arms into a little
bear, but only in water-colour, without glue or tempera. When
the countryman saw this not long after he was in despair,
and went to find Buonamico, begging him to be so good as to
remove the bear and repaint a child as at first, because he was
ready to satisfy him. Buonamico did this with pleasure, for a
wet sponge sufficed to set everything right, and he was paid
for his first and second labours without further delay. As I
should occupy too much space if I wished to describe all the
jests and paintings of Buonamico Buffalmacco, especially those
perpetrated in the workshop of Maso del Saggio, which was a
resort of citizens and of all the merry and jest-loving men in
Florence, I shall conclude this notice of him. He died at the
age of seventy-eight, and he was of the company of the Miseri-
cordia, because he was very poor, and had spent more than
he had earned, that being his temperament, and in his mis-
fortunes he went to S. Maria Nuova, a hospital of Florence.
He was buried in the year 1340, like the other poor in the Ossa,
the name of a cloister or cemetery of the hospital. His works
were valued during his lifetime, and they have since been
considered meritorious for productions of that age.

AMBRUOGIO LORENZETTI, Painter of Siena
(ob. circ. 1338)

GREAT as the debt owed by artists of genius to Nature un-
doubtedly is, our debt to them is far greater, seeing that they
labour to fill our cities with noble and useful buildings and with
beautiful compositions, while they usually win fame and riches
for themselves. This was the case with Ambruogio Lorenzetti,
painter of Siena, whose powers of invention were fine and pro-
lific, and who excelled in the arrangement and disposition of

the figures in his subjects. Evidence of this may be seen at the friars minor at Siena in a very gracefully painted scene by him in the cloister. Here he represented the manner in which a youth becomes a friar, and how he and some others go to the Soldan, and are there beaten and sentenced to the gallows, hung to a tree, and finally beheaded, during the progress of a fearful tempest. In this painting he has very admirably and skilfully depicted the disturbance of the air, and the fury of the rain and wind, through the efforts of the figures. From these, modern masters learned originally how to treat such a scene as it had been unknown before, for which reason the artist deserves the highest commendation. Ambruogio was a skilful colourist in fresco, and he exhibited great address and dexterity in his treatment of colours in tempera, as may still be seen in the pictures which he completed at Siena in the hospital called Mona Agnesa, in which he painted and finished a scene with new and beautiful composition. On the front of the great hospital he did in fresco the Nativity of Our Lady, and when she goes among the virgins to the temple.[1] For the friars of St. Augustine in that city he did the chapter-house, on the vaulting of which are represented the Apostles holding scrolls containing that part of the *Credo* which each of them made. At the foot of each is a short account to assist the picture in explaining the writing on these scrolls. On the principal wall are three scenes of the life of St. Catherine the Martyr, representing her dispute with the tyrant in a temple, and in the middle is the Passion of Christ with the thieves on the cross and the Maries below, supporting the Virgin, who has fainted. These things were finished by Ambruogio with considerable grace, and in a good style. He also depicted in the great hall of the palace of the Signoria at Siena the war of Asinalunga, the peace following, and the events in connection therewith, comprising a map, perfect for the time.[2] In the same palace he did eight scenes in *terra verde* very smoothly. It is said that he also sent to Volterra a picture in tempera which was much admired in that city; and at Massa, in conjunction with others, he did a chapel in fresco and a picture in tempera showing the excellence of his judgment and talent in the art of painting. At Orvieto he painted in fresco the principal chapel of St. Mary. After these works he betook himself to Florence, and in S. Procolo did a picture and

[1] In 1342; now in the Uffiz, Florence.
[2] Generally described as Good and Bad Government, a late work of the master, dated 1337 by Professor Venturi.

the life of St. Nicholas in small figures in a chapel, to please some of his friends, who were anxious to see the manner of his work. He completed this painting in so short a time, owing to his dexterity, that he enormously increased his name and reputation. This work, in the predella of which he made his own portrait, procured him an invitation to Cortona, in the year 1335, by command of the Bishop degli Ubertini, then lord of that city, where he worked in the church of S. Margherita, which had shortly before been erected on the summit of the mountain for the friars of St. Francis. He did this, particularly one half of the vaulting and walls, so well that even now, when they are almost destroyed by time, it is clear that the figures had very lovely expressions, and show that he deserved the commendation which he received. On the completion of this work Ambruogio returned to Siena, where he passed the remainder of his days, honoured not only because he was an excellent master in painting, but also because in his youth he had devoted himself to letters, which were a sweet and useful companion to painting, and such an ornament to all his life that they rendered him no less amiable and pleasing than the profession of painting had done. Thus he not only associated with men of letters and of worth, but was also employed on the affairs of his republic with much honour and profit. The manners of Ambruogio were in every respect meritorious, and rather those of a gentleman and a philosopher than of an artist. Moreover, and this tests the prudence of men more severely, he was always ready to accept what the world and time brought him, so that he supported with an equable mind the good and the evil which Fortune sent him. In truth, it is impossible to overestimate what art gains when associated with gentle manners and modesty, joined with other excellent traits, especially when these emanate from the intellect and from superior minds. Thus everyone should render himself no less pleasing by his manners than by the excellence of his art. At the very end of his life Ambruogio executed a much-admired picture for Monte Oliveto of Chiusuri. Soon after, at the age of eighty-three, he passed in a happy and Christian manner to the better life. His works were executed about 1340.

As has been said, the portrait of Ambruogio by his own hand may be seen in S. Procolo in the predella of his picture, where he is wearing a hood on his head. His skill as a designer may be seen in our book, which contains some things by his hand of considerable merit.

PIETRO CAVALLINI, Painter of Rome
(ob. 1364)

AT a time when Rome had been deprived for many centuries not only of good letters and of the glory of arms, but also of all the sciences and fine arts, there was born in that city, by God's will, one Pietro Cavallini, at the very time when Giotto, who may be said to have restored life to painting, held the chief place among the painters of Italy. Pietro, who had been a pupil of Giotto, and had done some mosaics with him in St. Peter's, was the first after him who illuminated that art, and who first showed signs that he was not an unworthy pupil of so great a master, when he painted over the door of the sacristy at Araceli some scenes which are now destroyed by time, and in S. Maria di Trastevere very many coloured things in fresco for the whole church. Afterwards he worked in mosaic in the principal chapel, and did the front of the church, proving that he was capable of working in mosaic without Giotto's assistance, as he had already succeeded in doing in painting. In the church of S. Grisogono he also did many scenes in fresco and endeavoured to make himself known as the best pupil of Giotto and as a good artist.[1] In the Trastevere also he painted almost the whole of the church of S. Cecilia in fresco, and many things in the church of S. Francesco appresso Ripa.[2] He then executed in mosaic the front of S. Paolo, outside Rome,[3] and in the middle nave did many scenes from the Old Testament. In executing some things in fresco for the chapter-house of the first cloister, he displayed such diligence that he won from men of judgment the reputation of a most excellent master, and was for the same reason so much favoured by the prelates that they employed him to do the wall-space between the windows inside St. Peter's. There he did the four Evangelists, of extraordinary size as compared with the figures usually seen in those days, executed very finely in fresco; also a St. Peter and a St. Paul, and a good number of figures in a ship, in which he has used the Byzantine style in conjunction with that of Giotto because it greatly pleased him. We see by this work that he spared no effort to give his figures the utmost possible relief, a thing he delighted in. But the best work produced by him in that city was in the church of Araceli sul Campidoglio mentioned above, where he painted

[1] The frescoes have perished, but some mosaics remain.
[2] Some of them have been brought to light of late years.
[3] Damaged by fire in 1823.

in fresco, on the vaulting of the principal apse, Our Lady with the Child in her arms, surrounded by a circle of suns; beneath her is the Emperor Octavian, adoring the Christ, who is pointed out to him by the Tiburtine sybil. The figures in this work, as has been said elsewhere, are much better preserved than the others, because the vaulting suffers less from dust than the walls. After these things Pietro came to Tuscany in order to see the works of the other pupils of his master Giotto, and those of the master himself. Upon this occasion he painted in S. Marco at Florence many figures which are not visible to-day, the church having been whitewashed, with the exception of an Annunciation which is beside the principal door of the church, and which is covered over. In S. Basilio, on the side of the flour mills, there is another Annunciation in fresco on the wall, so similar to the one which he had previously made for S. Marco, and to another which is at Florence, that there are those who believe, not without some amount of reason, that all of them are by the hand of this Pietro; certainly it is impossible that they could more closely resemble each other. Among the figures which he made in S. Marco at Florence was the portrait of Pope Urban V.[1] from life, with the heads of St. Peter and St. Paul. From this portrait Frà Giovanni da Fiesole copied the one which is in a picture in S. Domenico, at Fiesole. This is a fortunate circumstance, because the portrait which was in S. Marco was covered with whitewash as I have said, together with many other figures in fresco in that church, when the convent was taken from the monks who were there originally and given to the Friars Preachers, everything being whitewashed with little judgment and discretion. On his way back to Rome, Pietro passed through Assisi in order not only to see the buildings and notable works done then by his master and by some of his fellow-pupils, but to leave something of his own there. In the transept on the sacristy side of the lower church of S. Francesco he painted in fresco a Crucifixion of Jesus Christ with armed men on horseback, in varied fashions, with a great variety of extraordinary costumes characteristic of divers foreign nations. In the air he made some angels floating on their wings in various attitudes; all are weeping, some pressing their hands to their breasts, some crossing them, and some beating their hands, showing the extremity of their grief at the death of the Son of God, and all melt into the air, from the middle downwards, or

[1] Impossible, as he was not Pope till 1362-70. Probably he means Urban IV., 1261-5.

from the middle upwards. In this work, which is well executed in fresh and vivacious colouring, the joints of the lime are so well made that it looks as if it had all been done in a single day: in it I have found the arms of Walter, Duke of Athens, but, as it contains no date or other writing, I cannot affirm that it was executed by command of that prince. But besides the fact that everyone considers it to be by Pietro's hand, the style alone is a sufficient indication, while it seems most probable that the work was done by Pietro at the duke's command seeing that the painter flourished at the time when the duke was in Italy. Be that as it may, the painting is certainly admirable for an antique production, and its style, besides the common report, proclaims it as being by Pietro's hand. In the church of S. Marco at Orvieto, which contains the most holy relic of the Corporale, Pietro executed in fresco some scenes of the life of Christ and of the Host with much finish. It is said that he did this for M. Benedetto, son of M. Buonconte Monaldeschi, at that time lord and tyrant of the city.[1] Some further affirm that Pietro made some sculptures with success, because he excelled in whatever he set himself to do, and that the crucifix which is in the great church of S. Paolo outside Rome is by him. This is said to be the same one that spoke to S. Brigida in the year 1370, as we are bound to believe. By the same hand were some other things in that style which were pulled down when the old church of St. Peter's was destroyed to make the new one.

Pietro was very diligent in all his efforts, and endeavoured steadily to do himself honour and to acquire fame in art. Not only was he a good Christian, but very devoted and kind to the poor, and beloved for his goodness, not only in his native city of Rome, but by everyone who knew him or his works. In his extreme old age he devoted himself so thoroughly to religion, leading an exemplary life, that he was almost considered a saint. Thus there is no cause for marvel if his crucifix spoke to the saint, as is said, or that a Madonna, by his hand, has worked and still works miracles. I do not propose to speak of this work, although it is famous throughout Italy, and although it is all but certain that it is by Pietro's hand by the style of the painting; but Pietro's admirable life and piety to God are worthy of imitation by all men. Let no one believe from this, however, that it is impossible to attain to honoured rank without good conduct, and without the fear and grace of God, for constant

[1] The work was done by Pietro di Puccio, 1356–64. The Monaldeschi were a Guelph family, driven out of Orvieto in 1312.

experience proves the contrary. Giovanni of Pistoia was a pupil of Pietro, and did some things of no great importance in his native place. Pietro died at length in Rome, at the age of eighty-five, of the colic, caused by working at a wall, owing to the damp and by standing continually at that exercise. His paintings were executed about 1364. He was buried in S. Paolo outside Rome, with honour, and with this epitaph:

> Quantum Romanæ Petrus decus addidit urbi
> Pictura, tantum, dat decus ipse polo.

SIMONE MARTINI and LIPPO MEMMI, Painters of Siena (1285–1344; ob. 1357)

HAPPY indeed may we call those men who are inclined by nature to those arts which may bring them not only honour and great profit, but, what is more, fame and an all but immortal name. How much more happy then are those who, from their cradle, besides such an inclination, exhibit gentleness and civil manners, which render them very acceptable to all men. But the most happy of all—I speak of artists—are those who, besides having a natural inclination to the good and whose manners are noble by nature and training, live in the time of some famous writer, by whose works they sometimes receive a reward of eternal honour and fame in return for some small portrait or other courtesy of an artistic kind. This reward should be especially desired and sought after by painters, since their works, being on a surface and a field of colour, cannot hope for that eternity that bronze and marble give to sculpture, and which the strength of building materials affords to the architect. It was thus a very fortunate matter for Simone that he lived in the time of M. Francesco Petrarca, and happened to meet this amorous poet at the court of Avignon, anxious to have the portrait of Madonna Laura by his hand; because, when he had received one as beautiful as he desired, he celebrated Simone in two sonnets, one of which begins:

> Per mirar Policleto a prova fiso
> Con gli altri, ch' ebber fama di quell' arte;

and the other:

> Quando giunse a Simon l'alto concetto
> Ch'a mio nome gli pose in man lo stile.

In truth these sonnets, and the mention of the artist in one of his intimate letters in the fifth book, beginning *Non sum*

nescius, have given more fame to the poor life of Simone than all his own works have done or ever will do, for a day will come when they will be no more, whereas the writings of such a man as Petrarch endure for all time.

Simone Memmi of Siena, then, was an excellent painter, remarkable in his own day and much esteemed at the Pope's court, because, after the death of his master Giotto, whom he had followed to Rome when he did the *Navicella* in mosaic, and other things, he had imitated his master's style in making a Virgin Mary in the porch of St. Peter's and a St. Peter and a St. Paul in that place near where the bronze pineapple is, on a wall between the arches of the portico, on the outside. For this style he was praised, especially as he had introduced into the work a portrait of a sacristan of St. Peter's lighting some lamps for these figures in a most life-like manner. This led to Simone being summoned very urgently to the Pope's court at Avignon,[1] where he executed so many pictures in fresco and on panels that his works bore out the report which had preceded him thither. Returning to Siena in great credit and high in favour, he was employed by the Signoria to paint in fresco a Virgin Mary, with many figures about her, in a chamber in their palace.[2] He completed this with every perfection, to his great glory and advantage. In order to show that he was no less skilful in painting on panels than in fresco, he executed a panel in that palace, for which reason he was afterwards commissioned to do two in the Duomo[3] and a Madonna with the Child in her arms in a most beautiful attitude, above the door of the opera of that building. In this picture some angels which are holding up a standard in the air are flying and looking down on saints below them, who are surrounding Our Lady, forming a very beautiful and decorative composition.[4] That done, Simone was invited to Florence by the general of St. Augustine and did the chapter-house in S. Spirito, showing remarkable invention and judgment in the figures and horses, as may be believed on seeing the story of the Passion of Christ, remarkable alike for the ingenuity, discretion and exquisite grace displayed by the artist. The thieves on the cross are seen in the act of expiring, the soul of the good one being carried with rejoicing to heaven by angels, while that of the guilty one is roughly dragged down by devils to the torments of hell. Simone has also shown originality

[1] In 1339. [2] In 1315.
[3] One of these is the Annunciation in the Uffizi Gallery, dated 1333.
[4] Destroyed by earthquake in 1798.

and judgment in the disposition and bitter weeping of some angels about the cross. But most remarkable of all is the way in which the spirits cleave the air with their shoulders, because they maintain the movement of their flight while turning in a circle. This work would supply much clearer evidence of Simone's excellence if, in addition to the ravages of time, it had not been further damaged in the year 1560, through the fathers who, not being able to use the chapter-house on account of the damp, pulled down the little that remained of the paintings of this man, in replacing a worm-eaten floor by vaulting. About the same time Simone painted in tempera on a panel Our Lady and a St. Luke with other saints, which is to-day in the Chapel of the Gondi in S. Maria Novella, signed with his name.[1] Simone afterwards did three sides of the chapter-house of S. Maria Novella very successfully. On the first, that over the entrance door, he did the life of S. Domenic; on the next one towards the church he represented the religious of the order of that saint fighting against the heretics, who are represented by wolves attacking some sheep, these being defended by a number of dogs, spotted white and black, the wolves being repulsed and slain. There are also some heretics who have been convinced in the disputes and are tearing up their books, and, having repented, they confess, and their souls pass to the gate of Paradise, in which are many small figures doing various things. In heaven is seen the glory of the saints and Jesus Christ. In the world below the pleasures and delights are represented by human figures, especially some ladies seated, among whom is Petrarch's Laura drawn from life, clothed in green, with a small flame of fire between her breast and her throat. There also is the Church of Christ, guarding which are the Pope, the Emperor, the King, Cardinals, Bishops, and all the Christian Princes, among them, beside a knight of Rhodes, M. Francesco Petrarch, also drawn from life, which Simone did in order to keep green the memory of the man who had made him immortal. For the Church Universal he made the church of S. Maria del Fiore, not as it stands to-day, but as he had taken it from the model and design left by the architect Arnolfo in the opera, as a guide to those who were to continue the building after his death. As I have said elsewhere, no memory of these models would have been preserved, owing to the negligence of the wardens of S. Maria del Fiore, had not Simone painted them in this work.

[1] These frescoes are much later in date. They are now ascribed to Andrea da Firenze. The chapter-house was built in 1350, long after Simone's death.

On the third side, that of the altar, he did the Passion of Christ, who is going up from Jerusalem with the cross on His shoulder, and proceeds to Mount Calvary, followed by a throng of people, where He is seen raised on the cross between the thieves, together with the other incidents of that story. I shall not attempt to describe the presence of a good number of horses, the throwing of lots by the servants of the court for the raiment of Christ, the release of the holy Fathers from limbo, and all the other clever inventions which would be most excellent in a modern master and are remarkable in an ancient one. Here he occupies the entire wall and carefully makes the different scenes, one above the other, not dividing the separate subjects from one another by ornaments, as the ancients used to do, and according to the practice of many moderns, who put the earth above the sky four or five times. This has been done in the principal chapel of the same church, and in the Campo Santo at Pisa, where Simone painted many things in fresco, and was compelled against his will to make such divisions, as the other painters who had worked there, such as Giotto and Buonamico his master, had begun the scenes in this bad style. Accordingly, as the lesser evil, Simone adopted the style of the others in the Campo Santo, and made in fresco a Madonna above the principal door on the inside. She is borne to heaven by a choir of angels, who sing and play so naturally that they exhibit all the various expressions which musicians are accustomed to show when playing or singing, such as bending the ear to the sound, opening the mouth in various ways, raising the eyes to heaven, puffing the cheeks, swelling the throat, and in short all the movements which are made in music. Under this Assumption, in three pictures, he did some scenes from the life of S. Ranieri of Pisa.[1] In the first is the youth playing the psalter, to the music of which some little girls are dancing, a beautiful scene for the arrangement of the folds, the ornamentation of the clothes, and the head-dresses of those times. The same Ranieri is next seen rescued from such lasciviousness by St. Albert the hermit. He stands weeping with his face down, and his eyes red with tears, full of repentance for his sin, while God in the air, surrounded by a heavenly light, makes as if to pardon him. The second picture represents Ranieri distributing his property among God's poor, then mounting into a barque he has about him a throng of poor and maimed, of women and children, anxiously pressing forward to petition and to thank him. The same picture shows the

[1] The frescoes were not done till 1377, by the hand of Andrea da Firenze.

saint, after receiving the pilgrim's dress in the church, standing before Our Lady, who is surrounded by many angels, and promises him that he shall rest in her bosom at Pisa. The heads of all these figures are vigorous with a fine bearing. The third picture represents the saint's return after seven years from beyond the sea, where he had spent three terms of forty days in the Holy Land, and how, while standing in the choir and hearing the divine offices, where a number of boys are singing, he is tempted by the devil, who is seen to be utterly discomfited by the firm purpose guiding Ranieri not to offend God, assisted by a figure made by Simone to represent Constancy, who drives away the ancient adversary in confusion. The devil is represented with fine originality not only as terrified, but holding his hands to his head in his flight, with his head buried as far as possible in his shoulders, and saying, according to the words issuing from his mouth: "I can do no more." The last scene in the same picture is when Ranieri, kneeling on Mount Tabor, sees Christ miraculously in the air with Moses and Elias. All the parts of this work and other things which are not mentioned show that Simone was very ingenious, and understood the good method of composing figures gracefully in the style of the time. When these scenes were finished he made two pictures in tempera in the same city, assisted by Lippo Memmi his brother, who had also helped him to paint the chapter-house of S. Maria Novella and other works. Although Lippo did not possess Simone's skill, yet he followed his style so far as he was able, and did many things in fresco, in conjunction with his brother in S. Croce at Florence, the picture of the high altar of the Friars Preachers in S. Catarina at Pisa, and in S. Paolo on the River Arno, and besides many beautiful scenes in fresco, he did the picture in tempera now over the high altar, comprising Our Lady, St. Peter, St. Paul, St. John the Baptist, and other saints, to which work Lippo put his name. After these things he did by himself a picture in tempera for the friars of St. Augustine in S. Gimigniano, and acquired such fame thereby that he was obliged to send to Arezzo to the Bishop Guido de' Tarlati a picture with three half-length figures, which is now in the chapel of St. Gregory in the Vescovado. While Simone was working at Florence, a cousin of his who was a clever architect, Neroccio by name, succeeded in the year 1332 in getting the great bell of the commune of Florence to ring,[1] which no one had been able to accomplish for the space of seventeen years, except by the efforts

[1] According to Villani this was done in 1322, by Lando di Pietro di Siena.

of twelve men pulling. This man, however, balanced it so that it could be moved by two persons, and when once in motion one person alone could ring it, although it weighed more than sixteen thousand pounds; accordingly, in addition to the honour, he received three hundred gold florins as his reward, a considerable sum for that time.

But to return to our two masters of Siena. Besides the things already mentioned, Lippo executed from Simone's design a picture in tempera, which was taken to Pistoia and put over the high altar of the church of S. Francesco, where it was considered very fine. When Simone and Lippo at length returned to their native Siena, the former began a large coloured work over the great gate of Camollia. Here he represented the Coronation of Our Lady, with a quantity of figures, but the work remained incomplete, as he fell very sick, and succumbing to the disease he passed from this life in the year 1345,[1] to the great sorrow of the whole city, and of Lippo his brother, who gave him honoured burial in S. Francesco. Lippo afterwards finished many pictures which Simone had left imperfect. Among these were a Passion of Jesus Christ at Ancona, over the high altar of S. Niccola, in which Lippo finished what Simone had begun, imitating what he had done in the chapter-house of S. Spirito at Florence, and which Simone had entirely completed. This work is worthy of a longer life than it appears likely to enjoy, for it contains many finely posed horses and soldiers actively engaged in various matters, wondering whether or no they have crucified the Son of God. At Assisi he also finished some figures which Simone had begun in the lower church of S. Francesco, at the altar of St. Elizabeth, which is at the entrance of the door leading into the chapels, representing Our Lady, a St. Louis, King of France, and other saints, eight figures in all, from the knees upwards, but good and very well coloured. Besides this, Simone had begun in the principal refectory of that monastery, at the top of the wall, many small scenes and a Christ on a shaped cross. This remained unfinished, and is drawn, as may be seen to-day, in red with the brush on the *arricciato*. This method was favoured by the old masters in order to work in fresco with greater rapidity, for, after they had sectioned out all their work on the rough wall, they drew it with the brush, following a small design which served as a guide, increasing this in proportion to the size in which they proposed to execute the whole. That many other works were painted in

[1] He died at Avignon on 4 August, 1344.

the same manner as this is seen in those cases where the work has peeled off, the design in red remaining on the *arricciato*. But to return to Lippo. He drew very fairly, as may be seen in our book, in a hermit with his legs crossed. He survived Simone twelve years, doing many things for all parts of Italy, but especially two pictures in S. Croce at Florence. As the style of the two brothers is somewhat similar, their works may be distinguished thus: Simone wrote at the bottom of his: *Simonis Memmi Senensis opus*; Lippo omitted his surname and careless of his Latinity wrote: *Opus Memmi de Senis me fecit*. On the wall of the chapter-house of S. Maria Novella, besides the portraits of Petrarch and Laura mentioned above by Simone's hand, are those of Cimabue, Lapo the architect, Arnolfo his son, and Simone himself, the Pope being a portrait of Benedict XI. of Treviso, a Friar Preacher, whose figure had been given to Simone long before by his master Giotto, when the latter returned from the Pope's court at Avignon. In the same place, next to the Pope, he portrayed the Cardinal Niccola da Prato, who had at that time come to Florence as the Pope's legate, as Giov. Villani relates in his *History*.[1] Over Simone's tomb was set the following epitaph: "*Simoni Memmio pictorum omnium omnis aetatis celeberrimo. Vixit ann. lx. mens ii. d. iii.*" As may be seen in our book, Simone did not excel greatly in design, but was naturally full of invention and was very fond of drawing from life. In this he was considered the best master of his time, so that the lord Pandolfo Malatesta sent him to Avignon to make the portrait of M. Francesco Petrarch, at whose request he afterwards made the much-admired portrait of Madonna Laura.

TADDEO GADDI, Painter of Florence
(1300–1366)

IT is a truly useful and admirable task to reward talent largely at every opportunity, because great abilities which would otherwise lie dormant are excited by this stimulus and endeavour with all industry not only to learn, but to excel, to raise themselves to a useful and honourable rank, from which flow honour to their country, glory to themselves, and riches and nobility to their descendants, who, being brought up on such principles,

[1] He was sent to Florence to make peace between the factions, and arrived on 10 March, 1304. Villani: *Croniche*, lib. viii. cap. 69.

often become very rich and noble, as did the descendants of Taddeo Gaddi the painter, by means of his works. This Taddeo di Gaddo Gaddi of Florence, after the death of Gaddo, had been the pupil of his godfather Giotto for twenty-four years, as Cennino di Drea Ceninni, painter of Colle de Valdelsa writes. On the death of Giotto he became the first painter of the day, by reason of his judgment and genius, surpassing his fellow-pupils. His first works, executed with a facility due to natural ability rather than to acquired skill, were in the church of S. Croce at Florence in the chapel of the sacristy, where, in conjunction with his fellow-pupils of the dead Giotto, he did some fine scenes from the life of St. Mary Magdalene, the figures and draperies being very remarkable, the costumes being those then worn. In the Chapel of the Baroncelli and Bandini, where Giotto had already done a picture in tempera, Taddeo did some scenes from the life of the Virgin in fresco on the wall, which were considered very beautiful.[1] Over the door of the same sacristy he painted the scene of Christ disputing with the doctors in the temple, which was afterwards half destroyed when old Cosimo de' Medici built the novitiate, the chapel and the vestibule of the sacristy, in order to put a stone cornice above that door. In the same church he painted in fresco the Chapel of the Bellacci and that of St. Andrew, next to one of the three done by Giotto, in which he represented Christ calling Andrew and Peter from their nets, and the crucifixion of the latter Apostle with such truth that it was much admired and praised when it was completed, and is still held in esteem at the present day. Over the side door, and under the tomb of Carlo Marsupini of Arezzo, he made a dead Christ with the Maries, in fresco, which was much admired. Below the screen of the church, on the left-hand above the crucifix of Donato, he painted in fresco a miracle of St. Francis, where he raises a boy killed by a fall from a gallery, with an apparition in the air. In this scene he drew the portraits of his master Giotto, the poet Dante, Guido Cavalcanti, and some say of himself. In different places in the same church he made a number of figures, which are identified by artists from their style. For the Company of the Temple he painted the tabernacle which is at the corner of the via del Crocifisso, containing a fine Deposition from the Cross. In the cloister of S. Spirito he did two scenes in the arches next the chapter-house, in one of which he represented Judas selling Christ, and in the other the Last Supper with the Apostles. In the same

[1] 1332-8

convent over the door of the refectory he painted a crucifix and some saints, which distinguish him, among the others who worked there, as a true imitator of the style of Giotto, whom he always held in the highest veneration. In S. Stefano of the Ponte Vecchio he painted the picture and predella of the high altar with great care, and in the oratory of S. Michele in Orto he very skilfully represented in a picture a dead Christ, wept over by the Maries, and deposited in the sepulchre by Nicodemus with great devotion.[1] In the church of the Servites he painted the chapel of St. Nicholas, belonging to the Palagio family, with stories of that saint, where, in his painting of a barque, he has clearly shown, with the greatest judgment and grace, that he had a thorough knowledge of a tempestuous sea and of the fury of Fortune. In this work St. Nicholas appears in the air, while the mariners are emptying the ship and throwing out the merchandise, and delivers them from their danger. This work gave great satisfaction and was much admired, so that Taddeo was commissioned to paint the chapel of the high altar of that church. Here he did in fresco some stories of Our Lady, and in tempera on a panel Our Lady with many saints, a very vigorous representation. Similarly, on the predella of this picture he did some stories of Our Lady in small figures, into the details of which it is not necessary to enter, because everything was destroyed in the year 1467 when Ludovico, Marquis of Mantua, made in that place the tribune which is there now, from the design of Leon Battista Alberti, and the choir of the friars, causing the picture to be taken to the chapter-house of that convent, in the refectory of which he made, above the wooden panelling, the Last Supper of Jesus Christ with the Apostles, and above that a crucifix with many saints. When Taddeo had completed this work he was invited to Pisa, where he painted the principal chapel of S. Francesco in fresco, very well coloured, for Gherardo and Bonaccorso Gambacorti, with many figures and stories of the saint, and of St. Andrew and St. Nicholas. On the vaulting and the wall is Pope Honorius confirming the rule, and a representation of Taddeo from life, in profile, with a hood folded over his head. At the bottom of this scene are these words:

Magister Taddeus Gaddus de Florentia pinxit hanc historiam Sancti Francisci et Sancti Andreæ et Sancti Nicolai anno Domini MCCCXLII. de mense Augusti.

[1] Now in the Accademia, Florence.

In the cloister of the same convent he further made a Madonna in fresco, with the Child in her arms, very well coloured. In the middle of the church, on the left-hand on entering, he did a St. Louis the bishop, seated, to whom S. Gherardo da Villa magna, who was a friar of the order, is recommending one Frà Bartolommeo, then superior of the convent. The figures of this work, being drawn from life, exhibit the utmost vivacity and grace, in that simple style which was in some respects better than Giotto's, particularly in the expression of intercession, joy, grief, and other feelings, the good representation of which always constitutes the highest claim of the painter to honour. Taddeo then returned to Florence and continued for the commune the work of Orsanmichele,[1] rebuilding the pillars of the Loggia, using dressed and hewn stones in place of the original bricks, but without making any change in the design left by Arnolfo, who provided that a palace of two stories should be made above the Loggia for the preservation of the provisions of grain made by the people and commune of Florence. For the completion of this work the Art of the Porta S. Maria, to whom the charge of the structure had been entrusted, ordained the payment of the tolls of the piazza and of the grain market and some other changes of very small importance. But an ordinance of far more importance was that each of the arts of Florence[2] should make a pilaster for itself, placing on a niche in it the patron saint of each, and that every year the consuls of the arts should go to make offerings on their saints' feast days and keep their standard and insignia there all that day, but that the alms so collected should belong to the Virgin for the needy poor.

In the year 1333 a great flood had carried away the parapets of the Rubaconte bridge, thrown down the castle of Altafronte, left nothing of the Ponte Vecchio except the two middle piles, entirely destroyed the S. Trinità bridge, a single shattered pile alone standing, and half the alla Carraia bridge, breaking down the flood-gates of Ognissanti. For this cause the rulers of the

[1] The work was begun on 29 July, 1337. Villani: *Croniche*, lib. xi. cap. 67. The loggia was closed in to form an oratory in 1367, by Simone di Francesco Talenti.

[2] The arts or guilds of Florence formed the basis of the government of the city. They were of two orders, the greater and the lesser. The seven greater arts were: Lawyers (St. Luke), the Calimara or dealers in foreign cloth (St. John Baptist), money-changers (St. Matthew), woollen manufacturers (St. Thomas), physicians (Virgin Mary), silk manufacturers (St. John the Divine), and the furriers (St. James). The lesser arts were fourteen in number, including armourers (St. George), locksmiths (St. Mark), farriers (St. Eloi), drapers (St. Stephen), shoemakers (St. Philip), butchers (St. Peter). They were admitted to the full citizenship in 1378.

city took counsel together, because they did not wish that those who dwelt beyond the Arno should again suffer this inconvenience of having to cross by boats. Accordingly they called in Taddeo Gaddi, because his master Giotto had gone to Milan, and instructed him to make the model and design of the Ponte Vecchio, directing him to render it as strong and as beautiful as it could possibly be. To this end he spared neither pains nor expense, building it with such strong piers and such fine arches, all of hewn stone, that it now sustains twenty-two shops on either side, making forty-four in all, to the great benefit of the commune, which derives therefrom eight hundred florins yearly in rents. The breadth of the arches from one side to the other is 32 braccia, the middle way being 16, and the shops on either side 8 braccia. For this work, which cost sixty thousand gold florins, Taddeo not only deserved the praise accorded by his contemporaries, but he merits our commendation to-day to an even greater degree, for, not to speak of many other floods, the bridge was not shaken in the year 1557, on 13th September, when the Santa Trinità bridge, two arches of the Carraia, and a great part of the Rubaconte all fell, and much further damage was done, as is well known. Certainly no man of judgment can refrain from amazement, or at least wonder, when he considers how firmly the Ponte Vecchio resisted the impetus of the water, the timber, and other débris, without yielding. At the same time Taddeo laid the foundations of the Santa Trinità bridge, which was finished with less success in the year 1346 at a cost of twenty thousand gold florins. I say with less success, because, unlike the Ponte Vecchio, it was ruined by the flood of 1557. It was also under Taddeo's direction that the wall on the side of S. Gregorio was made at the same time, with driven piles, two piers of the bridge being taken to enlarge the ground on the side of the piazza de' Mozzi, and to set up the mills which are still there.

Whilst all these things were being done under Taddeo's direction and from his plans, he did not allow them to stop his painting, and did the tribunal of the old Mercanzia, where, with poetical imagination, he represented the tribunal of six men, that being the number of the chiefs of that magistracy, who are watching Truth taking out Falsehood's tongue, the former clothed in velvet over her naked skin, the latter in black: underneath are these lines:

La pura Verita per ubbidire
Alla santa Giustizia che non tarda
Cava la lingua alla falsa bugiarda.

Lower down are the following lines:

Taddeo dipinse questo bel rigestro
Discepol fu di Giotto il buon maestro.

In Arezzo some works in fresco were allotted to him which
he carried out with the greatest perfection, with the aid of his
pupil Giovanni da Milano. One of these, representing the Passion
of Jesus Christ, may still be seen in the oratory of the Holy
Spirit, in front of the high altar. It contains many horses, and
the thieves on the cross, and is considered a very beautiful thing
on account of his conception of the nailing to the cross, where
there are some figures which vividly express the rage of the
Jews, some drawing Him by the legs with a rope, others bringing
the sponge, and others in various attitudes, such as Longinus,
who pierces His side with the spear, and the three soldiers who
are playing for His garments, their faces depicting hope and
fear in throwing the dice. The first of these men stands in a
constrained attitude awaiting his turn, and is so eager to throw
that he apparently does not notice the discomfort; the second
is loading the dice-box, and frowns as he looks at the dice, his
mouth and eyes open as if from suspicion of fraud, showing
clearly to an observant beholder his eagerness to win; the third,
who is about to throw the dice, spreads out on the ground with
trembling arm the garments, where he shows with a smile that
he intends to throw them. On the sides of the church also may
be seen some stories of St. John the Evangelist, and there are
other things about the city which experts recognise as by
Taddeo's hand. Behind the high altar of the Vescovado we may
still see some stories of St. John the Baptist which are executed
with such wonderful style and design that they cannot fail to
excite astonishment. In the chapel of St. Sebastian, next the
sacristy in S. Agostino, he did the life of that martyr and the
dispute of Christ with the doctors, so well executed and finished
that the beauty and variety displayed, as well as the grace of
their colouring, are marvellous.

In Casentino, in the church of the Sasso del la Vernia, he
painted the chapel where St. Francis received the stigmata. Here
Taddeo was assisted in matters of minor importance by Jacopo
di Casentino, who thus became his pupil. When this was com-
pleted Taddeo returned with Giovanni da Milano to Florence,
where, in the city and without, they made a large number
of panels and pictures of importance. In the process of time
Taddeo acquired so much money that, by steadily saving, he
founded the wealth and nobility of his family, being always

considered a wise and prudent man. In S. Maria Novella he painted the chapter-house which was allotted to him by the prior of the place, who supplied him with the idea.[1] It is true that, because the work was a great one, and as the chapter-house of S. Spirito was uncovered at the same time as the bridges were building, to the great glory of Simone Memmi who painted it, the prior wished to secure Simone to do half of the work; accordingly he consulted Taddeo, who was very willing to agree to this, since Simone had been a fellow-pupil of Giotto with him, and they had always remained close friends and companions. O truly noble souls to love one another fraternally without rivalry, ambition, or envy, so that each rejoiced at the advancement and honour of his friend as if it had been his own! The work was accordingly divided, three sides being allotted to Simone, as I have said in his life, and the left side and the whole of the vaulting to Taddeo, who divided his work into four divisions or quarters, according to the disposition of the vaulting. In the first he made the Resurrection of Christ, in which he apparently endeavours to cause the glorified body to emit light, which is reflected on a city and on some mountain rocks; but he abandoned this device in the figures and in the rest of the composition, possibly because he was not confident of his ability to carry it out, owing to the difficulties which he foresaw. In the second compartment he made Jesus Christ delivering Peter from drowning, when the Apostles, who are managing the boat, are certainly very fine, and especially a man who is fishing with a line on the sea-shore (a thing first attempted by Giotto in the mosaic of the *Navicella* in St. Peter's), represented with vigorous and life-like expression. In the third he painted the Ascension of Christ, while the fourth represents the Descent of the Holy Spirit, remarkable for the fine attitudes of the Jews, who are endeavouring to enter the door. On the wall beneath are the seven sciences, with their names, and appropriate figures below each. Grammar habited like a woman is teaching a boy; beneath her sits the writer Donato. Next to Grammar sits Rhetoric, at whose feet is a figure with its two hands resting on books, while it draws a third hand from beneath a mantle and holds it to its mouth. Logic has a serpent in her hand, and is veiled, with Zeno of Elia at her feet reading. Arithmetic holds the tables of the Abacus, and under her sits Abraham,[2] its inventor. Music has musical instruments, with Tubal Cain beneath, beating with two hammers upon an anvil, with his ears listening to the sound.

[1] The work is by Andrea da Firenze. [2] Pythagoras.

Geometry has the quadrant and sextant, with Euclid beneath. Astrology has the sphere of the heavens in her hands, and Atlas under her feet. On the other side sit the seven theological sciences, each one having beneath it a person of an appropriate condition: pope, emperor, king, cardinal, duke, bishop, marquis, etc., the pope being a portrait of Clement V. In the middle, and occupying a higher place, is St. Thomas Aquinas, who was master of all these sciences, and certain heretics under his feet: Arius, Sabellius, and Averroes. About him are Moses, Paul, John the Evangelist, and some other figures, with the four cardinal virtues, and the three theological ones, in addition to an infinite number of other ideas set forth by Taddeo with no small design and grace, so that this may be considered the best devised and the most finely preserved of all his works. In the same S. Maria Novello, over the screen, he did a St. Jerome dressed as a cardinal. He held that saint in reverence, choosing him as the protector of his house, and after Taddeo's death his son Agnolo made a tomb for his descendants covered with a marble slab adorned with the arms of the Gaddi under this picture. For these descendants the cardinal Jerome, aided by their merits and the goodness of Taddeo, has obtained from God most distinguished places in the Church, such as clerkships of the chamber, bishoprics, cardinalates, provostships, and most honourable knighthoods. The descendants of Taddeo have uniformly valued and encouraged men of genius in painting and sculpture, assisting them to the utmost of their power. At length, when Taddeo had reached the age of fifty years, he was seized with a severe fever and passed from this life in the year 1350, leaving Agnolo his son and Giovanni to carry on the painting, recommending them to Jacopo di Casentino for their material well being, and to Giovanni da Milano for instruction in art. This Giovanni, besides many other things, made a picture, after Taddeo's death, which was placed in S. Croce at the altar of S. Gherardo da Villamagna, fourteen years after he had been left without his master, and also the high altar picture of Ognissanti, where the Umiliati friars are stationed, a much-admired work; and in Assisi he made for the tribune of the high altar a crucifix, Our Lady, and St. Clare, and on the side wall stories of Our Lady. He subsequently went to Milan, where he did many works in tempera and in fresco, and at length died there.

Now Taddeo always adopted Giotto's style, but did not greatly improve it, except in the colouring, which he made fresher and more vivid. Giotto had made such efforts to over-

come other difficulties of this art that, although he considered colouring also, yet it was not granted to him to master this completely. Taddeo, on the other hand, profiting by his master's labours, had an easier task, and was able to add something of his own in improving the colouring.

Taddeo was buried by Agnolo and Giovanni, his sons, in S. Croce, in the first cloister, and in the tomb which he had made for Gaddo, his father. He was much honoured in the verses of the learned of the time as a man who had deserved much for his character, and because he had, besides his pictures, successfully completed many structures very useful to his city. In addition to the works already mentioned, he had with care and diligence completed the campanile of S. Maria del Fiore from the design of his master Giotto. This campanile was so constructed that it would be impossible to join stones with more care, or to make a tower which should be finer in the matter of ornament, costliness and design. The epitaph made for Taddeo was as follows:

Hoc uno dici poterat Florentia felix
Vivente: at certa est non potuisse mori.

Taddeo's method of designing was very broad and bold, as may be seen in our book, which contains a drawing by his hand of the scene which he did in the chapel of St. Andrew in S. Croce, at Florence.

ANDREA DI CIONE ORCAGNA, Painter, Sculptor and Architect of Florence

(1308–1368)

IT is usually the case that, when a man of genius excels in one thing, he is easily able to learn others, especially such as are similar to his first profession, and which proceed, as it were, from the same source. An example of this is Orcagna of Florence, who was painter, sculptor, architect and poet, as will be said below. He was born in Florence, and while quite a child began to practise sculpture under Andrea Pisano, and so continued for some years. When he afterwards became desirous of enriching his invention for the purpose of composing beautiful scenes, he carefully studied design, aided as he was by Nature, who wished to make him a universal genius, and as one thing leads to another, he practised painting in colours, in tempera and fresco, and succeeded so well with the aid of Bernardo[1] Orcagna his

[1] *Rectius* Lionardo.

brother, that Bernardo himself procured his assistance to do the life of Our Lady in the principal chapel of S. Maria Novella, which then belonged to the family of the Ricci. This work was considered very beautiful, although, owing to the neglect of those who afterwards had charge of it, it was destroyed by water through the breaking of the roof not many years after, and consequently it is restored in its present manner, as will be said in the proper place. Suffice it to say that Domenico Grillandai, who repainted it, made considerable use of the inventions of Orcagna which were there. In the same church, and in conjunction with his brother Bernardo, Andrea did in fresco the chapel of the Strozzi, which is near the door of the sacristy and the belfry. In this chapel, which is approached by some stone steps, he painted on one wall the glory of Paradise, with all the saints in the various habits and head-dresses of the time. On the other wall he did Hell, with the holes, centres and other things described by Dante, of whom Andrea was a diligent student. In the church of the Servites, in the same city, he painted in fresco, also in conjunction with Bernardo, the chapel of the family of the Cresci, and in S. Pier Maggiore in a picture of considerable size, the Coronation of the Virgin,[1] and another picture in S. Romeo near the side door.

He and his brother Bernardo also painted in fresco together the façade of S. Apollinare, with such diligence that the colours are bright and beautiful and marvellously preserved to this day in that exposed place. The governors of Pisa, moved by the renown of these works of Orcagna, which were much admired, sent for him to do a part of the wall in the Campo Santo of that city, as Giotto and Buffalmacco had previously done.[2] Accordingly he put his hand to the work, and painted a Last Judgment, with some fancies of his own, on the wall towards the Duomo, next to the Passion of Christ made by Buffalmacco. In the first scene he represented all ranks of temporal lords enjoying the pleasures of this world, seating them in a flowery meadow under the shadow of many orange-trees, forming a most agreeable wood. Above the branches are some cupids, who are flying round and over a number of young women, evidently portraits of noble women and ladies of the day, though they are not recognisable after this lapse of time. The cupids are preparing to transfix the hearts of the ladies, near whom are young men and lords listening to playing and singing and watching the amorous

[1] Now in the National Gallery, London.
[2] These frescoes cannot be by Orcagna. Modern criticism inclines to attribute them to Pietro Lorenzetti.

dancing of men and maidens, delighting in the sweetness of their loves. Among these lords Orcagna drew Castruccio, the lord of Lucca, a youth of the most striking aspect, with a blue hood bound about his head and a sparrowhawk on his hand. Near him are other lords of the time, whose identity is not known. In fine, in this first part he represented in a most gracious manner and with much diligence all the delights of the world in accordance with the demands of the place and the requirements of art. On the other side of the same scene he represented, on a high mountain, the life of those who, being moved by penitence for their sins and by the desire of salvation, have escaped from the world to this mountain, which is thus full of holy hermits serving the Lord, and doing various things with very realistic expressions. Some are reading and praying, and are all intent on contemplation; while others are working to earn their living, and are exercising themselves in various activities. Here is a hermit milking a goat in the most vigorous and realistic manner. Below this is S. Macarius showing to three kings, who are riding to hunt with their ladies and suite, the corpses of three kings, partly consumed in a tomb, emblematic of the wretched lot of man, which are regarded with attention by the living kings in fine and varied attitudes, expressive of wonder, and they seem to be reflecting with self-pity that they themselves must shortly become such. For one of these kings on horseback Andrea drew the portrait of Uguccione della Faggiuola of Arezzo, a figure represented as holding his nose with his hand in order not to smell the odour of the dead kings. In the middle of this scene is Death, flying through the air and clothed in black, while he indicates that with his scythe he has taken the life of many who are prone, of every state and condition, poor, rich, lame, whole, young, old, men, women, and, in short, a multitude of every age and sex. And because Orcagna knew that the invention of Buffalmacco had pleased the Pisans, by which Bruno caused his figures in S. Paulo a ripa d'Arno to speak, making scrolls issue from their mouths, he has filled all these works of his with such writings, of which the greater number, being destroyed by time, cannot be deciphered. He makes some lame old men say—

> Da che prosperitade ci ha lasciati,
> O morte medecina d'ogni pena
> Deh vieni a darne omai l'ultima cena,[1]

[1] Since every happiness has abandoned us,
Come death, the cure of every grief,
Come and give us our last meal.

with other words which cannot be made out, and similar archaic verses composed by Orcagna himself, as I have discovered, for he was addicted to poetry, and wrote some sonnets. About these bodies are some devils, who take their souls out of their mouths and carry them to holes full of fire upon the top of a very high mountain. On the other hand, there are some angels who, in like manner, take the souls of the dead who happen to have been good, out of their mouths, and carry them flying to Paradise. In this scene is a large scroll, held by two angels, containing the following words:

> Ischermo di savere e di richezza,
> Di nobilitate ancora e di prodezza,
> Vale neente ai colpi di costei,[1]

with some other words which cannot easily be understood. Underneath, in the ornamentation of these scenes, are nine angels who hold some words written in the border of the painting in the vulgar tongue and in Latin, put there because they would spoil the scene if placed higher, and to omit them altogether did not appear fitting to the author, who considered this method very fine, and perhaps it was to the taste of that age. The greater part of these are omitted here in order not to tire the reader with impertinent matter of little interest, and moreover the greater number of the scrolls are obliterated, while the remainder are in a very imperfect condition. After this Orcagna made the Last Judgment. He placed Jesus Christ on high above the clouds in the midst of His twelve Apostles to judge the quick and the dead, exhibiting on the one side, with great art and vigour, the despair of the damned, as they are driven weeping to Hell by furious demons; and on the other side the joy and rejoicing of the elect, who are transported to the right-hand side of the blessed by a troop of angels led by the Archangel Michael. It is truly lamentable that, for lack of writers, the names and identity of few or none of these can be ascertained out of such a multitude of magistrates, knights and other lords, who are evidently drawn from life, although the pope there is said to be Innocent IV. the friend [2] of Manfred.

After this work and some sculptures in marble executed to his great glory in the Madonna, which is on the flanks of the Ponte Vecchio, Andrea left his brother Bernardo to work by

[1] Knowledge and wealth,
 Birth, and valour, all
 Are alike powerless against his strokes.

[2] A clerical error for enemy; *amico* for *nemico*.

himself in the Campo Santo at a Hell made according to Dante's description, which was afterwards much damaged in 1530, and restored by Solazzino, a painter of our own day. Meanwhile Andrea returned to Florence, where he painted in fresco in the middle of the church of S. Croce, on a very large wall on the right hand, the same things which he had done in the Campo Santo at Pisa, in three similar pictures, but omitting the scene in which S. Macarius is showing human wretchedness to the three kings, and the life of the hermits who are serving God on the mountain. But he did all the rest of that work, displaying better design and more diligence than at Pisa, but retaining almost the same methods in the inventions, style, scrolls and the rest, without changing anything except the portraits from life; because in this work he introduced the portraits of some of his dearest friends into his Paradise, while he condemned his enemies to hell. Among the elect may be seen the portrait in profile of Pope Clement VI. with the tiara on his head, who reduced the Jubilee from a hundred to fifty years, was a friend of the Florentines, and possessed some of their paintings which he valued highly. Here also is Maestro Dino del Garbo, then a most excellent physician, clothed after the manner of the doctors of that day with a red cap on his head lined with miniver, while an angel holds him by the hand. There are also many other portraits which have not been identified. Among the damned he drew il Guardi, sergeant of the commune of Florence, dragged by the devil with a hook. He may be recognised by three red lilies on his white hat, such as were worn by the sergeants and other like officials. Andrea did this because the sergeant had upon one occasion distrained his goods. He also drew there the notary and the judge who were against him in that cause. Next to Guardi is Cecco d'Ascoli, a famous wizard of the time, and slightly above him, and in the middle, is a hypocritical friar who has come out of a tomb and is furtively trying to mingle with the good, while an angel discovers him and thrusts him among the damned.

Besides Bernardo, Andrea had another brother called Jacopo, who devoted himself, but with little success, to sculpture. For this brother Andrea had sometimes made designs in relief in clay, and this led him to wish to do some things in marble to see if he remembered the principles of that art, which he had studied at Pisa, as has been said. Accordingly he applied himself earnestly to that pursuit, and attained to such a measure of success that he afterwards made use of it with credit, as will

be said. He next devoted all his energies to the study of architecture, thinking that he might have occasion to make use of it. Nor was he mistaken, for in the year 1355 the commune of Florence bought some private houses near the palace to enlarge that building and increase the piazza, and also to make a place where citizens could withdraw in wet weather, and in winter to do under cover the things which were done in the uncovered arcade when bad weather did not interfere. They procured a number of designs for the construction of a large and magnificent loggia near the palace for this purpose as well as for a mint for coining money. Among these designs, prepared by the best masters of the city, that of Orcagna was universally approved and accepted as being larger, finer and more magnificent than the others, and the large loggia of the piazza was begun under his direction by order of the Signoria and commune, upon foundations laid in the time of the Duke of Athens, and was carried forward with much diligence in squared stones excellently laid.[1] The arches of the vaulting were constructed in a manner new for that time, not being pointed as had previously been customary, but in half-circles after a new pattern, with much grace and beauty, and the building was completed under Andrea's direction in a short time. If it had occurred to him to erect it next to S. Romolo and to turn its back towards the north, which he perhaps omitted to do in order that it should be convenient for the door of the palace, it would have been a most useful construction for all the city, as it is a most beautiful piece of work, whereas it is impossible to remain there in winter owing to the strong wind. In the decoration of this loggia Orcagna made seven marble figures in half-relief between the arches of the façade representing the seven virtues, theological or cardinal.[2] These are so fine that, taken in conjunction with the whole work, they prove their author to have been an excellent sculptor as well as a distinguished painter and architect. Besides this he was in all his deeds a pleasant, well-bred and amiable man so that his fellow was never seen. And since he never abandoned the study of one of his three professions when he took up another, he painted a picture in tempera with many large figures while the loggia was building, and a predella of small figures for that Chapel of the Strozzi where his brother

[1] The work was decreed in 1356, but not carried out until 1376–81, when the architects were Benci di Cione and Simone di Francesco Talenti.

[2] The figures were made 1383–6 by Giovanni di Francesco Fetti, Giovanni d'Ambrogio and Jacopo di Piero from designs by Agnolo Gaddi.

Bernardo had already done some things in fresco. On this picture he wrote his name thus: *Anno Domini* MCCCLVII *Andreas Cionis de Florentia me pinxit*, being of opinion that it would exhibit his powers to better advantage than his works in fresco could. When this was finished he did some paintings on a panel which were sent to the Pope at Avignon, in the cathedral church of which they still remain. Shortly afterwards, the men of the company of Orsanmichele, having collected a quantity of money of alms and goods given to the Madonna there during the mortality of 1348, they decided that they would make about her a chapel or tabernacle richly adorned not only with marble carved in every manner and with other stones of price, but also with mosaic and ornaments of bronze, the best that could be desired, so that in workmanship and material it should surpass every other work produced up to that day whatever its importance. The execution of this was entrusted to Orcagna as being the foremost man of the age. He made a number of designs, one of which was chosen by the directors of the work as being the best of all. Accordingly the task was allotted to him and everything was committed to his judgment and counsel. He and his brother undertook to do all the figures, giving the rest to various masters from other countries. On the completion of the work,[1] he caused it to be built up and joined together very carefully without lime, the joints being of lead and copper so that the shining and polished marbles should not be blemished. This proved so successful, and has been of such use and honour to those who came after him, that it appears to an observer that the chapel is hollowed out of a single piece of marble, so excellently are parts welded together, thanks to this device of Orcagna. Although in the Gothic style, its grace and proportions are such that it holds the first place among the things of the time, owing chiefly to the excellent composition of its great and small figures and of the angels and prophets in half-relief about the Madonna. The casting of the carefully polished bronze ornaments which surround it is marvellous, for they encircle the whole work, enclose it and bind it together, so that this part is as remarkable for its strength as the other parts are for their beauty. But he devoted the highest powers of his genius to the scene in half-relief on the back of the tabernacle, representing in figures of a braccia and a half the twelve Apostles looking up at the Madonna ascending to heaven in a mandòrla, surrounded by angels. He represented himself in marble as one

[1] In 1359.

of the Apostles, an old man, clean shaven, a hood wound round his head, with a flat round face as shown in his portrait above, which is taken from this. On the base he wrote these words in the marble: *Andreas Cionis pictor florentinus oratorii archimagister extitit hujus*, MCCCLIX. It appears that the erection of the loggia and of the marble tabernacle, with all the workmanship involved, cost 96,000 gold florins, which were very well expended, because in architecture, in sculpture and other ornaments, they are comparable in beauty with any other work of the time, without exception, and so excellent as to assure to the name of Andrea Orcagna immortality and eternal greatness. In signing his paintings he used to write Andrea di Cione, sculptor, and on his sculptures, Andrea di Cione, painter, wishing his sculpture to recommend his painting and his painting his sculpture. Florence is full of his paintings, some of which may be recognised by the name, such as those in S. Romeo, and some by his style, like that in the chapter-house of the monastery of the Angeli. Some which he left imperfect were finished by his brother Bernardo, who survived him, though not for many years. Andrea, as I have said, amused himself in making verses and other poems, and when he was an old man he wrote some sonnets to Burchiello, then a youth. At length at the age of sixty he completed the course of his life in 1389, and was borne with honour to burial from his house in the via Vecchia de' Corazzai.

In the days of the Orcagna there were many who were skilful in sculpture and architecture whose names are unknown, but their works show that they are worthy of high praise and commendation. An example of such work is the Monastery of the Certosa of Florence, erected at the cost of the noble family of the Acciaiuoli, and particularly of M. Niccola, Grand Seneschal of the King of Naples, containing Niccola's tomb with his effigy in stone, and those of his father and a sister, both of whose portraits in the marble were made very skilfully from life in the year 1366. There also and by the same hand may be seen the tomb of M. Lorenzo, Niccola's son, who died at Naples, and was brought to Florence and buried there with most honourable obsequies. Similarly the tomb of the Cardinal S. Croce of the same family, which is before the high altar in a choir then newly built, contains his portrait in a marble stone very well executed in the year 1390.

The pupils of Andrea in painting were Bernardo Nello di Giovanni Falconi of Pisa, who did a number of pictures for the

Duomo of Pisa, and Tommaso di Marco of Florence, who, besides many other things, painted a picture in the year 1392 which is in S. Antonio at Pisa on the screen of the church. After Andrea's death, his brother Jacopo, who, as has been said, professed sculpture and architecture, was employed in the year 1328 [1] in building the tower and gate of S. Pietro Gattolini, and it is said that the four gilded stone lions at the four corners of the principal palace of Florence are by his hand. This work incurred no little censure, because it was placed there without reason, and was perhaps a greater weight than was safe. Many would have preferred the lions to have been made of copper gilded over and hollow inside, and then set up in the same place, when they would have been much less heavy and more durable. It is said that the horse in relief in S. Maria del Fiore at Florence is by the same hand. It is gilded, and stands over the door leading to the oratory of S. Zanobius. It is believed to be a monument to Pietro Farnese, captain of the Florentines, but as I know nothing more of the matter I cannot assert this positively. At the same time Andrea's nephew Mariotto made a Paradise in fresco for S. Michel Bisdomini in the via de' Servi at Florence, an Annunciation over the altar, and another picture with many figures for Mona Cecilia de' Boscoli, which is in the same church near the door. But of all Orcagna's pupils none excelled Francesco Traini, who executed for a lord of the house of Coscia, buried at Pisa in the chapel of St. Dominic in the church of S. Caterina, a St. Dominic standing upright of two and a half braccia on a panel on a gold ground, with six scenes from his life surrounding him, very vigorous and life-like and excellently coloured.[2] In the chapel of St. Thomas Aquinas in the same church he made a picture in tempera, with delightful invention, and which is much admired. He introduced a figure of St. Thomas seated, from life; I say from life because the friars of the place brought a portrait of him from the abbey of Fossanuova, where he had died in 1323.[3] St. Thomas is seated in the air with some books in his hand, illuminating with their rays and splendour the Christian people; kneeling below him are a large number of doctors and clerks of every condition, bishops, cardinals and popes, including the portrait of Pope Urban VI. Under the saint's feet are Sabellius, Arius, Averroes, and other heretics and philosophers with their books all torn. On either side of

[1] He has just stated that Andrea died in 1389!
[2] Done in 1344; now in the Accademia, Pisa.
[3] He died in 1274.

St. Thomas are Plato, showing the Timæus, and Aristotle pointing to his Ethics. Above is Jesus Christ, also in the air, with the four Evangelists about him. He is blessing St. Thomas, and apparently sending the Holy Spirit upon him, filling him therewith and with His grace. On the completion of this work Francesco Traini acquired great name and fame, for he had far surpassed his master Andrea in colouring, harmony and invention. Andrea was very careful in his designs, as may be seen in our book.

Tommaso called Giottino, Painter of Florence [1]

When there is emulation among the arts which are based on design and when artists work in competition with each other there is no doubt that men's abilities, being stimulated by constant study, discover new things every day to satisfy the varied tastes of man. For instance in painting, some set to work upon obscure and unusual subjects and, by displaying the difficulties therein, contrive to throw their own talent into relief. Others employ themselves on sweet and delicate things, conceiving that these should be more pleasing to the eye of the beholder as possessing more relief; so that they pleasantly attract the greater number of men. Others again paint smoothly, softening the colours and confining the lights and shades of the figures to their proper places, for which they merit the highest praise, displaying the process of the intellect with wonderful skill. This smooth style is always apparent in the works of Tommaso di Stefano, called Giottino, who was born in the year 1324, and, after he had learned the elements of painting from his father, he resolved while still a youth that he would most carefully imitate Giotto's style rather than that of his father, Stefano. He succeeded so well in this that he won thereby in addition to the style, which was much finer than his master's, the nickname of Giottino, which he always retained. Hence many, misled by his manner and name, believed him to be Giotto's son, but they fell into a very great error, for it is certain, or rather highly probable (since no one can affirm such things absolutely), that he was the son of Stefano, painter of Florence. Tommaso was so diligent in painting and so fond of

[1] Under this name Vasari has confounded three artists, Maso di Banco (fl. 1320–52); Giotto di Maestro Stefano, the true Giottino (fl. 1368) and Tomaso di Stefano.

it that, although not many of his works have been found, yet those which are extant are good and in excellent style. For the draperies, hair, beards and other details are executed and composed with such grace and care that they prove him to have achieved harmony in this art far more perfectly than either Giotto his master or Stefano his father.

In his youth Giottino painted in S. Stefano, at the Ponte Vecchio at Florence, a chapel by the side door, and although it has suffered a great deal from the damp, yet enough remains to prove the skill and genius of the craftsman. He next did SS. Cosmo and Damian in the Frati Ermini beside the mills, of which but little can now be seen owing to the ravages of time. He did a chapel in fresco in the old S. Spirito of that city, which was afterwards destroyed at the burning of that church. Over the principal door of the same church he painted in fresco the Descent of the Holy Spirit, and on the piazza of the church, at the angle of the convent towards the via della Cuculia, he did the tabernacle which may still be seen there, with Our Lady and other saints about her, who in their heads and other parts approach very closely to the modern style, because Tommaso endeavoured to vary and change the flesh-tints and displayed grace and judgment in the variety of colouring and draperies which he gave to all his figures. In the chapel of St. Silvester at S. Croce he did the history of Constantine with great care, with many fine ideas in the gestures of the figures. His next work was to be placed behind a marble ornament made for the tomb of M. Bettino de' Bardi, a man of eminent military rank of the time.[1] He represented him from life, in armour, rising on his knees from the tomb, summoned by the Last Trump sounded by two angels who accompany a Christ in the clouds, very well done. At the entrance to S. Pancrazio, on the right-hand side, he did a Christ carrying the Cross, and some saints near, markedly in Giotto's style. In S. Gallo, a convent outside the gate of that name, and which was destroyed at the siege, he painted a Pieta in fresco in a cloister, a copy of which is in S. Pancrazio mentioned above, on a pilaster beside the principal chapel. He painted SS. Cosmo and Damian in fresco in S. Maria Novella at the chapel of S. Lorenzo de' Giuochi, on the right-hand side on entering the church door, on the front wall. In Ognissanti he did a St. Christopher and a St. George, which were ruined by bad weather and were restored by some other painters,

[1] The tomb is that of Andrea de' Bardi, who died 1367, but it belonged in 1440 to Bettino, and hence the mistake.

through the ignorance of a rector who understood little of such matters. An uninjured work of Tommaso in the same church is in the tympanum over the sacristy door, which contains a Madonna in fresco, with the Child in her arms; it is a good thing, as he took pains with it.

By means of these works Giottino acquired so much renown, imitating his master, as I have said, both in design and in inventions, that the spirit of Giotto himself was said to be in him, owing to the freshness of his colouring and to his skill in design. Now, on 2nd July 1343, when the Duke of Athens [1] was hunted from Florence, and had by oath renounced the government and rendered the Florentines their liberty, Giottino was constrained by the Twelve Reformers of the State, and especially by the prayers of M. Agnolo Acciaiuoli, then a very distinguished citizen, who had great influence over him, to paint on the tower of the Podestà Palace the duke and his followers, M. Ceritieri Visdomini, M. Maladiasse, his Conservator and M. Ranieri of S. Gimignano, all with mitres of Justice on their heads, represented thus shamefully as a sign of contempt. About the duke's head he painted many beasts of prey and other sorts, indicative of his nature and character, and one of these counsellors had in his hand the palace of the priors of the city, which he was offering to the duke, like a false traitor. Beneath everyone of them were the arms and insignia of their families, with inscriptions which can now only be read with difficulty owing to the ravages of time. In his work the artist's style gave general satisfaction because it was well designed and very carefully executed. He next made a St. Cosmo and a St. Damian at the Campora, a place of the black monks outside the gate of S. Piero Gattolini. These were afterwards destroyed in whitewashing the church. On the bridge at Romiti in Valdarno he did the tabernacle which is built in the middle, painting it in fresco in a very fine style. It is recorded by many writers that Tommaso practised sculpture, and did a marble figure four braccia high for the campanile of S. Maria del Fiore at Florence, facing the spot where the orphan asylum now stands. At Rome again he successfully completed a scene in St. John Lateran in which he represented the Pope in various dignities, but the painting is now much damaged and eaten by time. In the house of the Orsini he did a hall full of famous

[1] The date should be 26th July. Walter de Brienne, Duke of Athens, a Frenchman, elected captain and protector of Florence in June 1342, endeavoured to become master of the city, but was expelled in the popular rising referred to.

men, and a very fine St. Louis on a pilaster at Araceli, on the right-hand side at the high altar. Above the pulpit in the lower church of S. Francesco at Assisi, that being the only place left undecorated, he painted a Coronation of Our Lady,[1] in an arch, surrounded by many angels, so graceful, with such beautiful faces, so soft and so delicate, exhibiting that harmony of colour peculiar to the artist, that he may clearly be compared with any of his predecessors. About this arch he did some stories of St. Nicholas. Similarly, in the middle of the church, in the monastery of S. Chiara, in the same city, he painted a scene in fresco of St. Clare, upheld in the air by two angels, which seem real, raising a dead child, whilst many beautiful women standing about are filled with amazement, all being very graceful in their head-dresses and the costumes of the time.[2] In the same city of Assisi, in an arch over the inside of the city gate which leads to the Duomo, he did a Madonna and Child with so much care that she seems alive, and a very fine St. Francis with another saint. These two works, although the scene with St. Clare is unfinished, for Tommaso returned sick to Florence, are perfect and worthy of all praise.

It is said that Tommaso was a melancholy and solitary man, but very diligent and fond of his art. This is clearly shown in a picture of his in tempera in the church of S. Romeo at Florence, placed on the screen on the right-hand side, for nothing was ever better done on wood. It represents a dead Christ surrounded by the Maries and Nicodemus, accompanied with other figures, who are weeping bitterly for the dead.[3] Their gentleness and sweetness are remarkable as they twist their hands and beat themselves, showing in their faces the bitter sorrow that our sins should cost so dear. It is a marvellous thing, not that Tommaso could rise to this height of imagination, but that he could express his thought so well with his brush. Consequently this work deserves the highest praise. not so much because of the subject and conception as for the art in which he exhibited the heads of some who are weeping, for although the brows, eyes, nose and mouth are distorted by the emotion, yet this does not mar or destroy the beauty of his faces, which usually suffers much at the hands of those who represent weeping if they are not versed in the good methods of art. But it is no wonder that Giottino devoted so much care to this picture, because the

[1] Professor Venturi pronounces these frescoes to be anterior to 1316.
[2] These paintings are anterior to 1316.
[3] Now in the Uffizi as school of Giotto, probably by Maso di Banco.

object of all his labour was rather fame and glory than any other reward or desire of gain, which causes the masters of our time to be less careful and good. Not only was Tommaso indifferent about acquiring great wealth, but he went without many of the comforts of life, living in poverty, seeking rather to please others than himself; accordingly, through neglecting himself and hard work, he died of phthisis at the age of thirty-two, and was buried by his relations outside S. Maria Novella at the gate of Martello, near the tomb of Bontura.

Giottino, who left more fame than property, had as pupils Giovanni Tossicani of Arezzo, Michelino, Giovanni dal Ponte and Lippo, who were meritorious masters of the art. Giovanni Tossicani excelled the others, and after Tommaso's death he executed many works in that same style, in all Tuscany, and particularly in the Pieve of Arezzo, where he did the chapel of S. Maria Maddalena of the Tuccerelli, and in the Pieve of Empoli, where he did a St. James on a pilaster. Again, he did some panels in the Duomo at Pisa which were afterwards removed to make way for modern works. His last work was executed in a chapel of the Vescovado of Arezzo, for the Countess Giovanna, wife of Tarlato da Pietramala, a fine Annunciation, with St. James and St. Philip. As this work was on a wall, the back of which is exposed to the north, it was all but destroyed by the damp, when Master Agnolo di Lorenzo of Arezzo restored the Annunciation, and soon after Giorgio Vasari, then quite a youth, restored the SS. James and Philip, to his great advantage, as he learnt a great deal which he had no opportunity of gathering from other masters, by observing Giovanni's methods, and from the shadows and colours of this work, damaged as it was. The following words of the epitaph to the Countess, who caused the work to be done, may still be read in this chapel: *Anno Domini* 1335 [1] *de mense Augusti hanc cappellam constitui fecit nobilis Domina comitissa Joanna de Sancta Flora uxor nobilis militis Domini Tarlati de Petramala ad honorem Beatæ Mariæ Virginis.*

I make no mention of the works of the other pupils of Giottino, because they are quite ordinary and bear little resemblance to those of their master and of Giovanni Tossicani, their fellow-pupil. Tommaso drew very well, as appears by some sheets by his hand which are in our book, which are very carefully executed.

[1] This date is an impossible one for a pupil of Giottino, who is stated by Vasari himself to have been born in 1324. It has been suggested that the work is by Giovanni di Francesco Toscani.

GIOVANNI DA PONTE, Painter of Florence
(1307–1365)

ALTHOUGH the old proverb that a bon-vivant never lacks means is untrue and unworthy of confidence, the contrary being the case, since a man who does not live temperately within his means comes at last to want, and dies in misery; yet it sometimes happens that Fortune rather assists those who throw away without reserve than those who are orderly and careful in all things. When the favour of Fortune is wanting, Death frequently repairs the defect and remedies the consequences of men's thoughtlessness, for it comes at the very moment when they would begin to realise, with sorrow, how wretched a thing it is to have squandered everything when young to pass one's age on shortened means in poverty and toil. This would have been the fate of Giovanni da S. Stefano a Ponte of Florence, if, after he had devoured his patrimony as well as the gains which came into his hand rather through good fortune than by his deserts, and some legacies which came to him from unexpected quarters, he had not reached the end of his life at the very time when he had exhausted his means. He was a pupil of Buonamico Buffalmacco, and imitated his master more in following worldly pleasures than in endeavouring to make himself a skilful painter. He was born in the year 1307, and was Buffalmacco's pupil in his youth. He executed his first works in fresco in the Pieve of Empoli in the chapel of St. Laurence, painting many scenes from the life of that saint with such care that so good a beginning was considered to promise much better things in the future. Accordingly he was invited in the year 1344 to Arezzo, where he did an Assumption in a chapel in S. Francesco. Being in some credit in that city, for lack of other artists, he next painted in the Pieve the chapel of St. Onofrio and that of St. Anthony, ruined to-day by the damp. He left other paintings in S. Giustina and S. Matteo, which were pulled down with the churches when Duke Cosimo was fortifying the city. Almost on this very spot, near S. Giustina, at the foot of the abutment of an ancient bridge, at the point where the river enters the city, they found a fine marble head of Appius Cæcus, and one of his son, with an ancient epitaph, equally fine, which are now in the Duke's wardrobe. When Giovanni returned to Florence, at the time when the middle arch of the S. Trinità bridge was being completed, he decorated a chapel built on the bridge, and dedicated

to St. Michael the Archangel, doing many figures, both inside and out, notably the whole of the façade. This chapel was carried away, together with the bridge, in the flood of 1557. Some assert that he owed his name of Giovanni dal Ponte to these works. In Pisa, in the year 1355, he did some scenes in fresco behind the altar in the principal chapel of S. Paolo a ripa d'Arno, which are now ruined by damp and time. Another work of his is the chapel of the Scali in S. Trinità at Florence,[1] and another beside it, as well as one of the stories of St. Paul beside the principal chapel, which contains the tomb of Maestro Paolo, the astrologer. In S. Stefano, at the Ponte Vecchio, he did a panel and other paintings in tempera and fresco for Florence and elsewhere which won him considerable renown. He was beloved by his friends, but rather in his pleasures than in his labours, and he was a friend of men of letters, and especially of all those who frequented the studios of artists in the hope of excelling in that profession; and although he had not troubled to acquire for himself what he desired for others, he never ceased to advise others to work diligently. At length, when he had lived fifty-nine years, he departed this life in a few days in consequence of a disorder of the chest. Had he lived a little longer, he would have suffered great hardships, as there remained hardly sufficient in his house to afford him decent burial in S. Stefano dal Ponte Vecchio. His works were executed about 1345.

Our book of designs of various ancient and modern masters contains a water-colour drawing by Giovanni representing St. George on horseback killing a serpent; also a skeleton: the two affording an excellent illustration of his method and his style in designing.

AGNOLO GADDI, Painter of Florence
(ob. 1396)

THE virtue and husbandry of Taddeo Gaddi afford an excellent illustration of the advantages and honours accruing from excellence in a noble art, for by his industry and labour he obtained a considerable property as well as a good name, and left the affairs of his family so ordered that when he passed to the other life his sons Agnolo and Giovanni were enabled without difficulty to lay the foundations of the vast wealth and dis-

[1] Painted in 1434 by Giovanni di Marco and Smeraldo di Giovanni.

tinction of the house of Gaddi, which is now amongst the noblest in Florence and of high repute in all Christendom. Indeed, it was no more than reasonable, after Gaddo, Taddeo, Agnolo and Giovanni had adorned with their art and talents so many considerable churches, that their descendants should be decorated with the highest ecclesiastical dignities by the Holy Roman Church and her pontiffs. Taddeo, whose life we have already written, left two sons, Agnolo and Giovanni, among his many pupils, and he hoped that Agnolo in particular would attain to considerable excellence in painting. But although Agnolo when a youth promised to far surpass his father, he did not realise the expectations which were then formed about him. Being born and brought up in ease, which is often a hindrance to application, he was more devoted to trading and commerce than to the art of painting. This is no new or strange circumstance, for avarice almost invariably proves a bar to those geniuses who would have attained the summit of their powers had not the desire of gain stood in their way in their first and best years.

In his youth Andrea did a small scene for S. Jacopo tra fossi at Florence, in figures of little more than a braccia high, representing the Resurrection of Lazarus, who had been four days dead.[1] Considering the corrupt state of the body, which had been in the tomb three days, he presented the grave clothes bound about him as soiled by the putrefaction of the flesh, and certain livid and yellowish marks in the flesh about the eyes, between quick and dead, very well considered. He also shows the astonishment of the disciples and other figures, who in varied and remarkable attitudes are holding their garments to their noses so as not to smell the stench of the corrupt body, and exhibit every shade of fear and terror at this marvellous event, as well as the joy and delight of Mary and Martha at seeing the dead body of their brother return to life. This work was deemed so excellent that there were many who thought that the talents of Andrea would prove superior to those of all the pupils of Taddeo, and even to those of the master himself. But the event proved otherwise, for as in youth will conquers every difficulty in the effort after fame, so it often happens that the years bring with them a certain carelessness which causes men to go backwards instead of forwards, as was the case with Agnolo. Owing to the high repute of his ability, the family of the Soderini, expecting a great deal, allotted to him the principal chapel of

[1] Painted soon after 1350.

the Carmine, where he painted the whole of the life of Our Lady, but in a style so inferior to the Resurrection of Lazarus that anyone could perceive that he had little desire to devote all his energies to the study of painting. In the whole of this great work there is not more than a single good scene, namely, that in which Our Lady is in an apartment surrounded by a number of maidens, in various costumes and headdresses proper to the time, and who are engaged in various employments, some spinning, some sewing, some winding silk, and some weaving and doing other things, all very well conceived and executed by Agnolo.

Similarly, in painting in fresco the principal chapel of the church of S. Croce for the noble family of the Alberti, he represented the incidents which took place on the Finding of the Cross,[1] executing the work with much skill, though it is somewhat lacking in design, the colouring alone being meritorious. He succeeded much better afterwards in some other paintings in fresco of the life of St. Louis in the chapel of the Bardi in the same church. He worked capriciously, sometimes with great care and sometimes with little. Thus in S. Spirito at Florence, inside the door leading from the piazza to the convent, over another door he did a Madonna and Child, with St. Augustine and St. Nicholas, all in fresco, so well that they look as if they had been painted yesterday. The secret of working in mosaic had as it were descended to Agnolo by inheritance, and in his house he had the tools and other apparatus used by his grandfather Gaddo; accordingly, to pass the time and because he had these things, rather than for any other reason, he did some work in mosaic when he had the whim. Thus, since many of the marble facings of the octagonal exterior of S. Giovanni were wasted by time, and as the damp had pierced through and done considerable injury to the mosaics previously executed there by Andrea Tafi, the Consuls of the Art of the Merchants proposed to restore the greater part of this marble covering, in order that no further damage should be done, and also to repair the mosaics. The commission for this was given to Agnolo, and in the year 1346 he caused the building to be covered with new marble, overlaying the joints to a depth of two fingers with great care, notching the half of each stone as far as the middle. He then cemented them together with a mixture of mastic and wax, and completed the whole with such care that from that time forward neither the vaulting nor the roof has ever suffered

[1] Finished in 1394.

any harm from the weather. His subsequent restoration of the mosaics led by his advice to the reconstruction from his well-devised plans of the whole of the marble cornice surrounding the church, under the roof, in its present form, whereas it was originally much smaller and by no means remarkable. He also directed the construction of the vaulting for the hall of the Podeàta Palace,[1] where an ordinary roof had formerly existed, so that in addition to the added beauty which it gave the room, it rendered it proof against damage by fire from which it had suffered a long while before. By his advice the present battlements were added to the palace, where nothing of the kind had previously existed.

While these works were proceeding, he did not entirely abandon painting, but executed in tempera a picture of Our Lady for the high altar of S. Pancrazio, with St. John the Baptist, St. John the Evangelist, the brothers St. Nereus, Achilleus, and Pancrazius, and other saints hard-by.[2] But the best part of this work, and indeed the only part of it which is really good, is the predella filled with small figures, divided into eight scenes dealing with the Madonna and St. Reparata. Subsequently, in a picture for the high altar of S. Maria Novella at Florence, executed for Baron Capelli in 1348, he made a very fair group of angels dancing about a Coronation of the Virgin. Shortly afterwards he painted in fresco a series of subjects from the life of the Virgin in the Pieve of Prato,[3] which had been rebuilt under the direction of Giovanni Pisano in 1312, as has been said above, in the chapel where Our Lady's girdle was deposited, and he did a number of other works in other churches of that same country which is full of very considerable monasteries and convents. In Florence he next painted the arch over the gate of S. Romeo, and in Orto S. Michele did in tempera a Christ disputing with the Doctors in the Temple. At the same time, for the enlargement of the piazza of the Signori, a large number of buildings was pulled down, and notably the church of S. Romolo, which was rebuilt from Agnolo's plans. In the churches of this city many pictures by his hand may be seen, and a quantity of his works may be recognised in the territory. These he produced with great advantage to himself, although he worked rather for the sake of following in the steps of his ancestors than from any inclination of his own; for he had

[1] Carried out by Neri Fioravanti, about 1340.
[2] Now in the Accademia, Florence.
[3] Done about 1367.

devoted all his attention to trading, which proved more advantageous to him, as appeared when his sons, who did not wish to live by painting any longer, devoted themselves entirely to commerce, opening an establishment at Venice in conjunction with their father, who after a certain time abandoned painting altogether, except as an amusement and pastime. By dint of trading and practising his art, Agnolo had amassed very great wealth when he came to die in the sixty-third year of his life, succumbing to a malignant fever which carried him off in a few days. His pupils were Maestro Antonio da Ferrara, who did many fine works in S. Francesco at Urbino and at Città di Castello, and Stefano da Verona,[1] who painted with the greatest perfection in fresco, as may be seen in several places in his native Verona, and at Mantua, where his works are numerous. Among other things he excelled in his beautiful rendering of the expressions of the faces of children, women and old men, as his works show, which were all imitated and copied by that Piero da Perugia, miniature painter, who illuminated all the books in the library of Pope Pius in the Duomo of Siena, and who was a skilful colourist in fresco. Other pupils of Agnolo were Michaele da Milano and his own brother Giovanni, who, in the cloister of S. Spirito, where the arches of Gaddo and Taddeo are, painted the Dispute of Christ with the Doctors in the Temple, the Purification of the Virgin, the Temptation of Christ in the Wilderness, and the Baptism of John, but after having given rise to the highest expectations he died. Cennino di Drea Cennini da Colle of Valdelsa also learned painting from Andrea. He was very fond of his art and wrote a book describing the methods of working in fresco, in tempera, in glue and in gum, and also how to illuminate and all the ways of laying on gold.[2] This book is in the possession of Giuliano, goldsmith of Siena, an excellent master and fond of these arts. The first part of the book deals with the nature of colours, both minerals and earths, as he had learned it of Agnolo his master. As he did not perhaps succeed in painting with perfection, he was at least anxious to know the peculiarities of the colours, the temperas, the glues and of chalks, and what colours one ought to avoid mixing as injurious, and in short many other hints which I need not dilate upon, since all these matters, which he then considered very great secrets, are now universally known. But I must not omit to

[1] i.e. Stefano da Zevio.

[2] Cennino was Agnolo's only real pupil. His *Trattato della Pittura* was first printed in 1821. An English translation exists by Mrs. Herringham under the title *The Book of the Art of Cennino Cennini*.

note that he makes no mention of some earth colours, such as dark terra rossa, cinnabar and some greens in glass, perhaps because they were not in use. In like manner umber, yellow-lake, the smalts in fresco and in oil, and some greens and yellows in glass which the painters of that age lacked, have since been discovered. The end of the treatise deals with mosaics, with the grinding of colours in oil to make red, blue, green and other kinds of grounds, and with mordants for the application of gold, but not at that time for figures. Besides the works which he produced with his master in Florence, there is a Madonna with saints by his hand under the loggia of the hospital of Bonifazio Lupi,[1] of such style and colouring that it has been very well preserved up to the present day.

In the first chapter of his book Cennino says these words in speaking of himself: "I, Cennino di Drea Cennini da Colle of Valdelsa, was instructed in this art for twelve years by Agnolo di Taddeo of Florence, my master, who learned the art of his father, Taddeo, whose godfather was Giotto and who was Giotto's pupil for twenty-four years. This Giotto transmuted the art of painting from Greek into Latin, and modernised it, and it is certain that he possessed it more completely than any one else had ever done." These are Cennino's very words, by which it appears that, as those who translate from Greek into Latin render a very great service to those who do not understand Greek, so Giotto, in transmuting the art of painting from a style which was understood by no one, except perhaps as being extremely rude, into a beautiful, facile and smooth manner, known and understood by all people of taste who possess the slightest judgment, conferred a great benefit upon mankind.

All these pupils of Agnolo did him the greatest credit. He was buried by his sons, to whom he is said to have left the value of 50,000 florins or more, in S. Maria Novella, in the tomb which he had made for himself and his descendants, in the year 1387. The portrait of Agnolo by his own hand may be seen in the Chapel of the Alberti in S. Croce in the scene in which the Emperor Heraclius is bearing the cross; he is painted in profile standing beside a door. He wears a small beard and has a red hood on his head, after the manner of the time. He was not a good draughtsman, judging by some sheets from his hand which are in our book.

[1] The loggia was begun after 1376. It was altered and restored in 1787.

Berna, Painter of Siena
(ob. 1381)

IF the thread of life of those who take pains to excel in some
noble profession was not frequently cut by death in the best
years, there is no doubt that many geniuses would attain the
goal desired by them and by the world. But the short life of
man and the bitterness of the various accidents which inter-
vene on every hand sometimes deprive us too early of such men.
An example of this was poor Berna of Siena, who died while
quite young, although the nature of his works would lead one
to believe that he had lived very long, for he left such excellent
productions that it is probable, had he not died so soon, he would
have become a most excellent and rare artist. Of his works one
may see in Siena, in two chapels of St. Agostino, some small
scenes of figures in fresco, and in the church, on a wall which
has recently been demolished to make chapels there, a scene of
a young man led to execution, of the highest imaginable excel-
lence, the representation of pallor and of the fear of death being
so realistic that it merits the warmest admiration. Beside the
youth is a friar who is consoling him, with excellent gestures,
and in fine the entire scene is executed with such vigour as to
leave no doubt that Berna had penetrated deeply into the
horror of that situation, full of bitter and cold fear, since he
was able to represent it so well with the brush that the actual
event passing before one's eyes could not move one more. In
Cortona, besides many things scattered up and down the city,
he painted the greater part of the vaulting and walls of the
church of S. Margherita where the Zoccolanti friars now are.
From Cortona he proceeded to Arezzo in the year 1369, at the
very time when the Tarlati, formerly lords of Pietramala, had
finished the convent and church of S. Agostino, under the
direction of Moccio, sculptor and architect of Siena. In the
aisles of this building, where many citizens had erected chapels
and tombs for their families, Berna painted in fresco in the
chapel of St. James, some scenes from the life of that saint.
Among these the most remarkable is the story of the cozener
Marino, who through love of gain had contracted his soul to
the devil by a deed executed with his own hand and then
recommended his soul to St. James, begging him to free him
from his promise, whilst a devil shows him the deed and makes
a great disturbance. Berna expresses the emotions of all these

figures with great vigour, especially in the face of Marino, who is divided between his fear and his faith and confidence in St. James to deliver him, although he sees the marvellously ugly devil against him, employing all his eloquence to convince the saint. St. James, after he has brought Marino to a thorough penitence for his sin, and the promise given, delivers him and brings him back to God. According to Lorenzo Ghiberti, Berna reproduced this story in S. Spirito at Florence before it was burned, in a chapel of the Capponi dedicated to St. Nicholas. After these works Berna painted a large Crucifixion in a chapel of the Vescovado of Arezzo for M. Guccio di Vanni Tarlati of Pietramala, with Our Lady at the foot of the cross, St. John the Baptist, St. Francis in a very sad attitude, and St. Michael the Archangel, with such care that he deserves no small praise, especially as it is so well preserved that it might have been done yesterday. At the foot of the cross, lower down, is the portrait of Guccio himself, in armour and kneeling. In the Pieve of the same city he did a number of stories of Our Lady for the chapel of the Paganelli, and there drew from life a portrait of the Blessed Rinieri, a holy man and prophet of that house, who is giving alms to a crowd of poor people surrounding him. Again, in S. Bartolommeo he painted some scenes from the Old Testament and the story of the Magi, and in the church of S. Spirito he did some stories of St. John the Evangelist, drawing his own portrait and those of many of his noble friends of the city in some figures there. When these labours were completed he returned to his native city and did many pictures on wood, both small and great. But he did not remain there long, because he was invited to Florence to decorate the chapel of St. Nicholas in S. Spirito, as mentioned above, which was greatly admired, as well as to do some other things which perished in the unfortunate fire at that church. In the Pieve of S. Gimignano di Valdelsa he did in fresco some scenes from the New Testament. When he was on the point of completing these things he fell to the ground from the scaffolding, suffering such severe injuries that he expired in two days, by which art suffered a greater loss than he, for he passed to a better sphere. The people of S. Gimignano gave him honourable burial in that Pieve, with stately obsequies, having the same regard for him when dead as they had entertained for him while alive, while for many months they were constantly affixing to the tomb epitaphs in the Latin and vulgar tongues, for the people of those parts take a natural delight in *belles lettres*. This then was the

fitting reward of the honourable labours of Berna, that those whom he had honoured with his paintings should celebrate him with their pens.

Giovanni da Asciano, who was a pupil of Berna, completed his work and did some pictures for the hospital of the Scala at Siena. In Florence also he did some things in the old houses of the Medici, by which he acquired a considerable reputation. The works of Berna of Siena were produced about 1381. Besides what we have already said, he was a very facile draughtsman and the first who began to draw animals well, as we see by some sheets by his hand in our book, covered with wild beasts of various parts of the world, so that he merits the highest praise and that his name should be honoured among artists. Another pupil of his was Luca di Tome of Siena, who painted many works in Siena and in all Tuscany, but especially the picture and chapel of the Dragomanni family in S. Domenico at Arezzo. The chapel is in the German style and was very handsomely decorated by that picture and by the frescoes executed there by the skill and talent of Luca of Siena.

Duccio, Painter of Siena
(fl. 1282–1339)

THERE is no doubt that those who invent anything noteworthy occupy the greatest share of the attention of historians. The reason for this is that original inventors are more noticed and excite more wonder, because new things always possess a greater charm than any improvements subsequently introduced to perfect them. For if no one ever made a beginning, there would never be any advance or improvement, and the full achievement of marvellous beauty would never be attained. Accordingly Duccio, a much-esteemed painter of Siena, is worthy to receive the praise of those who have followed him many years after, since in the pavement of the Duomo of Siena he initiated the setting in marble of figures in chiaroscuro, in which modern artists have performed wonders to be seen there in these days. Duccio devoted himself to the imitation of the old style and with perfectly sound judgment gave the correct forms to his figures, which he produced admirably in spite of the difficulties presented by such an art. Imitating the paintings in chiaroscuro, he designed the first part of the pavement with his own hand; and painted a picture in the Duomo which was then put at the

high altar and afterwards removed to make room for the tabernacle of the Body of Christ which is now seen there.[1] According to Lorenzo di Bartolo Ghiberti, this picture was a Coronation of Our Lady, very much in the Byzantine style, though mingled with much that is modern. It was painted on both sides, as the altar stood out by itself, and on the back Duccio had with great care painted all the principal incidents of the New Testament in some very fine small figures. I have endeavoured to discover the whereabouts of the picture at the present time, but although I have taken the utmost pains in the search, I have not succeeded in finding it or of learning what Francesco di Giorgio the sculptor did with it, when he restored the tabernacle in bronze as well as the marble ornaments there. At Siena Duccio did many pictures on a gold ground and an Annunciation for S. Trinità, Florence. He afterwards painted many things at Pisa, Lucca and Pistoia for different churches, which were all much admired and brought him much reputation and profit. The place of his death is not known, nor are we aware what relations, pupils or property he left. It is enough that he left to art the inheritance of his invention of chiaroscuro representation in marble, for which he is worthy of the highest commendation and praise. He may safely be enumerated among the benefactors who have increased the dignity and beauty of our craft, and those who pursue investigations into the difficulties of rare inventions deserve a special place in our remembrance for this cause apart from their marvellous productions.

It is said at Siena that in 1348 Duccio designed the chapel which is on the piazza in front of the principal palace. It is also recorded that another native of Siena, called Moccio, flourished at the same time. He was a fair sculptor and architect and did many works in every part of Tuscany, but chiefly at Arezzo in the Church of S. Domenico, where he made a marble tomb for one of the Cerchi. This tomb supports and decorates the organ of that church, and if some object that it is not a work of high excellence, I reply that it must be considered a very fair production seeing that Moccio made it in the year 1356 while quite a youth. He was employed on the work of S. Maria del Fiore as under-architect and as sculptor, doing some things in marble for that structure. In Arezzo he rebuilt the church of S. Agostino,

[1] Painted 1308–11. It was installed in pomp in the latter year, but removed in 1506 to make room for a bronze tabernacle by Vecchietta. It is now in the Opera of the Duomo. Portions of the predella are in the National Gallery, London, the Berlin Gallery, and in private possession.

which was small, in its present form, the expense being borne by the heirs of Piero Saccone de' Tarlati, who had provided for this before his death at Bibbiena in the territory of Casentino. As Moccio constructed this church without vaulting, and imposed the burden of the roof on the arcading of the columns, he ran a risk, for the enterprise was indeed too bold. He also built the church and convent of S. Antonio, which were at the Faenza gate before the siege of Florence, and are now entirely in ruins. In sculpture he decorated the gate of S. Agostino at Ancona with many figures and ornaments resembling those at the gate of S. Francesco in the same city. In this church of S. Agostino he also made the tomb of Frà Zenone Vigilanti, bishop and general of the order of St. Augustine, and finally the loggia of the merchants in that city, which has from time to time received, for one cause and another, many improvements in modern style and ornamentation of various descriptions. All these things, although very much below the general level of excellence of to-day, received high praise then owing to the state of information of the time. But to return to Duccio, his works were executed about the year of grace 1350.

ANTONIO, Painter of Venice
(1309–1383)

THERE are many men who, through being persecuted by the envy and oppressed by the tyranny of their fellow-citizens, have left their native place and have chosen for a home some spot where their worth has been recognised and rewarded, producing their works there and taking the greatest pains to excel, in order, in a sense, to be avenged on those by whom they have been outraged. In this way they frequently become great men, whereas had they remained quietly at home they might possibly have achieved little more than mediocrity in their art. Antonio of Venice, who went to Florence, in the train of Agnolo Gaddi, to learn painting, so far acquired the proper methods that not only was he esteemed and loved by the Florentines, but made much of for this talent and for his other good qualities. Then, becoming possessed by a desire to return to his native city and enjoy the fruits of his labours, he went back to Venice. There, having made himself known by many things done in fresco and tempera, he was commissioned by the Signoria to paint one of the walls of the Council Chamber, a work which

he executed with such skill and majesty that its merits should have brought him honours and rewards; but the rivalry, or rather the envy, of the other artists, together with the preference accorded by some noblemen to other and alien painters, brought about a different result. Hence poor Antonio, feeling himself repelled and rebutted, thought it would be as well to go back to Florence, deciding that he would never again return to Venice, but would make Florence his home altogether. Established accordingly in that city, he painted in an arch in the cloister of S. Spirito the calling of Peter and Andrew from their nets, with Zebedee and his sons. Under the three arches of Stefano he painted the miracle of the loaves and fishes, exhibiting great diligence and love, as may be seen in the figure of Christ Himself, whose face and aspect betray His compassion for the crowd and the ardent charity which leads Him to distribute the bread. The same scene also shows very beautifully the affection of an Apostle, who is very active in distributing the bread from a basket. The picture affords a good illustration of the value in art of always painting figures so that they appear to speak, for otherwise they are not prized. Antonio showed this on the outside wall in a small representation of the Fall of the Manna, executed with such skill and finished with such grace that it may truly be called excellent. He next did some stories of St. Stephen in the predella of the high altar of S. Stefano at the Ponte Vecchio, with so much loving care that even in illuminations it would not be possible to find more graceful or more delicate work. Again he painted the tympanum over the door of S. Antonio on the Carraia bridge. This and the church were both pulled down in our own day by Monsignor Ricasoli, bishop of Pistoia, because they spoiled the view from his houses, and in any case, even if he had not done so, we should have been deprived of the work, for, as I have said elsewhere, the flood of 1557 carried away two arches on this side, as well as that part of the bridge on which the little church of S. Antonio was situated. After these works Antonio was invited to Pisa by the wardens of the Campo Santo, and there continued the series dealing with the life of St. Ranieri, a holy man of that city, which had been begun by Simone of Siena and under his direction.[1] In the first part of Antonio's portion of the work is a representation of the embarkation of Ranieri to return to Pisa, with a goodly number of figures carefully finished, including the portrait of Count Gaddo, who had died ten years before,

[1] 1384-6.

and of Neri, his uncle, who had been lord of Pisa.[1] Another
notable figure in the group is that of a man possessed, with the
face of a madman, distorted, convulsive gestures, his eyes
glistening, and his mouth grinning and showing his teeth, so
remarkably like a person really possessed that nothing more
true or life-like can be imagined. The next picture contains
three figures, lost in wonder at seeing St. Ranieri reveal the
devil in the form of a cat on a tub to a fat innkeeper, who
looks like a boon companion, and who is commending him-
self fearfully to the saint; these figures may be called really
lovely from the excellence of their attitudes, the style of the
draperies, the variety in the heads, and all other particulars.
Hard-by are the women of the innkeeper, who could not
possibly be represented with more grace, as Antonio has
made them with the costumes and styles suitable to maid-
servants at an inn, so that nothing better can be imagined.
Nothing of this artist gives more pleasure than the wall con-
taining another scene from the same series in which the canons
of the Duomo of Pisa, in the fine robes of the time, very different
from those in use to-day and very graceful, receive St. Ranieri
at table, all the figures being made with great care. The next of
his scenes is the death of the saint, containing fine represen-
tations not only of the effect of weeping, but of the movements
of certain angels who are carrying his soul to heaven surrounded
by a brilliant light, done with fine originality. In the scene where
the saint's body is being carried by the clergy to the Duomo
one can but marvel at the representation of the priests singing,
for in their gestures, carriage and all their movements in their
various parts they exactly resemble a choir of singers. This
scene is said to contain a portrait of the Bavarian.[2] Antonio
likewise painted with the greatest care the miracles wrought
by Ranieri when he was being carried to burial, and those
wrought in another place, after his body had been deposited
in the Duomo, such as blind who receive their sight, withered
men who recover the use of their limbs, demoniacs who are
released, and other miracles represented with great vigour.
But one of the most remarkable figures of all is a dropsical
man, whose withered face, dry lips and swollen body exhibit
with as much realism as a living man could the devouring
thirst of those suffering from dropsy, and the other symptoms

[1] Count Gaddo Gherardesca, who died 1320. Neri is an abridgement
of Ranieri.
[2] Louis of Bavaria, the Emperor who died in 1347.
 *G 784

of that disease. Another marvellous thing for the time in this work is a ship delivered by the saint after it had undergone various mishaps. It contains an excellent representation of the activity of the mariners, comprising everything that is usually done in such emergencies. Some are casting into the greedy sea without a thought the valuable merchandise won with so much toil, some are running to preserve the ship, which is splitting, and in short performing all the other duties of seamen which it would take too long to tell. Suffice it to say that all are executed with remarkable vigour, and in a fine style. In the same place, beneath the lives of the Holy Fathers painted by Pietro Laurati of Siena, Antonio did the body of the Blessed Oliver and the Abbot Paphnuce, and many circumstances of their lives, represented on a marble sarcophagus, the figure being very well painted. In short, all the works of Antonio in the Campo Santo are such that they are universally considered, and with good cause, to be the best of the entire series of works produced there by many excellent masters at various times. In addition to the particulars already mentioned, Antonio did everything in fresco, and never retouched anything *a secco*.[1] This is the reason why his colours have remained so fresh to the present day, and this should teach artists to recognise the injury that is done to pictures and works by retouching *a secco* with other colours things done in fresco, as the treatises state, for it is an established fact that this retouching ages the painting, and the new colours which have no body of their own will not stand the test of time, being tempered with gum-dragon, egg, size, or some such thing which varnishes what is beneath it, and it does not permit the lapse of time and the air to purify what has been actually painted in fresco upon the soft stucco, as they would do had not other colours been superimposed after the drying. Upon the completion of this truly admirable work Antonio was worthily rewarded by the Pisans, who always entertained a great affection for him. He then returned to Florence, where he painted at Nuovoli outside the gate leading to Prato, in a tabernacle for Giovanni degli Agli, a dead Christ, with a quantity of figures, the story of the Magi, and the Last Judgment, all very fine. Invited next to the Certosa, he painted for the Acciaiuoli, who built that place, the picture of the high altar, which survived to our own day, when it was consumed by fire through the carelessness of a sacristan of the monastery, who left the censer hung at the altar

[1] Fresco painting in secco is that kind which absorbs the colours into the plaster and gives them a dry sunken appearance.—*Fairholt*.

full of fire, which led to the picture being burnt. It was afterwards made entirely of marble by the monks, as it is now. In the same place this same master did a very fine Transfiguration in fresco on a cupboard in the chapel. Being much inclined by nature to the study of herbs, he devoted himself to the mastery of Dioscorides, taking pleasure in learning the properties and virtues of each plant, so that he ultimately abandoned painting and devoted himself to distilling simples with great assiduity. Having thus transformed himself from a painter into a physician, he pursued the latter profession for some time. At length he fell sick of a disorder of the stomach, as some say, through treating the plague, and finished the course of his life at the age of seventy-four in the year 1384, when the plague was raging in Florence. His skill as a physician equalled his diligence as a painter, for he gained an extensive experience in medicine from those who had employed him in their need, and he left behind him a high reputation in both professions. Antonio was a very graceful designer with the pen, and so excellent in chiaroscuro that some sheets of his in our book, in which he did the arch of S. Spirito, are the best of the age. Gherardo Starnini of Florence was a pupil of Antonio, and closely imitated him, while another pupil of his, Paolo Uccello, brought him no small credit. The portrait of Antonio of Venice by his own hand is in the Campo Santo at Pisa.

JACOPO DI CASENTINO, Painter
(1310–1380)

As the fame and renown of the paintings of Giotto and his pupils had been spread abroad for many years, many who were desirous of obtaining fame and riches by means of the art of painting, animated by the hope of glory, and by natural inclination, began to make progress towards the improvement of the art, feeling confident that, with practice, they would be able to surpass in excellence Giotto, Taddeo and the other painters. Among these was one Jacopo di Casentino, who was born, as we read, of the family of M. Cristoforo Landino of Pratovecchio, and was associated by a friar of Casentino, then superior at the Sasso della Vernia, with Taddeo Gaddi, while he was working in that convent, in order that he might learn design and colour. In a few years he so far succeeded that, being taken to Florence in the company of Giovanni da Milano, in the service

of their master, Taddeo, where they were doing a number of things, he was asked to paint in tempera the tabernacle of the Madonna of the Old Market, with the picture there, and also the one on the Via del Cocomoro side of the Piazza S. Niccolo. A few years ago both of these were restored by a very inferior master to Jacopo. For the dyers he did the one at S. Nofri, on the side of their garden wall, opposite S. Giuseppe. While the vaulting of Orsanmichele, upon its twelve pillars, was being completed, and covered with a low, rough roof, awaiting the completion of the building of the palace, which was to be the granary of the commune, the painting of these vaults was entrusted to Jacopo di Casentino, as a very skilled artist. Here he painted some prophets and the patriarchs, with the heads of the tribes, sixteen figures in all, on an ultramarine ground, now much damaged, without other ornamentation. He next did the lower walls and pilasters with many miracles of Our Lady, and other things which may be recognised by their style. This done, he returned to Casentino, and, after painting many works in Pratovecchio, Poppi, and other places of that valley, he proceeded to Arezzo, which then governed itself with a council of sixty of the richest and most honoured citizens, to whom all the affairs of the state were entrusted. Here, in the principal chapel of the Vescovado, he painted a story of St. Martin, and a good number of pictures in the old Duomo, now pulled down, including a portrait of Pope Innocent VI. in the principal chapel. He next did the wall where the high altar is, and the chapel of S. Maria della Neve, in the church of S. Bartolommeo, for the chapter of the canons of the Pieve; and for the old brotherhood of S. Giovanni de' Peducci he did a number of scenes from the life of that saint, which are now whitewashed over. He also did the chapel of St. Christopher in the church of S. Domenico, introducing a portrait of the Blessed Masuolo releasing from prison a merchant of the Fei family, who built the chapel. This saint was a prophet in his day and predicted many misfortunes for the Aretines. In the church of S. Agostino, Jacopo did some stories of St. Laurence in fresco in the chapel and at the altar of the Nardi with marvellous style and skill. Since he also practised architecture, he was employed by the sixty chief citizens mentioned above to bring under the walls of Arezzo the water which comes from the slopes of Pori, 300 braccia from the city. In the time of the Romans this water had been originally brought to the theatre, traces of which still exist, and thence from its situation on the hill where the fortress now is, to the amphitheatre of the city

in the plain, the buildings and conduits of this being afterwards entirely destroyed by the Goths. Thus after Jacopo had, as I have said, brought the water under the wall, he made the fountain, then known as the Fonte Guizianelli, but is now called by corruption Fonte Viniziana. It remained standing from that time, that is 1354, until 1527, but no longer, because the plague of the following year, and the war which followed, deprived it of many of its advantages for the use of the gardens, particularly as Jacopo did not bring it inside, and for these reasons it is not standing to-day, as it should be.

Whilst Jacopo was engaged in bringing water to the city he did not abandon his painting, and in the palace which was in the old citadel, destroyed in our day, he did many scenes of the deeds of the Bishop Guido and of Piero Sacconi, who had done great and notable things for the city both in peace and war. He also did the story of St. Matthew under the organ in the Pieve, and a considerable number of other works. By these paintings, which he did in every part of the city, he taught Spinello of Arezzo the first principles of that art which he himself had learned from Agnolo, and which Spinello afterwards taught to Bernardo Daddi,[1] who worked in the city and adorned it with many fine paintings which, united to his other excellent qualities, brought him much honour among his fellow-citizens, who employed him a great deal in magistracies and other public affairs. The paintings of Bernardo were numerous and highly valued, first in S. Croce, the chapels of St. Laurence and of St. Stephen of the Pulci and Berardi, and many other paintings in various other parts of that church. At length, after he had painted some pictures on the inside of the gates of the city of Florence, he died, full of years, and was buried honourably in S. Felicita in the year 1380.

To return to Jacopo. In his time, in the year 1350, was founded the company and brotherhood of the painters. For the masters who then flourished, both those who practised the old Byzantine style and those who followed the new school of Cimabue, seeing that they were numerous, and that the art of design had been revived in Tuscany and in their own Florence, created this society under the name and protection of St. Luke the Evangelist, to render praise and thanks to God in the sanctuary of that saint, to meet together from time to time, remembering the welfare of their souls as well as of the bodies of those who might be in need of assistance at various times. This is still the practice

[1] Fl. 1317–49.

of many of the arts in Florence, but it was much more common in former times. Their first sanctuary was the principal chapel of the hospital of S. Maria Nuova, which was granted them by the family of the Portinari. The first governors of the company were six in number, with the title of captains, and in addition there were two councillors and two chamberlains. This may be seen in the old book of the company begun then, the first chapter of which opens thus:

"These articles and regulations were agreed upon and drawn up by the good and discreet men of the art of the Painters of Florence, and in the time of Lapo Gucci, painter; Vanni Cinuzzi, painter; Corsino Buonaiuti, painter; Pasquino Cenni, painter; Segnia d'Antignano, painter. The councillors were Bernardo Daddi and Jacopo di Casentino, painters: Consiglio Gherardi and Domenico Pucci, painters, the chamberlains."

The company being thus formed by the consent of the captains and others, Jacopo di Casentino painted the picture of their chapel, representing St. Luke drawing a picture of Our Lady, and in the predella, all the men of the company kneeling on one side and all the women on the other. From this beginning, whether they meet or no, the company has existed continuously from this time and has recently been remodelled, as is related in the new articles of the company approved by the Most Illustrious Lord, Duke Cosimo, the most gracious protector of these arts of design.

At length Jacopo, overwhelmed with years and toil, returned to Casentino and died there at Prato Vecchio, at the age of eighty. He was buried by his relations and friends in S. Agnolo, an abbey of the Camaldoline order, outside Prato Vecchio. Spinello introduced his portrait into a picture of the Magi in the old Duomo, and his style of draughtsmanship may be seen in our book.

SPINELLO, Painter of Arezzo
(1333-1410)

UPON one of the occasions when the Ghibellines were driven from Florence, Luca Spinelli, who had gone to live at Arezzo, had a son born to him there, to whom he gave the name of Spinello. This boy had so much natural inclination to be a painter that, almost without a master and while still quite a child, he knew more than many who have practised under the

best teachers, and, what is more, he contracted a friendship with Jacopo di Casentino while the latter was working at Arezzo, and learned something from him, so much so indeed that before he was twenty years of age he was a far better master, young as he was, than Jacopo, who was already an old man. Spinello's early reputation as a good painter induced M. Dardano Acciaiuoli to employ him to decorate the church of S. Niccolo by the Pope's hall, which he had just erected, behind S. Maria Novella in the via della Scala, and there buried a brother who was a bishop. Here Spinello painted scenes from the life of St. Nicholas, bishop of Bari, in fresco, completing the work in 1334 after two years of unremitting labour.[1] In it he exhibited equal excellence as a colourist and as a designer, so that the colours remained in excellent preservation up to our own day, and the excellence of the figures displayed until a few years ago, when they were in great part damaged by a fire which unfortunately broke out in the church at a time when it happened to be full of straw, brought there by some indiscreet persons who made use of the building as a barn for the storage of straw. The fame of the work induced M. Barone Capelli, citizen of Florence, to employ Spinello to paint in the principal chapel of S. Maria Maggiore[2] a number of stories of the Madonna in fresco, and some of St. Anthony the abbot, and near them the consecration of that very ancient church by Pope Paschal II. Spinello did all this so well that it looks as if it had all been the work of a single day and not of many months, as was actually the case. Near the Pope is the portrait of M. Barone from life, in the dress of the time, excellently done and with good judgment. On the completion of this Spinello worked in the church of the Carmine in fresco, doing the chapel of St. James and St. John, the Apostles,[3] where, among other things, he has given a very careful representation of the request made of Christ by the wife of Zebedee and mother of James, that her sons should sit the one on the right and the other on the left of the Father in the kingdom of heaven. A little farther on one sees Zebedee, James and John leaving their nets and following Christ, done with wonderful vigour and style. In another chapel of the same church, beside the principal one, Spinello also did in fresco some stories of the Madonna and the Apostles, their miraculous appearance to her before her death, her death and her being

[1] The chapel was built in 1334 and painted in 1405.
[2] These paintings are not by Spinello, but by his son Filippo.
[3] The chapel was destroyed by fire in 1771, but heads of Apostles are in the National Gallery.

carried to heaven by angels. As the scene was on a large scale, and the chapel, being a very small one of not more than ten braccia in length and five in height, would not take it all, especially in the case of the Assumption of Our Lady, Spinello very judiciously continued the scene to the vaulting on one of the sides at the place where Christ and the angels are receiving her. In a chapel of S. Trinità, Spinello made a very fine Annunciation, and for the high-altar picture of the church of S. Apostolo he painted in tempera the Descent of the Holy Spirit upon the Apostles in tongues of fire. In S. Lucia de' Bardi he also painted a small panel and did a larger one for the chapel of St. John the Baptist, decorated by Giotto.

After these things, and on account of the great reputation which his labours in Florence had procured for him, Spinello was recalled to Arezzo by the sixty citizens who governed it, and was commissioned by the commune to paint the story of the Magi in the old Duomo outside the city, and in the chapel of S. Gismondo a St. Donato, who, by means of a benediction, causes a serpent to burst. Similarly he made various figures on many pilasters of that Duomo, and on a wall he did a Magdalene in the house of Simon anointing Christ's feet, with other paintings which there is no need to mention, since that church is now entirely destroyed, though it was then full of tombs, the bones of saints and other notable things. But in order that the memory of it may at least remain, I will remark that it was built by the Aretines more than thirteen hundred years ago,[1] at the time when they were first converted to the faith of Jesus Christ by St. Donato, who afterwards became bishop of the city. It was dedicated to him, and richly adorned both within and without with very ancient spoils of antiquity. The ground plan of the church, which is discussed at length elsewhere, was divided on the outside into sixteen faces, and on the inside into eight, and all were full of the spoils of those times which had originally been dedicated to idols; in short, it was, at the time of its destruction, as beautiful as such a very ancient church could possibly be. After the numerous paintings which he had done in the Duomo, Spinello painted for the Chapel of the Marsupini, in S. Francesco, Pope Honorius confirming and approving the rule of that saint, introducing a portrait of Innocent IV., wherever he may have obtained it. In the chapel of St. Michael the Archangel, in the same church in which the bells are rung, he painted many scenes relating to him; and

[1] It was built in the eleventh century.

rather lower down, in the chapel of M. Giuliano Baccio, he did an Annunciation, with other figures, which are much admired. The whole of these works in this church were done in fresco with great boldness and skill between the years 1334 and 1338.[1] In the Pieve of the same city he afterwards painted the chapel of SS. Peter and Paul, and below it that of St. Michael the Archangel; for the fraternity of S. Maria della Misericordia he did the chapel of SS. James and Philip; and over the principal door of the fraternity, which is on the piazza, that is to say, in the tympanum, he painted a Pieta, with a St. John, at the request of the rectors of the fraternity. The foundation of the brotherhood took place in this way. A certain number of good and honourable citizens began to go about asking alms for the poor who were ashamed to beg, and to succour them in all their necessities, in the year of the plague of 1348. The fraternity acquired a great reputation, by means of the efforts of these good men, in helping the poor and infirm, burying the dead, and performing other kindred acts of charity, so that the bequests, donations and inheritances left to them became so considerable that they amounted to one-third of the entire wealth of Arezzo. The same happened in 1383, which was also a year of severe plague. Spinello, then being of the company, often had occasion to visit the infirm, bury the dead, and perform other like pious duties which the best citizens have always undertaken and still do in that city. In order to leave a memorial of this in his paintings, he painted for the company, on the wall of the church of S. Laurentino and Pergentino, a Madonna with her mantle open in front, and beneath her the people of Arezzo, comprising portraits of many of the earliest members of the fraternity, drawn from life, with wallets round their necks and a wooden hammer in their hands, like those with which they knocked at the doors to ask alms. Similarly, in the company of the Annunciation he painted the large tabernacle outside the church, and part of a portico opposite it, and the picture of the company, which is an Annunciation, in tempera. The picture, which is now in the church of the nuns of S. Giusto, where a little Christ, who is at His mother's neck, is espousing St. Catherine, with six small scenes in little figures of the acts of that saint, is also a work of Spinello and much admired. Being afterwards invited to the famous abbey of Camaldoli in Casentino in the year 1361, he painted for the hermits of that place the picture of the high altar, which was taken away in

[1] These dates are impossible. The work belongs to Spinello's last years.

the year 1539, when the reconstruction of the entire church
was completed and Giorgio Vasari did a new picture, painting
the principal chapel of the abbey all in fresco, the transept of
the church in fresco and two pictures. Summoned thence to
Florence by D. Jacopo d'Arezzo, abbot of S. Miniato in Monte
of the order of Monte Oliveto, Spinello painted the vaulting
and four walls of the sacristy of that monastery,[1] besides the
picture of the altar, all in tempera, with many stories of the
life of St. Benedict, executed with much skill and a great vivacity
in the colouring, learned by him by means of long practice and
continual labour, with study and diligence, such as are necessary
to everyone who wishes to acquire an art perfectly. After these
things the said abbot left Florence and received the direction
of the monastery of S. Bernardo of the same order, in his native
land, at the very time when it was almost entirely completed
on the land granted by the Aretines, on the site of the Colosseum.
Here the abbot induced Spinello to paint in fresco two chapels
which are beside the principal chapel, and two others, one
on either side of the door leading to the choir in the
transept of the church. In one of the two, next the principal
chapel, is an Annunciation in fresco, made with the greatest
diligence, and on a wall beside it is the Madonna ascending
the steps of the Temple, accompanied by Joachim and Anna;
in the other chapel is a crucifix with the Madonna and St. John
weeping, and a St. Bernard adoring on his knees. On the inner
wall of the church, where the altar of Our Lady stands, he painted
the Virgin with the Child at her neck, which was considered a
very beautiful figure, and did many other things for the church,
painting above the choir Our Lady, St. Mary Magdalene and
St. Bernard very vigorously. In the Pieve of Arezzo, in the
chapel of St. Bartholomew, he did a number of scenes from the
life of that saint, and on the opposite side of the church, in the
chapel of St. Matthew, under the organ, which was painted by
his master Jacopo di Casentino, besides many stories of that
saint, which are meritorious, he did in the vaulting the four
Evangelists in some medallions, in an original style, for above
the bust and human limbs he gave St. John the head of an eagle,
St. Mark the head of a lion, St. Luke that of an ox, while only
St. Matthew has a human face, that is to say an angel's. Out-
side Arezzo he decorated the church of S. Stefano, built by the
Aretines upon many columns of granite and marble, to honour
and preserve the names of several martyrs who were put to

[1] About 1387.

death there by Julian the Apostate. Here he did a number of
figures and scenes with great finish and such a style of colouring
that they were in a wonderfully fresh state of preservation
when they were destroyed not many years ago. But the really
remarkable piece of work in that place, besides the stories of
St. Stephen, in figures larger than life-size, is the sight of Joseph,
in the story of the Magi, beside himself with joy at the coming
of those kings, and keenly watching the kings as they are
opening the vessels of their treasures and are offering them to
him. In the same church is a Madonna offering a rose to the
little Christ-child, which was and is considered a most beautiful
figure, and so highly reverenced by the Aretines that, when the
church of S. Stefano was pulled down, without sparing either
pains or expense, they cut it out of the wall, ingeniously re-
moved it and carried it into the city, depositing it in a small
church in order to honour it, as they do, with the same devotion
which they bestowed upon it at first. There is no wonder that
the work inspired such reverence, for it is a natural characteristic
of Spinello to endow his figures with a certain simple grace,
partaking of modesty and holiness, so that his saints and par-
ticularly his Virgins breathe an indefinable sanctity and divinity
which inspire men with the utmost devotion. This may be seen
also in a Madonna which is at the corner of the Albergetti, in one
on an outside wall of the Pieve in Seteria, and in another of the
same kind on the side of the canal. By Spinello's hand also is
the Descent of the Holy Spirit on the Apostles, on the wall of
the hospital of S. Spirito, which is very fine, as are the two
scenes below representing SS. Cosmo and Damian cutting a
healthy leg off a dead Moor to attach it to a man whose broken
limb they have removed. In like manner the *Noli me tangere*
between these two works is very beautiful. In a chapel of the
company of the Puracciuoli on the piazza of S. Agostino he did
a very finely coloured Annunciation, and in the cloister of that
convent he painted a Madonna in fresco with St. James and
St. Anthony and the portrait of an armed soldier kneeling there,
with these words: *Hoc opus fecit fieri Clemens Pucci de Monte
Catino, cujus corpus jacet hic, etc. Anno Domini* 1367 *die* 15
mensis Maii. The representations in the chapel of that church
of St. Anthony and other saints are known by their style to be
by Spinello's hand, and he afterwards painted the whole of a
portico in the hospital of S. Marco, now the monastery of the
nuns of S. Croce, as their original house, which was outside, was
pulled down. The figure of St. Gregory the Pope, among the many

represented in this work, standing beside a Misericordia, is a portrait of Pope Gregory IX. The chapel of SS. Philip and James at the entry into the church of S. Domenico in the same city was done in fresco by Spinello in a fine and vigorouss tyle, as was also a three-quarter length figure of St. Anthony, painted on the wall of the church, which is so fine that it apes life. It is placed in the midst of four scenes from his life, and these and many other scenes of the life of St. Anthony, also by Spinello's hand, are in the chapel of St. Anthony, in the church of S. Giustino. On one side of the church of S. Lorenzo he painted some stories of the Madonna, and outside the church he painted her seated, doing the work very gracefully in fresco. In a small hospital opposite of the nuns of S. Spirito, near the gate on the road to Rome, the whole of the portico is painted by his hand with a representation of the dead Christ in the lap of the Maries, executed with so much skill and judgment that it proves him to have equalled Giotto in the matter of design and to have far surpassed him as a colourist. In the same place he has represented Christ seated, with a very ingenious theological signification, having placed the Trinity inside a sun so that the same rays and the same glory issue from each of the three figures. But the same fate has befallen this work as has happened to many others, to the infinite loss of the lovers of this art, for it was pulled down to make way for the fortifications of the city. At the company of the Trinity may be seen a tabernacle outside the church by Spinello, very finely done in fresco, comprising the Trinity, St. Peter and SS. Cosmo and Damian dressed in the robes habitually worn by the physicians of the time.

During the production of these works D. Jacopo d'Arezzo was appointed general of the congregation of Monte Oliveto, nineteen years after he had employed Spinello to do a number of things at Florence and at Arezzo, as has been said above. Being stationed according to the custom of the order, at Monte Oliveto the greater of Chiusuri in the Siena district, as being the principal house of that body, he conceived a longing to have a beautiful picture made in that place. Accordingly he sent for Spinello, remembering how well he had been served upon other occasions, and induced him to do the picture for the principal chapel.[1] Here Spinello produced a large number of figures in tempera, both small and great, on a gold ground, with great judgment, and afterwards caused these to be framed in an ornament in half-relief by Simone Cini of Florence, while in some parts he put an

[1] Painted about 1385, a portion is in the Accademia, Florence.

additional ornament with stucco of a rather firm glue, which proved very successful. It was gilded all over by Gabriello Saracini, who wrote at the bottom the three names: Simon Cini of Florence did the carving, Gabriello Saracini the gilding, and Spinello di Luca of Arezzo the painting, in the year 1385.

On the completion of this work Spinello returned to Arezzo, having received numerous favours from the general and other monks, besides his payment. But he did not remain long there, for the city was in disorder owing to the feuds of the Guelph and Ghibelline parties and was just then sacked.[1] He removed with his family and his son Parri, who was learning painting, to Florence, where he had a goodly number of friends and relations. In that city, in order to pass the time, he painted an Annunciation in a tabernacle outside the gate at S. Piero Gattolini on the Roman road, where the way branches to Pozzolatico, a work which is now half destroyed, and other pictures in another tabernacle, where the hostelry of Galluzzo is. Being afterwards invited to Pisa to finish in the Campo Santo beneath the life of St. Ranieri the remainder of other subjects in a blank space, in order to unite them to the scenes painted by Giotto, Simone of Siena and Antonio of Venice, he there executed in fresco six stories of St. Petitus and St. Epirus.[2] The first represents the saint as a young man, presented by his mother to the Emperor Diocletian, and appointed general of the armies which were to march against the Christians. As he is riding with his troop Christ appears to him, and showing him a white cross commands the youth not to persecute Him. Another scene represents the angel of the Lord giving to the saint, while he is riding, the banner of the Faith, with a white cross on a red field, which has ever afterwards constituted the arms of the Pisans, because St. Epirus had besought God to give him a sign to wear against the enemy. Next to this is another scene of a fierce battle engaged between the saint and the pagans, many armed angels fighting for the victory of the former. Here Spinello produced many things worthy of consideration in that day when art had not yet the ability nor any good method of expressing the ideas of the mind in colour in a lively manner. Among many other things in this composition are two soldiers who have seized each other by the beard, and are endeavouring to kill each other with the naked swords which they hold in their disengaged hands; their faces and all the movement of their

[1] In 1384. [2] Correctly, SS. Ephysius and Politus; painted 1390-2.

limbs show the desire of victory, their proud spirits being without fear and of the highest courage. Also among those who are fighting on horseback there is a finely executed knight who is pinning the head of an enemy to the earth with his lance, the other having fallen backward from his terrified horse. Another scene shows the saint presented to the Emperor Diocletian, who is questioning him about the Faith, and who afterwards consigns him to the torture, putting him in a furnace in which he remains uninjured, whilst the servants who are active on every side are burned in his stead. In short, all the acts of the saint are shown, to his beheading, after which his soul is carried to heaven. The last scene shows the transportation of the bones and relics of St. Petitus from Alexandria to Pisa. The whole work in its colouring and conception is the finest, most finished and best executed of Spinello's paintings, and this is shown by its present excellent state of preservation, for its fresh appearance excites the wonder of everyone who sees it. When this work in the Campo Santo was completed, Spinello painted in the church of S. Francesco, in the second chapel from the high altar, many stories of St. Bartholomew, St. Andrew, St. James and St. John the Apostles, and he might perhaps have remained longer at work in Pisa, because his paintings were admired and rewarded there, but seeing the city thrown into an uproar and turned upside down through the murder of M. Pietro Gambacorti by the Lanfranchini, who were Pisan citizens,[1] he once more removed to Florence with all his family, for he was by this time an old man. He remained there for one year only, and in the Chapel of the Macchiavelli in S. Croce, dedicated to SS. Philip and James, he did many stories of the life and death of those saints. The picture of the chapel he did at Arezzo, and sent it on from there in the year 1400, for he was anxious to return to his native place, or, to speak more correctly, to the place which he looked upon as such. Having thus returned thither at the age of seventy-seven or more, he was lovingly received by his relations and friends, and remained there, much loved and honoured, until the end of his life, which was in the ninety-second year of his age. Although at the time of his return to Arezzo he was quite an old man, and had enough property to enable him to live without working, yet he could not remain idle, since he had always been accustomed to work, and undertook to do some stories of St. Michael for the company of S. Agnolo in that city. These are roughly drawn in red on the

[1] On 21 October, 1392, by Jacopo d'Appiano, not the Lanfranchini.

plastered wall, as was the most ordinary method of the old artists, and as an example he did a single scene in one corner, colouring it entirely, which gave considerable satisfaction. Having afterwards agreed upon the price with the wardens, he completed the entire front of the high altar, representing Lucifer establishing his seat in the north, and the fall of the angels, who change into devils as they rain upon the earth.[1] In the air is St. Michael fighting with the serpent of seven heads and ten horns, and in the middle of the lower part is Lucifer already changed into a hideous monster. It gave Spinello so much satisfaction to make him horrible and distorted that it is said (so great is the power of imagination) that the figure he had painted appeared to him in a dream, and demanded when the artist had seen him so ugly, asking why he did him so great an indignity with his brush. Spinello awoke from his dream speechless from fear, and shook so violently that his wife hastened to assist him. Yet he was in great danger of dying suddenly, through the failure of the heart, owing to this misfortune, and it caused his death a short while afterwards, until which time he lived in an utterly dispirited manner with staring eyes. He died greatly lamented by his friends, and left the world two sons: one called Forzore was a goldsmith, who did some admirable work in *niello* in Florence; the other, Parri, who followed his father and pursued the art of painting, far surpassing Spinello in design. The Aretines were much grieved at this sad chance, although Spinello was old, and at being deprived of ability and excellence such as his. He died at the age of ninety-two, and was buried in S. Agostino at Arezzo, where there is a stone with a coat of arms made after a fancy of his own, containing a hedgehog. Spinello was far better able to design than to put his thoughts into practice, as our book of designs shows, which contains two Evangelists in chiaroscuro and a St. Louis by his hand, all very fine. His portrait given above was taken by me from one which was in the old Duomo before it was pulled down. His paintings were executed between the years 1380 and 1400.

[1] Portions of this work are in the National Gallery.

GHERARDO STARNINA, Painter of Florence [1]
(?1354–?1408)

CERTAINLY those who travel far from home to work in other
parts very frequently do so to the advantage of their tempera-
ment, for, by seeing divers customs abroad, even if they be of
a rather perverse nature, they learn to be reasonable, amiable
and patient with much greater ease than they would have
done had they remained at home. Indeed, those who desire
to refine men in their worldly conversation need look for no
other fire and no better cement than this, because those who are
naturally rough become gentle, and the gentle become even more
gracious. Gherardo di Jacopo Starnina, painter of Florence,
though rather hasty than good-natured, being very hard and
rough in his dealings, did more harm by this to himself than
to his friends, and it would have been even worse for him had
he not remained a long time in Spain, where he learned to be
gentle and courteous, for he there became so changed from his
former nature that, when he returned to Florence, a very large
number of those who had mortally hated him before his depar-
ture received him with very great friendliness and continued to
cherish a great affection for him, so gentle and courteous had
he become. Gherardo was born in Florence in the year 1354,
and as he grew up and was naturally inclined to the art of
designing, he was put with Antonio of Venice to learn to design
and to paint. In the space of many years he not only learned
the art and practice of colours, but had shown his ability by
some things produced in a good style; accordingly he left
Antonio and began to work on his own account. In the Chapel
of the Castellani at S. Croce, which was given to him to paint
by Michaele di Vanni, an honoured citizen of that family, he
did in fresco many stories of St. Anthony the abbot and of
St. Nicholas the bishop, with such diligence and in such a good
style that they attracted the attention of certain Spaniards
then staying in Florence on business, and, what is more, induced
them to take him to Spain to their king, who saw and received
him very gladly, there being at that time a great lack of good
painters in that country. Nor was it a difficult matter to induce
Gherardo to leave his country, for as he had had hard words

[1] No works have survived that can, with any confidence, be attributed
to this master.

with some men after the affair of the Ciompi[1] and the appointment of Michele di Lando as gonfaloniere, he was in considerable danger of his life. Accordingly he went to Spain and did many things for the king there, and became rich and honoured by the great rewards which he earned for his labours.[2] At length, becoming desirous of showing himself to his friends and relations with his improved fortunes, he returned home and was warmly welcomed and received in a very friendly manner by all his fellow-citizens. It was not long before he was employed to paint the chapel of St. Jerome in the Carmine, where he did many stories of that saint, and in the story of Paul, Eustace and Jerome he represented some of the Spanish costumes of the day with very happy invention and an abundance of fashions and ideas in the attitudes of the figures. Among other things, in a scene where St. Jerome is receiving his earliest instruction, he represented a master who has caused one boy to mount upon the back of another and strikes him with the whip in such a manner that the poor child is twisting his legs with pain and appears to be crying out and trying to bite the ear of the boy who is holding him. The whole is executed with much grace and lightness, and Gherardo appears to have delighted in these touches of nature. In like manner, when St. Jerome, being at the point of death, is making his will, he has hit off some friars in a delightful and realistic manner, for some are writing, others listening attentively and looking about, observing all the words of their master with great earnestness. This work won Starnina much fame and a high rank among artists, and his courteous and mild manners gave him a great reputation, so that his name was famous throughout Tuscany and indeed in all Italy. Being at this time invited to Pisa to paint the chapter-house of S. Niccola in that city, he sent in his place Antonio Vite of Pistoia, because he did not wish to leave Florence. Antonio, who had learned Starnina's style under him, did the Passion of Jesus Christ there, completing it as it now appears in the year 1403, to the great delight of the Pisans. Afterwards, it is said, he finished the Chapel of the Pugliesi; and as the works which he did there at S. Girolamo greatly pleased the Florentines, because he had expressed in a lively manner many gestures

[1] The name given to the rising of the esser people in 1378 against the powerful guilds, resulting in a wider distribution of the powers of government. The lower classes won and appointed Michele del Lando as their gonfaloniere. Ciompi means the lowest classes.

[2] It is conjectured that some remains of paintings in a chamber in the Escorial may be his work, done for King John I.

and attitudes which had not been attempted by any painters before his time, the commune of Florence in the year that Gabriel Maria, lord of Pisa,[1] sold that city to the Florentines for 200,000 crowns (after Giovanni Gambacorta had stood a siege of thirteen months, although even he at length agreed to the sale), employed Starnina to paint on a wall of the Palazzo di parte Guelfa, St. Denis the bishop, with two angels, and below it an accurate representation of the city of Pisa. In the execution of this he displayed such diligence in every detail, especially in the colouring in fresco, that, notwithstanding the action of air and water and a northern aspect, the picture has always remained in excellent condition, and has all the appearance of having been newly painted, so that it has always been considered worthy of high praise. Gherardo having by this and other works acquired a great reputation and much renown both at home and abroad, envious death, always the enemy of worthy achievements, cut off at the height of his powers the great promise of much better things than the world had yet seen from him; and having come to his end unexpectedly in the forty-ninth year of his age, he was buried with much pomp in the church of S. Jacopo sopra Arno.

The pupils of Gherardo were Masolino da Panicale, who was at first an excellent goldsmith and then a painter, and some others whom it is not necessary to mention, as they did not possess any remarkable talent.

The portrait of Gherardo occurs in the story of St. Jerome, mentioned above; he is one of the figures who are standing round the dying saint, represented in profile with a hood on his head and a mantle buttoned about him. In our book are some drawings of Gherardo done with the pen on parchment, which are of considerable excellence.

LIPPO, Painter of Florence [2]
(1357–after 1430)

INVENTION has been, and always will be, considered the true mother of architecture, painting and poetry, as well as of all the superior arts and of all the marvels produced by man. It affords great delight to artists and displays for them the fantasies and

[1] Gabriel Maria Visconti in 1406.
[2] Vasari seems to have confused several masters under this common name, which is short for Filippo, i.e. Philip.

caprices of those imaginative minds which discover the infinite variety of things, while the abundant praise bestowed on such novelties acts as an incentive upon all those who are engaged upon noble works, who impart extraordinary beauty to the things they produce, though concealed and veiled, while they sometimes adroitly praise others, sometimes blame them, without making themselves too well understood. Lippo, then, painter of Florence, who was as varied and choice in his inventions as his works were really unfortunate and his life short, was born at Florence about the year of grace 1354; and although he took up the art of painting very late, when he was already grown up, yet he was so far assisted by natural inclination and by his fine talents that he soon distinguished himself brilliantly. He first painted in Florence, and in S. Benedetto, a large and fine monastery outside the Pinti gate belonging to the Camaldoline order, now destroyed, he did a number of figures which were considered very beautiful, particularly the whole of a chapel, which affords an example of how close study quickly leads to great performances in anyone who honestly takes pains, with the desire for fame. Being invited to Arezzo from Florence, he did for the chapel of the Magi in the church of S. Antonio a large scene in fresco in which they are adoring Christ; and in the Vescovado he did the chapel of St. James and St. Christopher for the family of the Ubertini. All these things were very fine, for the invention displayed in the composition of scenes and in the colouring. He was the first who began, as it were, to play with his figures, and to awaken the minds of those who came after him, a thing which had never been done before, only suggested. After he had done many things in Bologna and a meritorious picture at Pistoia, he returned to Florence, where he painted the chapel of the Beccuti in S. Maria Maggiore in the year 1383 with scenes from the life of St. John the Evangelist. Following on from this chapel, which is beside the principal one, on the left-hand, six scenes from the life of this saint are represented along the wall, by the same hand. Their composition is excellent and they are well arranged, one scene in particular being very vivid, namely that in which St. John causes St. Dionisius the Areopagite to put his vest on some dead men, who come to life again in the name of Jesus Christ, to the great wonderment of some who are present who can hardly believe their own eyes. The foreshortening of some of the dead figures shows great art and proves that Lippo was conscious of some of the difficulties of his profession and endeavoured to some extent to overcome them. It was

Lippo also who painted the wings of the tabernacle of the church of S. Giovanni, where are Andrea's angels and his St. John, in relief, doing some stories of St. John the Baptist in tempera, very carefully finished.[1] Being fond also of working in mosaic, he made a beginning in that church over the door leading towards the Misericordia, between the windows, which was considered very beautiful and the best work in mosaic produced in that place up to that time. In the same church he further repaired some mosaics which had been damaged. Outside Florence, in S. Giovanni frà l' Arcora, without the gate leading to Faenza, destroyed during the siege, he painted a number of figures in fresco beside Buffalmacco's Crucifixion, which were considered very beautiful by all who saw them. In certain small hospitals near the Faenza gate and in S. Antonio inside that gate near the hospital he did some poor men, in fresco, in varied styles and attitudes, very beautifully executed, and in the cloister within he made, with beautiful and new invention, the vision of St. Anthony of the deceits of the world, and next to that the desires and appetites of men, who are drawn hither and thither to divers things of this world, the whole of the work being executed with much thought and judgment.[2] Lippo also did mosaic work in many places of Italy, and in the parte Guelfa at Florence he made a figure with a glazed head, while Pisa contains a number of his productions. Yet in spite of all this he must be considered a really unfortunate man, since at the present time the greater part of his works have disappeared, having been destroyed in the siege of Florence, and also because his career was terminated in a very tragic manner; for, being a quarrelsome man and liking turmoil better than quiet, he happened one morning to say some very insulting words to an opponent at the tribunal of the Mercanzia, and that evening, as he was returning home, he was dogged by this man and stabbed in the breast with a knife, so that in a few days he perished miserably. His paintings were produced about 1410.

There flourished at Bologna in Lippo's time another painter whose name was also Lippo Dalmasi,[3] who was a worthy man, and among other things he painted a Madonna in the year 1407, which may still be seen in S. Petronio at Bologna and which is held in great veneration. He also painted in fresco the tympanum above the door of S. Procolo, and in the church of S. Francesco, in the tribune of the high altar, he made a large Christ, half-

[1] The work of Lippo di Benevieni, in 1315.
[2] By Lippo di Corso, born 1357. [3] 1376-1410.

length, and a St. Peter and a St. Paul, in a very graceful style. Under these works may be seen his name written in large letters. He also designed very fairly, as may be seen in our book, and he afterwards taught the art to M. Galante da Bologna, who came to draw much better than he, as may be seen in the same book in a portrait of a figure dressed in a short coat with wide open sleeves.

DON LORENZO, Monk of the Angeli of Florence, Painter (1370–? 1425)

I BELIEVE that it is a great joy to a good and religious person to find some honourable employment for his hands, whether it be letters, music, painting, or other liberal and mechanical arts which involve no reproach but are on the contrary useful and helpful to other men, for after the divine offices the time may be passed with the pleasure taken in the delightful labours of pleasant exercises. To these advantages we may add that not only is such a monk esteemed and valued by others during his lifetime, except by such as are envious and malignant, but he is honoured by all men after his death, for his works and the good name which he has left behind him. Indeed, whoever spends his time in this manner lives in quiet contemplation without any danger from those ambitious stirrings which are almost always to be seen among the idle and slothful, who are usually ignorant, to their shame and hurt. If it should happen that a man of ability acting thus is slandered by the malicious, the power of virtue is such that time will re-establish his reputation and bury the malignity of the evil disposed, while the man of ability will remain distinguished and illustrious in the centuries which succeed. Thus Don Lorenzo, painter of Florence, being a monk of the order of the Camaldolines in the monastery of the Angeli (founded in 1294 by Frà Guittone of Arezzo of the order of the Virgin Mother of Jesus Christ, or of the Rejoicing Friars as the monks of that order were commonly called), devoted so much time in his early years to design and to painting that he was afterwards deservedly numbered among the best men of his age n that profession. The first works of this painter-monk, who adopted the style of Taddeo Gaddi and his school, were in the monastery of the Angeli, where besides many other things he painted the high-altar picture, which may still be seen in their church. When completed it was placed there in the year 1413, as may be seen by the letters written at the bottom of the frame.[1]

[1] Now in the Uffizi.

He also painted a picture for the monastery of S. Benedetto of the same order of the Camaldoli, outside the Pinti gate, destroyed at the siege of Florence in 1529. It represented the Coronation of Our Lady and resembled the one he had previously done for the church of the Angeli. It is now in the first cloister of the monastery of the Angeli, on the right-hand side in the Chapel of the Alberti. At the same time, and possibly before,[2] he painted in fresco the chapel and altar-picture of the Ardinghelli in S. Trinità, Florence, which was then much admired, and into this he introduced portraits of Dante and Petrarch.

In S. Piero Maggiore he painted the Chapel of the Fioravanti and in a chapel of S. Piero Scheraggio he did the altar-picture, while in the church of S. Trinità he further painted the Chapel of the Bartolini. In S. Jacopo sopra Arno a fine picture by his hand may still be seen, executed with infinite diligence, after the manner of the time. Also in the Certosa outside Florence he painted some things with considerable skill, and in S. Michele at Pisa, a monastery of his own order, he did some very fair pictures. In Florence, in the church of the Romiti (Hermits), which also belonged to the Camaldolines, and which is now in ruins as well as the monastery, leaving nothing but its name Camaldoli to that part beyond the Arno, he did a Crucifix on a panel, besides many other things, and a St. John, which were considered very beautiful. At last he fell sick of a cruel abscess, and after lingering for many months he died at the age of fifty-five, and was honourably buried by the monks in the chapter-house of their monastery as his virtues demanded.

Experience shows that in the course of time many shoots frequently spring from a single germ owing to the diligence and ability of men, and so it was in the monastery of the Angeli, where the monks had always paid considerable attention to painting and design. Don Lorenzo was not the only excellent artist among them, but men distinguished in design flourished there for a long time both before and after him. Thus I cannot possibly pass over in silence one Don Jacopo of Florence, who flourished a long time before Don Lorenzo, because as he was the best and most exemplary of monks, so he was the best writer of initial letters who has ever existed before or since, not only in Tuscany but in all Europe, as is clearly testified not only by the twenty large choir books which he left in his monastery, with the most beautiful writing, and the largest perhaps in all Italy, but an endless number of other books which may still be

[2] In 1400.

found in Rome, in Venice and many other places, notably in
S. Michele and S. Mattia at Murano, a monastery of the Camaldo-
line order. By these works the good father has richly deserved
the honours accorded to him many years after he had passed to
a better life, his celebration in many Latin verses by Don Paolo
Orlandini, a very learned monk of the same monastery, as well
as the preservation of the right hand which wrote the books,
with great veneration in a tabernacle, together with that of
another monk, Don Silvestro, who illuminated the same books
with no less excellence, when the conditions of the time are
taken into consideration, than Don Jacopo had written them.
I, who have seen them many times, am lost in astonishment
that they should have been executed with such good design
and with so much diligence at that time, when all the arts of
design were little better than lost, since the works of these
monks were executed about the year of grace 1350, or a little
before or after, as may be seen in each of the said books. It is
reported, and some old men relate, that when Pope Leo X. came
to Florence he wished to see and closely examine these books,
since he remembered having heard them highly praised by the
Magnificent Lorenzo de' Medici, his father; and that after he had
attentively looked through them and admired them as they were
all lying open on the choir-desks, he said, "If they were in
accordance with the rules of the Roman Church and not of the
Camaldolines, we should like some specimens for St. Peter's at
Rome, for which we would pay the monks a just price." There
were, and perhaps still are, two very fine ones at St. Peter's
by the same monks. In the same monastery of the Angeli
is a quantity of very ancient embroidery, done in a very
fine style, with excellent designs by the fathers of the house
while they were in perpetual seclusion, with the title not of
monks but of hermits, and who never came out of the monastery
as the nuns and monks do in our day. This practice of seclusion
lasted until 1470. But to return to Don Lorenzo. He taught
Francesco Fiorentino, who, after his death, did the tabernacle
which is at the corner of S. Maria Novella at the top of the via
della Scala leading to the Hall of the Pope. He also had another
pupil, a Pisan, who painted in the Chapel of Rutilio di Ser Baccio
Maggiolini, in the church of S. Francesco at Pisa, Our Lady, a
St. Peter, St. John the Baptist, St. Francis and St. Ranieri, with
three scenes of small figures in the predella of the altar. This
painting, executed in 1315,[1] was considered meritorious for a

[1] 1415 is the correct date.

work done in tempera. In our book of designs I have the theological virtues done by Don Lorenzo's hand in chiaroscuro, with good design and a beautiful and graceful style, so that they are perhaps better than the designs of any other master of the time. Antonio Vite of Pistoia was a meritorious painter in Lorenzo's time, and is said to have painted, among many other things described in the life of Starnina, in the palace of the Ceppo of Prato, the life of Francesco di Marco, who was the founder of that pious place.

TADDEO BARTOLI, Painter of Siena
(1363–1422)

THOSE artists who put themselves to a great deal of pains in painting in order to win fame deserve a better fate than the placing of their works in obscure and unhonoured places, where they may be blamed by persons whose knowledge of the subject is not considerable. Their productions ought to be so prominently placed with plenty of light and air that they may be properly seen and examined by everyone. This is the case of the public work of Taddeo Bartoli, painter of Siena for the chapel of the palace of the Signoria at Siena. Taddeo was the son of Bartolo, son of the master Fredi, who was a mediocre painter in his day, and painted scenes from the Old Testament on a wall of the Pieve of S. Gimignano, on the left-hand side on entering. In the middle of this work, which if the truth must be told was not very good, the following inscription may still be read: *Ann: Dom.* 1356 *Bartolus magistri Fredi de Senis me pinxit.* Bartolo must have been young at the time, for there is a picture of his of the year 1388, in S. Agostino of the same district, on the left-hand side on entering the principal door. The subject is the Circumcision of Our Lord, with certain saints, and it is in a far better style both as regards design and colouring, some of the heads being really fine, although the feet of the figures are in the ancient style. In fact, many other works of Bartolo may be seen about that district. But to return to Taddeo, as the best master of the time, he received a commission, as I have said, to paint the chapel of the palace of the Signoria for his native place, and he executed it with such diligence,[1] with consideration for so honoured a place, and he was so richly rewarded by the Signoria, that he greatly increased his glory and renown. Thus not only

[1] In 1407.

did he afterwards make many pictures for his native land, to his great honour and benefit, but he was invited and asked of the Signoria of Siena as a great favour by Francesco da Carrara, lord of Padua,[1] to go there, as he did, and do some things in that most noble city. He did some pictures and other things there, notably in the Arena and in the Santo, with great care, to his own great honour and to the infinite satisfaction of the said lord and of the whole city. Returning subsequently to Tuscany he did a picture in tempera in S. Gimignano, which is something in the style of Ugolino of Siena and is now behind the high altar of the Pieve facing the choir of the priests. He next went to Siena, but did not remain long there, as he was summoned to Pisa by one of the Lanfranchi, a warden of the Duomo. Having proceeded thither, he did for the Chapel of the Nunziata the scene where the Madonna is ascending the steps of the temple, to where the priest in his pontificals is awaiting her, a highly finished work. The face of the priest is the portrait of the man who had invited him, while his own is hard-by. On the completion of this work, the same patron induced him to paint over the chapel in the Campo Santo the Coronation of Our Lady by Jesus Christ, with many angels, in most beautiful attitudes and very finely coloured. For the chapel of the sacristy of S. Francesco at Pisa Taddeo also painted a picture in tempera of the Madonna and some saints, signing his name to it and the year 1394.[2] About the same time he did some pictures in tempera at Volterra,[3] and another picture at Monte Oliveto, while on the wall he did a Hell, following the arrangement of Dante as regards the division of the damned and the nature of their punishment, but as regards the site he either could not or would not imitate him, or perhaps he lacked the necessary knowledge. He also sent to Arezzo a picture which is in St. Agostino containing a portrait of Pope Gregory IX., the one who returned to Italy after the papal court had been so many decades in France. After these things he returned to Siena, but did not make a long stay there as he was invited to Perugia to work in the church of S. Domenico. Here he painted the whole of the life of St. Catherine in the chapel dedicated to that saint, and did some figures in S. Francesco beside the sacristy door which may still be discerned to-day, and are recognisable as being by Taddeo because

[1] Presumably Francesco II., 1390–1406.
[2] Now in the Vienna Gallery.
[3] There is a picture in the Palazzo Communale at Volterra of a Virgin enthroned, with saints, signed and dated 1411.

he always retained the same manner. Shortly after, in the year 1398, Biroldo, lord of Perugia,[1] was assassinated. Taddeo accordingly returned to Siena, where he devoted constant work and steady application to the study of art, in order to make himself a worthy painter. It may be affirmed that, if he did not perhaps attain his purpose, it was not on account of any defect or negligence on his part, but solely because of an obstructive malady which prevented him from ever fully realising his desire. Taddeo died at the age of fifty-nine, after having taught the art to a nephew of his called Domenico. His paintings were done about the year of grace 1410. Thus, as I have said, he left Domenico Bartoli, his nephew and pupil, who devoted himself to the art of painting, and painted with superior skill. In the subjects which he represented he exhibited much more abundance and variety in various matters than his uncle had done. In the hall of the pilgrims of the great hospital of Siena there are two large scenes in fresco by Domenico,[2] which contain perspectives and other decorations composed with considerable ingenuity. It is said that Domenico was modest and gentle and of a singularly amiable and liberal courtesy, which did no less honour to his name than the art of painting itself. His works were executed about the year of Our Lord 1436, and the last were in S. Trinità at Florence, a picture of the Annunciation and the high-altar picture in the church of the Carmine.

Alvaro di Piero of Portugal flourished at the same time, and adopted a very similar style, but made his colouring more clear and his figures shorter. In Volterra he did several pictures, and there is one in S. Antonio at Pisa and others in various places, but as they are of no great excellence it is not necessary to mention them. In our book there is a sheet of drawings by Taddeo containing a Christ and two angels, etc., very skilfully executed.

LORENZO DI BICCI, Painter of Florence [3]
(1350 –? 1427)

WHEN those who excel in any honourable employment, no matter what, unite with their skill as craftsmen, a gentleness of manners, of good breeding, and especially courtesy, serving

[1] Biordo Michelotti. [2] Painted 1440.
[3] Practically all the works assigned to Lorenzo in this notice are by his son, Bicci di Lorenzo.

those who employ them with speed and goodwill, there is no
doubt that they are pursuing to their great honour and advan-
tage almost everything which can be desired in this world. This
was the case with Lorenzo di Bicci, painter of Florence, born
in Florence in the year 1400, at the very moment when Italy
was beginning to be disturbed by the wars which brought her
to such straits. He was in very good credit from his earliest
years; for under his father's discipline he learned good manners,
and from Spinello's instruction he acquired the art of painting,
so that he had a reputation not only of being an excellent
painter, but of being a most courteous and able man. While
he was still a youth, Lorenzo did some works in fresco at Florence
and outside to gain facility, and Giovanni di Bicci de' Medici,
having remarked the excellence of his style, employed him to
paint in the hall of the old house of the Medici, which afterwards
was left to Lorenzo, natural brother of Cosmo the Ancient,
after the great palace was built, all those famous men who
may still be seen in a very good state of preservation. This
work being completed, Lorenzo di Bicci was anxious, like the
doctors who experiment in their art on the skins of poor rustics,
to have practice in the art of painting in a place where things
are not so closely criticised, and for some time he accepted
everything which presented itself; hence, outside the gate of
S. Friano at the ponte a Scandicci, he painted a tabernacle, as
it may now be seen, and at Cerbaia under a portico he painted
very agreeably a Madonna and many saints on a wall. After-
wards a chapel in S. Marco at Florence was allotted to him by
the family of the Martini, and on the walls he painted in fresco
a number of scenes from the life of Our Lady, and for the altar-
piece the Virgin herself in the midst of many saints.[1] In the
same church over the chapel of St. John the Evangelist, of the
family of the Landi, he painted in fresco the Angel Raphael and
Tobias. In the year 1418 for Ricciardo di M. Niccolo Spinello,
on the piazza front of the convent of S. Croce, he painted a large
scene in fresco of St. Thomas examining the wounds of Jesus
Christ in the presence of all the other Apostles, who are kneeling
reverently at the sight.[2] Next to this scene and also in fresco
he did a St. Christopher, twelve and a half braccia high, which
is a rare thing, because, with the exception of the St. Christopher
of Buffalmacco, a largerfigure had never been seen, and although
the style is not good, it is the most meritorious and best pro-
portioned representation of the saint taken as a whole. Besides

[1] Finished in 1433. [2] Painted in 1440 by Bicci di Lorenzo.

this the pictures were executed with such skill that, although they have been exposed to the air for many years, for they face the north, they have suffered the violence of rain and storm and yet they have never lost the brilliancy of their colouring and are in no wise injured by these accidents. Lorenzo also made a crucifix with many figures inside the door which is in the middle of these figures, called the Door of the Knocker, at the request of the same Ricciardo and of the superior of the convent, and on the encircling wall he did the confirmation of the rule of St. Francis by Pope Honorius, and then the martyrdom of some friars of that order, who are going to preach the faith to the Saracens. In the arches and on the vaulting he did some kings of France, friars and followers of St. Francis, drawing them from life, as well as many learned men of the order, distinguished by their several dignities of bishop, cardinal and pope. Among these are the portraits from life of Popes Nicholas IV. and Alexander V., in medallions. For all these figures Lorenzo made the grey habits, but with variety owing to his skill in workmanship, so that they all differ from one another, some inclining towards red, others to blue, some being dark and others more light, so that all are varied and worthy of consideration. What is more, it is said that he produced these works with such facility and speed that when the superior, who was entertaining him at dinner, called him one day, when he had just made the colour for a figure and was beginning it, he answered, "Fill up your plates and I will come when I have finished this figure." Accordingly it is said with a great show of reason that no one ever exhibited such quickness of the hands, such skill in colouring, or was so resolute as he. By his hand also is the tabernacle in fresco which is beside the nunnery of Foligno and the Madonna and saints over the door of the church of that nunnery, among them being a St. Francis espousing Poverty. In the church of Camaldoli at Florence he painted for the company of the Martyrs some scenes of the martyrdom of certain saints, and decorated the chapels on either side of the principal chapel. As these paintings gave great satisfaction to the whole city, he was commissioned, on their completion, to paint a wall of the church in the Carmine for the family of the Salvestrini, now almost extinct, there being so far as I know no other surviving member than a friar of the Angeli at Florence, called Frà Nemisio, a good and pious monk. Here he did the martyrs, when they are condemned to death, being stripped naked and made to walk bare-footed on thorns sown by the

servants of the tyrants, whilst they are on the way to be
crucified, and higher up they are represented on the cross in
varied and extraordinary attitudes. In this work, the largest
which had ever been produced, everything is done with great
skill and design, according to the knowledge of the time, being
full of the expressions showing the divers ways of dying of
those who are put to death with violence. For this cause I am
not surprised that many men of ability have made use of some
things found in this picture. After this Lorenzo did many other
figures in the same church, and decorated two chapels in the
transept. At the same time he did the tabernacle at the corner
of the Cuculia, and the one in the via de' Martelli on the front
of the houses, and over the Martelli door of S. Spirito he did a
St. Augustine in fresco, who is giving the rule to his brethren.[1]
In S. Trinità in the Chapel of Neri Compagni he painted in fresco
the life of St. John Gualbert. In the principal chapel of S. Lucia
in the via de' Bardi he did some scenes in fresco from the life
of St. Lucy for Niccolo da Uzzano, whose portrait he introduced
there from life, together with those of some other citizens.[2]
This Niccolo, with the assistance and model of Lorenzo, built
his own palace near the church, and began a magnificent college
or studium between the convent of the Servites and that of
S. Marco, that is to say, where the lions now are. This truly
magnificent work, rather worthy of a prince than of a private
citizen, was not completed, because the immense sum of money
which Niccolo left in his bank at Florence for the building and
endowment of it were expended by the Florentines on war and
other needs of the city. Although Fortune can never obscure
the memory and greatness of the spirit of Niccolo da Uzzano,
the community suffered a great loss by the non-completion of
the work. Therefore, let anyone who desires to help the world
in such a manner, and to leave an honourable memorial of
himself, do so himself in his lifetime, and not trust to the good
faith of posterity and of his heirs, as it very rarely happens
that a thing is fully carried out where it is left to successors to do
it. But to return to Lorenzo. Besides what has been already men-
tioned, he painted a Madonna and certain saints very fairly
in a tabernacle on the Rubaconte bridge in fresco. Not long
after Ser Michele di Fruosino, master of the hospital of S. Maria
Nuova at Florence, a building founded by Folco Portinari,
citizen of Florence, proposed, as the property of the hospital
had increased, to enlarge his church, dedicated to St. Giles,

[1] Painted in 1469 by Neri di Bicci. [2] Painted before 1427.

which was then outside Florence and quite small. Accordingly he consulted Lorenzo di Bicci, his close friend, and on 5th September, 1418, he began the new church, which was completed in its present form in a year, and then solemnly consecrated by Pope Martin V. at the request of Ser Michele, who was the eighth master and a member of the family of the Portinari. Lorenzo afterwards painted this consecration, at the desire of Ser Michele, on the front of the church, introducing the portrait of the Pope and of some cardinals.[1] This work was then much admired as something new and beautiful. For this cause Lorenzo was judged worthy to be the first to paint in the principal church of his native city, that is S. Maria del Fiore, where, under the windows of each chapel, he did the saints to which they are dedicated[2]; and afterwards, on the pillars and through the church, he did the twelve Apostles with the crosses of the consecration, as the church was solemnly consecrated in that very year by Pope Eugenius IV. of Venice.[3] In the same church the wardens, by public ordinance, employed him to paint on the wall in fresco a deposition, in imitation of marble, in memory of the Cardinal de' Corsini, whose effigy is there, upon the sarcophagus. Above this is another like it, in memory of Master Luigi Marsili, a most famous theologian, who went as ambassador with M. Luigi Guiccardini and M. Guccio di Gino, most honoured knights, to the Duke of Anjou. Lorenzo was afterwards invited to Arezzo by Don Laurentino, abbot of S. Bernardo, a monastery of the order of Monte Oliveto, where he painted scenes from the life of St. Bernard in fresco in the principal chapel for M. Carlo Marsupino. But as he was about to paint the life of St. Benedict in the cloister of the convent, after he had painted the principal chapel of the church of S. Francesco, for Francesco de' Bacci the elder, where he alone did the vaulting and half the tympanum, he fell sick of a chest affection. Accordingly he caused himself to be carried to Florence, and left instructions that Marco da Montepulciano, his pupil, should do these scenes from the life of St. Benedict in the cloister, from a design which he had made and left with D. Laurentino. These Marco did to the best of his ability, completing them in the year 1448, on 24th April, the whole work being in chiaroscuro, and his name may be seen written there, with verses which are not less rude than the painting. Lorenzo returned to his country, and, having recovered, he painted on the same wall of the convent of S. Croce,

[1] The church was consecrated in 1420 and painted in 1424.
[2] In 1440. [3] On 25 March, 1436.

where he had done the St. Christopher, the Assumption of Our Lady surrounded in heaven by a choir of angels, and below a St. Thomas receiving the girdle. In the execution of this work, as Lorenzo was sick, he got Donatello, then quite a youth,[1] to help him, and by means of such effective aid it was completed in the year 1450, so that I believe it to be the best work both in design and in colouring that Lorenzo ever produced. Not long after, being an old man and worn out, he died at the age of about sixty years, leaving two sons who practised painting, one of whom, named Bicci, assisted him in many of his works, and the other, called Neri, drew the portraits of his father and himself in the chapel of the Lenzi in Ognissanti, in two medallions, with letters about them giving the names of both. In this same chapel Neri did some stories of Our Lady, and took great pains to copy many of the costumes of his day, both of men and women. He did the altar-picture for the chapel in tempera, and painted some pictures in the abbey of S. Felice, of the Camaldoline order, on the piazza of Florence, as well as the high altar of S. Michele of Arezzo of the same order. Outside Arezzo, at S. Maria delle Grazie, in the church of S. Bernardino, he did a Madonna with the people of Arezzo under her mantle, and on one side St. Bernardino is kneeling, with a wooden cross in his hand, such as he was accustomed to carry when he went through Arezzo preaching; and on the other side are St. Nicholas and St. Michael the Archangel. The predella contains the acts of St. Bernardino and the miracles which he performed, especially those done in that place. The same Neri did the high-altar picture for S. Romolo at Florence,[2] and in the chapel of the Spini in S. Trinità he did the life of St. John Gualbert in fresco, as well as the picture in tempera which is above the altar. From these works it is clear that, if Neri had lived, instead of dying at the age of thirty-six, he would have done better and more numerous works than his father Lorenzo. The latter was the last master to adopt the old manner of Giotto, and accordingly his life will be the last in this first part, which we have now completed, with God's help.

[1] He would be 64! [2] In 1453.

INTRODUCTION TO PART II

WHEN I first undertook to write these Lives I did not purpose to make a mere list of the artists with an inventory, so to speak, of their works. I should not consider it a worthy end of all my labours, which, if not distinguished, have certainly been long and tedious, merely to find out their numbers, their names and countries, and to relate in what cities or places their paintings, sculptures or buildings may now be found. This I could have done by a mere table without introducing my own criticisms anywhere. But I have remarked that those historians who are proclaimed by common consent to have written with the best judgment have not been contented with confining themselves to a bare narration of facts, but with all diligence and the utmost curiosity they have investigated the motives, the methods, and the lives of the worthies of old in the management of their affairs, have taken pains to point out their errors, their fine strokes, their expedients, and the prudent course sometimes taken in the management of affairs, and, in short, all that they have done, wisely or negligently, with prudence, reverence, or generosity. Such are the methods of those who regard history as the mirror of human life, not merely to write down a dry record of the events which happen to a prince or to a republic, but to set forth the opinions, counsels, decisions and plans of men, the causes which lead to successful or unsuccessful action. This is the true spirit of a history that really teaches men how to live, and renders them prudent; and this, next to the pleasure derived from seeing things both past and present, is the true end of history. For these reasons I have undertaken to write the history of the finest artists, in order, first, to assist the arts to the utmost of my power, and next, to honour them, so that so far as I am able I have adopted this method in imitation of the great historians. Thus I have endeavoured not only to relate what the artists have done, but I have tried to distinguish the good from the better, and the best from the medium work, to note somewhat carefully the methods, manners, processes, behaviour and ideas of the painters and sculptors,

investigating into the causes and roots of things, and of the improvement and decline of the arts which took place at divers times and in divers persons for the benefit of those who cannot do so for themselves. At the beginning of these Lives I spoke of the nobility and antiquity of these arts, as was suitable at that stage, passing by many things of Pliny and other authors of which I might have made use, if I had not been anxious, perhaps against the judgment of many, to leave everyone free to see for himself the fancies of others in their proper setting. It now appears to me that the present opportunity is a fitting one to do what I could not do then, if I wished to avoid tediousness and length fatal to the attention I desire, namely, to disclose my purpose and intention more carefully, and to show to what end I have divided the body of these Lives into three parts. It is very true that some excel in the arts by diligence, some by study, some by imitation, and others again by a knowledge of the sciences, which are all useful aids, while some unite all these attributes or the greater number of them; but here I will deal only in generalities, because in the individual Lives I have said enough of the methods, arts, manners, and the causes of good, superior and pre-eminent workmanship, and I will review the matter generally, considering rather the nature of the times than the persons, whom I have divided into three parts, or ages if you will, in order not to push the investigation too far, from the renaissance of the arts until the century in which we live, differing from each other in a very marked manner. Thus in the first and earliest period the three arts are seen to be very far from perfection, and though they possess some amount of excellence, yet this is accompanied by such imperfections that they certainly do not merit extravagant praise. But since they prepared the way and formed the style for the better work which followed, it is not possible to say anything but good of them, and I must give them rather more glory than their works deserve in themselves, and than if it was necessary to judge them by the perfect rules of the art. In the second part there is a manifest improvement both in the inventions and in the execution, with more design, a better style and greater finish, the roughness of the old style being got rid of, and that rudeness and want of proportion which the grossness of the time had brought in its train. But who will venture to say that anyone perfect in everything was found in this period, who produced things equal to the present state of invention, design and colouring? Who has observed in them the soft shading away of the figures with the dark

colouring, the light being left on the prominent parts only, and who has seen there the perforation and fine finishing of the marble statues which are done to-day? This praise certainly belongs alone to the third period, of which I may safely say that art has done everything that is permitted to an imitator of Nature, and that it has risen so high that its decline must now be feared rather than any further progress expected. Turning these things over carefully in my mind, I conclude that it is a property and peculiarity of these arts that from a humble beginning they gradually improve and attain the summit of perfection. I am led to believe this by an observation of the same phenomena in the other liberal arts, and the fact that there is a species of relationship between them is an argument of its truth. The fate of painting and sculpture in the ancient times must have been so similar that with a change of names their cases would be exactly alike. It we may credit those who lived near those times, and who were able to see and judge the labours of the ancients, the statues of Canachus were very hard and without any vivacity or movement, and withal considerably removed from the truth; the same is said of those of Calamides, although they were somewhat smoother. Myron followed, and although he did not precisely imitate the truth of Nature, yet he endowed his works with such excellent proportion and grace that they might, without exaggeration, be termed beautiful. In the third degree of succession came Polycletus and the other renowned men who are said to have attained absolute perfection, as we are bound to believe. The same progress, again, must have taken place in painting, because it is said that the works of those who painted in a single colour, and who were called Monochromatists, did not attain to a high stage of perfection, and we may readily believe this. In the succeeding works of Zeuxis, Polygnotus, Timanthes, and the rest, who only employed four colours, the lineaments, outlines and forms are unreservedly praised, though doubtless they left something to be desired. But in the productions of Erione,[1] Nicomachus, Protogenes and Apelles everything is so perfect and beautiful that one can conceive nothing better, for they not only painted the form and gestures of the body with the highest excellence, but the emotions and passions in addition. But I pass these by, for we are forced to estimate them by the opinions of others, who frequently do not agree, the very dates being uncertain, although in this matter I have followed the best authors. We now come to our

[1] He probably means Echion.

own day, in which the eye is a considerably better guide and
judge than the ear. To take one subject, is it not manifest what
improvements and advances have been made in architecture
from the time of Buschetto the Greek to that of Arnolfo the
German and of Giotto? The buildings of the day show this, in
the churches, pilasters, columns, bases, capitals, and all the
cornices with their formless members, such as those of S. Maria
del Fiore at Florence, the incrustation of the exterior of S. Giov-
anni, S. Miniato, the Vescovado of Fiesole, the Duomo of
Milan, S. Vitale of Ravenna, S. Maria Maggiore at Rome, and
the old Duomo outside Arezzo, where, apart from some good
remnants of antique fragments, there is nothing well ordered
or executed. But those two men introduced considerable im-
provements, so that the art made no little progress under them,
for they improved the proportions, and not only made the build-
ings stable and strong, but also in some measure ornate, though
to be sure their ornaments were confused and very imperfect,
and, if I may say so, not very decorative. For in their columns
they did not observe the measurements and proportions required
by the art, nor did they distinguish the orders, so that there
were not distinctively Doric, Corinthian, Ionic, or Tuscan, but
mixed after a rule of their own, which consisted of absence of
rule. They made them very thick or very slender, as it happened
to suit their purpose. Their invention proceeded in part from
their own brains and in part from remnants of antiquity which
they had seen. Their plans were partly borrowed from good
sources and partly the accretions of their own fancies, so that
when the walls were erected they had a different form. Yet
anyone who compares these things with those which preceded
them will remark an improvement in every particular, and will
observe certain things which are somewhat out of favour in
our day, such as some small temples of brick covered with
stucco at S. Giovanni Lateran at Rome.

　　I make the same observations with regard to sculpture, which
in the first age of its renaissance had some excellencies, for it
had shaken off the rude Byzantine style which was so rough that
it smacked far more of the quarry than of the talent of the
artist, the statues being utterly devoid of folds, pose, or move-
ment, and hardly worthy to be called statues. Afterwards,
when design had been improved by Giotto, marble and stone
figures were also greatly improved by such men as Andrea
Pisano, his son Nino, and his other pupils, who were far better
than their predecessors. They endowed their statues with more

flexibility and set them in considerably improved postures, as did the two Sienese, Agostino and Agnolo, who, as I have said, made the tomb of Guido, bishop of Arezzo, and also those Germans who made the façade of Orvieto. Thus sculpture manifestly made some progress at this time, the figures receiving a better form and a better arrangement of folds and draperies, some of the heads a better carriage, while the attitudes were less stiff, so that, in short, there is a sign of an attempt to reach the good. But nevertheless they fell far short of it, because the art of design was not then very perfect, and there was no great number of good works for them to imitate. Accordingly the masters of that day, whom I have put in the first part, merit praise and esteem for their productions, because it must be remembered that they, as well as the architects and painters of the time, had no assistance from their predecessors, and were obliged to find a way for themselves; and a beginning, however poor, is always worthy of praise by no means poor.

Painting enjoyed little better fortune at this time, except that it was more practised owing to its popularity with the people, so that it had more professors who thus made more evident progress than was perceived in the other two arts. Thus we see that the original Byzantine style was entirely abandoned, at first through the efforts of Cimabue and then by the help of Giotto. From it arose a new style which I like to call Giotto's, because it was introduced by him and his pupils, and was afterwards universally admired and imitated. In this the profile surrounding the whole figure is abandoned, as well as the lustreless eyes, the tip-toed feet, the attenuated hands, the absence of shadow, and all the other Byzantine absurdities, which were replaced by graceful heads and beautiful colouring. Giotto in particular improved the attitudes of the figures, and began to give a measure of vivacity to the heads and folds to the draperies, which made a closer approach to Nature than is seen in the work of his predecessors, while he partially discovered the art of foreshortening figures. He also was the first to express the emotions, so that fear, hope, rage and love may be partly recognised. He rendered his style smooth where it was originally uneven and rugged, and if he did not succeed in giving his eyes the beautiful expression of life, or the right expressions to his weeping figures, or make his hair pretty, his beards downy, his hands knotty and muscular, or his nudes like the reality, he must be excused on account of the difficulty of the art, and because he had not seen any painters better than himself. Amid the general

poverty of art and of the time everyone can grasp the excellence of his judgment displayed in his works, his observation of expression and his ready following of Nature, for his figures naturally perform what they have to do and prove that his judgment, if not perfect, was very good. The same qualities appeared subsequently in the others, as in the colouring of Taddeo Gaddi, which is softer and more forceful, has better flesh-tints and better coloured draperies, while the movements of the figures are more powerful. Simon of Siena excelled in the composition of scenes, Stefano Scimmia [1] and Tommaso introduced great improvements in design, in new ideas in perspective, and in shading and harmonising the colours, while adhering steadily to Giotto's style. A like amount of skill and dexterity was exhibited by Spinello of Arezzo, Parri his son, Jacopo di Casentino, Antonio of Venice, Lippi, and Gherardo Starnini, and the other painters who laboured after Giotto, following his expressions, lineaments, colouring and style, making some improvements it is true, but not to such an extent as to make it appear that they wished to introduce another method. Thus anyone who has followed my argument will see that the three arts were, so to speak, merely sketched up to this point, and that they lacked much of the perfection which belongs to them, and if there had been no improvement to follow, the advances they made would have been of little service, and would not have been worthy of much esteem. I hope that no one will believe me to be so gross or of so little judgment as not to be aware that the things of Giotto, of Andrea Pisano, of Nino, and all the rest, whom I have put together in the first part on account of their resemblance in style, would deserve more than a moderate amount of praise if they were to be compared with the works produced after their time. I was well aware of this when I praised them. But those who take into consideration the nature of their age, the scarcity of artists, the difficulty of obtaining good assistance, will consider them not merely beautiful, as I have said, but miraculous, and will take infinite pleasure in noticing the first efforts and those sparks of excellence which began to appear in their paintings and sculptures. The victory of L. Marcius in Spain was not of such great importance as many of the triumphs of the Romans, but considering the time, the place, the circumstances, the persons, and the numbers, it was considered stupendous and worthy to this day of the praises which

[1] i.e. the Ape (of Nature), his nickname.

are lavishly bestowed upon it by the historians. For all these reasons I have considered that these artists deserve not only a careful account from me, but all the praise which I have so readily and sincerely bestowed upon them. It seemed to me that it would not be displeasing to artists to hear these Lives and to examine the methods and styles of those men, and possibly they may draw no small advantage from them. If so, I shall be greatly delighted, and shall consider it a rich reward for this labour, in which it has been my sole object to serve and please them to the extent of my powers.

Having now, if I may say so, taken these three arts from the nurse, and having passed the age of childhood, there follows the second period in which a notable improvement may be remarked in everything. The inventions are more lavish with figures, richer in ornaments, design is more firmly grounded and more natural and life-like, while even in the works executed with less skill there is purpose and thought expressed with diligence, the style is lighter, the colours more charming, so that little is wanting of complete perfection, and the truth of Nature is exactly imitated. In the first place, by means of the study and diligence of the great Filippo Brunelleschi, architecture once again discovered the measurements and proportions of the ancients, as well in the round columns as in the square pilasters and in the rough and the polished corners; order is distinguished from order, the difference between them being made apparent, matters are arranged to proceed according to rule with more order, things are partitioned out by measure, design shows increased power and method, gracefulness pervades everything and exhibits the excellence of the art, the beauty and variety of capitals and cornices are rediscovered, so that the plans of churches and other buildings are well conceived, the buildings themselves being ornate, magnificent and in proportion. An example is afforded by the stupendous cupola of S. Maria del Fiore at Florence, in the beauty and grace of its lantern, in the varied and gracefully decorated church of S. Spirito, in the no less beautiful S. Lorenzo, in the curious invention of the octagonal church of the Angioli, in the airy church and convent of the abbey at Fiesole, and in the magnificent and grandiose commencement of the palace of the Pitti, not to speak of the convenient and commodious erection due to Francesco di Giorgio of the palace and church of the Duomo of Urbino,[1] the rich and powerful castle of Naples, the impregnable

[1] The architect was Luciano di Laurana, not Francesco di Giorgio.

castle of Milan, and many other notable buildings of that time. These works may safely be called beautiful and good, although they do not yet possess that finesse and a certain exquisite grace and finish of the cornices, with delicate and light methods of marking leaves, and in making the extremities of foliage, and other perfections which came afterwards, as will be seen in the third part, which will contain those who surpassed the other architects of old in perfection, grace, finish, fertility and dexterity. I cannot call it perfect at this stage, although certainly beautiful and good, because improvements were afterwards made in it; so I think I may reasonably assert that something was still lacking. Certainly there were some things truly miraculous which have not been excelled even in our own day, and perhaps never will be; such, for example, as the lantern of the cupola of S. Maria del Fiore, and the cupola itself as regards its size, where Filippo not only dared to equal the ancients in the body of the building, but to surpass them in the height of the walls. Nevertheless, as we are dealing in generalities, the perfection and excellence of a single thing must not be advanced to prove the excellence of all. The same applies to painting and to sculpture also, in which we may see to-day works of rare excellence by masters of this second period, such as those of Masaccio in the Carmine, who painted a naked man shivering with cold, and produced other vigorous and spirited works, but as a general rule they did not attain to the state of perfection of the third age, of which I shall speak when the time comes. Here I must confine myself to the men of the second period. To speak in the first place of the sculptors who made such great advances on the early style that they left little for the third period to complete. They introduced so much more grace, nature, order, design and proportion into their works that their statues begin to appear almost like living persons and not mere statues as the first ones were. This is shown in the works produced during the renovation of the style, as will be seen in the second part, where the figures of Jacopo dalla Quercia of Siena possess more movement, grace, design and diligence, those of Filippo a better knowledge of the muscles, better proportions and more judgment, and those of their pupils exhibit the same qualities. But Lorenzo Ghiberti added yet more in his production of the doors of S. Giovanni, in which he displayed his invention, order, style and design so that his figures seem to move and breathe. Although Donato lived at the same time, I was uncertain whether I ought not to place him in the third period, since his works are up to the level of

the good antiques; placed in the second period, I may call him the standard of the others, because he combined in his person all the qualities which were distributed among many others, for he imparted to his figures a movement, life and reality which make them worthy to rank with modern works, and even with those of antiquity, as I have said.

At this time also painting made equal advances, and in this art Masaccio entirely freed himself from Giotto's style, his heads, draperies, buildings, nudes, colouring and foreshortening being in a new manner, introducing that modern style which has been adopted by all our artists from that time to our own day, embellished and enriched from time to time with additional graces, invention and ornaments. This will be seen when we are dealing with the separate Lives, where we shall meet with a new method of colouring, of foreshortening, natural attitudes, a much better expression of the emotions of the spirit and of the gestures of the body, joined to a constant endeavour to get nearer to the truth of Nature in design, while the faces are exactly like those of men as they were seen and known by the artists. Thus they sought to reproduce what they saw in Nature and no more, and thus they came to consider more closely and understand more fully. This encouraged them to make rules for perspective, and to get their foreshortening in the exact form of natural relief, proceeding to the observation of shadows and lights, shading and other difficulties, composing their scenes with greater regard for probability, attempting to make their landscapes more like reality, as well as the trees, grass, flowers, air, clouds and other natural phenomena, so that it may be said without fear of contradiction that the arts are not only improved, but have reached the flower of their youth, giving promise of fruit in the future, that they would soon attain to their age of perfection.

And now with God's help I shall begin the Life of Jacopo dalla Quercia of Siena, to be followed by those of other architects and sculptors until we come to Masaccio, who was the first to improve design in painting, when we shall see what a debt is due to him for his new discovery. I have chosen Jacopo as a worthy beginning for this second part, and shall follow the order of styles, showing in each life the difficulties presented by their beautiful, difficult and most honourable arts.

Jacopo dalla Quercia, Sculptor of Siena
(? 1371–1438)

Jacopo was the son of Master Piero di Filippo of la Quercia, a place in the territory of Siena, and he was the first sculptor after Andrea Pisano, Orcagna, and the others named above, who, by applying himself with greater study and diligence to sculpture, began to show that it was possible to approach Nature, and was also the first to inspire others with courage and the belief that it would be possible to equal her in some sort. His first works of importance were done at Siena, at the age of nineteen, under these circumstances. The Sienese had an army out against the Florentines under the captains Gian Tedesco, nephew of Saccone da Pietramala, and Giovanni d'Azzo Ubaldini. The latter fell sick in the country, and when brought to Siena he died.[1] His death was a great blow to the Sienese, and at his obsequies, which were very splendid, they caused a wooden erection in the form of a pyramid to be made, on which was placed an equestrian statue of the general by Jacopo's hand, of more than life-size, executed with much judgment and invention. In the execution of this work, Jacopo employed a device not in use up to that time, of constructing a framework for the horse and figure of pieces of wood and laths fitted together, wrapped about with straw, tow and hemp, the whole being tightly bound together, and then covered with the clay mixed with a cement composed of woollen cloth, paste, and glue. This method of construction was, and is, undoubtedly the best for such things, because, although they appear to be heavy, yet after they are finished and dry they prove to be light, and being covered with white they resemble marble, and are very pleasing to the eye, as was this work of Jacopo. In addition to these advantages, such works do not crack as they would do if they were made of dried clay only. In this style the models for sculptures are made to-day, to the great convenience of artists, who in this way always have a model before them of the exact proportions of the sculptures upon which they are engaged, so that they are under no small obligation to Jacopo, who is said to have been the inventor of this device. Jacopo next made two panels of hard wood, carving on them the figures, beards and hair with such patience that they were a

[1] 1393.

marvel to behold. After these panels, which were placed in the
Duomo, he did some prophets of moderate size in marble, which
are on the front of that building, and he would have pursued
this work had it not been for the plague, famine and the civil
discords of the Sienese, who, after several revolts, had thrown
the city into disorder, and driven out Orlando Malevolti,[1] by
whose favour Jacopo had been employed in his native place
with much honour. Accordingly he left Siena, and through the
efforts of some friends he was invited to Lucca, and there made
a tomb for the wife of Paulo Guinigi, the lord of the city, who
had recently died, in the church of S. Martino.[2] On the pedestal
of this he made some infants in marble bearing a festoon, so
beautifully finished that they are like living flesh and blood.
On the sarcophagus which is upon this pedestal he did the
effigy of Paulo's wife, who was buried there, with admirable
finish, and at her feet, and on the same stone, he made a dog
in full relief, emblematical of her fidelity to her husband. After
the departure, or rather the expulsion, of Paolo from Lucca in
the year 1429,[3] when the city won its freedom, this sarcopha-
gus was removed from its place and all but entirely destroyed
because of the hatred which the Lucchese bore to the memory
of Guinigi. Yet the reverence which they felt for the beauty
and the ornamentation restrained them, and led them soon
after to set up the sarcophagus and the effigy at the entrance
door of the sacristy, with great care, where they now are, the
chapel of Guinigi becoming the property of the community.
About this time Jacopo learned that the art of the merchants
of the Calimara of Florence proposed to have a bronze door
made for the church of S. Giovanni, where Andrea Pisano had
previously laboured, as already narrated. He went to Florence [4]
to make himself known, more especially because this work was
to be entrusted to the one who should display the best evidence
of his skill in producing one of the scenes in bronze. Arrived
at Florence he not only made the model, but completed and
finished a well-conceived scene, which gave so much satisfaction
that, had not the excellent Donatello and Filippo Brunelleschi
been among his rivals, their knowledge surpassing his, he would
have secured this important work. But as matters turned out
otherwise, he left for Bologna, where, by means of the favour
of Giovanni Bentivogli, he was commissioned [5] by the overseers

[1] In 1390. [2] She died in 1406, and the tomb was made in 1413.
[3] It happened in September 1430. [4] In 1402.
[5] On 25 March, 1425; but Giovanni Bentivogli was killed in June 1402.

of the church of S. Petronio to make the principal door of that
building in marble. Here he adopted the Gothic style in order
not to depart from the manner in which the building had
already been begun, filling the spaces which interrupt the rows
of pillars bearing this corner and tympanum with scenes
executed with great devotion. To this work he gave twelve
years, doing with his own hand the foliage and ornamention of
the door with the greatest imaginable diligence and care. Each
of the pilasters bearing the architrave, cornice and tympanum
contains five bas-reliefs, and there are five in the architrave,
making fifteen in all. In these he carved scenes from the Old
Testament, from the creation of man by God to the Flood and
Noah's ark, giving a great aid to sculpture, as from the time of
the ancients until then there had been no one to produce works
in bas-relief, so that that species of work was rather lost than
degenerate. In the tympanum he made three marble figures of
life-size in full relief, namely Our Lady with the Child, very
beautifully done, S. Petronius and another saint all well arranged
in fine attitudes. The Bolognese, who had imagined that it would
not be possible to produce any marble work equal, much less
superior, to that which Agostino and Agnolo of Siena had done
on the high altar of S. Francesco in that city, in the old style,
had to admit that they were mistaken when they perceived
how much finer these were. Being next requested to return to
Lucca, Jacopo did so very readily, and for Federigo di maestro
Trenta del Veglia he did a marble slab in S. Friano [1] there,
with the Virgin and Child, St. Sebastian, St. Lucy, St. Jerome
and St. Sigismund, in a good style with grace and design, and in
the predella beneath he did scenes from the life of each saint,
in half-relief. This was a very pretty and pleasing work, as
Jacopo had displayed much art in making his figures retire
gradually on the different planes, and in diminishing those
which were farthest away. In like manner he encouraged others
to endow their works with grace and beauty by new methods,
and on two large stones he made the effigies of Federigo, the
donor of the work, and his wife, in bas-relief, for their two
tombs. On these stones are the words:

Hoc opus fecit Jacobus magistri Petri de Senis, 1422.

When Jacopo afterwards proceeded to Florence, the wardens
of S. Maria del Fiore, having heard a good report of him,
employed him to make the marble front which is over the door

[1] i.e. Frediano, done in 1413.

of that church, leading to the Nunziata.[1] Here he represented
a Madonna in a mandorla[2] carried to heaven by a choir of angels,
who are playing and singing, displaying the most beautiful
movements and attitudes, for there is vigour and decision in
their flight, such as had never been seen before. In like manner
the Madonna is clothed so gracefully and simply that nothing
better could be desired, for the folds of the drapery are soft and
beautiful, the clothes following the lines of the figure, and while
covering the limbs disclose every turn. Under this Madonna is
a St. Thomas receiving the girdle. In short, this work, completed
by Jacopo in four years, represents his powers at their highest,
for, besides his natural desire to do well, the rivalry of Donato,
Filippo and Lorenzo di Bartolo, some of whose works had already
appeared and were much admired, proved an even greater
stimulus. His work was so good that even to this day it is
regarded by modern artists as most rare. On the other side of
the Madonna opposite St. Thomas Jacopo made a bear climbing
a pear-tree. Upon this caprice of his many things were related
at the time, and I might add some more, but I refrain in order
to leave everyone free to follow his own belief and judgment.
After this Jacopo, wishing to see his native country again,
returned to Siena, and on his arrival seized the opportunity
which he had desired of leaving an honourable memorial of
himself there. The Signoria of Siena had decided to erect a very
rich marble ornament for the water which Agnolo and Agostino
of Siena had brought to the piazza in the year 1343, and this
work they entrusted to Jacopo for the price of 2200 gold crowns.
Accordingly he made a model and fetched the marble, set to
work, and completed it to the great satisfaction of his fellow-
citizens, who no longer called him Jacopo dalla Quercia but
Jacopo dalla Fonte ever after.[3] In the midst of this work he
carved the glorious Virgin Mary, the special protector of the
city, making her rather larger than the other figures and in a
graceful and original style. About her he put the seven Theo-
logical Virtues, whose soft and delicate heads he made with a
beautiful expression and in such fashion that it is clear that he
was making advances towards excellence, overcoming the diffi-
culties of the art and giving grace to the marble, shaking off
the old-fashioned style employed by sculptors up to that time,

[1] The Porta della Cintola, but it is the work of Nanni di Banco, done
1414–21.
[2] An almond-shaped glory surrounding the entire figure.
[3] Begun in 1409 and finished 1419.

who made their figures without a break and devoid of the least grace, whilst Jacopo rendered his soft and flesh-like, finishing the marble with patience and delicacy. Besides these he did some scenes of the Old Testament, namely, the creation of our first parents and the eating of the forbidden fruit, in which the woman's face is beautiful and gracious, and her comportment exhibits such reverence to Adam in placing him first that it does not seem as if he could possibly refuse her. Besides this, the remainder of the work is full of beautiful ideas and adorned with lovely children and other ornaments of lions and wolves, the arms of the city, all produced by Jacopo with devotion, skill and judgment in the space of twelve years. By his hand also are three very fine scenes in bronze of the life of St. John the Baptist, in half-relief,[1] which are about the font of S. Giovanni below the Duomo, as well as some other bronze figures in full relief, one braccia high between the two scenes, which are really excellent and admirable. For the excellence of these works, and for the goodness of his well-ordered life, Jacopo deserved the honour of knighthood accorded to him by the Signoria of Siena,[2] as well as his subsequent appointment to be one of the wardens of the Duomo. This latter office he discharged so well that the building was never better managed either before or after, as although he only lived three years after the charge was entrusted to him, yet he made a number of useful and notable repairs. Although Jacopo was only a sculptor, yet he could design very fairly, as is shown by some sheets of his in our book, which rather resemble the work of an illuminator than that of a sculptor. His portrait, at the head of this Life, I had from Maestro Domenico Beccafumi, who told me many things about the virtue, goodness and kindness of Jacopo. Exhausted by his continual labours, he at length died at the age of sixty-four, and was honourably buried in his native Siena by his friends and relatives, lamented by the whole city. And he was certainly fortunate in that his worth was recognised by his fellow-citizens, since it rarely happens that men of ability are universally loved and honoured in their native land.

Matteo, sculptor of Lucca,[3] was a pupil of Jacopo, who in the year 1440 did the little octagonal marble temple in the church of S. Martino in that city, for Domenico Galigano of

[1] Jacopo's panel is the angel appearing to Zacharias, done in 1419, but not cast till 1430.

[2] In 1435. [3] Matteo Civitali, 1435-1501.

Lucca. This contains the image of Holy Cross, which is said to have been miraculously carved by Nicodemus,[1] one of the seventy-two disciples of Our Lord. The temple is really very fine and well proportioned. The same Matteo carved a marble figure of St. Sebastian in full relief, three braccia high and very finely designed, the attitude being excellent and the work well finished. By his hand also is a slab containing three figures in three niches, in the church [2] which is said to contain the body of St. Regolo, another slab in S. Michele containing three marble figures, and the statue of Our Lady which is at one of the outside angles of the same church, which show that Matteo strove hard to equal his master, Jacopo.

Niccolo Bolognese was another pupil of Jacopo, and among other things he completed in an exquisite manner the marble shrine at Bologna, full of scenes and figures, and containing the body of St. Dominic, which was left unfinished by Niccola Pisano. From this work he won such fame and profit that he was ever afterwards known as Master Niccolo dell' Arca (of the Shrine). He completed this work in the year 1460, and then made a Madonna of bronze, four braccia high, for the front of the palace where the Legate of Bologna now dwells, putting it in its place in the year 1478. In fine, he was an excellent master and a worthy pupil of Jacopo dalla Quercia of Siena.

Niccolo, Sculptor of Arezzo
(? 1360 – alive 1444)

Niccolo di Piero,[3] citizen of Arezzo, flourished at the same time, in the same art of sculpture, and was of almost equal excellence; but in proportion as Nature was liberal in endowing him with such gifts, as genius and a quick intelligence, so was Fortune sparing in affording him her benefits. Owing to his poverty and the ill-treatment of his nearest relations, he left Arezzo for Florence, having first studied sculpture with good results under the instruction of Maestro Moccio, sculptor of Siena, who did some things in Arezzo, as I have remarked elsewhere, although Moccio was not a very good master. For many months after his arrival at Florence Niccolo did whatever came

[1] A crucifix of cedar wood, reputed to have been carried by the sea to Lucca from Palestine, in 782. The temple was built in 1484.
[2] i.e. S. Martino.
[3] Niccolò di Piero Lamberti

to his hand, both on account of his pressing poverty and want, and because of the rivalry of some youths, who by dint of much study and toil worthily competed with him in sculpture. At length, after much labour, Niccolo became a very good sculptor, and was employed by the wardens of S. Maria del Fiore to make two statues for the campanile. These were placed on the side facing the Canonica on either side of some of which Donato afterwards made, and were considered very fair, as no better works in full relief then existed. Owing to the plague of 1383, Niccolo left Florence, and returned to his native place. Here he found that the plague had brought great wealth to the brotherhood of S. Maria della Misericordia, of whom I have spoken above, through the bequests left to them by various people of the city, from devotion to that sacred place and admiration for the men who, throughout the plague, had tended the sick and buried the dead, undeterred by danger. It was resolved to build the front of that place of grey stone, as marble was not easily obtainable. Niccolo therefore began this task, which had been begun in the Gothic style, and with the assistance of a number of masons from Settignano he carried the work to a successful completion, doing, for the middle arch of the front, with his own hand, a Madonna and Child, with some angels holding her mantle open to shelter the people of the city beneath her, for whom SS. Laurentinus and Pergentinus are interceding. For two niches at the side he made statues three braccia high, one of St. Gregory the Pope, the other of St. Donato, the bishop and protector of the city, in a very graceful and meritorious style. There are indications to show that before he did these works he had in his youth already done three large figures in terra cotta above the door of the Vescovado, which have at the present time been almost entirely destroyed by the frost. At the same period of his life he also did a St. Luke in *macigno* stone, which was placed on the front of the Vescovado. In the chapel of St. Blaise in the Pieve he did a very fine statue of the saint in terra-cotta, and another terra-cotta statue of St. Anthony for the church of that saint, besides another saint to stand over the door of the hospital of that place. While he was engaged upon these and other like works, the walls of Borgo a S. Sepolcro were thrown down by an earthquake. Niccolo was sent for to make a design for a new wall, which he accordingly did with considerable judgment, his being much better and stronger than the first. Working thus, sometimes in Arezzo, and sometimes in the neighbouring places, Niccolo

remained quietly and contentedly at home. But war, the arch-
enemy of his art, occasioned his departure, for the city of
Arezzo was turned upside down by the expulsion from Pietra-
mala of the sons of Piero Saccone, the castle being utterly
destroyed.[1] Accordingly Niccolo left his home and proceeded
to Florence, where he had worked before, and made a marble
statue four braccia high for the wardens of S. Maria del Fiore,
which was afterwards placed on the left side of the principal
door of that church. In this statue, a seated Evangelist,[2] Niccolo
proved that he was really a sculptor of merit, and he won great
praise for it, for, as we shall see later, no better work in full
relief had as yet been seen. Being invited then to Rome by
order of Pope Boniface IX., he fortified and improved the form
of the castle of S. Angelo, as being the foremost architect of the
day. Returned to Florence he made two small marble figures [3]
for a corner of Or. S. Michele facing the art of wool, for the
masters of the mint. These were placed on the pilaster above
the niche where the St. Matthew now stands, placed there after-
wards. So well were they adapted to the top of the niche that
they obtained much praise at the time, and have always been
greatly admired, for Niccolo seems to have surpassed himself
in this work, and he never did anything better. Indeed, they
are so good that they will bear comparison with any other work
of the same kind; and they brought their author so much credit
that he was considered worthy to be among those invited to
compete for the bronze doors of S. Giovanni. In this contest,
however, he was surpassed, and the doors were allotted to
others, as I shall relate elsewhere. Niccolo then proceeded to
Milan, and was made director of the works of the Duomo
there, doing some things in marble which gave great satis-
faction. Being at length recalled by the Aretines in order to
make a tabernacle for the Sacrament, he was forced to stop at
Bologna on his way back to make the tomb of Pope Alexander V.[4]
in the convent of the friars minors, that Pope having expired
in the city. Although he had resolutely declined to undertake
this work, he was unable to resist the entreaties of M. Leonardo
Bruni, an Aretine, who had been a favourite secretary of the
Pope. Niccolo accordingly made the tomb, drawing the Pope
from life. It is true that, on account of the difficulty of obtaining
marble and other stones, the tomb and ornaments were entirely
made of stucco and terra cotta, as was the Pope's effigy on the

[1] In 1384. [2] St. Mark. [3] An Annunciation.
[4] Ob. 1410. The tomb is by Sperandio da Mantova, made in 1482.

sarcophagus, the entire work being set up behind the choir of the church. On the completion of this task Niccolo fell sick, and died soon afterwards, at the age of sixty-seven. He was buried in the same church in the year 1417. His portrait was made by his close friend, Galasso of Ferrara, who painted at that time in Bologna in competition with Jacopo and Simone, painters of Bologna,[1] and with one Cristofano, of whom I am uncertain whether he was of Ferrara or of Modena, as some say. All these painted many things in fresco in a church called La Casa di Mezzo, outside the S. Mammalo gate.[2] On one side Cristofano did from the creation of Adam to the death of Moses, while Simone and Jacopo did thirty scenes from the birth of Christ to the Last Supper. Galasso subsequently did the Passion, the name of each artist being written under their respective works. These paintings were executed in 1404. The remainder of the church was then painted very neatly with stories of David by other masters. These paintings are highly esteemed by the Bolognese, and not without cause, for they are very meritorious for early works, and are in a fresh and good condition. Some say that Galasso, when very old, worked in oils also, but I have never found any of his works except in fresco, either in Ferrara or in any other place. Cosme[3] was a pupil of his, who painted a chapel in S. Domenico at Ferrara, and the doors of the organ of the Duomo, as well as many other things which are superior to the paintings of his master, Galasso. Niccolo was a good draughtsman, as our book may testify, for it contains an Evangelist and three horses' heads by his hand, very well designed.

DELLO, Painter of Florence
(1404–1453)

ALTHOUGH Dello of Florence has at all times been known as a painter exclusively, yet he also studied sculpture, in which his first works were produced, long before he began to paint, as he did a Coronation of Our Lady in terra cotta in the tympanum over the entrance door of the church of S. Maria Nuova, and inside the church the twelve Apostles. In the church of the Servites he did a dead Christ in the lap of the Virgin, and a number of other works in every part of the city. But being a

[1] Jacopo Avanzi possibly, and Simone Benvenuti.
[2] Now known as Madonna di Mezzaratta.
[3] Cosimo Tura, c. 1420–95

capricious man, and perceiving that he was not making sufficient
profit from his works in terra cotta and that his necessities
required more substantial help, he resolved to devote himself
to painting, as he designed well, and in this he achieved success,
for he quickly learned to colour with skill, as many of his
paintings in the city prove, especially those containing small
figures, which he executed with more grace than the larger ones.
This proved a fortunate circumstance for him, for at that time
large wooden chests like tombs were in use in the chambers of
citizens, and with various other fashions for the lids no one
omitted to have these chests painted, the top with various
subjects, the sides and other parts being decorated with the
arms or insignia of the house. The scenes represented on the
body of the chest were usually fables from Ovid and other
poets, or stories related by the Greek and Latin historians, and
hunting, jousting, love-stories, and other like things, according
to each man's taste. The inside was lined with linen or cloth
according to the rank and wealth of the owner, for the better
preservation of the clothes and other valuables kept in them.
What is more, not only were chests painted in this manner,
but the beds, the backs of chairs, the frames and other orna-
ments of the rooms which were magnificent in those days, and
a number of them may be seen in every part of the city. This
style of thing was practised for many years, and even the most
excellent painters employed themselves without feeling ashamed,
as many would now be, in painting and gilding such things. The
truth of this is illustrated by some chests, chair-backs and frames
in the apartments of Lorenzo de' Medici the Magnificent, which
were not painted by the hands of common painters, but by
excellent masters, with jousts of tournaments, hunting, feasting
and other spectacles, produced at that time with judgment,
originality and marvellous art. Some survivals of these things
may be seen not only in the palaces and old houses of the Medici,
but examples are to be found in all the noblest houses of Florence,
while there are some interested in these old, magnificent and
honourable customs who have not removed such articles to
make room for modern ornaments and practices. Dello, then,
being a very skilful and excellent painter, chiefly as I have said
in making small pictures with much grace, devoted himself for
many years with great profit and honour to nothing else than
decorating and painting chests, chair-backs, beds and other
ornaments in the style mentioned above, so that this may be
termed his chief and peculiar profession. But nothing in this

world, however good and admirable, is firm or durable, for men became more refined, and soon made richer ornaments, carving walnut and overlaying it with gold, making a most sumptuous decoration, as well as painting admirable scenes in oils for such furnishings, which serve to show the magnificence of the citizens who used them, as well as the excellence of the painters. But to come to Dello's works: he was the first who devoted himself with diligence and skill to this sort of painting, and in particular he did the entire furniture of a room for Giovanni de' Medici, which was considered a very rare thing and most beautiful of its kind, as the existing remains serve to show. It is said that Donatello, then a youth, assisted him, moulding the stucco, the gypsum and glue, and doing some scenes and ornaments in bas-relief which, when gilded over, blended most beautifully with the painted part. This work, and many others like it, are mentioned at great length by Drea Cennini in his book, of which I have so frequently spoken. And since it is good to preserve some memory of these old things, I have caused some by Dello's own hand to be preserved in the palace of Duke Cosimo, which are, and always will be, worthy of attention, if for nothing else than the varied styles of clothes worn by the men and women of that day represented there. Dello also worked in *terra verde* in fresco at the corner of the cloister of S. Maria Novella, doing the scene where Isaac is blessing Esau. Soon after this work he was invited to Spain to serve the king, and he there acquired such credit that no artist could have desired better.[1] Although I do not know of any particular works which he produced in those parts, yet, as he returned laden with riches and honours, it is just to conclude that they were of considerable beauty and excellence. After a year or so, during which he had been royally paid for his labours, Dello became desirous of returning to Florence, in order to show his friends how he had grown very wealthy from the extreme of poverty. The king graciously granted him permission to go, although he would gladly have detained him, if such had been Dello's desire, and as a distinguished mark of favour created him a knight. Accordingly Dello returned to Florence to obtain the confirmation of his privileges; but they were denied him by the action of Filippo Spano degli Scolari, who at that time had returned victorious over the Turks, as grand seneschal of the King of Hungary.[2] But

[1] He went to Venice in 1427 and proceeded to Spain in 1433.
[2] Dello came back in 1446, but Scolari returned in 1410. He was a Florentine captain (1369-1426) who won several victories over the Turks in the service of the Emperor Sigismund.

as Dello immediately wrote to the King of Spain complaining of this injustice, the king wrote to the Signoria so warmly in his favour that the much-desired and merited honour was granted to him without more ado. As Dello was returning to his house on horseback, with the colours, and clothed with brocade and honoured by the Signoria, he was jeered at as he was passing through Vacchereccia, where many goldsmiths' shops then were, by some intimate friends of his youth, either in mockery or as a joke. When he heard the remarks he turned to the speakers and put his hands to his nose, and, without saying a word, departed, so that hardly anyone greeted him except those who had sneered at him. For this and for other causes, which indicated to him that envy was no less active against him in his native place than malignity had been in the time of his extreme poverty, he thought of returning to Spain. Accordingly he wrote to the king, who replied to him, and he returned to those parts where he was warmly welcomed.[1] He was always viewed with favour there, and could work and live like a noble, always painting in an apron of brocade. Thus then he retreated before envy, and lived in honour near the king. He died at the age of forty-nine, and was honourably buried by his royal master with this epitaph:

> Dellus eques Florentinus
> Picturæ arte percelebris
> Regisque Hispaniarum liberalitate
> Et ornamentis amplissimus.
> H. S. E.
> S. T. T. L.

Dello was not a very good draughtsman, but was among the earliest to discover the importance of a just representation of the muscles of naked bodies, as is seen in some designs of his in chiaroscuro in our book. His portrait in chiaroscuro occurs in the scene of the drunkenness of Noah caused by his son Ham, in S. Maria Novella, by the hand of Paolo Uccello.

NANNI D'ANTONIO DI BANCO, Sculptor of Florence (ob. 1421)

NANNI D'ANTONIO DI BANCO inherited a patrimony of considerable wealth, and his blood was far from being ignoble, yet, as he took delight in sculpture so far from thinking it a disgrace to

[1] In 1449.

learn and practice that art, he rather considered it a glory, and he produced such fruit that his fame will endure for ever, and he will be the more renowned as it is known that he devoted himself to that noble art not from want but from a veritable love of it for its own sake. He was one of the pupils of Donato, before whom I have placed him because he died so much earlier. He was somewhat deliberate, but modest, unassuming and gentle in his demeanour. There is a marble St. Philip by his hand in Florence, on a pilaster outside the oratory of Or. S. Michele.[1] This work was originally entrusted to Donato by the art of shoe-makers, but as they could not arrange the price with him they gave the work to Nanni, as if they meant to slight Donato. The former promised that he would accept whatever payment they might give him. But things did not turn out that way, for, when the statue was completed and set up in its place, he asked a much higher price than Donato had originally done. Both parties referred the dispute to Donato, the consuls of the art feeling certain that he would fix a much lower price than he had claimed for himself, because he would feel slighted at not having been employed. However, they deceived themselves, for Donato decided that Nanni should be paid much more for the statue than he had asked himself. The consuls absolutely refused to accept this judgment, and exclaimed to Donato, "Why, if you would have done this work for a lower price, do you value it more highly when it is by another, and insist upon his being paid more than he himself has asked, for you must know, as we also do, that it would have been done much better by yourself?" Donato laughingly answered, "This worthy man is not my equal in this art, and produces his work with much more toil than I do, consequently, it seems to me, you are bound, as just men, to pay him for the time he has spent upon it." Thus Donato's award decided the matter and brought both parties to an agreement. The figure is well posed and the head graceful and life-like; the draperies are not crude, and fit the figure very well. In a niche beyond this one are four saints in marble, which were a com-mission to Nanni given him at the same time by the art of the smiths, carpenters and masons. It is said that, when he had his figures all ready, each completely carved out by itself and the niche constructed, it was only with great difficulty that he could get even three figures in, as he had made some with their arms out. In his despair and distress he begged Donato to advise him how to make good this unlucky lack of foresight. Donato laughed

[1] Done in 1408.

at the accident, and said, "If you will pay for a dinner for me and all the apprentices of my workshop, that will fortify me to get your saints into the niche without any trouble." Nanni readily agreed to this, and Donato sent him to Prato upon some affairs and to do other business that would occupy him a few days. When he had gone, Donato set to work with all his pupils and boys and cut down the statues, a back here and an arm there, and so, by one making room for another, he grouped them together showing a hand on the back of one of them. Thus the good judgment of Donato so far covered over the error of Nanni that the statues still standing in that place show the liveliest demonstration of concord and brotherhood, and no one would detect the error who was unaware of the circumstances. On his return Nanni perceived that Donato had set everything right and remedied every disorder, and most heartily thanked him, paying for the dinners with the utmost good-will. Under the feet of these four saints, in the ornamentation of the tabernacle, is a scene in half-relief in the marble in which a sculptor is carving a child very naturally, and a bricklayer is at work assisted by two others. All these small figures are very well arranged and busy over their occupations. On the façade of S. Maria del Fiore, on the left-hand side of the middle door as one enters the church, is an Evangelist[1] by the same artist, which is a very fair figure for that time. It is supposed that the St. Eligius which stands outside the oratory, already mentioned, of Or. S. Michele, and which was made for the art of the farriers, is also by Nanni, as well as the marble niche and the bas-relief below representing St. Eligius shoeing a horse possessed by the devil.[2] This is so well done that Nanni deserves great praise for it. He would have deserved and achieved much greater things had he not died young, yet even on the strength of these few works Nanni was reputed a sculptor of considerable merit, and being a citizen of Florence, he obtained many offices in his native city. In these duties, and in all the other affairs of life, he bore himself as a just and reasonable man should, and was greatly loved. He died of the colic in the year 1430, at the age of forty-seven.

[1] St. Luke; now inside. [2] Done in 1415.

Luca della Robbia, Sculptor of Florence
(1397–1482)

Luca della Robbia, sculptor of Florence, was born in the year 1388, in the house of his forefathers, which stands under the church of S. Barnaba in Florence. He was carefully brought up, so that not only was he able to read and write, but, like most Florentines, he could do such arithmetic as he needed. He was then set by his father to learn the goldsmith's art from Leonardo di Ser Giovanni, who was then esteemed the best exponent of that craft in Florence. Under this man Luca learned to design and to model in wax, and, his courage increasing, he went on to make some things of marble and of bronze. As these proved quite successful, he was led to abandon entirely the craft of goldsmith, and he devoted himself so thoroughly to sculpture that he did nothing else, spending all his days in chiselling, and his nights in designing. So diligent was he that frequently at night, when his feet grew cold, he would put them in a basket of shavings, such as carpenters leave by planing, to keep them warm, so that he need not leave his designing. I am in nowise astonished at this, seeing that no one ever excels in any worthy exercise who does not begin, while still a child, to support cold and heat, hunger and thirst, and other discomforts; and those who think that it is possible to attain to honour in ease and comfort are entirely deceived, for progress is made not in sleeping, but by watching and studying continually. Luca was barely fifteen years old when he was invited to Rimini with other young sculptors to make some figures and other marble ornaments for Sigismondo di Pandolfo Malatesta, lord of that city, who was then building a chapel in the church of S. Francesco, and a tomb for his dead wife.[1] In this work Luca afforded a striking proof of his ability in some bas-reliefs which may still be seen. He was then recalled to Florence by the wardens of S. Maria del Fiore, where he did five small subjects in marble for the campanile, on the side next the church, to complete the series designed by Giotto, and next to the sciences and arts previously done by Andrea Pisano, as I have related. In the first scene Luca represented Donatus teaching grammar; in the second, Plato and Aristotle, for philosophy; in the third is a man playing the lute, for music; the fourth is Ptolomæus, for astrology; and the fifth

[1] Begun in 1447.

Euclid, for geometry.[1] These subjects in finish grace and design were a considerable advance on the two done by Giotto, who, as I have said, represented Apelles at work, for painting, and Phidias with his chisel, for sculpture. The wardens being thus made cognisant of Luca's worth and persuaded by M. Vieri de' Medici, then a prominent popular citizen who was very fond of Luca, entrusted to him the marble ornamentation of the organ which was being constructed on a large scale, to be placed over the door of the sacristy of the church.[2] For the base of this work Luca made scenes representing choirs of music singing in various ways, and he worked so cunningly and achieved such success that, although it is sixteen braccia from the ground, one may perceive the swelling of the cheeks of the singers, the beating of the hands of the director of the music on the shoulders of the lesser ones, and, in short, the various ways of playing, singing, dancing and other pleasant actions which constitute the charm of music. Above the framework of this decoration Luca made two figures of gilt metal representing two nude angels, beautifully finished, as indeed was the whole work, which was considered most rare. It is true that Donatello, who afterwards did the ornamentation of the other organ opposite this one, displayed much more judgment and skill than Luca, as will be said in the proper place, because he did almost the whole of the work in the rough as it were, not delicately finishing it, so that it should appear much better at a distance than Luca's; as it does, for with all his care and skill the eye cannot appreciate it well because of the very polish and finish, which are lost in the distance, as it can the almost purely rough hewn work of Donato. To this matter artists should devote much attention, because experience shows that all things seen at a distance, whether they be paintings or sculptures or any other like thing, are bolder and more vigorous in appearance if skilfully hewn in the rough than if they are carefully finished. Besides the effect obtained by distance, it often happens that these rough sketches, which are born in an instant in the heat of inspiration, express the idea of their author in a few strokes, while on the other hand too much effort and diligence sometimes sap the vitality and powers of those who never know when to leave off. Anyone who realises that all the arts of design, and

[1] Allotted 1437 and finished 1440. The man playing the lute represents Orpheus; Astronomy and Geometry are shown together, and Vasari omits Tubal Cain.
[2] Commissioned 1431, and set up 28 August, 1438.

not painting alone, are allied to poetry, also knows that as poems composed in a poetic fervour are the true and genuine, and far better than those produced with effort, so the works of men who excel in the arts of design are better when they are the result of a single impulse of the force of that fervour than if they are produced little by little with toil and labour. The man who knows already from the first what he is going to do, as should always be the case, invariably proceeds on his way towards perfect realisation with great ease. At the same time, since men are not all of one stamp, there are some, though they are rare, who do not do well unless they go slowly. Not to speak of painters, it is said among poets that the Very Rev. and learned Bembo expends months and even years of effort to make a sonnet, so that it is small wonder if this should sometimes be the case in our arts. But for the most part the contrary is the rule, as I have said above; and yet the vulgar prefer a certain external and apparent delicacy, where the lack of what is essential is concealed by the care bestowed, to a good work produced with reason and judgment but not so smooth or so highly finished.

But to return to Luca. He finished this work, which gave great satisfaction, and was then commissioned to do the bronze door of the sacristy,[1] which he divided into ten compartments, five on each side. At each corner he placed a man's head, all of them being different: youths, old men, men of middle age, bearded, clean shaven, in fact, every variety and all good of their kind, so that the framework is most ornate. In the scenes for the panels, beginning from the top, he represented a Madonna of wonderful grace, with the Child in her arms, and the resurrection of Christ from the tomb. Beneath these, in each of the first four panels, is the figure of an Evangelist, and under them are the four Doctors of the Church who are writing in various attitudes. All this work is so clear and so highly finished that it is a marvel, and it shows the advantage to Luca of his early training as a goldsmith. On the completion of these things he made an estimate of what he had gained upon them, and of the time which he had expended in making them, and came to realise how slight had been his advantage, and how great his labour. Accordingly he determined to abandon marble and bronze, and to see if he could derive greater advantage from other methods. It then occurred to him that clay can be manipulated with ease and little trouble, and that the only thing

[1] In 1446, in conjunction with Michelozzo and Maso di Bartolommeo. Payments continue up to 1468; all the work was done by Luca.

required was to discover a means whereby work produced in this material could be preserved a long time. By dint of many experiments he discovered a method of protecting it from the injury of time, for he found that he could render such works practically imperishable, by covering the clay with a glaze made of tin, litharge, antimony and other materials, baked in the fire in a specially constructed furnace. For this method, of which he was the inventor, he won loud praises, and all succeeding ages are under an obligation to him.

Having thus succeeded in attaining his purpose, Luca's first work was for the tympanum over the bronze door which he had made for the sacristy of S. Maria del Fiore, beneath the organ; this being a Resurrection of Christ of such beauty that when it was set up it was admired as a work of great value.[1] The wardens immediately desired him to do another for the tympanum of the door where Donatello had made the ornament of the organ.[2] Accordingly Luca made a very fine representation of Jesus Christ ascending to heaven. Now this method, beautiful and useful as it was (especially for places where there is water, and where on account of damp and other reasons there can be no pictures), did not satisfy Luca, and he found a means of improving it. Whereas his first works were simply white, he now introduced colour into them to the wonder and admiration of everyone. Among the earliest to employ Luca upon works in coloured clay was the magnificent Piero di Cosimo de' Medici, for whom he decorated with various fancies, in half-relief, the whole of the vaulting of the scriptorium in a palace built, as I shall relate, by Cosimo, his father, and also the pavement, a remarkable work and very cool in summer. It is certainly wonderful that, although this method was then very difficult, the utmost care being required in baking the clay, Luca should have brought this work to such a pitch of perfection that the vaulting as well as the pavement look as if they were made of a single piece only.

The fame of these things spread not only throughout Italy but all through Europe, and to such an extent that the Florentine merchants kept Luca constantly employed, to his great advantage, sending his works to every part of the world. And because he could not satisfy all their demands by himself, he took away his brothers, Ottaviano and Agostino, from the chisel and set them to do this work, at which they all gained far more than they had hitherto done in sculpture. Besides the

[1] In 1443. [2] In 1446.

works which they sent to France and Spain, they also did many things in Tuscany, notably the very handsome vaulting with octagonal ornaments of the marble chapel in the church of S. Miniato a Monte for Piero de' Medici, which rests upon four columns in the middle of the church.[1] But the most remarkable work of this kind which issued from his hands was the vaulting of the chapel of St. James in the same church, where the cardinal of Portugal is buried.[2] In this, although it is without sharp angles, they made the four Evangelists in four medallions at the corners, and in the middle the Holy Spirit, in a medallion, filling the remainder of the space with scales which cover the vault and diminish gradually as they approach the centre. Nothing of the same kind could be better, nor could any constructive work be more carefully carried out. In a small arch over the door of the church of S. Piero Buonconsiglio, below the Mercato Vecchio, he did a Madonna surrounded by angels in a very life-like manner. Over the door of a little church near S. Pier Maggiore he did another Madonna, in a half-circle, and some angels, which are considered very fine.[3] Again, in the chapter-house of S. Croce, erected by the family of the Pazzi under the direction of Pippo di ser Brunellesco, he did all the figures in terra cotta, both within and without.[4] It is said that Luca sent some very fine figures in full relief to the King of Spain, together with some works in marble. For Naples he made in Florence the marble tomb for the infant brother of the Duke of Calabria, decorated with many ornaments in terra cotta, a work in which he was assisted by his brother Agostino. Luca next endeavoured to discover a method of painting figures and subjects in the flat in terra cotta, in order to impart life to his representations. As an experiment he did a medallion which is over the niche of the four saints on the exterior of Or. S. Michele. On this flat surface he gave five examples of the tools and insignia of the handicraftsmen, with very beautiful ornamentation. He did two other medallions in the same place, in relief, one of Our Lady for the art of the apothecaries, and in the other, for the merchants, he made a lily above a bale, surrounded by a festoon of flowers and leaves of various kinds, so well done that they look quite natural and not like painted terra cotta.[5] For

[1] In 1448.

[2] The chapel was built in 1462. The medallions contain Virtues; the four Evangelists were done by Luca for the similar work of S. Giobbe, Venice.

[3] Now in the Bargello.

[4] The Pazzi Chapel was begun in 1429 and completed 1443.

[5] The first medallion is over Nanni di Banco's four saints; the Madonna was done about 1465; the lily in 1463 over Verocchio's St. Thomas.

M. Benozzo Federighi, bishop of Fiesole, he made a marble tomb in the church of S. Brancazio, with the recumbent effigy of the bishop upon it, from life, and three other half-length figures.[1] In the ornamentation of the pilasters of this work he painted on the flat some festoons made up of fruits and flowers, and so natural that it would be impossible to do better with a brush and colours. Indeed, this work is a marvel and most rare, for Luca has made the lights and shades so well that one would imagine it impossible to obtain such results from the fire. If this artist had lived longer we should have seen even greater things issue from his hands, because shortly before his death he had begun to make scenes and to paint figures on flat surfaces, some pieces of which I have seen in his house, which have led me to believe that he would have succeeded had not death, which always snatches away the best when they are about to make some improvement in the world, deprived him of life before his time.

Luca's brothers, Ottaviano and Agostino, survived him, and the latter had a son, another Luca, who was a very learned man in his day. Agostino took up the art after Luca, and in the year 1461 he made the façade of S. Bernardino at Perugia, introducing three subjects in bas-relief, and four finely executed figures in full relief, beautifully finished. To this work he signed his name thus: AGUSTINI FLORENTINI LAPICIDÆ.

Andrea,[2] Luca's nephew, a member of the same family, was an excellent workman in marble, as may be seen in the chapel of S. Maria delle Grazie outside Arezzo, where he made for the community many small figures in full and in half-relief on a large marble ornament which was made for a Virgin by the hand of Parri di Spinello of Arezzo. Andrea also did the terracotta slab for the Chapel of Puccio di Magio in S. Francesco in that city, and that of the Circumcision for the family of the Bacci. Again, in S. Maria in Grado, there is a very fine slab by his hand with a number of figures, and on another slab at the high altar in the company of the Trinity is a God the Father, by him, supporting with His arms the crucified Christ, surrounded by a multitude of angels, while St. Donato and St. Bernard kneel beneath. He also did a number of bas-reliefs in the church and other places of the Sasso della Vernia, which have been preserved in that desert place, where no painting could have

[1] Federighi died in 1450; the tomb was commissioned 1455; it has been in the Trinità since 1890.
[2] 1435-1525.

endured for a moment. Andrea also worked in Florence, doing all the terra-cotta figures which are on the loggia of the hospital of S. Paolo, as well as the babes both naked and in swaddling clothes which are in the medallions between the arches on the loggia of the hospital of the Innocents,[1] all of which are truly admirable and display his great talents. Besides these things he did an infinite number of other works in the course of his life, which lasted eighty-four years. Andrea died in the year 1528, and when I was a child I remember that he said to me that he had been one of those who carried Donato to his grave, and I recall with what pride the worthy old man spoke of this. But to return to Luca. He was buried among his people in the family tomb in S. Pier Maggiore, where Andrea was afterwards laid. The latter left two sons, who were friars in S. Marco under the reverend Frà Girolamo Savonarola, whom the della Robbia always greatly reverenced, and they made his portrait in the same way in which it may still be seen in the medals. Besides these two friars Andrea had three other sons, Giovanni, who devoted himself to art, and Luca and Girolamo, who were sculptors. Giovanni had three sons, Marco, Lucantonio and Simone, who all died of the plague in the year 1527, and who had shown much promise. Luca was very diligent with the terra cotta, and, in addition to a number of other works, he made the pavement of the papal loggia which were erected in Rome by Pope Leo X., under the direction of Raphael of Urbino, and that of many other chambers where he introduced that Pope's device. Girolamo, the youngest of all the brothers, devoted himself to working in marble, in terra cotta, and in bronze, and had already made himself very proficient in competition with Jacopo Sansovino, Baccio Bandinelli, and other masters of his time, when he was taken to France by some Florentine merchants. There he did a number of works for King Francis at the Madrid, a place not far from Paris, and notably a palace with many figures and other ornaments made of a stone resembling our own limestone of Volterra, but of a better quality, because it is soft to work and hardens with time. He also did many works of terra cotta at Orleans, and in every part of that kingdom, acquiring a great reputation and much wealth. Learning that Luca, his brother, was the only member of his family left in Florence, and being himself rich and alone in the service of King Francis, he sent for him, hoping to leave him prosperous and in good credit. But this design was frustrated, for Luca

[1] Done 1463-6.

died a short while after, and Girolamo was once more left solitary. Accordingly he determined to return home, there to enjoy the riches which he had amassed by his toil and sweat, and also to leave some memorial of himself there. He came to live in Florence in the year 1553, but was practically forced to change his plan, because Duke Cosimo, from whom he hoped to obtain honourable employment, became engaged in the war with Siena. Accordingly Girolamo returned to die in France, and not only did his house die out and his family become extinct, but art was deprived of the knowledge of the proper method of glazing; because, although that kind of sculpture has been occasionally practised since their time, yet no one has ever approached the excellence attained by the elder Luca, Andrea, and the other members of the family.

If I have dilated upon these matters more than may appear necessary, I hope everyone will excuse me, because, since Luca discovered this new kind of sculpture, which the Romans, so far as we know, did not possess, it was necessary to speak of it at length as I have done. If after completing Luca's life I have dealt succinctly with his descendants, down to our own day, it is in order that I may not have to refer to the matter again. Thus Luca, in passing from one thing to another, from marble to bronze and from bronze to clay, did not do so from slothfulness or because he was capricious, unstable and discontented with his art, as many are, but because Nature led him on to new things, and because of his need for an employment suited to his taste, which should cause him less fatigue and bring him more profit. Thus it was that he came to enrich the world and the art of design with a new art, both useful and beautiful, while he won glory and immortal fame for himself. Luca was an excellent and graceful draughtsman, as may be seen in some sheets in our book—the lights being in white lead—one of which contains his portrait by his own hand, executed with great diligence with the aid of a mirror.

PAOLO UCCELLO, Painter of Florence
(1397–1475)

PAOLO UCCELLO [1] would have been the most delightful and imaginative genius since Giotto that had adorned the art of painting, if he had devoted as much pains to figures and animals

[1] His name was Paolo Doni.

as he did to questions of perspective, for, although these are ingenious and good in their way, yet an immoderate devotion to them causes an infinite waste of time, fatigues nature, clogs the mind with difficulties, and frequently renders it sterile where it has previously been fertile and facile. In cases where an artist devotes more attention to this than to his figures, there arises a dry style full of profiles, generated by the desire of sifting things too thoroughly, in addition to which he frequently becomes solitary, eccentric, melancholy and poor. This was the fate of Paolo Uccello, who, being endowed by Nature with a sophistical and subtle disposition, took pleasure in nothing except the investigation of difficult and impossible questions of perspective; and although these were fanciful and fine, yet they affected his treatment of figures so much that they became worse and worse as he grew older. There is no doubt that he did violence to Nature in these too exacting studies, and although on the one hand they rendered his mind more subtle, yet his works were destitute of that facility and grace which belongs naturally to those who guide their energies in the proper direction with an intelligence full of good judgment, and who avoid a certain subtlety which quickly results in work that has something painful, dry, laboured and in bad style, exciting the compassion of the spectator rather than his admiration. Inspiration demands the active co-operation of the intellect joined with enthusiasm, and it is under such conditions that marvellous conceptions, with all that is excellent and divine, come into being. But Paolo, without ever wasting a moment, was always attracted by the most difficult things of art, and brought to perfection the method of representing buildings, to the tops of their cornices and roofs, in perspective from their plans and elevations. This was done by intersecting lines, diminishing at the centre; the point of view, whether high or low, being first decided. He laboured so hard over these difficulties that he invented a method and rules for planting figures firmly on their feet and for their gradual foreshortening and diminution in proportion as they recede, a matter that was previously left to chance. He also discovered the method of tracing the ribs and arches of vaulting, the foreshortening of floors by diminishing the receding beams, and the way to make round columns follow the turn made by the sharp corner of a house, doing this from a ground plan. When engaged upon these matters Paolo would remain alone, like a hermit, with hardly any intercourse, for weeks and months, not allowing himself to be seen. But although

these things were difficult and fine, yet if he had spent the same time in the study of figures, which he could make with a very good design, he would have arrived at perfection, whereas, by wasting his time on these notions, he remained more poor than famous throughout the course of his life. Thus, when Paolo showed his intimate friend, Donatello the sculptor, mazzocchi[1] with projecting points and bosses, represented in perspective from different points of view, spheres with seventy-two facettes like diamonds, and on each facette shavings twisted round sticks, with other oddities upon which he wasted his time, the sculptor would say, "Ah, Paolo, this perspective of yours leads you to abandon the certain for the uncertain; such things are only useful for marquetry, in which chips and oddments, both round and square, and other like things, are necessary."

The first paintings of Paolo were in fresco in an oblong niche in the hospital of Lelmo, where he represented St. Anthony, the abbot, between SS. Cosmo and Damian, in perspective. In the Annalena nunnery he did two figures, and over the left door inside the church of S. Trinità he did stories of St. Francis, such as his receiving the stigmata, his support of the church on his shoulders, and his encounter with St. Dominic. In S. Maria Maggiore, in the chapel next the side door which leads to S. Giovanni, where are the picture and predella of Masaccio, he did an Annunciation in fresco, containing a house which deserves notice, a new and difficult thing in that day, because it was the first work which showed to artists in a good style how lines may be made to diminish towards the vanishing-point with grace and proportion, and demonstrated how a small and insignificant space on a plain surface may be made to appear large and remote, and those who are able to add the lights and shadows to this in their proper places cause a veritable illusion to the eye, so that a painting is made to appear real and in relief. Not satisfied with this achievement, he was anxious to represent a more difficult thing in some columns foreshortened in perspective, which bend round and break the sharp angle of the vaulting, where the four Evangelists are, a thing which was considered fine and difficult, and indeed Paolo was ingenious and proficient in that profession. In S. Miniato, outside Florence, he did the cloister partly in *verde terra* and partly in colour, representing the lives of the Holy Fathers, in which he did not

[1] Mazzocchio is described as a coronet furnished with spikes or bosses, set over a coat of arms, or as a hoop of wood covered with cloth, which surrounds the upper part of the head.

carefully observe a proper consistency in the employment of his colours, for he made his fields blue, his city red, and his buildings of various hues according to his fancy. In this he was at fault, for buildings which are represented to be of stone cannot and ought not to be coloured of another tint. It is said that, while Paolo was engaged upon this work, the abbot of the place gave him hardly anything but cheese to eat. Tired of this treatment, Paolo, being a shy man, determined that he would no longer go there to work. When the abbot sent for him, and when he heard the friars asking for him, he was never at home; and if he met by accident any members of the order in Florence, he took to flight as fast as he could in order to escape them. One day two of the more curious among them, younger than himself, caught him up, and asked why he did not return to finish the work which he had begun, and why he ran away when he saw the friars. Paolo replied, "You have reduced me to such a condition that not only do I run away from you, but I am unable to work or to pass by places where carpenters are. This is entirely due to the thoughtlessness of your abbot, who, by means of his dishes and soups, which are always made with cheese, has put so much cheese into my body, that as I consist entirely of that commodity, I am in terror lest they should take me to turn into glue. If I went on any longer at this rate, I should soon be not Paolo, but cheese." The friars left him, laughing loudly, and related all to the abbot, who induced him to return to work, and provided other food for him besides cheese. In the chapel of S. Girolamo of the Pugliesi in the Carmine he painted the altar front of SS. Cosmo and Damian. In the house of the Medici he painted some scenes of animals in tempera on canvas. He always delighted to paint animals, and took the utmost pains to do so well. His house was always full of painted representations of birds, cats, dogs and every sort of strange animal of which he could get drawings, as he was too poor to have the living creatures themselves. His favourite animals were birds (*uccelli*), and from this circumstance he derived his name, Paolo Uccelli. In the same house, among other scenes of animals, he made some lions fighting each other with such terrible vigour and fury that they seem alive. Among many other scenes there is one particularly remarkable of a serpent fighting with a lion, and showing fury in its powerful movements and the poison which it is shooting from its mouth and eyes, while a little country girl hard-by is looking after an ox, beautifully foreshortened. The design for this drawing, by Paolo's own hand,

is in our book as well as that of the peasant girl who is in the act of running away from the animals in her fright. The same scene contains some very life-like shepherds, and a landscape which was considered a very fine thing in its day. On some other canvasses he made scenes of men-at-arms of the time on horse-back, comprising a goodly number of portraits. He was after-wards allotted some scenes in the cloister of S. Maria Novella.[1] The first of these is in the way from the church to the cloister, and represents the creation of the animals, with an infinite number of different creatures, birds, beasts and fishes. He was, as I have said, very fanciful, and took great delight in making animals well, showing the pride of some lions, eager to fight, the fleetness and timidity of certain stags and bucks, in addition to which the birds and fishes with their feathers and scales are most realistic. Here also he made the Creation of man and of woman, with their Fall, in a beautiful style, carefully and finely executed. In this work he took pleasure in the colouring of the trees, which had not usually been well done up to that time. He was the first among the old painters who won a name for doing landscapes well, and he brought this branch of art to a greater pitch of perfection than his predecessors. It is true that those who succeeded him made them more perfectly, because with all his efforts he never succeeded in giving them that softness and unity achieved in the oil-paintings of our own day. But Paolo was absorbed by his questions of perspective, and continued to persevere with his vanishing-point, doing everything which he saw: fields, arable land, ditches and other details of Nature in his dry, sharp style, whereas if he had picked out what was good and had worked specially at those things which turn out well in pictures, his works would have been among the most perfect. When he had completed this task, he worked in the same cloister beneath two scenes by the hands of other artists, painting the Flood and Noah's ark, representing the dead, the tempest, the fury of the winds, the flashes of lightning, the rooting up of trees, and the terror of men with such pains, and with so much art and diligence, that it is impossible to praise it too highly. In perspective he has represented a dead body, foreshortened, whose eyes are being pecked out by a crow, and a drowned child, whose body, being full of water, is arched up. He further represented various human emotions, such as the disregard of the water by two men fighting on horseback, the extreme terror of death of a woman and a man who are riding

[1] About 1446.

a buffalo; but as his hind-parts are sinking they are despairing of all hope of safety. The work is of such excellence that Paolo acquired the greatest fame from it. His use of perspective in this, in the diminution of figures, the representation of large masses and other things, is certainly very striking. Under this scene he painted Noah's drunkenness and the irreverence of Canaan his son, introducing the portrait of his friend Dello, painter and sculptor of Florence, with Shem and Japhet, who are covering his shame. Here in perspective he made a cask, the curved lines being considered very fine. Here also is a trellis-work covered with grapes, the squares of which diminish towards the vanishing-point; but he was at fault, because the diminution of the lower plane, where the feet of the figures are set, follows the lines of the trellis, and the cask does not follow the same vanishing-lines. I am amazed that so accurate and diligent a man should have fallen into such an error. He further made the sacrifice of Noah, the ark being open in perspective, with ranges of perches in the upper parts divided into regular rows where the birds are stationed, which fly out in flocks foreshortened in several directions. In the air appears God the Father above the sacrifice which Noah and his sons are making. This is the most difficult figure represented by Paolo in all his works, because it is flying towards the wall with the head foreshortened, and it has such force, and is in such strong relief, that it has the appearance of forcing its way through. Besides this, Noah is surrounded by a large number of different animals of great excellence. In fact Paolo imparted such softness and grace to all this work that it is beyond comparison superior to all his others, being praised not only at that time, but much admired to-day. In S. Maria del Fiore, in memory of Giovanni Acuto, an English captain of the Florentines, who died in the year 1393, he made a remarkably fine horse of exceptional size in *terra verde* surmounted by the figure of the captain in chiaroscuro of the colour of *terra verde*, forming part of a picture ten braccia high, in the middle of one side of the church, where he drew a large sarcophagus in perspective as if the body was inside, the mounted figure, armed as a captain, being above this.[1] The work was considered a very fine example of that kind of painting, and is still so esteemed, and if Paolo had not represented the horse as moving his legs on one side only, a thing horses cannot do without falling, the work would be perfect. The error probably was due to the fact that he could not ride, and had no practical knowledge

[1] Sir John Hawkwood died 17 March, 1394. The work was done in 1436.

of horses as of other animals. The perspective of the horse, which is very large, is fine, and on the pedestal is the inscription PAOLI UCCELLI OPUS. At the same time, and in the same church, over the principal doorway he painted in colours the dial of the hours, with four heads at the corners, coloured in fresco. He also did in *verde terra* [1] the loggia overlooking the garden of the monastery of the Angeli, and facing westward, representing under each arch a scene from the life of St. Benedict the abbot, including the most noteworthy events of his life until the time of his death. Among a number of striking incidents, there is one where a monastery has fallen through the machinations of the devil, and under the stones and timbers lies a dead friar. No less noteworthy is the terror of another monk, round whose naked form, as he flies, the draperies flutter in most graceful folds. The work has so greatly influenced the ideas of artists that they have always imitated this device. Very beautiful also is the figure of St. Benedict in the act of raising the dead friar, with gravity and devotion, in the presence of all his monks. In fact, all these scenes contain things that are worthy of attention, especially in some instances where the perspective has been carried out to the very slates and tiles of the roof. In the death scene of St. Benedict there are some remarkably fine representations of infirm and decrepit people, who have come to see him, while the monks are making his obsequies and lamenting. Among all these men so affectionate and devoted to the saint, there is a remarkable figure of an old monk with crutches under his arms, who displays admirable feeling and possibly hopes to recover his health. Although this work contains no coloured landscapes and not many buildings or difficult perspectives, yet the design is large and there is much that is good. Many houses of Florence possess a number of small pictures in perspective for the sides of couches, beds and other things, by Paolo's hand, and there are some battle scenes by him in four pictures on wood at Gualfonda, on a terrace in the garden, which belonged to the Bartolini, containing horses and armed men in the apparel of the time.[2] Among the men are portraits of Paolo Orsino, Ottobuono da Parma, Luca da Canale, and Carlo Malatesta, lord of Rimini, all commanders of that time. These pictures being damaged, and having suffered a

[1] Green earth, used as a pigment—it is silicious earth coloured by protoxide of iron.
[2] Three of these battle scenes are in public galleries: the Uffizi, the Louvre and the National Gallery. They are supposed to represent the battle of S. Romano, fought in 1432.

good deal, were restored in our own day by Giuliano Bugiardini, who has done them more harm than good. Paolo was taken by Donato to Padua, when the latter was working there, and painted some giants at the entry of the house of the Vitali, in *verde terra*, which are so good that Andrea Mantegna thought very highly of them, as I have found from a Latin letter written by Girolamo Campagnolo to M. Leonico Tomeo, the philosopher. The vaulting of the Peruzzi was done by Paolo in fresco, by triangles in perspective, and in the corners he painted the four elements, associating an appropriate animal with each: with earth a mole, with water a fish, with fire a salamander, and with air a chameleon, which lives upon it and can assume every colour. Having never seen a chameleon, he displayed a remarkable simplicity in representing it as a large and awkward camel swallowing air, though it is really like a small shrivelled lizard. It is certain that Paolo's labours in painting were very severe, for he designed so much that he left his chests full of drawings to his relations, as they have themselves informed me. But although it is undoubtedly a good thing to make designs, yet it is better to carry them out in practice, for large works enjoy a longer life than sheets of drawings. Our book contains a quantity of figures, perspectives, birds and wonderfully fine animals, but the best thing of all is a *mazzocchio* drawn in outline only, but so fine that only Paolo's patience could have accomplished it. Eccentric as he was, Paolo loved talent in artists, and in order that he might leave a memorial of them to posterity, he drew the portraits of five of the most distinguished on a long panel and kept it in his house.[1] One was Giotto, as the light and father of the art, then Filippo di ser Brunnelleschi for architecture, Donatello for sculpture, himself for perspective and animals, and his friend Giovanni Manetti for mathematics, with whom he frequently talked and argued on questions of Euclid. It is said that, upon his being commissioned to do a St. Thomas examining the wounds of Christ, over the door of that saint in the Mercato Vecchio, he devoted all his abilities to the task, saying that he wished it to be a proof of his worth and knowledge. Accordingly he shut it round with a hoarding so that no one should see it until it was finished. One day he fell in with Donato, by himself, who asked, "What is this work of yours which you are keeping so close?" Paolo simply said, "You shall see." Donato would not press him to say more, and expected, as usual, to see a miracle when the time came. One morning, when

[1] Now in the Louvre; critics attribute it to Antonello da Messina.

Donato happened to be in the Mercato Vecchio buying fruit, he saw Paolo uncovering his work, and went up courteously to greet him. Paolo, who was curious to hear his opinion, asked him what he thought of the picture. After Donato had made a good inspection of it he said, "Ah, Paolo, now that you ought to be covering it up, you uncover it." This criticism made Paolo very sad, for he had obtained much more blame for this last labour of his than he had expected praise, and being thoroughly discouraged he would not venture out, but shut himself up in his house, devoting himself to perspective, which left him in poverty and obscurity to the end of his days. Arrived at a great age, with little comfort for his advanced years, he died in the eighty-third year of his life, in 1432, and was buried in S. Maria Novella. He left a daughter who could design, and a wife who used to say that Paolo would remain the night long in his study to work out the lines of his perspective, and that when she called him to come to rest, he replied, "Oh what a sweet thing this perspective is!" And in truth, if it was sweet to him, his labours have rendered it no less dear and useful to those who have practised it after him.

LORENZO GHIBERTI, Painter of Florence
(1378–1455)

THERE is no doubt that those who attain to fame among men by means of some gift usually afford a most blessed light of example to many who arise after them and to those who live in the same age, while, in addition to this, they earn infinite praise and extraordinary rewards in their lifetime. There is nothing which more excites the minds of men, and which makes the difficulties of study appear less irksome, than the honour and benefit which afterwards accrue from the sweat of virtue; thus difficult undertakings are rendered easy to everyone, and a noble ambition inflames men to greater efforts in order to earn the praises of the world. Great numbers of those who hear and see what has been accomplished set themselves to work to earn what their countrymen have won, and this was the reason why in ancient times the virtuous were rewarded with riches, or honoured with triumphs and statues. But, as it rarely happens that merit is not persecuted by envy, it is necessary to endeavour

to overcome this so far as is possible by extreme excellence, or that men should fortify themselves to resist its attacks. In this Lorenzo di Cione Ghiberti, otherwise di Bartoluccio, was eminently successful, both by his merit and his good fortune, for Donato the sculptor, and Filippo Brunelleschi the architect, both excellent artists and his contemporaries, admitted that he was a better master in casting than they were, however natural it would have been for them to say the contrary. This indeed redounds to their glory and the confusion of many who presumptuously push themselves to the front to the exclusion of men of ability, and after painfully labouring a thousand years to make one thing, produce nothing and merely disturb and harass the skill of others by their malignity and envy.

Lorenzo was the son of Bartoluccio Ghiberti, and learned the art of a goldsmith with his father from his earliest years, for the latter was an excellent workman, and taught his son that trade, so that he was soon surpassed by his pupil. But Lorenzo took far more pleasure in the art of sculpture and of design, sometimes using colours, and at other times making small figures of bronze, finishing them with much grace. He was also very fond of imitating the dies of antique medals, and made the portraits of many of his friends. Whilst he was working with Bartoluccio and endeavouring to become proficient in that profession, the plague broke out in Florence in the year 1400, as he himself relates in a book he has written upon matters relating to the arts, which is in the possession of the venerable M. Cosimo Bartoli, a nobleman of Florence. In addition to the plague, many civil discords and other troubles were rife in the city, obliging him to leave it, and he set out in company with another painter to the Romagna. At Rimini he painted a chamber for the Sig. Pandolfo Malatesta, and did many other works which were carefully finished, giving great satisfaction to Pandolfo, who, while still a youth, took great delight in matters of design. Lorenzo, however, continued to pursue his study of design, and to work in relief in wax, stucco, and other like things, knowing that such small reliefs are a sculptor's method of drawing, and that without them it is impossible to attain to perfection. He had not been long absent from home when the plague ceased, and the Signoria of Florence and the art of the merchants, seeing that there were a number of excellent artists in sculpture at that time, both foreigners and Florentines, thought that it would be a favourable opportunity to make the other two doors of S. Giovanni, the ancient and principal

church of the city, a matter which had frequently been dis-
cussed. It was arranged by them that all the masters considered
to be the best in Italy should be invited to come to Florence
to compete in making bronze panels similar to those which
Andrea Pisano had done for the first door. Bartoluccio wrote
to inform Lorenzo of this decision, for he was then working at
Pesaro, and advised him to return to Florence to show what
he could do, that this was an excellent opportunity for him to
make his name and to show his ability, in addition to which he
might turn the matter to such advantage that neither of them
would need to work any longer at making earrings. The words
of Bartoluccio so moved Lorenzo that, despite the favours heaped
upon him by Pandolfo, by the painter, and by all the court,
Lorenzo obtained leave from that lord to depart, and bid fare-
well to the painter, although they were very sorry and reluctant
to let him go. Their promises and offers of higher wages availed
nothing, for to Lorenzo it seemed worth a thousand years to
return to Florence, and he accordingly set out and reached his
home in safety. Many foreigners had already arrived and reported
themselves to the consuls of the arts. From among them seven
masters in all were selected: three Florentines, and the remainder
Tuscans. A provision of money was set apart for them, and it
was stipulated that within a year each of them should produce,
as an example of his skill, a bronze panel of the same size as
those of the first door. It was determined that the scene repre-
sented should be the sacrifice of Isaac by Abraham, which was
considered to be a good subject in which the masters could
grapple with the difficulties of the art, because it comprises a
landscape, figures both nude and draped, and animals, while
the figures in the foreground might be made in full relief, those
in the middle distance in half-relief, and those in the back-
ground in bas-relief. The competitors for this work were:
Filippo di ser Brunellesco, Donato and Lorenzo di Barto-
luccio, Florentines, and Jacopo dalla Quercia of Siena, Niccolo
d'Arezzo his pupil, Francesco di Vandabrina,[1] and Simone da
Colle, surnamed "of the bronzes," who all promised the consuls
to have their panels ready at the appointed time. They set to
work and devoted all their study and diligence, all their strength
and knowledge, to surpass each other, keeping what they did
a close secret, so that they might not light upon the same ideas.
Lorenzo alone, who enjoyed the help of Bartoluccio, who made
him take great pains and prepare many models before he resolved

[1] Valdambrino.

upon adopting any one of them, continually brought his fellow-citizens, and also passing strangers if they understood the trade, to see his work and hear their opinion. By the aid of their criticisms he was enabled to produce a model which was beautifully made and absolutely without a fault. Having shaped his figures and cast the whole in bronze, it proved excellent; and he and his father, Bartoluccio, polished it with such devotion and patience that it was impossible for it to have been better finished. When the time arrived for it to be exhibited in the competition, his panel and those of the other masters were handed over to the art of the merchants to be adjudicated upon. When they came to be examined by the consuls and several other citizens many various opinions were expressed. Numbers of strangers had assembled in Florence, some painters, some sculptors, and some goldsmiths, who were invited by the consuls to come and judge the works in conjunction with others of the same professions who lived in Florence. They numbered thirty-four persons in all, each of them being an adept in his art, and although there were differences of opinion among them, some preferring the style of one and some that of another, yet they were agreed that Filippo di ser Brunellesco and Lorenzo di Bartoluccio had composed and finished a larger number of figures better than Donato had done, although his panel exhibited great powers of design. In that of Jacopo dalla Quercia the figures were good but lacking in delicacy, in spite of the good design and the care bestowed. The work of Francesco di Vandabrina contained good heads and was well finished, but the composition was confused. That of Simone da Colle was a good cast, because he was a founder by profession, but the design was not very good. The production of Niccolo d'Arezzo, showing great skill, was marred by stunted figures and absence of finish. Lorenzo's alone was perfect in every part, and it may still be seen in the audience chamber of the art of the merchants. The whole scene was well designed and the composition excellent, the figures being slender and graceful, the pose admirable and so beautifully finished that it did not look as if it had been cast and polished, but rather as if it had been created by a breath. Donato and Filippo, when they perceived what diligence Lorenzo had devoted to his work, withdrew to one side and agreed that the work ought to be given to him, for it seemed to them that public and private interests would thus be best served, and as Lorenzo was a young man, not past twenty, he would be able to realise in the production of this work the great

promise of his beautiful scene, which, according to their judgment, he had made more excellently than the others, adding that it would be more shameful to dispute his right to pre-eminence than generous to admit it. Accordingly Lorenzo began on that door opposite the opera of S. Giovanni,[1] constructing a large wooden frame for a part of it of the exact size he desired, in the shape of a frame with the ornamentation of heads at the angles about the spaces for containing the scenes and the surrounding friezes. After he had made the mould and dried it with all diligence, he set up a huge furnace, which I remember having seen, and filled the frame with metal. He did this in some premises he had bought opposite S. Maria Nuova, where the hospital of the weavers, known as the Threshing-floor, now stands. But realising that all was not going well, he did not lose courage or become distracted, but traced the cause of the disorder and altered his mould with great quickness without anyone knowing it, recasting the work, which came out most successfully. He went on similarly with the rest of the work, casting each scene separately, and then putting them in their appointed places. The division of the scenes was similar to that adopted by Andrea Pisano in the first door designed for him by Giotto. He represented twenty scenes from the New Testament, and beneath these he left eight spaces. Beginning from the bottom he made the four Evangelists, two on each door, and then four Doctors of the Church, similarly arranged, differing from each other in their attitudes and draperies, one writing, one reading, the others reflecting, and in their varied expressions they are very life-like and excellently made. In the framework about the scenes is a border of ivy leaves and other things, which are set in the framework, and at each corner is the head of a man or a woman in full relief, representing prophets and sibyls, all very good in their variety, and displaying the excellence of Lorenzo's genius. Above the Doctors and Evangelists already mentioned, beginning from the bottom on the side nearest S. Maria dei Fiore, there are four pictures, the first an Annunciation, in which the attitude of the Virgin exhibits terror and sudden fear as she gracefully turns herself at the coming of the angel. Next to this he made the birth of Christ, Our Lady lying down and resting while Joseph is contemplating the shepherds and angels who are singing. On the other side from this, and on the other part of the door, but on the same level, is the story of the coming of the Magi and adoration of Christ, giving Him

[1] Commissioned 23 November, 1403, completed 20 April, 1424.

tribute, comprising the court which followed them with horses and equipments, made with great skill. Next to this is Christ disputing in the Temple with the doctors, where the wonder and attention of the doctors who are listening to Him are no less finely expressed than the joy of Mary and Joseph at finding Him again. Returning to the other end, over the Annunciation is the scene of the baptism of Christ in the Jordan by John, the postures of the figures exhibiting the reverence of the one and the faith of the other. Beside this is the temptation of Christ by the devil, who is terrified by the words of Jesus, and is in an attitude expressive of his fear, recognising that He is the Son of God. Next to this, on the other part, is Christ driving out the changers from the Temple, overthrowing their money, victims for sacrifice, doves, and other merchandise, where the figures of some men who are falling over each other in their flight are very graceful and well imagined. Next to this Lorenzo put the shipwreck of the Apostles, where Peter leaves the boat and is sinking in the water, while Christ upholds him. This scene is remarkable for the varied attitudes of the Apostles who are at work in the ship, and the faith of Peter is expressed by his coming towards Christ. Returning to the other end once again, over the Baptism is the transfiguration on Mount Tabor, where Lorenzo expresses in the attitude of the Apostles the bedazzlement experienced by mortal eyes at the heavenly vision: Christ is displayed in His divinity between Moses and Elias, holding His head high and His arms open. Beside this is the resurrection of Lazarus, who emerges from the tomb bound hand and foot, and stands upright to the astonishment of the spectators. Martha is there and Mary Magdalene, who is kissing the feet of the Lord with the utmost humility and reverence. Next to this, on the other part, is the entry into Jerusalem on an ass, while the children of the Hebrews, in varied attitudes, throw down their garments, olive branches and palms, and the Apostles are following the Saviour. Beside this is a very fine Last Supper very well arranged, as the Apostles are seated round a long table, half of them being on one side and half on the other. Over the Transfiguration he made the Agony in the Garden, where the three Apostles may be observed sleeping in various attitudes. Next to this is Christ receiving the kiss of Judas, where there are many noteworthy things, the Apostles running away, and the Jews represented as taking Christ, with great vigour. On the other part is Christ bound to the column, His face somewhat distorted with the pain of the scourging and in a compassionable

attitude, while the Jews who are scourging Him show their terrible rage and vindictive feeling. Following this is the scene when He is brought before Pilate, who washes his hands and sentences Him to the cross. Over the Agony in the Garden and in the last row of scenes is Christ carrying the cross and going to His death, led by a fierce band of soldiers who are dragging Him along with rough gestures. Grief and weeping are expressed in the gestures of the Maries, so that had one been present it would not have been possible to realise the scene better. Besides this Lorenzo made Christ on the cross, with Our Lady and St. John the Evangelist seated on the ground in attitudes full of grief and indignation. Next to this, on the other part, is the Resurrection, the guards overcome by the thunder stand like dead men, while Christ is ascending in an attitude which has all the attributes of glorification in the perfection of His beautiful members, created by the skilful industry of Lorenzo. The last space contains the coming of the Holy Spirit, the attitudes and expectancy of those who receive it being exquisite. No time or labour was spared to make the work perfect. The limbs of the nude figures are most beautiful in every part, and although the draperies still possess something of the old-fashioned style of Giotto, yet the general tendency is towards the modern manner, and figures of this particular size possess a certain delicate gracefulness. In fine, the composition of the various scenes is so well managed that it deserves the praise originally accorded by Filippo, and even more. From his fellow-citizens Lorenzo obtained the most complete recognition of his labours, and won the highest praise from them and from all artists, both native and foreign. The entire work cost 22,000 florins, including the outside ornamentation, which is also of metal, and the festoons of fruit and animals carved there. The metal doors weighed 34,000 pounds. When the work was completed, the consuls of the art of the merchants felt that they had been very well served, and, as everyone praised Lorenzo, they proposed that he should make a bronze statue four and a half braccia high in memory of St. John the Baptist for the exterior of Or san Michele, in the niche belonging to the cloth dressers. Accordingly he began this, and never rested until he had finished it. The work has been much admired, and the artist put his name to it on the hem of the robe; it was set up in the year 1414, and shows an approach towards the good modern style in the head, in an arm, which looks as if it was actual flesh, and in the hands and the whole attitude of the

figure. He was the first to begin to imitate the masterpieces of the ancient Romans, studying them very carefully, as everyone should who wishes to become a good craftsman. For the frontis-piece of the niche he made an experiment in mosaic, introducing a half-figure of a prophet. Lorenzo's fame had already spread through all Italy and beyond as the most skilful modern founder. Accordingly, when Jacopo dalla Fonte and Vecchietto of Siena and Donato were required to decorate the baptistery of S. Gio-vanni with some scenes and figures in bronze, and as the Sienese had seen Lorenzo's work in Florence, they negotiated with him and employed him to make two scenes of the life of St. John the Baptist.[1] One of them is the baptism of Christ, comprising a quantity of nude and draped figures, very richly wrought, and the other John before Herod. In these scenes Lorenzo surpassed and vanquished the other artists there, and accordingly he received great praise from the Sienese and from others who saw them. The masters of the mint at Florence had to make a statue for one of the niches outside Or. S. Michele, opposite the art of wool, which was to be a St. Matthew of the same height as the St. John mentioned above.[2] They allotted the task to Lorenzo, who executed it to perfection, and received more praise for it than for his St. John, because it was more modern in style. This induced the consuls of the art of wool to propose that he should make another statue, also of metal, in the next niche, which should be of the same size as the others, and represent their patron, St. Stephen.[3] This he also completed, giving a fine polish to the bronze, so that it afforded no less satisfaction than his other works. At this time Maestro Leonardo Dati[4] was general of the Friars Preachers, and in order to leave a memorial of himself to his native place, in S. Maria Novella, where he had professed, he employed Lorenzo to make a bronze tomb surmounted by his effigy in the attitude of death. The praise accorded to this work led to Lorenzo being employed to make one in S. Croce for Ludovico degli Albizzi and one for Niccolo Valori. After these things Cosimo and Lorenzo de' Medici, wishing to honour the bodies and relics of the three martyrs Prothus, Hyacinth and Nemesius, had them fetched from Casen-tino, where they had remained for many years in slight esteem, and employed Lorenzo to make a metal shrine,[5] in the middle of which are two angels in bas-relief, holding a garland of olive

[1] Commissioned 1417, finished 1427.
[2] Commissioned 1419, set up 1422.
[3] In 1425. [4] Who died in 1423.
[5] Now in the Bargello, Florence.

branches encircling the names of the martyrs. The relics were deposited in this shrine, and placed in the church of the monastery of the Angeli at Florence, with these words carved in marble on the side towards the church of the monks: *Clarissimi viri Cosmas et Laurentius fratres neglectas diu Sanctorum reliquias martyrum religioso studio ac fidelissima pietate suis sumptibus aereis loculis condendas colendasque curarunt.* On the outer side, where the little church faces the street, are these words carved in the marble beneath a coat of arms with the balls: *Hic condita sunt corpora sanctorum Christi martyrum Prothi et Hyacinthi et Nemesii. Ann. Dom.* 1428. This having proved so successful, the wardens of S. Maria del Fiore became desirous of having a sarcophagus and tomb of metal constructed to receive the body of St. Zanobius, bishop of Florence, of the dimensions of three and a half braccia by two.[1] Besides the decoration of divers ornaments, Lorenzo made a scene on the body of the tomb representing the incident where the saint raises the child left in his custody by its mother, and who had died during her absence on a pilgrimage. The second scene is of another child, killed by a cart and raised by the saint, who also raises one of the two servants sent to him by St. Ambrose, who was left dead on the Alps, the other sorrowing in the presence of St. Zanobius, who is comforting him and saying, "He is sleeping; go and you will find him alive." At the back are six small angels, holding a garland of elm leaves, on which are carved some sentences in praise of the saint. This work was carried out and completed with every industry and art, so that it received extraordinary praise as a beautiful thing. While the works of Lorenzo were increasing his reputation every day, and he was engaged upon work in silver and gold as well as bronze for numberless individuals, there came into the possession of Giovanni, the son of Cosimo de' Medici, a large cornelian carved with the flaying of Marsyas by Apollo. It was said to have been used by the Emperor Nero as a seal. As the stone was large, and very valuable for its size and the wonderful carving on it, Giovanni gave it to Lorenzo to make a mount of wrought gold for it. The artist laboured at it for many months, surrounding this beautiful work with a carved ornamentation no less perfect than the carving on the stone itself. This event led him to do many more things in gold and silver, which are no longer to be found. For Pope Martin he made a gold fastening for his cope, with figures in full relief and jewels of great price

[1] Finished 1446.

among them, a most excellent piece of work. He also made a mitre, marvellously chased with gold leaves and many small figures in full relief in the midst, which was considered very beautiful, and besides the fame which he acquired he benefited considerably owing to the liberality of the Pope. In the year 1439 Pope Eugenius came to Florence to unite the Greek and Latin churches and to hold a Council. When he saw Lorenzo's works he was equally delighted with them and with the artist himself. Accordingly he employed Lorenzo to make a gold mitre for him, weighing fifteen pounds, with pearls weighing five and a half pounds, the whole, including the jewels, being valued at 30,000 gold ducats. It is said that there were six pearls like filbert nuts, and it is impossible to imagine the curious beauty of the setting of the jewels in a variety of children and other figures, forming a very graceful ornamentation as shown by the design for it. For this work Lorenzo received most hearty thanks from the pontiff for himself and his friends, besides the first payment.

Florence had acquired such celebrity by the works of the most ingenious artist that the consuls of the art of the merchants determined to assign to him the third door of S. Giovanni, to be likewise made in metal. In the case of the first door Lorenzo had, by their direction, carried out the ornamentation which surrounds the figures and binds together the framework, like that of Andrea Pisano. But now the consuls, recognising how greatly Lorenzo had excelled him, resolved to move the middle door, which was Andrea's, and to put it up opposite the Misericordia, and to employ Lorenzo to make new doors for the middle, judging that he would devote his utmost energies to the task.[1] They left the whole matter in his hands, saying that they gave him full liberty to do as he pleased and that he should make it as ornamental, rich, perfect and beautiful as he possibly could, or as could be imagined, without regard to time or expense, and that as he had surpassed all the other figure-makers up to that time, he should in this work surpass himself.

Lorenzo began his task, lavishing upon it the very best of his powers. He divided the door into ten squares, five on each side, the spaces left for the scenes being a braccia and a third in size. In the ornamentation of the framework surrounding the scenes are upright niches containing figures in almost full relief to the number of twenty, and all very beautiful, such as a nude Samson embracing a column and holding a jaw-bone in his

[1] Commissioned 2 January, 1425, set up 1452.

hand, displaying the highest degree of perfection attained by
the ancients in their figures of Hercules, whether of bronze or
of marble; as does a Joshua who is in the act of speaking to his
army. Besides these, there are many prophets and sibyls dressed
in various styles of draperies, and with varied arrangements of
their heads, hair and other ornaments, as well as twelve recum-
bent figures in the niches in the transverse parts of the frame.
At the corners he made circles containing heads of women,
youths and old men, to the number of thirty-four,[1] introducing
his own portrait in the middle of the door, near the place where
he has inscribed his name. The older man beside him is his father,
Bartoluccio. In addition to the heads he made foliage, mould-
ings and other ornaments with the greatest mastery. The
scenes represented on the door are taken from the Old Testa-
ment. The first represents the creation of Adam and of Eve
his wife, most perfectly executed, showing that Lorenzo did his
utmost to render their members as beautiful as possible, for
he wished to show that they were the most lovely creatures
that ever issued from the hand of God, and that they surpassed
everything which He had made in His other works. In the same
scene he represented them eating the apple and being driven
together out of Paradise, the figures in this act exhibiting the
first effect of their sin, as they are conscious of their shame and
cover it with their hands, while they show their penitence when
they are being expelled from Paradise by the angel. In the
second square are Adam and Eve with Cain and Abel as little
children; there also is Abel's sacrifice of the first fruits with
Cain's less acceptable offering, in which Cain's gestures are
expressive of envy towards his brother, and Abel's of love to
God. A singularly beautiful incident here is Cain ploughing with
a pair of oxen, very true and natural in their labour of drawing
the plough with the yoke. A fine figure also is that of Abel slain
by Cain as he is keeping the sheep. This last action exhibits the
cruel and pitiless brother slaying Abel with a club, so remarkable
that the very bronze shows the lassitude of the dead members
of Abel's beautiful person. In the distance in bas-relief is God
asking Cain, "Where is thy brother?" four scenes being com-
bined to form each picture. In the third space Lorenzo made
Noah coming out of the ark with his wife, sons, daughters and
daughters-in-law, and all the animals, both birds and beasts,
which are carved each one after its kind, with the greatest
perfection that is allowed to art in the imitation of Nature, the

[1] There are four recumbent figures and twenty-four heads.

ark being seen open, and the general desolation is represented in very low relief with inexpressible grace. The figures of Noah and his sons are represented with wonderful vivacity as he is offering the sacrifice, and in the sky appears the rainbow, the token of peace between God and Noah. But more excellent than the others is the scene where he plants the vine and exposes himself in his drunkenness, while his son Ham mocks him. Indeed, it would not be possible to represent a sleeping man better, in the abandonment of his intoxication, or the consideration and affection, displayed in admirable gestures, of his other two sons, who are covering him. Here also may be seen the vine, the cask, and other implements for making wine, introduced with such skill that they form no impediment to the story, but constitute a beautiful ornament. For the fourth scene Lorenzo chose the appearance of the three angels in the plain of Mamre, making them all alike, while the holy old man is adoring them with most appropriate and realistic expressions in the face and hands. Very excellent also are the servants waiting at the foot of the mountain to which Abraham has gone to sacrifice his son. Isaac is standing naked on the altar, and his father is endeavouring to obey the Divine command, with his arm raised, but is hindered by the angel, who detains him with one hand while with the other he points to the ram which is to be offered, thus delivering Isaac from death. This scene is really remarkably fine, there being a striking contrast between the delicate limbs of Isaac and the more robust ones of the servants, and not a stroke of the scene but has been represented with the most consummate art. In this work, in dealing with the difficulty of buildings, Lorenzo surpassed himself, and also in the scene of the birth of Isaac, and of Jacob and Esau, when the latter is hunting to do his father's will, and Jacob, instructed by Rebecca, is offering the roast kid, while wearing its skin about his neck, which Isaac is feeling, and giving him his blessing. This scene contains some remarkably fine and life-like dogs, and the expressions of Jacob, Isaac and Rebecca in their various actions are exceedingly good. Emboldened by the study of his art, which gave him ever greater facility, Lorenzo essayed to do things more difficult and ambitious, such as the sixth scene, when Joseph is thrown into a pit by his brethren, their sale of him to the merchants, their present of him to Pharaoh, his interpretation of the dream of the famine, the provision to meet this, and the honours accorded to Joseph by Pharaoh. Similarly also in the scenes where Jacob sends his sons to obtain

corn in Egypt, and their return to their father after being recognised by Joseph. In this work Lorenzo attempted a difficult task in the representation of a round temple in perspective, containing figures in various fashions carrying corn and flour, and many asses. Here also is the banquet given by Joseph to his brethren, the hiding of the gold cup in Benjamin's sack, the finding of it, and his recognition of his brothers and his affectionate embraces. This scene, on account of the expressions and the variety of incidents which it contains, is considered by all to be the ablest, the most difficult, and the finest in the whole work.

It is certain that it was impossible for Lorenzo, seeing his skill and grace with this type of statue, not to make the most beautiful figures when thinking out the composition of his admirable scenes. This appears in the seventh panel, where he represents Mount Sinai and Moses on the summit, kneeling reverently and receiving the laws from God. Half-way up the mountain Joshua is awaiting him, and at the foot the people are represented with wonderful truth in divers attitudes of terror at the thunder, lightning and earthquakes. He afterwards displayed great diligence and loving care in the eighth panel, which represents Joshua going to Jericho, crossing the Jordan, pitching the twelve tents filled with the twelve tribes, all very naturally; but the finest part is the bas-relief of the procession with the ark round the walls of the city to the blowing of trumpets, with the fall of the walls and the capture of the city by the Jews. Here the relief diminishes most carefully, from the figures in the foreground to the mountains, from the mountains to the city, and from the city to the distant landscape, all executed with the most perfect grace. And as Lorenzo daily became more expert in his art, the ninth panel shows the slaying of the giant Goliath, David cutting off his head in a proud, boyish attitude, the rout of the army of the Philistines by the host of God, with their horses, chariots and other implements of war. After that he made David returning with the head of Goliath in his hand, the people meeting him with music and dancing, the expressions being all appropriate and full of life. In the tenth and last scene it remained for Lorenzo to put forth all his powers. Here the Queen of Sheba visits Solomon with an immense escort. In this scene he introduced a building in perspective with great effect, the figures resembling those in the other scenes. There is also the ornamentation of the architraves which surround the

door, made up of fruit and festoons of the same high level of excellence. The entire work, in detail and as a whole, is a striking example of what may be accomplished by the skill and energy of a sculptor-artist in dealing with figures, some practically in relief, some in half-relief, and some in bas-relief, in invention and the composition of figures, and in the striking attitudes of the women and men, the variety of the buildings, the perspectives, the graceful comportment of both sexes, with a well-regulated sense of decorum, gravity in the old and lightness and grace in the young. Indeed, the doors may be said to be perfect in every particular, the finest masterpiece in the world whether among the ancients or the moderns. Right well does Lorenzo merit praise, for one day Michelagnolo Buonarroti stopped to look at the work, and on being asked his opinion he said, "They are so fine that they would grace the entrance of Paradise," a truly noble encomium pronounced by one well able to judge. Lorenzo certainly deserved his success, for he began them at the age of twenty and laboured at them with more than ordinary exertion for over forty years.

In polishing and cleaning this work after it was cast Lorenzo was assisted by many youths who afterwards became famous masters, such as Filippo Brunelleschi, Masolino da Panicale,[1] Niccolo Lamberti, goldsmiths, Parri Spinelli, Antonio Filareto, Paolo Uccello, Antonio del Pollaiuolo, then quite young, and by many others who were engaged together upon the same task, and by means of this association and mutual conference they benefited themselves no less than Lorenzo. Besides the payment which Lorenzo received from the consuls, the Signoria gave him a considerable property near the abbey of Settimo, and it was not long before he was admitted to the Signory and thus received the honour of entering the chief magistracy of the city. The Florentines deserve praise for their gratitude to this man, just as they merit blame for their ingratitude to many other excellent fellow-citizens. After this stupendous work, Lorenzo made the bronze ornamentation for the door of the same church which is opposite the Misericordia, introducing his marvellous foliage, but was unable to finish this on account of his unexpected death, after he had arranged everything and all but finished the model for the reconstruction of that door which Andrea Pisano had made. This model has fared badly in these days, but I saw it when I was a young man in the Borgo Allegri before it had been allowed to go to ruin by Lorenzo's descendants.

[1] He was not a pupil. Vasari has confused him with Maso di Cristofano.

Lorenzo had a son called Bonaccorso,[1] who finished the frieze and ornamentation which had been left incomplete, with great diligence, a decoration which I claim to be the rarest and most marvellous work in bronze in existence. He did not produce many works, as he died young, though he might have done much, seeing that he inherited the secret of casting things so as to preserve their delicacy, and he possessed the experience and knowledge necessary for perforating the metal in the manner adopted by Lorenzo. This master, besides works by his own hand, bequeathed to his heirs many antiques of marble and of bronze, such as the bed of Policletes, which was a rare treasure, a bronze leg of life-size, and some heads of women and men, with a quantity of vases, for which he had sent to Greece at a great expense. He also left some torsos and many other things, which were dissipated like his property, some being sold to M. Giovanni Gaddi, sometime clerk of the chamber. Among these was the bed of Policletes and the other more valuable articles. Bonaccorso left a son called Vettorio, who devoted himself to sculpture, but with little profit, as is proved by the heads which he made in the palace of the Duke of Gravina at Naples, which are not very good, for he never practised the art with affection and diligence, but allowed the property and other things left him by his father and grandfather to go to rack and ruin. Finally, one night he was slain by his servant,[2] who wished to rob him, as he was going to Ascoli as architect for Pope Paul III. Thus the family died out, though the fame of Lorenzo will endure for ever.

But to return to Lorenzo. He took an interest in many things and delighted in painting on glass. In S. Maria del Fiore he made the circular windows round the cupola, except one by the hand of Donato, representing Christ crowning the Virgin. Lorenzo also made the three rose-windows over the principal door of the same church, and all those of the chapels and the tribunes, as well as that in the façade of S. Croce. In Arezzo he made a window for the principal chapel of the Pieve, representing a Coronation of the Virgin, and two other figures for Lazzaro di Feo di Baccio, a wealthy merchant. But as all these were made of highly coloured Venetian glass they rather tend to darken the places where they are placed. Lorenzo was appointed to be the associate of Brunellesco when the latter was charged with the construction of the cupola of S. Maria del Fiore, but was afterwards removed, as I shall describe in Filippo's life. Lorenzo

[1] Bonaccorso was his grandson, son of Vittorio. [2] In 1442.

wrote a work in the vulgar tongue [1] treating of many things, but so that little profit can be derived from it. The only good thing that it contains, in my opinion, comes after the description of the ancient painters, particularly those cited by Pliny, where he makes a brief mention of Cimabue, Giotto, and many others of that time, and he has treated this much more briefly than he should, and that for no better reason than to discourse at length about himself and to describe minutely one by one the works which he produced. I must add that he intimates that the book was written by others; but later on, like one who is more accustomed to design, chisel and to found metal than to spin stories, in speaking of himself, he uses the first person *I did, I said,* and so forth. Having at length attained the sixty-fourth year of his life, he was attacked by a violent and continuous fever and died, leaving an immortal fame in his works and in the descriptions of writers. He was buried honourably in S. Croce. His portrait is on the principal door of S. Giovanni, in the middle border when the door is shut, being represented as bald, his father, Bartoluccio, being next him, and near them the following words may be read: *Laurentii Cionis de Ghibertis mira arte fabricatum.* Lorenzo's designs were excellent and made with great relief, as may be seen in our book of designs, in an Evangelist by his hand, and some other very fine works in chiaroscuro. Bartoluccio, his father, also designed very fairly, as is shown by another Evangelist by his hand in the same book, though perceptibly inferior to Lorenzo's. I had these designs, together with some by Giotto, from Vettorio Ghiberti in the year 1528, while I was still quite young, and I have always valued them highly on account of their excellence and in memory of such great men. If I had known what I now know, I might easily have had many other remarkably fine things which belonged to Lorenzo, at the time when I was an intimate friend of Vettorio and had constant relations with him. Among many verses in Latin and in the vulgar tongue which have been composed in honour of Lorenzo at various times, I select the following, which will make a fitting conclusion and spare the reader the annoyance of further quotations:

Dum cernit valvas aurato ex aere nitentes
In templo Michael Angelus, obstupuit
Attonitusque diu, sic alta silentia rupit;
O divinum opus! O janua digna polo!

[1] His *Commentarii* remained in manuscript until 1813 when it was printed in Cicognara's "Storia della Scultura," published at Venice. Vasari has used it freely for the earlier lives.

MASOLINO DA PANICALE, Painter of Florence [1]
(1383-1447)

I FEEL sure that the satisfaction of those who approach the topmost degree in the profession to which they devote themselves must be very great, for, besides the pleasure which they have in producing good work, they enjoy some fruits of their labours, and no doubt live peacefully and happily. If it chance that one is overtaken by death as he is progressing towards perfection in any science or art, his memory will not be completely lost if he has really taken pains to aim at the true end of art. Therefore everyone ought to exert himself to the utmost to attain to perfection, because, even if he is interrupted in mid-career, he will obtain praise, if not for the works which he was unable to complete, at least for his good intentions and the careful study displayed in the little that remains. Masolino da Panicale of Valdelsa, who was a pupil of Lorenzo di Ghiberti, and an excellent goldsmith in his youth, being the best finisher that Lorenzo had for his doors, was very dexterous and skilful in making the draperies of figures, and possessed a good style and intelligence in finishing. He used his chisel very skilfully in representing creases, both in human limbs and in draperies. At the age of nineteen he devoted himself to painting, and practised that art ever afterwards, learning colouring from Gherardo dello Starnina. He went to Rome to study, and while there did the hall of the old Orsini house on Monte Giordano. He subsequently returned to Florence because the air of Rome gave him headaches, and in the Carmine, next to the chapel of the Crucified, he did the St. Peter which may still be seen there. As this was praised by artists, it led to the Brancacci Chapel in the same church being alloted to him. Here he did scenes from the life of St. Peter, a part of which he completed with great diligence, comprising the four Evangelists on the vaulting, Christ calling Andrew and Peter from their nets, Peter weeping at the sin of his denial, and his preaching to convert the people.[2] Here also he painted the shipwreck of the Apostles, and St. Peter curing his daughter Petronilla. In the same scene he represented Peter and John going to the Temple and healing by a sign of the cross before the porch the poor cripple who asks an alms, and to whom they can give neither silver nor gold.

[1] Tommaso di Cristoforo Fini.
[2] Begun 1422. Some critics deny that he did any work in this chapel.

The figures in the whole of this work are made with remarkable grace, and there is a nobility in their bearing, beauty and harmony in the colouring, and power and relief in the design. The work was much admired for its novelty, it being in many respects wholly foreign to the manner of Giotto, but Masolino was overtaken by death while it was still imperfect. He was a man of excellent intellect, his paintings display great harmony and facility, and he completed them with much diligence and devotion. This ardour for study and desire to take pains which always animated him exercised an injurious influence upon his health, and brought him to the grave before his time, removing him from the world too cruelly. Masolino died young at the age of thirty-seven, disappointing the expectations which were held of him. His paintings were made about 1440. Paolo Schiavo took great pains to imitate his style, and made a Madonna at the corner of the Gori in Florence, with figures whose feet are fore-shortened. I have frequently examined Masolino's works, and have found his style very different from that of his predecessors, for he endowed his figures with majesty, and made the draperies soft, falling in elegant folds. The heads of his figures, too, are much superior to those of his predecessors, for he discovered a better method of treating the eyes, and many other parts of the body. He also began to understand the art of light and shade, for he worked in relief, and achieved many difficult foreshortenings admirably, such, for instance, as the poor man who is asking alms of St. Peter, his leg thrust out behind him, so that by means of the shadows on the colouring and the outline of the design he actually appears to be kicking the wall. Masolino further introduced a softer air into the faces of his women, and gave brighter clothes to his youths than the old artists had done, and he was fairly skilful in perspective. But the matter in which he chiefly excelled was colouring in fresco, his paintings being coloured and shaded with such grace that the flesh-tints possess an indescribable beauty. If he had been a perfect designer, as he might have been had he lived longer, he would have been numbered among the greatest, for his works are executed with grace, in a noble style, with beautiful and harmonious colouring and considerable power and relief in design, though this is not absolutely perfect.

PARRI SPINELLI, Painter of Arezzo
(1387–1452)

PARRI DI SPINELLO SPINELLI, painter of Arezzo, having learned the first principles of art from his own father, was invited to Florence by the influence of M. Leonardo Bruni of Arezzo, and was received by Lorenzo Ghiberti into the school where many youths were being instructed under his discipline. At that time the doors of S. Giovanni were being finished, and he was put to work on the figures there, together with many others, as has been said above. He thus contracted a friendship with Masolino da Panicale, being pleased with the latter's method of designing, and he imitated him in many things, as in part he followed the style of Don Lorenzo degli Angeli. Parri made his figures much more slender and tall than any painter who had preceded him, and where others made them at most ten heads high, he made his eleven and even twelve; nor were they ungraceful, for they were always supple and arched either to the left or to the right, to give them more spirit, as he expressed it. The drapery was very full and delicate, and in all his figures it fell from above the arms to the feet. He coloured beautifully in tempera, perfectly in fresco, and was the first who ceased to employ verdaccio[1] as a ground for his flesh-tints to cover them afterwards with red flesh-colour and chiaroscuro in the manner of water-colour as Giotto and the other old painters had done. Thus Parri used fast colours in making mixtures and tints, putting them with great discretion in the places where they appeared to the best advantage: the clear colours in the highest places, the medium ones in the sides, and the dull ones at the edges. By these methods he displayed great facility in his work, and ensured his paintings in fresco a long life, because the colours, being put in their places with a soft thick brush, were harmoniously blended, and the work rendered so smooth that nothing better could be desired, and his colours have no equal. After Parri had been absent from his country for many years he was recalled to Arezzo by his relations after his father's death, and there, besides many things which it would take too long to describe, he did some which I must on no account omit to mention. In the old Duomo he painted three different Madonnas in fresco; and inside, on the left-hand of the principal entrance of that church, he painted

[1] A green colour made of ochre, white and cinabrese, according to Cennino Cennini, which was laid on over the *intonaco*.

in fresco a story of the Blessed Tommasuolo, a hermit of the Sacco, a holy man of the time. As this man habitually carried in his hand a mirror in which, as he affirmed, he saw the Passion of Jesus Christ, Parri drew him kneeling with the mirror in his right hand, holding it up to heaven. Above, on a throne of clouds, is Jesus Christ surrounded by all the mysteries of the Passion, everything being reflected in the mirror with exquisite art, so that not only the Blessed Tommasuolo, but anyone who looks at the picture may see it. It was certainly a charming and ingenious idea, and it has taught succeeding artists to use mirrors in a similar fashion for many things. I will take this opportunity of relating an action of this holy man in Arezzo. He was untiring in his efforts to bring about concord among the Aretines, preaching now here and now there to no purpose, so that at length he perceived that he was wasting his time. One day he entered the palace where the Sixty used to meet, for he was accustomed to the daily spectacle of consultations from which nothing ever resulted except to the harm of the city. When he saw that the hall was full, he filled his lap with live coals, and entering with these to where the Sixty and all the other magistrates were assembled, he threw them at their feet, saying boldly, "Signors, the fire is amongst you, try to save yourselves," and so saying he departed. This simple act of the holy man effected by God's grace what his preaching and threats had failed to do: the Aretines became united soon after, and the city was governed for many years in complete peace and tranquillity

But to return to Parri. After the work mentioned above, he painted in fresco a Christ crucified, in a chapel of the church and hospital of S. Cristofano, next to the company of the Nunziata, for Mona Mattea de' Testi, wife of Carcascion Florinaldi, who left the church considerable benefactions, with many angels about His head flying in the darkened air and weeping bitterly. At the foot of the cross are the Magdalene and the other Maries holding the fainting Virgin in their arms, and on the other side are St James and St. Christopher. On the walls he painted St. Catherine, St. Nicholas, the Annunciation, and Christ at the column, and in the tympanum over the door of the church a Pietà, St. John, and Our Lady. But those inside have been destroyed by the chapel in front of them, and those of the tympanum were pulled down to make room for a modern stone doorway, and to erect with the funds of the company a nunnery for a hundred nuns. For this nunnery Georgio Vasari made a much-admired

model, but it was afterwards altered and transformed into a most debased form by those who unfortunately had the charge of this great work; for it often occurs to certain coxcombs, who are usually ignorant, to make a show of understanding things, and to meddle with the architect in superintending, so that they usually spoil the original plans and models of the designers who have devoted much study to their profession, inflicting considerable damage on posterity, who are thus deprived of useful, convenient, beautiful and ornamental things especially desirable in buildings which are to serve for the common benefit.

Parri also worked in the church of S. Bernardo, a monastery of the monks of Monte Oliveto, doing the two chapels on either side of the principal entry. In the right-hand one, dedicated to the Trinity, he did a God the Father sustaining in His hands a crucified Christ, above whom is the Holy Spirit as a dove, with a choir of angels, and on a wall there he did some excellent representations of saints. In the other chapel, dedicated to Our Lady, is the Nativity of Christ, containing some women washing the Child in a little wooden tub, with surpassing feminine grace. In the distance are some shepherds in the rustic habit of the time keeping their flocks, very life-like, and attentively listening to the words of the angel, who is telling them to go to Nazareth. The other wall contains the Adoration of the Magi, with their baggage, camels, giraffes, and all the suite of the three kings, who are reverently offering their treasures and adoring the Christ, who is in His mother's lap. Besides these, Parri did some very fine scenes in fresco on the vaulting and exterior parts. It is said that, while he was engaged upon this work, Frà Bernardino of Siena, a Franciscan, and a holy man, was preaching at Arezzo, and had brought many of his friars to a truly religious life, and converted many other people. He asked Parri to make the model for their church of Sargiano. Learning that there was a wood near a spring a mile from the city where many foul deeds were done, he went there one morning, followed by all the people of Arezzo, bearing a great wooden cross in his hand, such as he was accustomed to carry, and after a solemn discourse he caused the fountain to be thrown down and the wood to be felled.[1] Shortly after this he founded a small chapel there, in honour of Our Lady, as S. Maria delle Grazie. He employed Parri to paint inside the Virgin in glory, opening her mantle and enfolding all the people of Arezzo. This Virgin afterwards worked many miracles and continues to do so. In the same place,

[1] In 1444.

the community of Arezzo afterwards erected a most beautiful
church, in the middle of which Parri's Madonna is placed, with
many marble ornaments and figures about it, and above the
altar, as I have said in the Lives of Luca della Robbia and Andrea
his nephew, and as will be related from time to time in the Lives
of those whose works adorn that place. Not long afterwards
Parri, led by his devotion to St. Bernardino, drew his portrait
in fresco on a large pillar of the old Duomo. Here also he drew
the same saint in the chapel dedicated to him, glorified in
heaven, and surrounded by a legion of angels, with three half-
sized figures, the two on the sides representing Patience and
Poverty, and the one above Chastity, the three virtues which
were associated with the saint up to the time of his death.
Beneath his feet are some bishops' mitres and cardinals' hats,
showing that he scorned the world and despised such dignities.
Under these pictures was drawn the city of Arezzo, as it then
was. Outside the Duomo Parri painted in fresco an Annunciation
for the company of the Nunziata in a small chapel or maestà.
The Virgin is distorted by fear. Above, at the crossing of the
vaulting, he did two angels in each corner flying in the air and
playing on various instruments, so that they appear to be
producing beautiful harmonies which may almost be heard.
On the walls are four saints, two on each side. But the place in
which he seems to have given rein to his fancy is on two pillars
which bear the front arch at the entry, the one containing an
exquisite Charity tenderly suckling a child, and playing with
another, while she holds a third by the hand; the other is Faith,
represented in a new manner as holding a chalice and the cross
in one hand, while with the other she empties a vessel of water
on the head of a child, baptising him a Christian. These figures
are beyond doubt the best which he ever did in the whole course
of his life, and they are marvellous even when compared with
modern works. Inside the city, in the church of St. Agostino,
Parri painted a number of figures in fresco in the choir of the
friars, which may be recognised as his through the style of the
draperies, and long, slender and bended figures, which I have
referred to above. In the transept of the church of S. Giustino
he painted in fresco a St. Martin on horseback cutting off a part
of his cloak to give to a poor man, and two other saints. On a
wall in the Vescovado he painted an Annunciation, now half
ruined through having been exposed for many years. In the
Pieve of the same city he painted the chapel which is now near
the apartments of the Wardens, but this has been almost entirely

destroyed by the damp. It has been the misfortune of this un-
lucky painter that the majority of his works have been destroyed
by the damp or by demolition. On a round column of the Pieve
he painted a St. Vincent in fresco, and in S. Francesco he did
in half-relief a Madonna surrounded by saints for the family
of the Viviani, and in the tympanum over this the Apostles
receiving the Holy Spirit. In the vaulting he painted some other
saints, and on one side a Christ with the cross on His shoulder,
shedding blood from His side into a cup, and surrounded by
some beautifully painted angels. In the chapel of the company
of the stonecutters, masons and carpenters opposite this, he
made four crowned saints with the tools of their crafts in their
hands, and a Madonna, while beneath them, and also in fresco,
he represented two scenes of their acts and their decapitation
and being thrown into the sea. In these scenes the action and
movement of those who are taking up the bodies in sacks on to
their shoulders to carry them to the sea are very vigorous and
life-like. On the right-hand wall, near the high altar of S. Do-
menico, Parri painted a Madonna, St. Anthony, and St. Nicholas
in fresco for the family of the Alberti of Catenaia, the lords of
that place before they came to live in Arezzo and Florence after
its destruction. That these two branches are from the same
stock is proved by the identity of their arms. It is true that those
of Arezzo are not called degli Alberti but da Catenaia, while
the reverse is the case with those of Florence. I remember having
seen and read that the abbey of the Sasso, which was in the
Alps of Catenaia, now in ruins but rebuilt lower down, and
nearer the Arno, was erected by these same Alberti for the
congregation of Camaldoli, and now it belongs to the monastery
of the Angeli at Florence, which owes it to this same family,
which is a very noble one at Florence. In the old audience-
chamber of the brotherhood of S. Maria della Misericordia Parri
painted Our Lady with the population of Arezzo beneath her
mantle, drawing from life the portraits of those who then ruled
that holy place, dressed in the customary habit of the time.
Among them is one called Braccio, who, when spoken of to-day,
is called Lazzaro Ricco; he died in 1422, and left all his property
to that place, which employed it in serving God's poor, practising
holy works of mercy with much charity. On either side of the
Madonna are St. Gregory the Pope and St. Donato, bishop and
protector of the people of Arezzo. The governors of that brother-
hood, having been so well served by Parri, employed him to
make a picture in tempera of Our Lady with the Child on her

arm, and some angels drawing apart her mantle, beneath which are the people, while below are the martyrs St. Laurence and St. Pergentinus. On the 2nd of June in every year the picture is taken out, raised aloft, and carried in solemn procession by the men of the company to the church of these saints, a silver shrine containing the bodies of the saints being placed upon it. The shrine is the work of Forzore, a goldsmith, and Parri's brother.[1] They are taken out and the altar is set up beside the cross, under a tent, because the church is too small to contain the people who flock to this festival. The predella on which the picture rests contains the martyrdom of the saints in small figures, marvellously executed for so small a work. By Parri's hand also is a tabernacle in the Borgo under the balcony of a house, containing an Annunciation in fresco, which is much admired; and in the company of the Puraccioli, at S. Agostino, he did a most beautiful St. Catherine the virgin and martyr in fresco. Similiarly, in the church of Muriello, he painted for the brotherhood of the clerks a St. Mary Magdalene, three braccia high, and in the chapel of St. Nicholas, at the entrance to S. Domenico, where the bell-ropes are, he painted in fresco a large crucifix with four figures, executed so well that it looks as if it had just been completed. In the arch he did two stories of St. Nicholas, one where he is throwing the gold balls for the young girls, and the other where he is freeing two persons from death, the figure of the executioner, who is preparing to cut off their heads, being excellent. While Parri was engaged upon this work, he was attacked by some of his relations, with whom he was engaged in some suit, but as some other people came upon the scene he was rescued, and they did him no harm. However, it is said that the fright which he experienced caused him to give his figures thenceforward a startled expression, as well as to lean to one side. As he was often attacked by evil tongues and by the bites of envy, he made in this chapel a scene of the burning of tongues, some devils making the fire; in the air is Christ cursing them, and on one side these words: A LINGUA DOLOSA. Parri was a diligent student of art, and designed excellently, as is shown by many drawings by his hand which I have seen, especially a frieze of twenty scenes of the life of St. Donato, made for a sister of his who embroidered beautifully. It is thought that he did it for an ornament for the high altar of the Vescovado. In our book there are some sheets of his very beautifully drawn with the pen. His portrait by Marco da Montepulciano, a pupil

[1] His cousin; it is now in the sacristy.

of Spinello, was painted in the cloister of S. Bernardo at Arezzo.
He lived fifty-six years, and shortened his life by being of a
melancholy temperament, solitary, and too assiduous in his
study of the arts and in working. He was buried in S. Agostino,
in the same tomb in which his father, Spinello, had been laid,
and his death was a great grief to all men of talent who had
known him.

MASACCIO DI S. GIOVANNI of Valdarno, Painter
(1401–1428)

IT is a frequent practice of Nature when she produces a person
of great excellence in any profession to raise up another to rival
him at the same time and in a neighbouring place, so that they
may help one another by their emulation and talents. This
circumstance, besides being of singular assistance to those
immediately concerned, also inflames the spirits of those who
come after, to endeavour by study and industry to attain to
the same honour and glorious reputation which they hear praised
every day in their predecessors. That this is true is shown by
Florence having produced in the same age Filippo, Donato,
Lorenzo, Paolo Uccello and Masaccio, each one pre-eminent in
his kind, who not only rid themselves of the rude and rough style
in vogue until then, but by their beautiful works incited and
inflamed the minds of their successors to such an extent that
these employments have been brought to their present state of
grandeur and perfection. For this we are indeed under great
obligation to those pioneers who, by means of their labours,
pointed out the true way to rise to the highest level. For the
good style of painting we are chiefly indebted to Masaccio.
Desiring to acquire renown, he reflected that, as painting is
nothing more than an imitation of all natural living things,
with similar design and colouring, so he who should follow
Nature most closely would come nearest to perfection. This
idea of Masaccio led him, by dint of unceasing study, to acquire
so much knowledge that he may be ranked among the first who
freed themselves of the hardness, the imperfections and diffi-
culties of the art, and who introduced movement, vigour and
life into the attitudes, giving the figures a certain appropriate
and natural relief that no painter had ever succeeded in obtaining
before. As his judgment was excellent, he felt that all figures
which do not stand with their feet flat and foreshortened, but

are on the tips of their toes, are destitute of all excellence and style in essentials, and show an utter ignorance of foreshortening. Now, although Paolo Uccello had devoted himself to this question, and had achieved something towards smoothing the difficulty, Masaccio did his foreshortenings much better, varying the methods and taking various points of view, achieving more than any of his predecessors. His works possess harmony and sweetness, the flesh-colour of the heads and of his nudes blending with the tints of the draperies, which he delighted to make in a few easy folds, with perfect nature and grace. This has proved most useful to artists and for it he deserves as much praise as if he had invented it. For the things made before his time may be termed paintings merely, and by comparison his creations are real, living and natural.

Masaccio was a native of castello S. Giorgio of Valdarno, and it is said that some figures made by him in his early childhood may be seen there. He was very absent-minded and happy-go-lucky, his whole attention and will being devoted exclusively to his art, and he paid little attention to himself and less to others. He never took any heed or gave a thought to the cares or affairs of the world, not even about his clothes, and never collected from his debtors except when he was in extreme need, so that he was called Masaccio,[1] instead of his real name Tommaso, not because he was vicious, for he was goodness personified, but on account of his extreme carelessness, in spite of which his kindness in helping and giving pleasures to others was beyond all praise. He began to practise at the time when Masolino da Panicale was engaged upon the Chapel of the Brancacci in the Carmine at Florence, and he followed as closely as possible in the footsteps of Filippo and Donato, although his art was different, and his constant endeavour was to make his figures life-like and real, as much like Nature as possible. Thus he drew his lineaments in the modern style, and painted so that his works may safely stand beside any modern drawing or colour piece. He diligently studied methods of work and perspective, in which he displayed wonderful ingenuity, as is shown in a scene of small figures now in the house of Ridolfo del Ghirlandaio, in which, besides the Christ delivering the man possessed, there are some very fine buildings so drawn in perspective that the interior and exterior are represented at the same time, as he took for the point of view not the front, but the side, for its

[1] Maso is an abbreviation for Tommaso, i.e. Thomas. Thus Masolino means little Thomas, and Masaccio big, hulking, clumsy Thomas.

greater difficulty. More than any other master he introduced
nudes and foreshortenings into his paintings, things little
practised before his day. He was a very facile workman, and
the arrangement of his draperies was extremely simple, as I
have said. By his hand is a picture in tempera representing Our
Lady in the lap of St. Anne, with the Child at her neck, which is
now in S. Ambrogio at Florence in the chapel next to the door
leading into the nuns' parlour.[1] On the screen of the church of
S. Niccolo, beyond the Arno, is a picture by his hand painted
in tempera, in which, besides an Annunciation, there is a house
full of columns beautifully drawn in perspective. Besides the
drawing of the lines, which is perfect, he shaded off his colours
so that they are gradually lost to sight, a fact which proves him
the master of perspective. In the Badia at Florence he painted
on a pillar, opposite one of those which bear the arch of the high
altar, St. Ivo of Britanny, represented in a niche with his feet
foreshortened, as seen from below. This brought him no small
praise, because it had not been so well done by others before.
Beneath the saint, and above another cornice, he represented
the windows, children and poor assisted by him in their want.
Below the screen of S. Maria Novella he painted a Trinity which
is placed above the altar of St. Ignatius, between Our Lady and
St. John the Evangelist, who are contemplating the crucified
Christ. At the sides are two kneeling figures, who, as far as one
can guess, are portraits of the donors, but they are not much
in evidence, being covered by a gold ornamentation. But the
most beautiful thing there besides the figures is a barrel vault
represented in perspective, and divided into squares full of
bosses, which gradually diminish so realistically that the building
seems hollowed in the wall. In S. Maria Maggiore he painted in
a chapel, beside the lateral door leading to S. Giovanni, the altar-
picture with Our Lady, St. Catherine, and St. Julian; and in the
predella he made some scenes in small figures of the life of St.
Catherine, and St. Julian slaying his father and mother.[2] In the
middle he made the Nativity of Christ with a simplicity and
vivacity all his own. In a picture in one of the chapels in the
screen of the Carmine at Pisa he did Our Lady and the Child,
with some small angels playing music at her feet; one playing
the lute and listening with his ear down to the harmony he has
produced. The Madonna is placed between St. Peter, St. John the

[1] Now in the Uffizi, Florence.

[2] This action, somewhat equivocal in a saint, was committed by St. Julian
Hospitaller, owing to a misapprehension. He spent the remainder of his
life in expiation.

Baptist, St. Julian and St. Nicholas, all figures of great vigour and life. In the predella beneath are scenes from the lives of those saints in small figures, the middle being occupied by the three Magi offering their gifts to Christ. In this part there are some very fine horses drawn from life—one could not wish for better— and the men of the suite are dressed in the various costumes in use at the time. Above, to complete the picture, there are saints arranged in panels about a crucifix. It is thought that the figure of a saint dressed as a bishop, painted in fresco by the door in that church which leads to the convent, is by Masaccio's hand, but I think it is clear that it is the work of his pupil, Frà Filippo. On his return from Pisa, Masaccio painted a life-size representation of a nude man and woman, now in the Palla Ruccellai house. Not feeling at ease in Florence, and being urged by his love and devotion to art, he determined to go to Rome in order to study and surpass his rivals. When there he acquired the greatest fame and did a chapel in the church of S. Clemente for the Cardinal of S. Clemente, representing in fresco the Passion of Christ, with the thieves on the cross, and the life of St. Catherine the martyr.[1] He likewise did many pictures in tempera which have all been dispersed or lost during the troubles of Rome. There is one in the church of S. Maria Maggiore, in a small chapel near the sacristy, containing four saints so well executed that they appear as if in relief. In the middle is St. Mary of the Snows and the portrait from life of Pope Martin, who is tracing the foundations of the church with a spade, and near him is the Emperor Sigismund II.[2] One day Michelagnolo was examining this work with me and praised it greatly, adding that those men were living in the time of Masaccio. While the latter was in Rome, Pisanello and Gentile da Fabriano were at work on the walls of the church of S. Janni for Pope Martin, and they had allotted a part of it to Masaccio, when he received the news that Cosimo de' Medici, by whom he had been much assisted and favoured, had been recalled from exile.[3] Accordingly he returned to Florence, where the Brancacci Chapel in the Carmine was entrusted to him, Masolino da Panicale, who had begun it, having died. Before he put his hand to this work he did, as a specimen of his skill, the St. Paul that is near the bell-ropes, to show what progress he had made in art.

[1] Done in 1417. Now considered to be the work of Masolino.
[2] Martin V., 1417–31 and Sigismund, 1410–37; there was only one Emperor of this name.
[3] In 1434.

Decidedly he exhibited extraordinary ability in this painting, the saint's head (a portrait of Bartolo di Angiolino Angiolini) expressing such vigour that it seems only to lack the power of speech. Anyone who was not acquainted with St. Paul would recognise in this figure the Roman citizen joined to that invincible and divine spirit all intent on the cares of the Faith. In this same picture he showed his knowledge of foreshortening a view seen from below in a truly marvellous manner, and in the Apostle's feet, how he has overcome a difficulty and shaken off the old rude manner, which, as I have said, made all the figures stand on the tips of their toes. This method lasted until his day without anyone correcting it, and he alone and first of all brought in the good style of to-day. While he was engaged upon this work, the consecration of the Carmine church took place,[1] and as a memorial of this Masaccio painted the scene as it occurred, in *verde terra* and chiaroscuro, in the cloister over the door leading to the convent. There he drew the portraits of a great number of citizens in mantle and hood, who are taking part in the procession, including Filippo di ser Brunellesco in sabots, Donatello, Masolino da Panicale, who had been his master, Antonio Brancacci, who employed him to do the chapel, Niccolo da Uzzano, Giovanni di Bicci de' Medici, and Bartolommeo Valori, which are also in the house of Simon Corsi, a Florentine nobleman, by the same hand. He also drew there Lorenzo Ridolfi, then ambassador of the Florentine republic at Venice,[2] and not only did he draw all these notabilities from life, but also the door of the convent, and the porter with the keys in his hand. The work possesses many perfections, for Masaccio's knowledge enabled him to put five or six people in a row upon the piazza, judiciously diminishing them in proportion as they recede, according to the point of view, a truly marvellous feat, especially as he has used his discretion in making his figures not all of one size, but of various stature, as in life, distinguishing the small and the stout from the tall and the slender, all foreshortened in their ranks with such excellence that they would not look otherwise in real life. After this he returned to the work in the Brancacci Chapel, continuing the series of St. Peter begun by Masolino, and finished the part comprising the story of the keys, the healing of the infirm, raising the dead, healing the sick with his shadow on the way to the Temple with St. John.[3] But the most notable of all is

[1] On 19 April, 1422.
[2] He went twice on embassies, in 1402 and 1425. [3] About 1425.

where Peter, in order to pay tribute, takes the money by Christ's direction from the fish's belly. Here Masaccio has painted his own portrait, with the aid of a mirror, in the guise of an Apostle, standing at the end, and so well done that it is like life; remarkable also are the ardour of St. Peter in his request and the attention of the Apostles in their various attitudes about Christ, awaiting His decision with gestures full of life and naturalness. St. Peter in especial, in his efforts to get the money from the fish's body, has his face quite red from bending; more admirable still is the payment of the tribute, including the representation of counting the money, and the satisfaction of the man who is receiving it, who looks at the money in his hand with the greatest delight. He also painted there the raising of the king's son by SS. Peter and Paul. But the work remained unfinished owing to Masaccio's death, and was afterwards completed by Filippino. In the scene where St. Peter is baptising, a nude figure is much admired as it stands among the others and shivers with the cold, executed in the finest relief, and in a charming style, so that it has always been held in great esteem and admiration by all artists, both ancient and modern. For this reason the chapel has always been frequented by an infinite number of designers and masters up to the present time, and it still contains some heads of such naturalness and beauty that it may be affirmed that no master approached so closely to the moderns as Masaccio. For this cause his labours deserve unstinted praise, especially as he paved the way for the good style of our own day. That this is true is shown by the fact that all the celebrated painters and sculptors from that time until now have become excellent and distinguished by studying in that chapel, as, for example, Frà Giovanni da Fiesole, Frà Filippo, Filippino, who completed it, Alesso Baldovinetti, Andrea dal Castagno, Andrea del Verrocchio, Domenico del Grillandaio, Sandro di Botticello, Leonardo da Vinci, Pietro Perugino, Frà Bartolommeo of S. Marco, Mariotto Albertinelli, the divine Michelagnolo Buonarrotti, Raphael of Urbino also, who there first laid the foundation of his beautiful style, il Granaccio, Lorenzo di Credi, Ridolfo del Grillandaio, Andrea del Sarto, il Rosso, il Franciabigio, Baccio Bandinelli, Alonso Spagnuolo, Jacopo da Pontormo, Pierino del Vaga and Toto del Nunziata, in short, all who have endeavoured to learn the art have always gone for instruction to this chapel to grasp the precepts and rules of Masaccio for the proper representation of figures. If I have failed to mention many foreigners and Florentines in this list of those who went to

study in the chapel, it is because it follows that where the heads of the arts have gone the members will also go. High as Masaccio's reputation has always stood, it is nevertheless the firm conviction of many that he would have produced even better work if death, which carried him off at the age of twenty-six, had not cut short his time. Whether through envy or because good things do not usually last long, he died in the flower of his age, and so suddenly that doubts were not wanting that poison was the cause rather than mere chance.

It is said that when Filippo di ser Brunellesco heard of his death he said, "We have experienced a great loss in Masaccio," and he was plunged in deep grief, as the master had taken great pains to show him many points in perspective and architecture. Masaccio was buried in the church of the Carmine in the year 1443, and although no memorial was placed above him at the time, as he had been held in slight esteem during his life, yet he was honoured after his death with the following epitaphs:

That of Annibal Caro

Pinsi e la mia pittura al ver fu pari
L'atteggiai, l'avvivai, le diedi il moto
Le diedi affetto. Insegni il Bonarotto
A tutti gli altri e da me solo impari.

That of Fabio Segno

Invida cur Lachesis primo sub flore juventae
Pollice discindis stamina funereo?
Hoc uno occiso innumeros occidis Apelles:
Picturae omnis obit, hoc obeunte, lepos.
Hoc sole extincto extinguuntur sydera cuncta.
Heu! decus omne perit hoc perunte simul.

FILIPPO BRUNELLESCHI, Sculptor and Architect of Florence (1377–1446)

MANY whom Nature creates small and insignificant in appearance have their souls filled with such greatness and their hearts with such boundless courage that they cannot rest unless they undertake things of almost impossible difficulty, and bring them to completion to the wonder of all beholders, and no matter how vile and base things may be, they become in their hands valuable and lofty. Thus we should never turn up our noses when we meet persons who do not possess that grace and bearing which Nature might be expected to give to distinguished men when

they come into the world, for clods of earth hide veins of gold. It frequently happens that men of insignificant appearance possess great generosity of spirit and sincerity of heart, and when nobility of soul is joined to these characteristics the greatest marvels may be expected, for they endeavour to overcome the defects of their body by the virtues of their mind. This appears in Filippo di ser Brunellesco, as well as in Messer Forese da Rabatta and Giotto, who were all of mean appearance, but their minds were lofty, and of Filippo it may be said that he was given by Heaven to invest architecture with new forms, after it had wandered astray for many centuries, during which the men of the time had expended much treasure to bad purpose in erecting buildings devoid of arrangement, in bad style, of sorry design, with the queerest notions, most ungraceful grace, and worse ornament. It was Heaven's decree, after the earth had been so many years without a master mind and divine spirit, that Filippo should leave to the world the greatest and loftiest building, the finest of all the achievements of ancient and modern times, proving that the ability of the Tuscan artists though lost was not dead. It also adorned him with the highest virtues, among which was that of friendship, and no one was ever more kind and loveable than he. His judgment was free from passion, and when he perceived merit in others he put aside his own interest and that of his friends. He knew himself and communicated his own virtues to many, being always ready to assist his neighbours when in need. The mortal enemy of vice, he sought the society of those who practised virtue. He never wasted time, but was always engaged upon his own works or those of others, if they needed help, and was always visiting his friends and remembering them.

There lived in Florence, we are told, a man of excellent repute, of worthy habits and competent in his affairs, named Ser Brunellesco di Lippo Lapi, whose grandfather, called Cambio, was a learned man, the son of a very famous physician of the day, named Master Ventura Bacherini. This Ser Brunellesco took to wife a virtuous lady of the noble family of the Spini, and as part of her dower he had a house, in which he and his sons dwelt until their death, situated opposite S. Michele Berteldi, at a corner beyond the piazza degli Agli. While he was living there a son was born to him in the year 1377, whom he named Filippo after his dead father, the event causing the greatest rejoicings. In the child's early youth his father carefully taught him the first principles of letters, in which he exhibited much

intelligence, but he did not exert his full powers, as if he did not wish to attain to great perfection in this, intending apparently to devote himself to things of greater utility. This greatly displeased Ser Brunellesco, who wished to make him a notary or to follow his great-great-grandfather's profession. But perceiving that the boy was always returning to art and manual work, he made him learn the abacus and writing and then put him with a goldsmith, a friend of his, so that he should learn to design. Greatly delighted, Filippo began to learn and practise that art, so that before many years he could set stones better than a practised craftsman. He did niello and grotesques, such as half-length silver figures of two prophets placed at the head of the altar of S. Jacopo of Pistoia [1] and considered very beautiful, made by him for the wardens of the city, and works in bas-relief where he showed such a thorough grasp of that trade that his mind was clearly ready to pass to higher things. Coming into contact with some studious artists he began to study with enthusiasm motion, weights and wheels, how they may be made to revolve and what sets them in motion, and so produced with his own hand some excellent and very beautiful clocks. Not contented with this he aspired to practise sculpture on a large scale, and this led to a constant association in practising that art with Donatello, a youth of skill and great promise, and so great an affection grew up between them, owing to their high qualities, that they did not seem able to live apart from one another. Although Filippo was skilled in many things and practised several professions, yet he did not devote so much time to them as to prevent his being considered an excellent architect by persons qualified to judge. He proved this in his decorations for various houses, such as that of Appollonio Lapi, his kinsman, at the corner of the Ciai towards the Mercato Vecchio, where he did many things during the building. Outside Florence he did the same in the tower and house of the Petraia at Castello. In the palace of the Signoria he arranged and separated off all the apartments where the offices of the officials of the Monte were situated, and constructed the doors and windows in a style borrowed from the ancients not much in use then, because architecture was in a very crude state in Tuscany. Filippo was next commissioned to make a statue in linden wood of St. Mary Magdalene in penitence for the friars of S. Spirito, to be placed in a chapel, and as he had made many small things in sculpture he was anxious to prove that he could also succeed in large ones. When the statue was

[1] In 1400.

finished and set up it was considered most beautiful, but it perished in the fire at that church in 1471, together with many other notable things. He paid great attention to perspective, which was badly understood at the time, many errors being perpetrated, and spent much time over it, but at length he discovered unaided a method of getting it perfectly true; this was to trace it with the ground plan and elevation by means of intersecting lines, a useful addition to the art of design. He took such delight in this that he drew with his own hand the piazza of S. Giovanni, with all the divisions of the black and white marble incrustation, diminishing them with a singular grace; and he also did the house of the Misericordia, with the shops of the wafer-makers; the vault of the Pecori, with the column of St. Zanobi on the other side. The praise accorded to the work by artists and connoisseurs so much encouraged him that before long he began another, drawing the palace, the piazza and the loggia of the Signori, with the shelter of the Pisani and all the buildings about, thus awakening the spirit of other artists, who afterwards bestowed much study upon them. In particular, he taught Masaccio the painter, then a youth and his close friend, who did honour to his instructor, as appears in the buildings which occur in his works. He further showed it to those who do tarsia work, which is an art of inlaying coloured woods, stimulating them to such an extent that he gave rise to many good and useful things produced in that art both then and afterwards which have brought fame and profit to Florence for many years. One evening Messer Paolo dal Pozzo Toscanelli happened to be entertaining some friends in a garden and invited Filippo, who, hearing him speak of mathematics, cultivated his friendship and learned geometry from him, and, although Filippo was not a lettered man, he was able to argue so well from his own practice and experience that he often astonished M. Paolo. Then again Filippo interested himself in the Christian Scriptures, and never failed to be present at the disputes and preaching of learned persons, making so much profit through his excellent memory that M. Paolo used to say that when he heard Filippo argue he thought he was listening to a new St. Paul. At this time also Filippo studied Dante, thoroughly familiarising himself with the localities and measurements, and often quoting the poet in his arguments. His mind was always contriving and imagining ingenious and difficult things, and he found a kindred spirit in Donato, with whom he would have friendly discussions, in which they both delighted,

on the difficulties of their profession. Thus, one day when Donato had finished a wooden crucifix (which was placed in S. Croce in Florence, under the scene where St. Francis raises the child, painted by Taddeo Gaddi), he wished to have Filippo's opinion; but he repented, for Filippo said that he had put a rustic on the cross. Donato then retorted, "Take some wood and make one yourself," as is related at length in his life. Filippo, who never lost his temper, however great the provocation, quietly worked on for several months until he had completed a wooden crucifix of the same size, of extraordinary excellence, and designed with great art and diligence.[1] He then sent Donato to his house before him, quite ignorant of the fact that Filippo had made such a work, so that he broke an apron-full of eggs and things for their meal which he had with him, while he regarded the marvel with transport, noting the art and skill shown by Filippo in the legs, body and arms of the figure, the whole being so finely and harmoniously composed that Donato not only acknowledged himself beaten but proclaimed the work as a miracle. It is now placed in S. Maria Novella, between the Chapel of the Strozzi and that of the Bardi of Vernio, where it is still greatly admired by the moderns. The worth of these truly excellent masters being thus made apparent, they were commissioned by the art of the butchers and the art of the linen-drapers to make two marble figures for their niches in Or. S. Michele. Filippo left Donato to do these by himself, as he himself was otherwise engaged, and Donato brought them to a successful completion. After this, in the year 1401, it was proposed to make the two bronze doors of the church and baptistery of S. Giovanni, sculpture having advanced so greatly, because from the time of the death of Andrea Pisano there had not been any masters capable of carrying them out. Accordingly this purpose was made known to the sculptors then in Tuscany, who were invited to come, provided with maintenance and set to prepare a panel. Among those thus invited were Filippo and Donato, Lorenzo Ghiberti, Jacopo della Fonte, Simone da Colle, Francesco di Valdambrina and Niccolo d' Arezzo. The panels were completed that same year, and when they came to be exhibited in competition they were all most beautiful, each different from the other. That of Donato was well designed and badly executed; that of Jacopo dalla Quercia was well designed and executed, but with faulty perspective of the figures; that of Francesco di Valdambrina had poor invention and tiny figures; the worst of all were

[1] About 1410.

those of Niccolo d' Arezzo and Simone da Colle, and the best that of Lorenzo di Ghiberti, combining design, diligence, invention and art, the figures being beautifully made. Not much inferior to his, however, was the panel of Filippo, on which he had represented Abraham sacrificing Isaac, with a servant extracting a thorn from his foot while waiting for Abraham, and an ass grazing, which merits considerable praise. When the scenes came to be exhibited, Filippo and Donato were only satisfied with that of Lorenzo, judging it to be better adapted to its peculiar purpose than those of the others. So they persuaded the consuls with good arguments that the work should be given to Lorenzo, showing that both public and private ends would be best served thereby. This was a true act of friendship, a virtue without envy, and a clear judgment of their own limitations, so that they deserve more praise than if they had completed that work themselves. Happy spirits who, while assisting each other, rejoice in praising the work of others! How unhappy are the men of our own times, who try to injure others, and burst with envy if they cannot vent their malice. Filippo was requested by the consuls to undertake the work together with Lorenzo, but he refused, as he preferred to be the first in another art, rather than be equal or second in that. He presented his bronze to Cosimo de' Medici, who eventually caused it to be put in the old sacristy of S. Lorenzo, as the reredos of the altar, where it now is, while that of Donato was put in the art of the changers.[1] After the doors had been allotted to Lorenzo Ghiberti, Filippo and Donato met, and determined to leave Florence and go to Rome for a year or so, the one to study architecture and the other sculpture. Filippo did this because he wished to be superior to Lorenzo and Donato, since architecture is much more useful to men than either painting or sculpture. After Filippo had sold a small property of his at Settignano, they left Florence and proceeded to Rome, where at the sight of the grandeur of the buildings, and the perfection of the churches, Filippo was lost in wonder, so that he looked like one demented. He set to work to measure the cornices and take the plans of these buildings. He and Donato were constantly going about and spared neither time nor money. They left no place unvisited, either in Rome or its neighbourhood, and took measurements of everything when they had the opportunity. As Filippo was free from the cares of a family, he abandoned himself to his studies,

[1] Brunelleschi's is now in the Bargello, Florence; the whereabouts of Donato's is unknown.

neglecting to sleep and to eat, his only concern being architecture, which had been corrupted, studying the good ancient orders and not the barbarous Gothic style then in general use. Two great ideals possessed him: the one to bring back to light the true architecture, whereby he believed he should make a name for himself not inferior to that of Giotto and Cimabue, the other was to find a method, if possible, of vaulting the cupola of S. Maria del Fiore at Florence, the difficulty of which had deterred anyone, after the death of Arnolfo Lapi, from wishing to attempt it, except by incurring a great expense for a wooden covering. However, he did not communicate this purpose of his to Donato or to any living soul, but in Rome he attentively observed all the difficulties of the vaulting of the Rotonda. He had noted and drawn all the vaulting in the antique, and he was continually studying the subject, and if pieces of capitals, columns, cornices and bases of buildings were found buried he and Donato set to work and dug them out to find the foundations. From this a report spread in Rome, when they passed by, carelessly dressed, and they were called the men of the treasure, for it was believed that they were studying necromancy in order to find treasure. The reason for this was that one day they had found an ancient earthen vessel full of medals. Filippo came to be short of money and he went about setting precious jewels for some goldsmiths, friends of his. On Donato returning to Florence he was left alone, and he studied the more ardently and diligently among the ruins of ancient buildings. He drew every sort of building, round and square, and octagonal churches, basilicas, aqueducts, baths, arches, coliseums, amphitheatres, and every temple of brick, noting the methods of binding and clamping as well as the turning of the vaulting. Finding by examination that all the large stones had a hole in the middle of the under-side, for the iron tool used for drawing the stones up, called by us the *ulivella*, he reintroduced this system and brought it into general use. He then studied the Doric, Ionic and Corinthian orders, one after the other, and to such purpose that he was able to reconstruct in his mind's eye the aspect of Rome as it stood before its fall.

The air of the city caused him a slight disorder in the year 1407, and he was advised by his friends to take a change. Accordingly he returned to Florence, where many buildings had suffered by his absence, and on his arrival he was enabled to supply many designs and much advice. The same year there took place a gathering of architects and engineers of the district upon the method of vaulting the cupola, at the instance of the wardens

of S. Maria del Fiore and the consuls of the art of wool. In this Filippo took part, giving his advice that it was necessary to take away the roof of the building and not to follow Arnolfo's design, but to raise the walls fifteen braccia, and make a large eye in the middle of each face, for this would both lessen the weight on the piers beneath and the cupola could be vaulted more easily. Models accordingly were prepared and the work started. One morning, some months after his return, Filippo was on the piazza of S. Maria del Fiore with Donato and other artists discussing antique sculptures, and Donato was relating how, when he returned from Rome, he had made a journey to Orvieto, to see the far-famed marble façade of the Duomo, the work of various masters, and considered a notable thing at that time, and how, in passing afterwards through Cortona, he had entered the Pieve, and seen a remarkable ancient marble sarcophagus, with a bas-relief,[1] a rare thing then, for the multitude of things discovered in our day had not then been dug out. Donato went on to say how excellently the master had done his work, describing the perfection and beauty with which he had completed it, and so inflamed Filippo with an ardent desire to see it that, just as he was, in his mantle, hood and sabots, he left them without saying a word of where he was going, and proceeded to Cortona, led by his love and affection for art. He saw the sarcophagus, admired it, and made a drawing of it, with which he returned to Florence without Donato or anyone else being aware that he had left the city, for they thought he must be engaged upon designing or contriving something. On his return he showed his carefully executed drawing, and Donato greatly marvelled at this proof of Filippo's love for his art. He remained many months at Florence, where he secretly made many models and machines, all designed for the work of the cupola, always joking with his fellow-artists, this being the time of his jest about the fat man and Matteo.[2] He also frequently went to assist Lorenzo Ghiberti in the polishing of his doors, by way of relaxation. But one morning the whim took him to leave for Rome, for he knew that it was proposed to appoint engineers to vault the cupola, and he thought it would redound more to his credit if he were sent for from a distance than if he remained in Florence. Accordingly, while he was at Rome he received a letter begging him to come to Florence, for they had considered the nature of the work and the sagacity of his mind, as he had exhibited a confidence and

[1] A combat between Centaurs and Lapiths, now in the Duomo.
[2] A practical joke to induce the victim to doubt his own identity.

courage which had not been shown by the other masters, who were totally at a loss, as were the builders, being helplessly convinced that a method could never be found to vault the cupola, and that beams large enough to span the distance and bear the weight of such a structure above them did not exist. Filippo, who wished for nothing better, returned with the utmost alacrity. On his arrival, the wardens of S. Maria del Fiore and the consuls of the art of wool met together and told him all the difficulties, from the least to the greatest, which had been raised by the masters, who were also present. Filippo answered as follows: "Wardens, there is no doubt that great things always present difficulties in their execution, and this particular one offers questions especially hard to solve, harder than you are perhaps aware. I do not know if even the ancients ever vaulted anything so tremendous as this, and I have often thought of the framework, both within and without, and how it might be safely constructed, and I have never been able to make up my mind, for the breadth of the building troubles me no less than its height. If it had been circular, it would have been possible to follow the methods observed by the Romans in vaulting the Pantheon or Rotonda at Rome, but here it is necessary to follow the eight sides, and to dovetail and chain the stones together, questions of great difficulty. But when I remember that the church is dedicated to God and to the Virgin, I am confident that what is done in their memory will not fail for lack of knowledge, and that the architect will receive aid in his strength, wisdom and ingenuity. But of what assistance can I be, as the work is none of mine? However, I will say that if the work were entrusted to me, I should resolutely set myself to find a means of vaulting it without too much trouble; but I have not yet thought of the matter, and yet you wish me to find a means! But if you propose to have it vaulted, you should not appeal to me only, for I do not think I am competent to give advice on so great a matter, but you should ordain that within a year, and on an appointed day, architects shall come to Florence, not only Tuscans and Italians, but Germans, French, and others, to give their advice, so that, after the question has been discussed and settled by so many masters, the work may be begun, and be entrusted to the man who will give proof of the best methods and ability to carry it out. I can give you no better advice than this." This suggestion of Filippo pleased the consuls and wardens, but they would have preferred him to have made a model in the meantime, and to have devoted his attention to the question. But he affected carelessness, and,

having taken leave of them, said that he had received letters requesting him to return to Rome. When the consuls perceived that their prayers, united with those of the wardens, could not detain him, they induced many of his friends to use their influence, and as this did not succeed, one morning, on the 26th May, 1417, the wardens decreed him an allowance of money, which is to be found debited to him in the books of the opera, all this being done to satisfy him. But he remained firm to his purpose, and leaving Florence he returned to Rome, where he devoted himself to constant study in preparation for this great work, for he felt confident that no one but himself could carry it out. His advice about bringing new architects to consult had been given with no other purpose but in order that they might bring their testimony to the greatness of his genius, rather than because he thought that they would find a means to vault the tribune and take up such a difficult burden, A great deal of time was lost before the architects assembled. They were summoned from afar by means of directions given to the Florentine merchants living in France, Germany, England and Spain, who were commissioned to spend any amount of money to obtain the principal, most experienced and gifted men of those regions. At length, in 1420, all these foreign masters and those of Tuscany were assembled at Florence with all the principal Florentine artists, and Filippo returned from Rome. They all met together in the Opera of S. Maria del Fiore, in the presence of the consuls and wardens and a chosen number of the ablest citizens, so that, after the opinion of everyone had been taken, the method of vaulting the tribune might be determined. They sent for the architects one by one and heard what they had to suggest. It was a remarkable thing to hear the curious and varied opinions upon the subject, for some said that they would build pillars from the ground level to bear arches to carry the beams which should support the weight; others thought it would be good to vault it with pumice stone, so that the weight might be lighter; and many agreed to make a pillar in the middle and construct it in the manner of a tent, like that of S. Giovanni at Florence; and there were not wanting those who said that it would be a good thing to fill the space with earth mixed with small coin and vault it, giving the people licence to go and take the earth so that it should be removed without cost. Filippo alone said that he could easily vault it without so many beams and pillars or earth, at a less expense than would be involved by a quantity of arches, and without a framework. The consuls expected some

flighty plan, and the wardens and all the citizens thought that Filippo had spoken like a madman, and they mocked at him, telling him to speak of something else, as his plan was the device of a fool. Filippo grew angry and said, "Sirs, reflect that it is not possible to do the thing in any other way, and yet you mock me, although you must know, if you are not obstinate, that it must not and cannot be done otherwise. According to the method I have thought out it is necessary to employ the ogive shape, and to make two vaults, an outer and an inner, with sufficient space to walk between them, and that the structure must be bound together at the angles of the eight sides by dove-tailing the stones, and by oak ties over the front of it. Moreover, it is necessary to consider the lights, the ladders, and the channels for carrying off the rain-water. And not one of you has thought that places may be prepared inside for making mosaics, and many other difficult things; but I who see the place vaulted know that there is no other way than the one I have described." The more he warmed in speaking in seeking to make his ideas clear so that they might understand and believe, the more doubts suggested themselves to them, causing them to believe less and to consider him foolish and flighty. Thus, after they had waved him off several times and he would not go, he was carried out from the audience by force by some youths, everyone thinking him utterly mad. Filippo afterwards said that he did not at that time dare to go into any part of the city for fear of it being said, "There goes that madman." The consuls at the audience were left in a state of confusion, both by the difficult methods of the first masters, and by the last one of Filippo, which they could not understand, for they thought that there were two stumbling-blocks in his way: the one being the double roof, which would be a great weight, and the other the construction without a framework. On the other hand, Filippo, who had studied the matter for so many years in order to get the work, was at a loss what to do, and was frequently tempted to leave Florence. Yet, as he wished to conquer, he must needs arm himself with patience, and he had seen enough to know the volatile nature of his fellow-citizens. He might have shown a small model which he had by him, but he did not wish to, because he saw how little the consuls understood and realised the envy of the artists and the instability of the citizens, who favoured now one and now another, according to the caprice of the moment. I do not wonder at this, for everyone in the city professes to know as much as the skilled masters, although those who really know

are few. But what Filippo had not been able to do before the united magistracy he attempted to achieve by attacking individuals, speaking with a consul here, a warden there, and to many citizens, and showing a part of his plan, so that he succeeded in getting them to decide to allot the work either to him or to one of the foreigners. Encouraged by this the consuls, wardens and citizens met together, and the architects disputed on the matter. But they were all routed by Filippo, and it is said that the dispute of the egg arose during these discussions. They wanted Filippo to declare his plan in detail, and to show his model as they had shown theirs, but he refused, and proposed to the masters assembled that whoever should make an egg stand upright on a flat marble surface should make the cupola, as this would be a test of their ability. He produced an egg and all the masters endeavoured to make it stand, but no one succeeded. Then they passed it to Filippo, who lightly took it, broke the end with a blow on the marble and made it stand. All the artists cried out that they could have done as much themselves, but Filippo answered laughing that they would also know how to vault the cupola after they had seen his model and design. And so it was resolved that he should have the conduct of the work, and he was invited to supply the consuls and wardens with fuller information. He returned home and wrote on a sheet the gist of his plan, as clearly as he could, to give it to the magistrates, in this form: "Sirs, in taking into consideration the difficulties of this structure, I find that it is impossible for anyone to make it perfectly round, seeing that the space over which the lantern is to go would be so great that, when any weight was put there, the whole would speedily fall down. Yet it appears to me that those architects who have not an eye to the eternity of their buildings, have no care for their memory and do not know what they are about. I accordingly resolved to make the inside of the vault in sections, corresponding with the outside, adopting the manner of the pointed arch, as that tends most upward, and when the weight of the lantern is imposed the whole will be made durable. The thickness of the mass at the base is to be 3¾ braccia, and it will diminish pyramidically as it rises to the point where the junction with the lantern is to be made, where it will be 1½ braccia thick. Then another vault is to be made outside the first one, 2½ braccia thick at the base, to preserve the inside one from the weather. This will also diminish in thickness towards the top, so that at the point of its junction with the lantern it will only be ⅔ of a braccia in width. At every angle there will be a

buttress, eight in all, and two for each front including one in the middle and making sixteen in all. On the inside and outside in the middle of the angles at each front there will be two buttresses, each one 4 braccia thick at the base. The two vaults will rise pyramidically in due relation to each other to the top of the circle which is closed by the lantern. Thus 24 buttresses in all will be made about the vaulting and six long arches of hard stone, well braced with iron, and covered over, the stonework and buttresses being all bound together with an iron chain. The masonry must be solid without a break to a height of $5\frac{1}{4}$ braccia, and then come the buttresses and the springs of the vaulting. The first and second circles will be strengthened at the base with long blocks of macigno stone set horizontally, so that both vaults of the cupola shall rest upon these stones. At every 9 braccia in the vaulting there will be small arches between the buttresses with ties of thick oak to bind the buttresses which support the inside vaulting. These oak ties will be covered with iron plates for the sake of the ascents. The masonry of the buttresses is to be entirely of macigno, as are the sides of the cupola, the walls to be tied to the buttresses to the height of 24 braccia and then built of bricks or pumice stone, as those who make it may decide, to obtain the utmost possible lightness. Outside a promenade will be made above the round windows with a terrace below and open parapets 2 braccia high, similar to the galleries below, forming two promenades one above the other on a decorated cornice, the upper one being open to the sky. The water will be carried off the cupola in a marble channel, $\frac{1}{3}$ braccia wide, and will throw the water to a part made of strong stone below the channel. On the outside of the cupola there will be eight marble ribs at the angles, as large as is necessary, 1 braccia high, above the cupola, corniced at the head, 2 braccia wide, so that there may be eaves and gutters everywhere. These must have a pyramidical form from the base to the top. The cupola will be built as aforesaid, without a framework, to the height of 20 braccia, and the rest in the manner preferred by the masters who are charged with the work, as practice will show the best method."

When Filippo had finished writing the above, he went in the morning to the magistrates and, on his showing them this sheet, they proceeded to consider it, and although they were not able to grasp it, yet, seeing the confidence of Filippo and that none of the other architects were on more certain ground, while he always exhibited the utmost assurance in his replies, which

would have led one to suppose that he had already vaulted ten such spaces, the consuls withdrew apart and proposed to give him the work. However, they wished to be shown how the vaulting could be made without a framework, though they approved of all the rest. Fortune favoured this desire, for since Bartolommeo Barbadori had previously proposed to erect a chapel at S. Felicita, and had consulted Filippo about it, the latter had undertaken the work, and caused the chapel to be vaulted without a framework. It is on the right as one enters the church, as is the holy-water vessel by the same hand. About the same time Filippo vaulted another chapel at S. Jacopo sopr' Arno for Stiatta Ridolfi, next to the chapel of the high altar, and these things inspired more confidence than his arguments. The consuls and the wardens being thus reassured by the document and the work which they had seen, allotted the cupola to him, making him head master by a majority of votes. But they would not allow him to build higher than twelve braccia, saying that they wished to see how the work succeeded, and that if everything prospered in the manner described by him, they would not fail to allow him to complete the rest. It seemed strange to Filippo that the consuls and wardens should display so much hardness and mistrust, and if he had not known that he was the only man who could accomplish the task he would not have undertaken it. However, his desire of glory led him to accept it, and he undertook to bring it to completion. His sheet was copied into a book, where the overseer entered the debtors and creditors for timber and marble. The same provision was made for his payment as other masters had received up to that time. When the artists and citizens learned that the work had been allotted to Filippo, some approved and others shook their heads, as people always do, some being thoughtless and others envious. While preparations for the building were going forward, a coterie of artists and citizens banded together and went to the consuls and wardens, representing that the matter had been too hastily settled, and that a work of such importance ought not to be entrusted to a single man. If they had no men of ability this would be pardonable, but there were many such, and the city would incur reproach, for when some accident happened, such as sometimes occur during great constructions, they would be blamed for having imposed so great a burden on one man alone, not to speak of the loss and shame which would thereby result to the public; and, besides, it would be well to give Filippo a colleague in order to bridle his ardour. Lorenzo

Ghiberti had proved his genius in the doors of S. Giovanni, and that he had influence with some who had power with the governors was clearly shown, for when they saw how Filippo's renown was growing they contrived that Ghiberti should be associated with him in the work, under the pretext of their love and affection for the building. Filippo was rendered so desperate and bitter when he heard what the wardens had done, that he proposed to flee from Florence, and had it not been for the consolations of Donato and Luca della Robbia he might have lost his reason. Fell and cruel indeed is the rage of those who in the blindness of their envy endanger honoured things and beautiful works in the strife of ambition. It was no thanks to them that Filippo did not break his models, tear up his plans, and in less than half an hour destroy all the labour of so many years. The wardens first made excuses to Filippo and persuaded him to proceed since he and no other was the inventor and author of the work, but nevertheless they gave Lorenzo the same salary. Filippo pursued his work with no good will, for he knew that all the labour would devolve upon him while he would have to share the honour and renown with Lorenzo. However, he took courage in the assurance that this condition would not endure for long, and together with Lorenzo he proceeded with the building in the manner described in his letter to the wardens. It then occurred to Filippo that he would make a model, as he had not previously done so, and having set his hand to it he gave it to Bartolommeo, a carpenter, to execute, a man who lived near his studio. In this he made all the difficult things to scale, such as the lighted and dark staircases, all manner of lights, doors, chains, and buttresses and also a part of the gallery. When Lorenzo heard of this he tried to see it, but as Filippo refused he became angry and determined to make a model of his own, in order that he might not appear to be drawing his salary for doing nothing. For his model Filippo received 50 lire 15 soldi, as appears by an entry in the book of Migliore di Tommaso, on 3rd October 1419, while Lorenzo Ghiberti was paid 300 lire for his trouble and expense, the reason for the difference being his greater influence and favour rather than any benefit or need that the building had of it. This torment of Filippo lasted until the end of 1426, Lorenzo and himself being equally known as the inventors, a thing which kept Filippo's mind in a perpetual state of ferment. Having planned many different ways he determined to rid himself of this incubus, knowing how little Lorenzo could do in the work. Filippo had carried the double vaulting of

the cupola to a height of 12 braccia, and now the chains of stone and timber were to be put up. As this was a difficult task, he decided to speak of it to Lorenzo in order to see whether he had taken this difficulty into consideration. So far was Lorenzo from having thought of such a thing that he answered that he relied on Filippo as being the inventor. This answer pleased Filippo, for it suggested a means of removing Lorenzo from the work and of showing that he did not possess the intelligence presupposed by his friends and by the favour which had put him where he was. The workmen were at a standstill, waiting for the beginning of the work above the 12 braccia, the construction of the vaulting and the making of the chains. They had already begun to close the cupola towards the top. For this it became necessary to make a scaffolding in order that the workmen and builders might work without danger. The height was such that a glance below was sufficient to make the blood run cold. The builders and other masters accordingly were waiting for directions for making the chains and the scaffolding, and as they heard nothing either from Lorenzo or from Filippo there arose a murmuring among them seeing that matters were not being carried on so rapidly as at first. Being poor men who lived by their hands, they feared that neither of the masters had the courage to proceed with the work, the best they could do being to finish and polish so much as had already been built. One morning Filippo did not appear at the work, bound up his head, took to his bed and called for hot plates and linen, pretending that he had the colic. When the masters who were waiting for orders heard this they went to Lorenzo and asked what they were to do. He answered that Filippo had the direction, and that it was necessary to wait for him. One of them asked, "But do you not know his intentions?" "Yes," said Lorenzo, "but I will do nothing without him." This he said to excuse himself, for he had not seen Filippo's model and had never asked him what plan he meant to follow, but in order that he might not appear ignorant he answered guardedly and in ambiguous words, particularly as he knew that he was in this work against Filippo's will. After the latter's illness had lasted for more than two days, the overseer of the work and several master builders went to see him and insisted that he should tell them what was to be done. He answered: "You have Lorenzo, let him do something," and nothing more could be drawn from him. When they heard this they fell to discussing the matter and greatly blamed the manner of the work. Some said that Filippo had taken to his

bed from grief that he had not sufficient courage to undertake the vaulting and that he repented of having ever begun it; his friends defended him, saying that his displeasure was caused by the disgrace of having Lorenzo given to him for a colleague, and that his pleurisy was caused by his efforts in the work. Meanwhile the building came to a standstill, and the builders and stonecutters were all but idle, so that they begun to murmur against Lorenzo, saying, "He can draw his salary all right, but cannot give directions for the work. If Filippo does not come, or if his illness lasts a long time, how will he manage? What fault of his is it that he is ill?" The wardens seeing the discredit attached to them for this state of affairs resolved to visit Filippo, and on their arrival, after condoling with him for his sickness, they informed him of the disorder in which the building then was and what trouble his sickness had caused. With words made passionate by his feint of illness and by his love for the work Filippo replied, "Is not Lorenzo there? Why does not he do something? I wonder at you coming to me." "He will do nothing without you," answered the wardens. "I could manage very well without him," was Filippo's retort. This sharp and two-edged answer sufficed them, and they departed, recognising that he was sick from his desire to have the work to himself. They therefore sent his friends to take him from his bed, intending to remove Lorenzo from the work. Filippo returned to the building, but perceiving the power and the influence behind Lorenzo, which allowed him to draw his salary without doing any of the work, he determined to find another method of holding him up to scorn and exposing his ignorance. Accordingly, in Lorenzo's presence, he made this proposal to the wardens: "Sirs, if we could ourselves determine the length of our own existence there can be no doubt that many works which are now left unfinished would have been completed. The accident of my recent sickness might have resulted in my death and stopped this work; yet in case either Lorenzo or myself falls sick, which God forfend, and that the progress of the work may not be suspended, it has occurred to me that as you, sirs, have divided the salary, so we may divide the work in order that each of us may show his knowledge, and be in a position to win honour and profit from the republic. We have at present two difficulties to solve: one is the scaffolding to permit the builders on the outside and inside of the structure to work in safety, as it is necessary for it to sustain men, stones and mortar, as well as the crane for lifting weights, and other similar instruments;

the other is the chain which is to be placed above the 12 braccia, to bind together the eight sides of the cupola in order that the whole of the superimposed weight may be so distributed that it will not push or spread but rest equally upon the entire edifice. Let Lorenzo take the one of these which he believes himself most capable of doing, so that I may prove my ability to deal successfully with the other, and that more time may not be lost." Lorenzo was bound in honour to accept one of these undertakings, however unwillingly, and he decided to take the chain as being more easy, trusting to the advice of the masons, and reflecting that there was a stone chain in the vaulting of S. Giovanni of Florence from which he might derive hints for a part if not the whole of the work. Thus one set to work at the scaffolding and the other at the chain, both completing their task. The scaffolding of Filippo was constructed with such ingenuity and industry that the contrary of what many had expected proved true, because the masons worked there in such security, drew up weights, and stood there as safely as if they had been on the level ground. The models of the scaffolding remained in the Opera. Lorenzo, with the utmost difficulty, succeeded in making the chain on one of the eight sides, and when it was completed the wardens brought Filippo to see it, but he said nothing to them. However, he spoke about it to some of his friends, saying that it was necessary to have a different ligature from that, and to have it laid in another fashion, and that it was not sufficient for the weight that was to be placed upon it, and would not stand the pressure, and that Lorenzo's salary as well as the money spent upon the chain had been thrown away. Filippo's opinion became known, and he was asked to show what he would have done if he had been employed to make the chain. As he had already made designs and models for this, he immediately produced them, and when the wardens and the other masters had seen these they recognised their mistake in favouring Lorenzo. Wishing to atone for this error, and to show that they were capable of recognising excellence, they made Filippo director and head of the work for life, and provided that nothing should be done without his consent. To prove their recognition of his work, they paid him 100 florins down, by a resolution of the consuls and wardens on 13th August, 1423, given by the hand of Lorenzo Paoli, notary of the work, to be paid by M. Gherardo di M. Filippo Corsini, and made him a provision of 100 florins yearly for life. Accordingly Filippo gave instructions for the continuation of the work, and he

followed its progress so closely that not a stone was laid without his personal supervision. On the other hand, Lorenzo, though vanquished and disgraced, was so favoured and assisted by his friends, that he continued to draw his salary, arguing that he could not be removed before the expiry of three years. Filippo was continually making designs for the smallest details, constructing models for scaffolds, and devising machines for raising weights. However, this did not prevent some ill-disposed persons, friends of Lorenzo, from annoying him by constantly making models in competition against him, to such an extent that Master Antonio da Verzelli made one, and other masters favoured and put forward by one citizen or another, showing their fickleness, ignorance and lack of understanding, for they possessed perfect things and they put forward imperfect and useless ones. At length the chains round the eight sides were completed, and the builders worked with spirit and a will; but as Filippo required more of them than before, and found fault daily with the building or some particulars, they became discontented. The leaders then took counsel together, saying that the work was difficult and dangerous, and they would not go on with it except at high wages, although their pay had been higher than the usual rate. In this way they hoped to be revenged on Filippo, and to benefit themselves. This dispute was equally displeasing to the wardens and to Filippo, and the latter, after thinking over the matter, took the step one Saturday of dismissing all his workmen. Finding themselves thus dismissed, and not knowing what the outcome would be, these men waited results, full of ill-will. But the following Monday Filippo set ten Lombards on the work, and stood over them himself, saying, Do this and that, and in one day he succeeded in teaching them so much that they continued to work there for many weeks. On the other hand, the builders who saw themselves dismissed and deprived of employment as well as put to shame, since they had no other work which was equally desirable, sent representations to Filippo that they were willing to return, pressing him to take them. But he kept them in suspense for many days, pretending that he did not want them, and at length engaged them at less wages than they had received before. Thus instead of gaining advantage for themselves, and being revenged on Filippo, they suffered loss and contumely.

The murmurers had now been silenced, and the genius of Filippo had so far triumphed in the smooth progress of the building, that all who were not blinded by passion considered that he

had displayed more ability in this structure than almost any other artist, ancient or modern. This feeling was caused by his producing his model, by which he showed with what care he had considered every detail: the ladders, the lights within and without, so that no one could injure himself in the darkness, and various iron staples for the purpose of mounting where it was steep, and similar considerations. Besides this, he had devised the iron staples to bear the scaffolding inside if it was ever to be adorned with mosaics or painting, and had put in the least dangerous places the channels for carrying off the water, showing where they should be covered, and where uncovered, arranging spaces and apertures to break the force of the winds, and to provide that tempests and earthquakes should not injure the structure, in all which things he proved how much he had profited by the long years he spent at Rome. When one considers how much attention he had paid to the joints, incrustations, nailing and ties of stone, one trembles at the thought that a single mind could compass so much. So greatly did his abilities increase that there was nothing, however difficult and hard, which he did not render easy and smooth. For example, he devised a method of raising weights by means of counterpoises and pulleys, so that a single ox was able to draw as much as six pair would otherwise have had difficulty in pulling. The building had by this time grown so much that it was a considerable journey to reach it from the ground, and much time was lost by the workmen in going to eat and drink, while they suffered great discomfort from the heat of the day. Filippo therefore contrived that inns should be opened on the cupola, where food could be cooked and wine sold. In this way no one left the work except at evening, which was a great advantage to the men and a considerable gain to the work. The progress and success of the building infused Filippo with more and more courage, and his efforts were unremitting. He would frequently go to the brick-kilns and examine the clay there, rubbing it carefully in his hands. He carefully examined the stones of the stonecutters to see that they were hard or if they contained any flaws, and showed them the way to make the joints by models made of wood and wax, or even of turnips, and doing the like with the ironwork for the smiths. He discovered a method of making hinges with a head and pivots, a great gain to architecture, which was indeed brought by him to a perfection probably never equalled among the Tuscans. In the year 1423 [1] Florence was delighted by the election of Filippo

[1] Should be 1425.

as one of the Signory by the quarter of S. Giovanni for the months of May and June, Lapo Niccolini being chosen gonfaloniere of justice by the quarter of S. Croce. In the Register Filippo is entered as Filippo ser Brunellesco Lippo, but this need not excite surprise, as he was thus named correctly after Lippo, his grandfather, and not de' Lapi. The Register contains similar examples in the case of others, as is well known by those who are acquainted with the ways of that time. Filippo performed the duties of that office as well as of other magistracies which he had in the city, in which he always displayed the weightiest judgment. As the vaulting was by this time being closed at the point where the lantern was to begin, Filippo had to decide finally what he would put there, although he had made more models of both vaults in clay and in wood, both at Rome and at Florence, than had been exhibited. Accordingly he determined to complete the gallery, and made various designs for it, which were in the Opera after his death, but have been lost owing to the carelessness of those in charge there. In our own day a part of one was made on one of the eight sides, but as it did not match the other work it was abandoned by the advice of Michelagnolo Buonarotti. Filippo also made a model for the lantern with eight sides, which is very beautiful for its originality, variety and decoration. He made a ladder up to the ball which was a marvel, but as he had stopped it up with a little wood at the point of entrance, no one but himself suspected its existence. Although he was now praised, and had overcome the envy and arrogance of many, yet he was not able to prevent all the masters in Florence from making their models in various fashions, so that even a lady of the house of Gaddi ventured to set up her judgment in competition with his. He, however, simply laughed at the presumption of others, and when his friends told him that he ought not to show his model to any aritst in order that they might not learn anything from it, he answered that there was only one true model and all the rest were vain. Some of the masters had adopted parts of Filippo's model in their own, so that when he saw them he said, "The next model of So-and-so will be entirely mine." Praise was lavished upon Filippo's work by all, but as they did not see any steps to ascend to the ball they concluded that it was defective. However, the wardens decided to allot this work to him, but stipulated that he should show them the way up. Filippo then removed the piece of wood at the base of the model and showed the ascent in a pillar in the form in which it exists to-day, of a

vaulted cylinder, and on one side a channel with bronze rings, where, by placing one foot after another, one may ascend to the top. He did not live to see the completion of the lantern, but he left directions in his will that it should be built as the model showed, and as he had directed in writing. If done otherwise he declared that the structure would fall, as it was vaulted in ogive and needed a counterpoising weight to render it more strong. He was not permitted to see this structure completed before his death, but was able to complete several braccia of it. He caused almost all the marble there to be well prepared. The people who saw it were amazed, believing it impossible that he could intend to place so great a weight above the vaulting. It was the opinion of many engineers that it would not bear the strain, and they thought it was a temptation of Providence to load it so heavily after having brought the work to that point. Filippo only laughed and made ready all the machines and every arrangement for the purpose of building, his brain being constantly busy in preparing and providing for every detail, even to the point of arranging that the worked marble should not be chipped when being raised into position. Thus all the arches of the tabernacles were cased in a wooden framework, and for the rest he left written instructions and models, as I have said. The extraordinary beauty of the structure is self-evident. Its height from the ground-level to the lantern is 154 braccia, the lantern itself being 36 braccia, the copper ball 4 braccia, and the cross 8 braccia, making 202 braccia in all. It may be safely asserted that the ancients never raised their buildings so high or incurred such great risks in contending with the skies as this building appears to, for it rises to such a height that the mountains about Florence look like its fellows. Indeed one would say that the heavens are incensed against it since it is continually being struck by lightning. Whilst this work was in progress Filippo erected many other buildings, as I shall describe in order below.

With his own hand he made the model of the chapter-house of S. Croce in Florence for the family of the Pazzi,[1] a work of great and varied beauty, and the model of the house of the Busini,[2] for the use of two families, and also the model for the house and loggia of the Innocenti,[3] the vaulting of which was erected without a scaffolding, a method now universally adopted. It is said that Filippo was invited to Milan to make the model for a fortress for the duke, Filippo Maria, and that he left

[1] Begun 1429. [2] Now Quaratesi, via Proconsolo, begun 1445.
[3] Begun 1420.

the care of the structure of the Innocenti to his close friend, Francesco della Luna. This Francesco made the surrounding ornamentation of an architrave, running downward from above, which is false according to architecture, When Filippo returned and blamed him for this, he replied that he had taken it from the church of S. Giovanni, which is ancient. " It is the only error in that building," replied Filippo, "and you have copied it." The model of this building by Filippo's hand was for many years in the art of Por S. Maria, and much valued as the structure was to have been completed. To-day it is lost. Filippo made the model of the abbey of the Regular Canons of Fiesole for Cosimo de' Medici.[1] It is a very ornate architecture, convenient and delightful; in fine really magnificent. The church with its barrel vaulting is roomy, the sacristy has its own conveniences, and indeed so has every other part of the monastery. But the most important consideration is that, having to erect the building on the flat on the steep side of the mountain, he made use of the basement with great skill, making cellars, lavatories, ovens, stables, kitchens, stores for wood, and other like conveniences, so that better could not be desired. He thus obtained a level base for his building, so that he was afterwards able to make on one plane the refectory, infirmary, noviciate, dormitory, library and other principal apartments of a monastery. All this was done at the cost of Cosimo de' Medici, both on account of his deep Christian piety and because of the affection he bore to Don Timoteo da Verona, a most excellent preacher of the order. In order the better to enjoy his conversation, he made many rooms for himself in the monastery, and lived there at his ease. On this building Cosimo spent 100,000 crowns, as we see by an inscription.[2] Filippo also designed the model of the fortress of Vicopisano, and at Pisa he designed the old citadel and fortified the sea bridge, while he further designed the new citadel for enclosing the bridge with the two towers. He also made the model of the fortress of the harbour of Pesaro, and on his return to Milan he did many things for the duke, including plans for the builders of the Duomo. At that time the church of S. Lorenzo at Florence was begun[3] by order of the parishioners, who had made the prior chief director of the works, he being a person who professed to understand such things, and who amused himself with architecture as a pastime, The building had already

[1] Begun 1439.
[2] The building was not finished until 1466. Some consider it the work of Leon Battista Alberti.
[3] In 1419.

been started with brick pillars when Giovanni di Bicci de' Medici, who had promised the parishioners and the prior that he would make the sacristy and a chapel at his own cost, invited Filippo to breakfast one morning, and after some preliminary conversation asked him his opinion about the new church. Filippo was constrained by Giovanni's prayers to give his opinion, and in speaking the truth blamed it in many things as a building designed by a man who probably had more learning than experience in such structures. Giovanni asked Filippo if he could devise anything better and finer, to which the latter replied, "Without doubt, and I wonder that you, as head, do not spend several thousand crowns and make a church with all that is requisite for the place and for the numerous family tombs of nobles, who, when they see a start made, will follow with their chapels to the utmost of their power, especially as we leave no other memory but the walls which bear witness to their authors for hundreds and thousands of years." Stirred by these words of Filippo, Giovanni determined to make the sacristy and principal chapel together with the body of the church, although no more than seven other houses would join him, the others not having the means, these seven being the Rondinelli, Ginori, dalla Stufa, Neroni, Ciai, Marignolli, Martelli and Marco di Luca, and these chapels were to be made in the cross. The sacristy was the first thing to be put in hand, and the church was afterwards built by degrees. And in the nave of the church chapels were granted one by one to notable citizens. The roofing-in of the sacristy was no sooner completed than Giovanni de' Medici passed to the other life,[1] leaving his son Cosimo. The latter being more enterprising than his father, and loving to cherish his memory, caused this building to be carried on. It was the first thing that he built, and he took such delight in it that up to the time of his death he was always erecting something there. Cosimo prosecuted this work with more ardour, and while one thing was under deliberation had another one completed. Having taken up this work as a pastime, he was almost continually at it, and his care provided that Filippo should finish the sacristy whilst Donato made the stucco as well as the stone ornament above and the bronze doors of the porch. There also he made his father Giovanni's tomb under a large marble slab, borne by four little columns, and standing in the midst of the sacristy, where the priests get ready. In the same place he made the tombs of his house, separating the women from the men, and

[1] In 1429.

in one of the two small chambers on either side of the altar of the sacristy he made a basin on one side and a place to wash the hands; in fact everything done there shows great judgment. Giovanni and the others had proposed to make the choir in the middle under the tribune. At Filippo's desire Cosimo moved it, so as to increase the size of the large chapel, which had been a small recess in the first design, and to be able to place the choir there as it now is. When this was finished, the middle tribune and the rest of the church still remained to be done, and these were not vaulted until after Filippo's death. The church is 144 braccia long and it contains many errors, among others that the columns rest on the ground without a dado beneath, which ought to reach to the level of the bases of the pilasters, placed upon the steps. The pilaster thus looks shorter than the column, and gives the whole work a stunted appearance. This was due to the advice of those who survived Filippo, who envied his name, and who in his lifetime had made models against him. While Filippo lived he ridiculed them in his sonnets, but after his death they revenged themselves not only in this work, but in all that was left to them to do. Filippo left the model, and a part of the capitular buildings of the priests of S. Lorenzo was finished in which he made the cloister 144 braccia long.

Whilst this work was going on, Cosimo de' Medici wished to build his palace, and accordingly opened his mind to Filippo, who, putting aside every other care, made him a most beautiful large model for it. He wished to have it erected opposite S. Lorenzo, on the piazza, and standing alone. Filippo had given such free rein to his art that Cosimo thought the building too sumptuous and grand, and more to escape envy than expense, he refrained from putting the work in hand. While he was at work on the model, Filippo would say that he thanked Fortune for giving him such a chance, for he had a house to build, a thing he had desired for many years, and it had fallen to his lot to make one which he was anxious and able to do. But learning afterwards Cosimo's resolve not to put that work in hand, he wrathfully broke the design into a thousand pieces. After his palace had been erected upon another plan, Cosimo repented that he had not followed Filippo's, and used to say that he had never spoken to a man of greater intelligence and wit than Filippo. The latter also made the model for the curious temple of the Angeli for the noble family of the Scolari, which was left incomplete as it is to-day, because the Florentines in their difficulties had spent the money upon some necessities

of the city, or, as some say, in the war which supervened with the Lucchese, in which they also expended the money left by Niccolo da Uzzano to build the Sapienza, as is related at length in another place. If this temple of the Angeli had been finished according to the model of Brunellesco, it would have been one of the finest in Italy, since the part that may now be seen cannot be too highly praised. The drawing by Filippo's hand for the ground plan and elevation of this octagonal church are in our book, with others of his designs. Filippo also planned a rich and magnificent palace for M. Luca Pitti outside the S. Niccolo gate at Florence in a place called Ruciano, but not at all like that which was begun by the same man in Florence, and carried as far as the second story, with such grandeur and magnificence that no finer piece of Tuscan work has yet been seen. The doors of this later palace are double, 16 braccia by 8, the windows of the first and second stories resembling the doors in every respect. The vaulting is double, and the entire edifice so artistic that nothing finer or more magnificent could possibly be desired. The one who carried out this work was Luca Fancelli, architect of Florence, who did many buildings for Filippo; and for Leon Battista Alberti he did the principal chapel of the Nunziata at Florence, for Ludovico Gonzaga, who took him to Mantua, where he did a goodly number of works, and there took a wife, and lived and died, leaving heirs who are still called the Luchi after him. The illustrious Lady Leonora di Toledo, Duchess of Florence, bought this palace not many years ago, by the advice of Duke Cosimo, her consort,[1] and enlarged it greatly, adding a large garden, which is partly on the flat, partly sloping, and partly hills, full of all manner of native and forest trees, with pleasant thickets, all sorts of evergreen plants, not to speak of the water, the fountains, conduits, fish-ponds, lime-trees, hedges, and other things proper to a magnificent prince, which I do not describe, because one who has not seen them cannot possibly imagine their grandeur and beauty. Indeed, Duke Cosimo could not possibly have undertaken anything more worthy of the power and greatness of his spirit than this palace, which really seems to have been built expressly for his Illustrious Excellency by M. Luca Pitti from Brunellesco's design. M. Luca was prevented from completing it because of his labours in matters of State, and his heirs having no means of completing it were glad to have this opportunity of pleasing the duchess, and saving it from going to ruin. While she lived she was always spending

[1] In 1549.

money upon it, but not so much that she could expect to see it speedily completed. If she had lived, indeed, she was disposed to spend 40,000 ducats upon it in a single year, as I have understood, in order that she might see it well advanced if not finished. Filippo's model being lost, her Excellency caused another to be made by Bartolommeo Ammannati, an excellent sculptor and architect, and the work was carried on in accordance with that, and a great part of the courtyard has been made of rustic work, like the exterior. Indeed, anyone who considers the greatness of this work will marvel that Filippo's mind should conceive such a building, which is not only magnificent in its exterior façade, but in the disposition of all the apartments. I pass over the view, which is very beautiful, and the amphitheatre formed by the pleasant hills descending to the walls of the palace, because, as I have said, it would take too long to describe them at length, and one who has not seen it cannot imagine how superior it is to any other royal edifice.

It is said that the apparatus of the Paradise of S. Felice in the piazza of that city was invented by Filippo for the representation or feast of the Annunciation according to the time-honoured custom of the Florentines. This thing was truly marvellous, and displayed the ability and industry of the inventor. On high was a heaven full of living and moving figures, and a quantity of lights which flash in and out. I will take pains to describe exactly how the apparatus of this machine was devised, seeing that the machine itself is destroyed, and the men are dead who could have spoken of it from experience. There is no hope that it will be reconstructed, for the Camaldoline monks no longer inhabit the spot, but the nuns of St. Peter Martyr; and the roof of the Carmine suffered considerable injury from these celebrations. For this effect Filippo had arranged a half-globe between two rafters of the roof of the church, like a hollow porringer or a barber's basin turned upside down. It was formed of thin laths secured to an iron star which revolved round a great iron ring upon which it was poised. The whole machine was supported by a strong beam of pine well bound with iron, which was across the timbers of the roof. In this beam was fixed the ring which held the basin in suspense and balance, which from the ground resembled a veritable heaven. At the base, on the inside edge, were certain wooden brackets just large enough for one to stand on, and at the height of a braccia and also inside another iron. On each of the brackets was placed a child of about twelve, making 1½ braccia with the iron, and so girt about that they

could not fall even if they wanted to. These children, twelve in all, being arranged, as I have said, on pedestals and clad like angels with gilt wings and caps of gold lace, took one another's hands when the time came, and extending their arms they appeared to be dancing, especially as the basin was always turning and moving. Inside this and above the head of the angels were three circles or garlands of lights arranged with some tiny lanterns which could not turn over. These lights looked like stars from the ground, while the beams being covered with cotton resembled clouds. From the ring issued an immense iron bar furnished with another ring at the side, to which was attached a slender cord which fell to the ground, as we shall see. The bar had eight branches, and revolved in an arc filling the entire space inside the basin. At the end of each branch was a plate as large as a trencher, on which a boy of nine was placed, tied in with an iron fixed at the height of the branch, but so as to allow him to turn in every direction. These eight angels, by means of a crane, descended from the top of the basin to beneath the plane of the beams bearing the roof, a distance of eight braccia, so that they could be seen and did not interfere with the view of the angels surrounding the inside of the basin. Inside what we may truthfully call the nosegay of eight angels, there was a copper mandorla filled with small lights placed in many niches, and set upon an iron like cannon, which, upon touching a spring, were all hidden in the hollow of the copper mandorla, and when the spring was not pressed all the lights appeared through holes there. When the nosegay had reached its place, the mandorla was slowly lowered by another crane to the stage where the performance took place. Above this stage, exactly where the mandorla was to rest, was a high throne with four steps, with an opening, through which the iron of the mandorla passed. A man was placed below the throne, and when the mandorla reached its station he secured it with a bolt. Inside the mandorla was a youth of about fifteen, representing an angel, surrounded by an iron and fixed in the mandorla so that he could not fall, and to permit him to kneel the iron was in three pieces, so that as he knelt one telescoped into the other. Thus, when the nosegay had descended and the mandorla rested on the throne, the man who fastened the mandorla unfastened the iron which bore the angel, so that he came out, walked along the stage, and when he came to where the Virgin was saluted her, and made the Annunciation. Then he returned to the mandorla, and the lanterns, which had been extinguished when

he stepped out, were relighted, and the iron which bore him was newly fastened by the unseen man beneath, whilst the angels of the nosegay sang, and those of the heaven turned about. It thus appeared a veritable Paradise, the more so as, in addition, a God the Father was placed beside the convex side of the basin, surrounded by angels similar to those above, and fastened with iron in such a manner that the heaven, the nosegay, the Deity, the mandorla, with the numerous lights and sweet music, represented Paradise most realistically. In addition to this, in order that the heaven might be opened or shut, Filippo added two large doors, five braccia high, one on either side, provided with iron or copper rollers running in grooves, so arranged that by drawing a slender cord, the doors opened or closed at will, the two parts of the door coming together or slowly separating. These doors had two properties, one was that, being heavy, they made a noise like thunder, the other was that, when closed, they formed a scaffold for fixing the angels and arranging the other things needed inside. These ingenious things and many others were invented by Filippo, although some assert that they were introduced long before. However this may be, it is well to speak of them, because the use of them has completely gone out.

But to return to Filippo. His fame and name had increased to such an extent that all who wanted to erect buildings sent for him from great distances, to procure designs and models by the hand of such a great man, and for this they brought the most distinguished influences to bear. Among those who wanted him was the Marquis of Mantua, who wrote a very pressing letter to the Signoria of Florence. And so Filippo was sent thither by them, and designed the dykes to hold in the Po, in the year 1445, and some other things, in conformity with the prince's desire, who made much of him, saying that Florence was worthy to have a citizen like Filippo, just as he deserved to have so noble and beautiful a city for his home. Similarly in Pisa, where he convinced the Count Francesco Sforza and Niccolo da Pisa of his superiority, in certain fortifications; when they commended him in his presence, saying that if every state had a man like Filippo, it might feel secure without arms. In Florence Filippo designed the house of the Barbadori, next to the tower of the Rossi in the Borgo S. Jacopo, which was not carried out, and he also designed the house of the Giuntini on the piazza of Ognissanti on the Arno. After this, the captains of the Guelph party in Florence proposed to erect a building containing a hall and audience-chamber for that magistracy, and entrusted it to

Francesco della Luna, who began the work.[1] He had already
raised it to a height of ten braccia from the ground, and com-
mitted many mistakes, when the charge of it was given to
Filippo, who brought that palace to its present shape and
magnificence. In building it he had to compete with Francesco,
who was favoured by many; indeed throughout his life Filippo
was forced to contend first with one and then with another, a
source of constant annoyance to him. Often they sought to win
honour with his designs, so that finally he refused to show any-
thing or trust anyone. The hall of this palace no longer serves
for the captains of the party, because the flood of 1557 did such
damage to the papers of the Monte that Duke Cosimo caused
the magistracy to be brought there for greater safety, as the
papers are of the highest importance. Thus the old hall of the
palace serves for the magistracy of the captains, and being
separated from the room which is used for the Monte, and
withdrawn to another part of the building, the convenient hall,
which now leads into the hall of the Monte, was made by Giorgio
Vasari by the commission of his Excellency. The same architect
designed a square balcony, supported, according to the arrange-
ment of Filippo, upon fluted pillars of macigno.

One Lent the preaching at S. Spirito at Florence was under-
taken by M. Francesco Zoppo, then a favourite with the people,
and he spoke eloquently in favour of the convent, the schools
for young men, and especially for the church which had recently
been burned. [2] The heads of the quarter, Lorenzo Ridolfi,
Bartolommeo Corbinelli, Neri di Gino Capponi, Goro di Stagio
Dati, and many other citizens, obtained permission from the
Signoria to take steps for the rebuilding of the church, making
Stoldo Frescobaldi the overseer. This man devoted the most
severe labour to this work, owing to the interest which he had
in the old church, the high-altar chapel of which belonged to his
family. Thus, from the very beginning, before money had been
raised by the rating of the tombs and of those who had chapels,
he spent many thousand crowns out of his own pocket, for
which he was recouped later. After they had deliberated upon
the matter, Filippo was sent for and made a model comprising
all the arrangements befitting a Christian church. He entirely
reversed the plan of the church, as he was most anxious that
the piazza should face the Arno, for it was there that all the
people from Genoa, the Riviera, the Lunigiana, the Pisano and
the Lucchese passed by, and they would see the magnificence

[1] In 1418 in the via delle Terme.　　　　　[2] In 1417.

of the structure. But as certain people were unwilling to allow their houses to be pulled down, Filippo's wish could not be carried out. Filippo then made the model of the church as well as of the friars' quarters in their present form.[1] The length of the church was 171 braccia, and its breadth 54 braccia, and it is so well arranged that no building could be richer, finer or more spacious in the disposition of its columns and other ornaments. Indeed, had it not been for the curse of those who, from lack of understanding more than anything else, spoil things beautifully begun, this would be the most perfect church in Christendom, as in some respects it is, being more beautiful and better divided than any other, although the model has not been followed, as is shown by some things begun outside which have not followed the dispositions of the interior for the doors and window decoration as shown in the model. It contains some errors attributed to Filippo which I pass over, for I do not believe that he would have fallen into them if he had continued the building of that church, all his work being done with great judgment, discretion, genius and art, and everything brought to perfection. This work puts the stamp of the highest worth upon his genius.

Filippo was witty in his conversation and acute in repartee, as for instance in the case of Lorenzo Ghiberti, who had bought a property at Monte Morello called Lepriano, on which he spent twice as much as he derived from it, and finally sold it in disgust. On being asked what was the best thing Lorenzo had done, Filippo replied, "The sale of Lepriano," possibly thinking that he owed him this because of their unfriendly relations. At last, having reached the great age of sixty-nine, Filippo passed to a better life on 16th April, 1446, after a life of labour in producing those works which should earn him an honoured name on earth and a place of rest in heaven. His loss caused great grief to his country, which knew him and valued him much more after his death than during his life. He was buried with honourable obsequies in S. Maria del Fiore, although his family tomb was in S. Marco under the pulpit towards the door, containing a coat of arms with two fig leaves and some green waves on a gold ground, as his ancestors came from Ficaruolo, a place on the Po, in the territory of Ferrara, the leaves denoting the place and the waves the river. His artist friends also grieved, especially the poorer ones, whom he was always helping. He lived as a good Christian and left to the world the savour of his goodness and striking virtues. It may safely be said that from the time of the

[1] The church was begun about 1436.

ancient Greeks and Romans until now there has been no man
more rare or more excellent than he, and he deserves the greater
praise because in his time the Gothic style was admired in all
Italy and practised by the old artists, as we see in a countless
number of buildings. He reintroduced the ancient cornices and
reinstated the Tuscan, Corinthian, Doric and Ionic orders in
their original form. He had a pupil from Borgo a Buggiano
called Il Buggiano,[1] who made the font of the sacristy of S.
Reparata, with some children throwing water, and also the
head of his master in marble, taken from life, which, after his
death, was placed in S. Maria del Fiore, at the right-hand of the
door on entering the church, where the following epitaph still
stands, put there by the public to honour Filippo after his death,
as he, when alive, had honoured his country:

D. S.

Quantum Philippus architectus arte Daedalea valuerit, cum
hujus celeberrimi templi mira testudo, tum plures aliae divino
ingenio ab eo adinventae machinae documento esse possunt. Qua-
propter ob eximias sui animi dotes singularesque virtutes, XV Kal.
Majas Anno MCCCCXLIV ejus B.M. corpus in hac humo supposita
grata patria sepeliri jussit.

Others wishing to honour him still more have added these two
lines:

Philippo Brunellesco Antiquae architecturae
instauratori S. P. Q. F. Civi suo benemerenti.

Gio Battista Strozzi composed this other:

Tal sopra sasso sasso
Di giro in giro eternamente io strussi
Che cosi passo passo
Alto girando al ciel mi ricondussi.

Other pupils of Filippo were Domenico dal Lago di Lugano,[2]
Geremia da Cremona, a fine worker in bronze, and a Sclavonian
who did a number of things in Venice, Simone, who, after making
a Madonna for the art of the apothecaries at Or. S. Michele,
died at Vicovaro while engaged upon a large work for the Count
of Tagliacozzo, Antonio and Niccolo of Florence,[3] who made a
bronze horse at Ferrara for the Duke Borso in the year 1461,
and many others whom it would take too long to mention.[4]
Filippo was unfortunate in some respects, as, besides the ceaseless

[1] Andrea di Lazzaro Cavalcanti. [2] Domenico Gagini.
[3] Antonio di Cristoforo; Niccolo Baroncelli.
[4] Professor Venturi conjectures that the statue is by Antonio and the
horse by Niccolo. It was set up a year after the latter's death.

opposition he encountered, some of his buildings could not be finished in his day and have not been completed since. It is especially regrettable that the monks of the Angeli could not finish their church, begun by him,[1] as has been said, for after they had expended more than 3000 crowns upon it, as may be seen, the money being partially raised from the art of the merchants and part from the Monte, the capital was dispersed and the building has long remained incomplete. Thus, as I said in the life of Niccolo da Uzzano,[2] whoever wishes to leave a memory of himself in this way should perform his things himself and not trust to others. This remark applies to a number of the buildings planned by Filippo Brunelleschi.

DONATO, Sculptor of Florence
(1386–1466)

DONATO, called Donatello by his friends, and who thus signed himself on some of his works, was born in Florence in 1383. Devoting himself to the art of design he became not only a most rare sculptor and marvellous statue-maker, but was skilful in stucco, versed in perspective and highly esteemed in architecture, while his works possessed such grace, design and excellence that they were held to resemble the excellent productions of the ancient Greeks and Romans more than those of any other. Thus he is deservedly placed in the front rank of those who first showed the beauty of bas-reliefs, which were executed by him with great facility and mastery, and a more than ordinary beauty showing that he thoroughly understood that work. Indeed no other artist surpassed him in this branch, and even in our own age no one has equalled him.

Donatello was reared from his childhood in the house of Ruberto Martelli, and earned the love of Ruberto and of all that noble family by his good qualities and by his ardour for work. In his youth he produced many things, which were not highly valued because they were so numerous. But the work that made his name and brought him into notice was an Annunciation in *macigno* stone, placed at the altar and chapel of the Cavalcanti in S. Croce, for which he made an

[1] About 1434.
[2] There is no Life of him in this work, for he was not an artist but a politician. The reference is to a paragraph in the life of Lorenzo di Bicci at page 197 above.

ornament in the grotesque manner, the base varied and twisted and the pediment a quarter-circle, adding six [1] infants bearing festoons, who seem to be afraid of the height, and to be reassuring themselves by embracing each other. But he showed especial genius and art in the figure of the Virgin, who, affrighted at the sudden appearance of the angel, moves her person timidly and sweetly to a modest reverence, turning with beautiful grace to the one who salutes her, so that her face displays the proper humility and gratitude due to the bestower of the un-expected gift. Besides this, Donato showed a mastery in the arrangement of the folds of the drapery of the Madonna and of the angel, and by a study of the nude he endeavoured to discover the beauty of the ancients which had remained hidden for so many years. He gave evidence of so much facility and art in this work that design, judgment and skilled use of the chisel could produce nothing finer.

In the same church, below the screen, beside the scene painted by Taddeo Gaddi, he made a wooden crucifix with extraordinary labour, and when he had finished it he thought it most remark-able, and showed it to Filippo di ser Brunellesco, his close friend, to have his opinion. From what Donato had said Filippo expected to see something much better than he actually did, and could not refrain from smiling. Donato perceived this and he adjured him by their friendship to give his opinion. Filippo then frankly replied that it seemed to him that he had put a rustic on the cross and not a body like Jesus Christ, who was most delicate in every member, and the most perfect man who was ever born. Donato thus hearing himself criticised so tren-chantly when he had expected praise, retorted, "If it was as easy to do things as to pass judgment, my Christ would seem to you to be a Christ and not a rustic: but take some wood and try and make one yourself." Without another word Filippo returned to his house, no one being aware of what he was doing, and began to make a crucifix, endeavouring to surpass Donato in order not to condemn his own judgment. After many months he brought it to the utmost perfection. This done, he invited Donato one morning to dine with him, and Donato accepted the invitation. Accordingly he proceeded to Filippo's house in his host's company, and when they reached the Mercato Vecchio, Filippo bought some things and gave them to Donato, saying, "Take these things to the house and wait for me there, and I will come directly." When Donato entered the house and had

¹ Four, to be accurate.

arrived on the spot he saw Filippo's crucifix in a good light and stopped to examine it. He found it so perfectly finished that, overcome with amazement and almost beside himself, he opened his hands and his lapful of eggs, cheese and other things was spilt and broken. But he stood wrapt in wonder and admiration like one demented. At this moment Filippo arrived, and said laughing, "What are you thinking about, Donato? What shall we dine upon seeing that you have upset everything?" "I have had enough this morning for my part," said Donato, "if you want yours take it. But enough, to you it is given to make Christs, to me rustics."

In the church of S. Giovanni in the same city Donato made the tomb of Pope Giovanni Costa, who had been deposed from the pontificate by the Council of Constance.[1] This work was a commission from Cosimo de' Medici, the close friend of Costa, and in it Donato represented the dead man in gilt bronze, with Hope and Charity in marble, while his pupil Michelozzo did the Faith. In the same church, opposite this work, may be seen a St. Mary Magdalene in wood, a very beautiful penitential figure, finely executed, as she is consumed by fasting and abstinence, so that her body exhibits a most perfect knowledge of anatomy in every part. In the Mercato Vecchio there is a stone figure of Plenty by Donato, placed upon a granite column by itself, which has been much admired by artists and all good judges for its excellent workmanship. The column upon which it stands was originally in S. Giovanni, among other granite columns supporting the inner cornice, which are still there. When it was taken away, another fluted column was put in its place, upon which the statue of Mars formerly stood in the middle of the church, being taken away when the Florentines were converted to the faith of Christ. The same artist, while still a youth, also made the prophet Daniel[2] in marble for the façade of S. Maria del Fiore, and a St. John the Evangelist seated, four braccia high, clothed in a simple habit, which has been much admired.[3] At the same place, on the angle facing the via del Cocomero, is an old man between two columns, more like the antique manner than any extant work of Donato, the head exhibiting that thoughtfulness which comes with years in those who are wasted by age and labour. For the interior of the same church he made

[1] Baldassare Coscia, who had been Pope John XXIII. He died 1419. His tomb was begun in 1425.
[2] Now inside, paid for in 1412. The figure represents Joshua.
[3] Done in 1408.

the ornamentation of the organ over the door of the old sacristy,[1] the figures depicted on it seeming in truth to be endowed with life and motion. For this reason it may be said that Donato employed his judgment as much as his hands, seeing that he made many things which look beautiful in the places where they are situated; but when they have been removed, and put elsewhere in another light or higher up, their appearance is changed and they create an entirely different impression. Thus Donato made his figures in such fashion that in his studio they did not appear half so remarkable as when they were set up in the appointed places. In the new sacristy of the same church he designed the children who hold the festoons which turn about the frieze, and he also designed the figures for the round window beneath the cupola containing the Coronation of Our Lady. This design is clearly superior to those of the other round windows. At S. Michele in Orto in that city he made the statue of St. Peter for the art of the butchers, a suave and marvellous figure, and a St. Mark the Evangelist[2] for the art of the linen-drapers, which he had undertaken to do in conjunction with Filippo Brunelleschi, but afterwards finished by himself, an arrangement to which Filippo had consented. This figure was executed by Donatello with so much judgment that when it was on the ground its excellence was not recognised by unskilled persons, and the consuls of the art were not disposed to accept it; but Donato asked them to allow it to be set up, as after he had retouched it the figure would appear quite different. This was done, the figure was veiled for fifteen days, and then, without having done anything more to it, he uncovered it, and filled everyone with admiration.

For the art of the armourers he made a fine statue of St. George armed,[3] the head exhibiting the saint's youthful beauty, valour and spirit with extraordinary realism and life for a piece of stone. Certainly no modern figures in marble display so much force and realism as Nature and art have produced in this by means of Donato's hand. On the marble pedestal which bears the niche he carved in bas-relief the slaying of the serpent, including a horse, which has been highly valued and praised. On the pediment he made a God the Father in bas-relief. Opposite the church of the said oratory he made a marble tabernacle for the Mercatanzia in the Corinthian Order, distinct from the Gothic style, to receive two statues, which he did not make owing to

[1] Commissioned 1433, finished 1440. Now in the Opera del Duomo.
[2] These two Apostles were done in 1412.
[3] Done about 1415. Removed to the Bargello in 1886.

disputes about the price. After his death Andrea del Verocchio made these two figures in bronze, as will be said. For the front of the campanile of S. Maria del Fiore he did four marble figures five braccia high, the two middle ones being portraits of Francesco Soderini as a youth and Giovanni di Borduccio Cherichini, now known as Il Zuccone.[1] This being considered a most rare work, and finer than anything else which he did, Donato used to say, when he wished to take an unusually solemn oath, "By the faith which I bear to my Zuccone"; and while he was at work on it he would look at it, and repeat, "Speak, plague take you, speak." On the side facing the Canonry, over the door of the campanile, he made an Abraham sacrificing Isaac and another prophet which were placed between two other statues.[2] For the Signoria of the city he made a metal cast which was placed in an arch of their loggia on the piazza, representing Judith cutting off the head of Holophernes, a work of great excellence and mastery, which displays to anyone who will consider the external simplicity of Judith in her dress and aspect the great spirit of that lady and the assistance of God, while the appearance of Holophernes exhibits the effects of wine and sleep, with death in his cold and drooping limbs. This work was so well carried out by Donato that the slender and beautiful cast excited the utmost admiration after he had polished it. The pedestal, which is a granite baluster of simple design, is full of grace and pleasing to the eye. He was so delighted with this work that he put his name on it, contrary to his usual custom, as we see by the words *Donatelli opus*. In the courtyard of the palace of the Signoria there is a nude David of life-size, who has cut off Goliath's head and places his raised foot upon it, while his right hand holds a sword.[3] This figure is so natural and possesses such beauty that it seems incredible to artists that it was not moulded upon a living body. This statue formerly stood in the courtyard of the Medici palace, and was carried to its present place on the exile of Cosimo. The Duke Cosimo has recently made a fountain on its former site [4] and caused the statue to be removed, reserving it for another courtyard which he proposes to make at the back of the palace, where the lions were. On the left-hand of the hall containing the clock of Lorenzo della Volpaia there is still a fine David in marble, with the head

[1] On the west front. The figures are John the Baptist, Jonas (the Zuccone), Jeremias; the fourth, Abdias, is by Rosso.

[2] Done in conjunction with Giovanni di Bartolo, called il Rosso, in 1421.

[3] Done about 1440; set up in the Palazzo Vecchio in 1495.

[4] Verrocchio's Boy with the Dolphin.

of Goliath under his foot, while in his hand he holds the sling with which he has slain him.[1] In the first court of the Casa Medici there are eight marble medallions containing representations of antique cameos, the reverse of medals, and some scenes very beautifully executed by him, built into the frieze between the windows and the architrave above the arches of the loggia. He also restored a Marsyas in antique white marble, placed at the exit from the garden, and a large number of antique heads placed over the doors and arranged by him with ornaments of wings and diamonds, the device of Cosimo, finely worked in stucco. In granite he made a lovely basin which throws up water, and a similar one in the garden of the Pazzi at Florence which also spouts water. In the same palace of the Medici there are Madonnas in marble and bronze, in bas-relief, and some scenes in marble, with fine figures marvellously done in shadow relief. The esteem which Cosimo entertained for Donato's talent was such that he kept him constantly employed, and Donato had so much affection for Cosimo that from the slightest indication he divined all that he required and punctiliously obeyed him. It is said that a Genoese merchant once employed Donato to make a fine bronze head of life-size and very light, so that it might be carried to a distance, and that the work was given to him through the intervention of Cosimo. When it was finished, and the merchant wished to pay for it, it seemed to him that Donato asked too much. The question was referred to Cosimo, who caused the head to be brought to the court of his palace, and placed among the pinnacles on the street front, that it might be the better seen. Cosimo then decided that the merchant's offer was inadequate, saying that the price asked was too small. The merchant, who thought it too high, said that Donato had completed it in a month or a little more, which came to more than half a florin a day. Donato turned round angrily, much incensed at the remark, and exclaiming to the merchant that in an instant he was able to destroy the work and toil of a year, gave the head a push into the street where it was broken into many pieces, saying that the merchant was accustomed to bargain for haricot beans but not for statues. Then he repented, and offered Donato double if he would make another, but the sculptor refused, though Cosimo united his prayers to those of the merchant. In the houses of the Martelli there are many scenes in marble and bronze, among them a David, three braccia high, and many other things generously given by him as a sign

[1] This is probably the David now in the Bargello.

of the service and love which he bore to such a family, and
especially a marble St. John[1] in full relief, three braccia high, a
most rare work, now in the house of the heirs of Ruberto Martelli,
who made a bond that it should never be pledged, sold or given
away, under severe penalties, as a testimony of the affection
they bore to Donato in recognition of his worth, and of his
gratitude to them for their protection and favours. He also
made a marble tomb for an archbishop, which was sent to
Naples, and is placed in S. Angelo at Seggio di Nido. It contains
three figures in full relief which bear the sarcophagus on their
heads, and on the body of the sarcophagus there is a remarkably
fine bas-relief which has been much admired.[2] In the house of
the Count of Matalone in the same city there is a horse's head
by Donatello, so fine that many believe it to be antique.[3] In the
town of Prato he made the marble pulpit where the girdle is
shown.[4] The panels contain some dancing children so beautifully
and marvellously carved that his mastery of his art may be said
to be displayed in this as signally as in his other things. To
support this work he made two bronze capitals, one of which
is still there, the other having been carried off by the Spaniards
when they ravaged the country. It happened at this time that
the Signoria of Venice, hearing of Donatello's fame, sent for him
to make a monument to Gattamelata[5] in the city of Padua.
He went there very willingly and made the bronze horse which
stands in the piazza of S. Antonio, displaying the chafing and
foaming of the animal and the courage and pride of the figure
who is riding him with great truth. He showed such skill in the
size of the cast in its proportions and general excellence that
it may be compared with any antique for movement, design,
artistic qualities, proportion and diligence. Not only did it fill
all the men of that day with amazement, but it astonishes every-
one who sees it at the present time. For this cause the Paduans
endeavoured by every means to make him a fellow-citizen and
to detain him there by all manner of favours. To keep him em-
ployed they allotted to him the predella of the high altar of the

[1] i.e. St. John the Baptist, still in the Casa Martelli.
[2] The tomb was that of Cardinal Brancacci, who died in 1427. The figures
represent the Assumption of the Virgin. The work was done in conjunction
with Michelozzo.
[3] Now in the National Museum, Naples. Goethe took it for an antique
when visiting the city.
[4] Done 1434–8.
[5] Erasmus de' Narni, a famous condottiere, who died at Venice in 1443.
The monument was cast in 1447 and unveiled in 1453. Donatello received
1650 gold ducats.

church of the friars minors, to represent scenes in the life of St. Anthony of Padua.[1] These bas-reliefs are executed with such judgment that masters in the art have been struck dumb with admiration in beholding them when they have considered their beautiful and varied composition, comprising such a number of remarkable figures placed in diminishing perspective. For the front of the altar he made the Maries weeping over the dead Christ. In the house of one of the Counts of Capodilista he made the skeleton of a horse of wood without glue, which may still be seen, in which the joints are so well made that he who reflects upon the method of such work may form an opinion of the capacity of the brain and the greatness of the spirit of the author. For a nunnery he made a St. Sebastian of wood at the request of a chaplain, their friend and his familiar, who was a Florentine. The chaplain brought him a rude old one which they had, asking Donato to make one like it, but though he endeavoured to imitate it, in order to please the chaplain and the nuns, he could not succeed, and though the model was rude, his own work was of his accustomed excellence and art. In conjunction with this he made many other figures of clay and stucco, and chiselled a very beautiful Madonna from the corner of a piece of old marble which the nuns had in their garden. An extraordinary number of his works may be met with all over Padua. But being considered as a miracle there and praised by every intelligent man, he determined to return to Florence, saying that if he remained longer at Padua he would have forgotten all that he ever knew, as he was so highly praised by everyone, and he returned gladly to his native town because there he was always being blamed, and this blame induced him to study and was productive of more glory. Accordingly he left Padua and, returning to Venice, left there a St. John the Baptist in wood, as a gift for the Florentine nation, for their chapel in the friars minor, executed by him with the greatest diligence and care, as a memorial of his excellence. In the city of Faenza he carved a St. John and a St. Jerome in wood,[2] which were not less highly esteemed than his other works. Returning next to Tuscany, he made a marble tomb in the Pieve of Montepulciano with a very fine scene.[3] In the sacristy of S. Lorenzo in Florence he made a

[1] The altar was completed in 1450.

[2] This latter figure is now in the Museo Civico. Professor Venturi considers it unworthy of Donatello.

[3] To Bartolommeo Agazzi, secretary to Pope Martin V. The work was allotted jointly to Donatello and Michelozzo in 1427 and completed in 1429. Portions remain in the Duomo at Montepulciano and two angels from it are in South Kensington Museum.

fine marble lavatory at which Andrea Vierocchio also worked,
and in the house of Lorenzo della Stufa he made some very life-
like heads and figures. Leaving Florence after this he went to
Rome, to imitate and study the antique as much as possible.
At that time he made a stone tabernacle of the Sacrament,
which is now in S. Pietro.[1] Returning to Florence and passing
through Siena, he undertook to make a bronze door for the
baptistery of S. Giovanni. But when he had made a model in
wood and had almost got the wax moulds ready for the casting,
Bernardetto di Mona Papera, a Florentine goldsmith and his
friend and familiar, arrived upon the scene, having come from
Rome, and succeeded in carrying him off to Florence, whether
for his own needs or for other reasons, and thus the work re-
mained imperfect, as if it had never been begun. The only thing
by his hand in that city is in the Opera of the Duomo, a St. John
the Baptist in metal, the right arm of which is wanting from the
elbow.[2] It is said that Donato did this because he did not receive
full payment. On his return to Florence he did the sacristy of
S. Lorenzo in stucco for Cosimo de' Medici, namely, four circles
at the foot of the vaulting with stories of the Evangelists in
perspective, partly painted and partly bas-relief. He made two
very beautiful little bronze doors, with the Apostles, martyrs
martyrs and confessors, and above these some flat niches, one
containing a St. Laurence and St. Stephen, and the other SS.
Cosmo and Damian.[3] In the crossing of the church he did four
saints in stucco of five braccia each, which are skilfully executed.
He also designed the bronze pulpits,[4] representing the Passion
of Christ, which possess design, force, invention and an abun-
dance of figures and buildings. As he could not work at them
himself on account of his age, his pupil, Bertoldo, completed
them and put the finishing touches. At S. Maria del Fiore he
made two colossal figures of bricks and stucco, which were
placed outside the church on the sides of the chapels as an
ornament. Over the door of S. Croce may be seen to this day a
bronze St. Louis of five braccia, finished by him.[5] When he was

[1] Rediscovered in 1886 and placed in the Sacristy Chapel of the Bene-
ficiati, S. Pietro.
[2] This was done in 1457. There are other works of Donatello's at Siena.
These are a panel on the Baptistery font of the head of St. John delivered
to Herod, done in 1425, but not delivered until 1457; five statuettes for
the font, and a slab for the tomb of Bishop Pecci in the Duomo, who died
1426, delivered in 1427.
[3] In 1440. [4] In 1461.
[5] Done for Orsanmichele in 1425; moved to the façade of S. Croce in
1463, and to the interior in 1860.

blamed for making this clumsily, it being considered perhaps the worst thing he ever did, he replied that he had made it so of set purpose, as it was a foolish trick to leave a kingdom to make oneself a friar. He also made in bronze the head of the wife of Cosimo de' Medici, which is preserved in the wardrobe of Duke Cosimo, where many other things of Donato in bronze and marble are preserved, among others a Madonna and Child in marble, in shadow relief, of matchless beauty, especially as it is surrounded with scenes in miniature by Frà Bernardo, which are admirable, as I shall relate when the time comes. In bronze the duke has a most beautiful and wondrous crucifix by Donato's hand in his studio, which contains a number of rare antiquities and beautiful medals. In the same wardrobe is the Passion of Our Lord in relief in a bronze panel, with a large number of figures, and in another panel, also of metal, another crucifix. Also in the house of the heirs of Jacopo Capponi, who was a good citizen and worthy gentleman, there is a marble Madonna in half-relief considered a most rare work. M. Antonio de' Nobili again, who was the duke's treasurer, had in his house a marble panel by Donato's hand containing a half-figure of Our Lady in bas-relief, so beautiful that M. Antonio esteemed it equivalent to all his other possessions, and it is equally highly valued by his son Giulio, a youth of singular goodness and judgment, the friend of all men of genius. In the house of Gio. Battista di Agnol Doni, a noble Florentine, there is a metal Mercury by Donato, 1½ braccia high, in full relief, and clothed in a curious fashion which is really very fine,[1] and not less rare than the other things which adorn his beautiful house. Bartolommeo Gondi, who is mentioned in the Life of Giotto, has a Madonna in half-relief made by Donato with incomparable love and diligence, but it must be seen in order to realise the light touch of the master in the poise of the head and arrangement of the draperies. M. Lelio Torelli again, the chief auditor and secretary of the duke, and not inferior as a lover of all the sciences and honourable employments than as an excellent jurisconsult, has a marble panel of Our Lady by Donatello's hand. And whoever desired to write in full of the life and works of this artist would have to make a longer story of it than is contemplated in the plan of this work, because Donato put his hand not only to the great things, of which enough has been said, but also to the smallest things of his art, making coats-of-arms on the chimney-pieces and fronts of houses of citizens, a very fine example of which may be seen

[1] It represents Cupido Alys; now in the Bargello.

on the house of the Sommai opposite the tower of the Vacca.
For the family of the Martelli he made a chest in the form of a
cradle, constructed of wicker-work, to serve as a tomb. But it
is below the church of S. Lorenzo, as no tombs of any sort appear
above except the epitaph of that of Cosimo de' Medici, which
also has its opening beneath like the rest. It is said that Donato's
brother, Simone, after making the model for the tomb of Pope
Martin V., sent for Donato to see it before he cast it. Accordingly
Donato went to Rome, and was there at the time when the
Emperor Sigismund went to receive the crown from Pope
Eugenius IV.,[1] so that he was constrained to take part in pre-
paring the festivities for this event in company with Simone,[2]
whereby he acquired great fame and honour. In the wardrobe
of Guidobaldo, Duke of Urbino, there is a fine marble bust by
the same hand, and it is supposed that it was given to the
duke's ancestors by Giuliano de' Medici the Magnificent, when
he was staying at that court, then full of many noble lords. In
short, Donato was so admirable in his every act that in skill,
judgment and knowledge he may be said to have been among
the first to illustrate the art of sculpture and the good design
of the moderns. He deserves the greater commendation, because
in his day antiquities had not been dug out, such as columns,
sarcophagi and triumphal arches. It was chiefly by his influence
that Cosimo de' Medici conceived the desire to introduce to
Florence the antiquities which are and were in the Casa Medici,
all of which were restored by his hand. He was free, affectionate
and courteous, and more so to his friends than to himself. He
thought nothing of money, keeping it in a basket suspended by
a rope from the ceiling, so that all his workmen and friends took
what they wanted without saying anything to him. He passed
his old age very happily, and when he could work no longer he
was assisted by Cosimo and other friends. It is said that when
Cosimo was on his death-bed he recommended Donato to his
son Piero, who diligently executed his father's wish and gave the
artist a property in Cafaggiuolo, which brought in sufficient
income to permit him to live in comfort. At this Donato was
greatly rejoiced, thinking himself more than assured against the
fear of dying of hunger. But he had not possessed it a year before
he returned to Piero and publicly renounced it, declaring that
he would not give up his peace of mind to think of household

[1] He was crowned 31 May, 1433.
[2] Not Donatello's brother. It has been conjectured that it was Simone
di Giovanni Ghini, though Professor Venturi considers this unlikely.

affairs and the troubles of the country, which bothered him one day out of three, as either the wind blew down his dove-cote, or his beasts were seized by the commune for taxes, or a tempest destroyed his vine and fruits. He had had enough of this, and would rather die of hunger than be obliged to think of such things. Piero laughed at his simplicity, and to relieve him from this vexation took back the estate and assigned to Donato a pension of the same value or more in money to be drawn from the bank weekly. This gave him the utmost satisfaction, and as the servant and friend of the house of the Medici he lived happily and care-free all the rest of his days. Having attained the age of eighty-three, he became so paralytic that he could no longer do the slightest work, and remained in bed in a poor little house which he had in the via del Cocomero, near the nuns of S. Niccolo. Growing daily worse and gradually wasting away, he died on 13th December, 1466, and was buried in the church of S. Lorenzo, near the tomb of Cosimo, as the latter had himself ordained, so that the dead body should be near him in death, as they had always been near in spirit when alive.

The citizens sorrowed greatly at his death, as well as the artists and all who knew him. Thus, in order to honour him more in death than they had done when he was alive, they gave him a stately funeral in that church, all the painters, architects, sculptors, goldsmiths, and indeed practically the whole population of the city, accompanying the cortège, while they used for a long time afterwards to compose in his praise various verses in divers languages, of which I will content myself with quoting those given below.

But before I come to the epitaphs, I have another matter to relate of him. When he was sick, shortly before his death, some of his relations went to see him, and after they had greeted him and offered their condolences, as was customary, they told him it was his duty to leave them an estate which he had at Prato, although it was a small one and brought in but little, and they earnestly besought him to do this. Donato listened patiently and then said, for he was just in everything, "I cannot gratify you, for I think it only right to leave it to the peasant who has always toiled there, and not to you who have never done any good to it or had any other thought than to possess it, which is the sole object of this visit. Go in peace." And in truth such relations, who only love their kin for the hopes which they have from them, ought to be treated after this fashion. Donato accordingly sent for the notary and left the estate to the peasant

who had always worked there, and who had probably conducted
himself better towards his master in his need than the relations
had done. His artistic properties Donato left to his pupils, who
were Bertoldo, a sculptor of Florence, who imitated him rather
closely, as may be seen in a fine bronze fight between men on
horseback, which is now in the wardrobe of Duke Cosimo; Nanni
d' Anton di Banco, who died before him; il Rossellino; Disiderio
and Vellano di Padoa, and indeed it may be said that everyone
who wished to excel in relief after his death was his pupil. In
design he was resolute, and made his drawings so skilfully and
boldly that they have no equal, as our book shows. I have here
both nude and draped figures by his hand, animals which excite
the liveliest admiration, and other equally beautiful things. His
portrait was made by Paolo Ucello, as related in the life of that
artist. The epitaphs are these:

Sculptura H. M. a Florentinis fieri voluit Donatello utpote homini,
qui ei, quod jamdiu optimis artificibus, multique saeculis, tum
nobilitatis tum nominis acquisitum fuerat, injuriave tempor.
perdiderat ipsa, ipse unus una vita infinitisque operibus cumulatiss,
restituerit, et patriae benemerenti hujus restitutae virtutis palmam
reportarit.

> Excudit nemo spirantia mollius aera:
> Vera cano: cernes marmora viva loqui,
> Graecorum sileat prisca admirabilis aetas
> Compedibus statuas continuisse Rhodon.
> Nectere namque magis fuerant haec vincula digna
> Istius egregias artificis statuas.

> Quanto con dotta mano alla sculptura
> Gia fecer molti, or sol Donato ha fatto:
> Renduto ha vita a' marmi, affetto, ed atto:
> Che piu, se non parlar, puo dar natura?

The world is so full of Donato's works that it may be truthfully
affirmed that no artist ever produced more than he. He took
delight in everything, and undertook all kinds of work without
looking whether it was common or pretentious. However, this
productiveness was very necessary to sculpture in some kinds
of round figures, half- and bas-reliefs, because, just as in the days
of the ancient Greeks and Romans, many combined to attain
perfection, so he, single-handed, brought perfection and delight
back to our age by the multitude of his works. Thus artists
ought to recognise the greatness of his art more than that of any
modern, for he, besides rendering the difficulties of art easy by
the number of his works, united in himself that invention,
design, skill, judgment, and every other faculty that can or

ought to be expected in a man of genius. Donato was very determined and quick, completing his things with the utmost facility, always performing much more than he promised. All his work was left to his pupil Bertoldo, principally the bronze pulpits of S. Lorenzo, which were polished by him and brought to their present state of completion.

I must not omit to mention that the learned and very reverend Don Vincenzio Borghini, of whom I have spoken above in another connection, having collected in a large book an immense number of designs by prominent painters and sculptors, both ancient and modern, has introduced, with much judgment, into the ornamental border of two sheets opposite each other, containing drawings by Donato and Michelagnolo Buonarotti, the following Greek phrases: to Donato,—Δωνατος, Βοναρρωτίζει, and to Michelagnolo, ἡ Βοναρρωτος Δωνατιζει, which in Latin run, "Aut Donatus Bonarottum exprimit et refert, aut Bonarottus Donatum," and in our tongue, "The spirit of Donato animates Buonarotto, or else that of Buonarotto first animated Donato."

MICHELOZZO MICHELOZZI, Sculptor and Architect of Florence
(? 1396 – 1472)

IF only men realised that they may live to an age when they can no longer work, there would not be so many who are compelled to beg in their old age, after having spent lavishly in their youth, when their considerable gains, blinding them to good counsel, caused them to spend more than was necessary, and much more than was fitting. Therefore, seeing the stigma that attaches to those who have descended from affluence to penury, everyone ought to endeavour by an honourable and temperate life not to be obliged to beg in his old age. Whoever will act like Michelozzo, who in this respect did not imitate his master Donato, only copying his ability, will live honourably all his life and will not be obliged to go about miserably seeking a livelihood in his last years.

In his youth Michelozzo studied sculpture and design with Donatello, and whenever a difficulty presented itself, whether in clay or wax, or with the marble, he worked so hard that his productions always displayed genius and great talent. But in one thing he surpassed many and even himself, for after Brunel-

lesco he was considered the most skilful architect of his time, the one most skilled in devising and planning palaces, convents and houses, showing the best judgment in their arrangements, as I shall relate in the proper place. Donatello employed him for many years, because he had great skill in working marble and in casting bronze, as may be seen in S. Giovanni at Florence in the tomb of Pope Giovanni Coscia, of which I have already spoken. He did the greater part of this, and to this day we see his statue of Faith, 2½ braccia high, a fine marble figure, standing beside Donatello's Hope and Charity, of the same size, where it does not suffer by the comparison. Over the door of the sacristy and opera, opposite S. Giovanni, Michelozzo made a little St. John in full relief, carefully finished and much admired.[1] Michelozzo was so friendly with Cosimo de' Medici that the latter, recognising his genius, employed him to make the model of the house and palace which is on the side of the via Larga next to S. Giovannino,[2] when he concluded that the one prepared for him by Filippo di ser Brunellesco was too sumptuous and magnificent, as has been said, and because it would have excited envy among the citizens which would more than counterbalance the gain to the city by its beauty and convenience or the advantage for himself. Accordingly the one designed by Michelozzo pleased him, and he caused it to be completed in its present form so conveniently and with so much beauty that there are majesty and grandeur in its very simplicity. Michelozzo deserves the more praise because this building was the first to be erected in the city after the modern order, containing a useful and beautiful division into apartments. The cellars are dug out to a depth of four braccia, with three above ground for the sake of the light, and comprise the buttery and larders. On the ground-floor there are two courtyards with magnificent loggie, communicating with salons, chambers, anti-chambers, studies, lavatories, kitchens, wells, secret and public staircases, and upon each floor are the dwellings and apartments for a family, with every convenience not only for a private citizen, as Cosimo then was, but for a king, however renowned and great, so that in our own day kings, emperors, popes and all the illustrious princes of Europe have been comfortably entertained there to the equal glory of the magnificence of Cosimo, and of Michelozzo's excellence as an architect. When Cosimo was exiled in 1433, Michelozzo, who greatly loved him and was

[1] Done by Antonio Rossellino in 1477.
[2] The Palazzo Riccardi, built about 1444.

very faithful to him, voluntarily accompanied him to Venice, and was with him during his stay there. Accordingly, besides the many designs and models which he made there of public and private dwellings for the friends of Cosimo, and for many noblemen, he made by Cosimo's order, and at his expense, the library of the monastery of S. Giorgio Maggiore, a place of the black monks of St. Justina, which was finished not only with walls, seats, wood-work and other ornaments, but filled with many books. This constituted the diversion and pastime of Cosimo until, being recalled in 1434 to his native place, he returned in triumph and Michelozzo with him. While Michelozzo was in Florence the public palace of the Signoria began to show signs of falling, because some columns of the courtyard gave way, owing to the great weight upon them, the foundation being weak and awry, and possibly because the pieces were badly joined and badly built. Whatever the cause may have been, the remedy was entrusted to Michelozzo, who willingly accepted the task, because near S. Barnaba at Venice he had successfully dealt with a similar danger. A nobleman who owned a house which was in danger of falling gave the charge of it to Michelozzo. As Michelagnolo Bonarotti has told me, he secretly caused a column to be made and collected a number of props, hid the whole in a boat in which he entered the house with some builders, and in a single night he had propped up the house and secured the column. Encouraged by this experience Michelozzo repaired the danger at the palace, winning honour for himself and for those who had favoured him by giving him such a charge, and he made new foundations and rebuilt the columns in their present state, having first made a framework of thick beams and strong uprights to support the centres of the arches, made of walnut wood, which together bore the weight originally sustained by the columns.[1] Then having gradually removed the badly joined pieces, he replaced them by pieces prepared with care, so that the building has suffered no harm, and has not moved a hair's-breadth. In order that his columns should be distinguished from the others, he made some octagonal ones at the angles, with capitals carved with leaves in the modern fashion, and others round, which may easily be distinguished from the old ones made by Arnolfo. The government of the city afterwards ordained, by Michelozzo's advice, that the arches of the columns should be eased and the weight of the walls upon them lightened, by rebuilding the courtyard afresh from the arches upwards,

[1] In 1454.

making windows in the modern style, like those which he had made for Cosimo in the courtyard of the palace of the Medici, and that bosses might be carved on the walls for the gold lilies, which may still be seen there. All this was carried out by Michelozzo with speed. In a line with the windows of the courtyard in the second story he made round openings, as a variant from the windows, to give light to the middle apartments above the first floor, where the hall of the Two Hundred now is. The third floor, now tenanted by the Signori and gonfaloniere, he made more ornate, separating off some chambers for the Signori in a line on the side towards S. Pietro Scheraggio, whereas they had previously slept all together in one room. There were eight of these chambers for the Signori, and a larger one for the gonfaloniere, and they all communicated with a passage, the windows of which looked out on the courtyard, Above this he made another convenient series of rooms for the servants of the palace, one of which, where the Treasury now is, contains the portrait of Charles, son of King Robert, Duke of Calabria, kneeling before a Madonna by Giotto. He also made the quarters for the pages, waiters, trumpeters, musicians, pipers, mace-bearers, ushers, heralds, and all the other apartments necessary in a palace of this description. At the top of the balustrade he arranged a stone cornice, encircling the courtyard, and near this a water-tank to collect the rain and supply some fountains at certain times. Michelozzo also restored the chapel where the Mass is heard, and many chambers near it, decorating the ceiling with gold lilies on a blue ground; for the upper and lower apartments of the palace he made new ceilings, covering all those already existing in the antique style. In short, he gave it every perfection that becomes such a building. He caused the water from the wells to reach the top floor, to which it was easily raised by means of a wheel. One thing only his genius was unable to remedy, namely, the public staircase, which was ill contrived from the first, ill placed and badly made, steep and without light, the steps being of wood from the first floor upwards. Nevertheless, he contrived that the entrance to the courtyard should have a flight of round steps and a door with pilasters of hard stone, surmounted by fine capitals carved by his hand, and a cornice and double architrave with a well-designed frieze, in which he arranged all the arms of the commune. He further made all the steps of hard stone up to the level of the Signoria's quarters, and fortified it at the top and in the middle with two portcullis, in case of riots, making at the

top a door called "The Chain," where an usher was always stationed to open and shut it according as he was directed by the governor. He strengthened the tower of the campanile with large iron stays, as it had cracked with the weight on the part which was falsely placed, namely, that above the cross-beams towards the piazza. And ultimately he so greatly improved and restored the palace that he won commendations from all the city, and amongst other rewards was made a member of the Collegio, a very honourable magistracy in Florence.[1] If anyone thinks that I have dealt at greater length with this matter than was necessary I must be excused, because after I had shown in the Life of Arnolfo that the original construction in 1298 was built out of the square and devoid of all reasonable measure, with unequal columns in the courtyard, large and small arches, inconvenient staircases, and the rooms awry and out of proportion, it was necessary that I should show to what condition the ingenuity and judgment of Michelozzo brought it, although even he could not make it a convenient place to inhabit, for no one could live there without the utmost discomfort.

When Duke Cosimo made it his residence in 1538, he began to bring it to a better form, but as his ideas were never understood or known by the architects whom he employed on the work for many years, he tried to see if it was not possible to repair the old building without destroying it, since it possessed some amount of good, by making the stairs and inconvenient apartments in better order and proportion, according to the plan he conceived. Accordingly he sent to Rome for Giorgio Vasari, painter and architect of Arezzo, who was serving Pope Julius III., and gave him a commission not only to arrange the rooms which he had begun in the upper part opposite the Corn Market, which were awry owing to the defects of the ground plan, but to contrive a plan whereby, without ruining the existing building, he might so arrange the interior of the palace that it would be possible to go from one part to another by secret and public stairs, and as easily as possible. Whilst the apartments already begun were adorned with gilt ceilings and oil-paintings, and the walls with fresco paintings, some being worked in stucco, Giorgio did away entirely with the plan of the palace, both the new and the old, and having long and carefully studied the matter, he began to bring it gradually to a good form and to reunite the disconnected apartments; hardly destroying anything that was already there, though some of the rooms were on one

[1] In 1462.

level and some on another. But in order that the duke should see the whole design, he made a wooden model to scale in the course of six months of the entire structure, which has rather the disposition and size of a castle than a palace. The model pleased the duke, and in accordance with it many convenient rooms were connected and made, and pleasant staircases, both public and private, communicating with every floor, in this manner relieving the salons which had been like a public street; for it had not been possible to go from one floor to another without passing through the middle of them, and the whole is magnificently adorned with a variety of paintings. Finally, the roof of the great hall was raised twelve braccia above its original height. Thus if Arnolfo, Michelozzo and the others who worked on that building from its foundation should return to life, they would not recognise it, and would take it for another and a new structure.

But to return to Michelozzo. The church of S. Giorgio being given to the friars of S. Domenic of Fiesole, they only remained there from mid-July to the end of January, because Cosimo de' Medici and his brother Lorenzo obtained for them from Pope Eugenius the church and convent of S. Marco, where the Silvestrine monks had originally been stationed, to whom S. Giorgio was given in exchange. The Dominicans being much inclined to religion and to the divine service and worship, ordained that the convent of S. Marco should be rebuilt on a larger and more magnificent scale from the design and model of Michelozzo, with all the conveniences which the friars could desire. It was begun in 1437, the first part constructed being the section which answers to the place above the old refectory, opposite the duke's stables, which Duke Lorenzo de' Medici had previously caused to be built. In this part twenty cells were constructed and roofed in, while the wooden furniture of the refectory was supplied and the whole finished in its present condition. From that point the work was not pursued for some time, as the friars were awaiting the result of a lawsuit brought against them by Maestro Stefano, general of the Silvestrines, who claimed the convent. When this was concluded in favour of the friars of S. Marco, the building was pursued. But as the principal chapel had been built by Ser Pino Bonaccorsi, there arose a dispute afterwards with a lady of the Caponsacchi, and through her with Mariotto Banchi, which afterwards led to endless litigation. Mariotto gave the chapel to Cosimo de' Medici after having deprived Agnolo della Casa of it, to whom

the Silvestrines had either given or sold it, and Cosimo gave
Mariotto 500 crowns for it. After Cosimo had in like manner
bought from the company of the Holy Spirit the site where the
choir now is, the chapel, the tribune and the choir were erected
from designs by Michelozzo, and completed by 1439.[1] After this
the library was constructed, 80 braccia long and 18 broad both
above and below, furnished with 64 cases of cypress wood full
of the most beautiful books. The dormitory was the next thing
to be finished, being made square, and then the cloister and all
the other apartments of the convent, which is believed to be the
best appointed, finest and most convenient in all Italy, thanks
to the talents and industry of Michelozzo, who completed it in
1452. It is said that Cosimo expended 36,000 ducats upon it,
and that while it was building he gave the friars 366 ducats a
year for their living. Concerning the building and consecration
of that temple there is an inscription on a marble slab over the
door leading into the sacristy which reads as follows:

Cum hoc templum Marco Evangelistae dicatum magnificis
sumptibus Cl. V. Cosmi Medicis tandem absolutum esset, Eugenius
Quartus Romanus Pontifex maxima Cardinalium Archiepiscoporum,
Episcoporum, aliorumque sacerdotum frequentia comitatus, id
celeberrimo Epiphaniae die solemni more servato consecravit. Tum
etiam quotannis omnibus, qui eodem die festo annuas statasque
consecrationis ceremonias caste pieque celebraverint, viserintve
temporibus luendis peccatis suis debiti septem annos totidemque
quadragesimas apostolica remisit auctoritato A.M. CCCC. XLII.

It was also from Michelozzo's design that Cosimo made the
noviciate of S. Croce at Florence, the chapel thereof and the
passage leading from the church to the sacristy, to the noviciate,
and to the stairs of the dormitory; the beauty, convenience and
grace of these not being one whit inferior to any of the buildings
erected by the truly magnificent Cosimo de' Medici or by Michel-
ozzo. Among other things, the door of macigno stone, leading
from the church to these places, was much admired in those
days for its originality and for its excellent decoration, for it
was not customary at that time to imitate ancient things of good
style as this does. It was also from Michelozzo's design and with
his advice that Cosimo de' Medici made the palace of Cafaggiuolo
in Mugello, giving it the form of a fortress, with ditches surround-
ing it, and arranged the farms, ways, gardens, fountains in
wooded groves, aviaries, and other requisites of a country house.
Two miles from the palace he made a convent for the bare-

[1] Restored and altered in 1678.

footed friars of St. Francis, in a place called il Bosco, which is a fine work. In like manner he made many various improvements at Trebbio, as may be seen. Two miles from Florence he made the palace of the villa di Careggi, which was a rich and magnificent structure. Michelozzo brought water to it in the fountain which may be seen there at the present time. For Giovanni, the son of Cosimo de' Medici, he made another magnificent palace at Fiesole,[1] the foundations being dug in the sides of the hill, at a great expense, but not without great advantage, as he utilised the basement for the vaults, larders, stables, butteries and other convenient things. Above, besides the usual chambers, halls and other apartments, he made some for books and others for music; in fine, in this building Michelozzo displayed to the full his ability as an architect. The building, besides what I have said, was so excellently constructed that it has never stirred a hair's-breadth. When it was completed, he built above it, at Giovanni's expense, the church and convent of the friars of St. Jerome, on the very top of the hill. Michelozzo also made the design and model which Cosimo sent to Jerusalem for the hospice which he erected there for the pilgrims visiting Christ's sepulchre. He further sent the design for the six windows on the façade of S. Pietro at Rome, which were afterwards made there, with the arms of Cosimo de' Medici. Three of these have been removed in our own day, and reconstructed by Paul III. with the Farnese arms. On Cosimo's learning that S. Maria degli Angeli at Ascesi was suffering greatly from lack of water, to the very great discomfort of the people who go there every 1st of August for the indulgence, he sent Michelozzo to the place. That artist brought a spring which rises on the side of the hill to the fountain, covering it with a very pretty and rich loggia resting on columns formed of separate pieces and bearing the arms of Cosimo. Inside the convent, and also by Cosimo's commission, he carried out many useful improvements for the friars. Lorenzo de' Medici the Magnificent subsequently restored it at more expense and with more ornament, offering to the Madonna the waxen image which may still be seen there. Cosimo also caused the street leading from Madonna degli Angeli to the city to be paved. Before Michelozzo left the neighbourhood he designed the old citadel of Perugia.

On his return to Florence, he built the house of Giovanni Tornabuoni next to the Tornaquinci almost exactly like the palace which he had made for Cosimo, except that the front is

[1] The Villa Mozzi.

plain and not of blocks or surmounted by a cornice.[1] After the death of Cosimo, who had loved Michelozzo like a dear friend, his son Piero employed him to construct in marble the chapel containing the crucifix in S. Miniato in sul Monte.[2] In the half-circle of the arch behind the chapel Michelozzo carved a falcon in bas-relief with the diamond, the device of Cosimo, a truly beautiful work. Piero de' Medici next proposed to make the chapel of the Annunciation in the church of the Servites[3] entirely in marble, and desired Michelozzo, who was by this time an old man, to give his opinion, both because he greatly admired his talents and also because he knew what a faithful friend and servant he had been to his father, Cosimo. When Michelozzo had complied, the charge of the work was entrusted to Pagno di Lapo Partigiani,[4] sculptor of Fiesole, who had many things to take into consideration, as it was necessary to include a great deal in a small space. Four marble columns of about 9 braccia, double fluted and of Corinthian work, the bases and capitals being variously carved and the members doubled, support the chapel. Above the columns are laid architraves, a frieze and cornices, also double and carved, full of varied fancies and containing the device and arms of the Medici and foliage. Between these and the other cornices made for another row of windows there is a large inscription carved in beautiful marble. Below it, by the ceiling of the chapel, and between the four columns, there is a marble slab richly carved with enamels worked in fire and mosaics with various fancies, of the colour of gold and precious stones. The pavement is full of porphyry and serpentine, mixed with other rare stones, well joined and tastefully arranged. The chapel is enclosed by a bronze grille with chandeliers above, all fixed to a marble framework, which makes a very fine finish to the bronze and chandeliers. The front exit from the chapel is also of bronze and excellently disposed. Piero left instructions that thirty silver lamps should be put about the chapel to light it, and this was done, but as they were destroyed in the siege the duke many years ago gave orders that they should be replaced. This has now been done for the most part and the work goes on. However, lamps have always been kept lighted there, as Piero directed, although they were not of silver. To these ornaments Pagno added a large copper lily which rises from a vase, which is placed at an angle of the

[1] The Palazzo Corsi Salviati in the via Tornabuoni; remodelled when the street was widened.
[2] In 1448. [3] Begun in 1461. [4] Portigiani.

cornice, and is made of painted wood, the part holding the lamps being overlaid with gold. However, the cornice alone does not bear this great weight, as the whole is sustained by two branches of the lily made of iron and painted green. These are fastened with lead into the marble angle of the cornice, holding the others, which are of copper, suspended in the air. This work was indeed carried out with judgment and invention, for which reason it deserves much admiration as a beautiful and ingenious production. Beside the chapel another was made towards the cloister, which serves as a choir for the friars, the windows opening upon the courtyard. These give light not only to the chapel, but, being opposite two similar windows, to the organ chamber also, which is adjacent to the marble chapel. Against the wall of the choir is a large cupboard in which the plate of the Nunziata is kept, and the arms and device of the Medici may be seen in every part of these ornaments. Outside the chapel of the Annunciation, and opposite it, the same artist made a large bronze lustre 5 braccia high, and the marble vessel for holy water at the entrance of the church, with a remarkably fine St. John in the middle. Over the bench where the friars sell the candles he made a marble Madonna and Child of half-length in semi-relief, of life-size, and did another like it in the Opera of S. Maria del Fiore where the wardens are.

At S. Miniato al Tedesco, Pagno did some figures in conjunction with his master Donato while he was still a young man, and in the church of S. Martino at Lucca he made a marble tomb opposite the chapel of the Sacrament for M. Piero Nocera, who is there drawn from life.[1] In the twenty-fifth book of his work, il Filarete wrote that Francesco Sforza, fourth Duke of Milan, gave to Cosimo de' Medici the Magnificent a most beautiful palace in Milan,[2] and that he, to show his gratitude to the duke for such a gift, not only richly adorned it with marble and carved woodwork, but enlarged it under Michelozzo's direction, making it $87\frac{1}{2}$ braccia instead of 84 braccia. Besides this, he had many things painted there, notably scenes from the life of the Emperor Trajan, in a loggia. Into these he introduced the portraits of Francesco Sforza, Bianca, his wife, and their children, together with those of many other lords and magnates, and in addition the portraits of eight emperors, to which Michelozzo, with his own hand, added that of Cosimo.

[1] The work of Matteo Civitale, and signed.
[2] The Casa Vismara, via de' Bossi, done in 1455. The portal has been set up in the Castello.

He further introduced the arms of Cosimo into every one of the apartments, in divers fashions, in conjunction with his device of the falcon and diamond. All these paintings were by the hand of Vincenzio di Zoppa,[1] a painter of no mean repute in that country at the time.

It is found that the money expended by Cosimo in the restoration of this palace was paid by Pigello Portinari, a Florentine citizen who was then director of the bank at Milan and Cosimo's agent, and he lived in that palace. In Genoa there are some works of Michelozzo in marble and bronze, and many other works in other places which may be recognised by the style. I will content myself with what I have already said about him. He died at the age of sixty-eight, and was buried in his tomb at S. Marco in Florence. His portrait by the hand of Frà Giovanni is in the sacristy of S. Trinità, where he is represented as an old Nicodemus wearing a hood on his head taking Christ down from the cross.[2]

ANTONIO FILARETE and SIMONE, Sculptors of Florence

IF Pope Eugenius IV., when he proposed to make the door of S. Pietro at Rome in bronze, had taken pains to seek to have excellent men for that work, as he might easily have done, for Filippo di ser Brunellesco, Donatello and other rare artists were then alive, the work would not have been performed in such a sorry manner as we see it. But probably, like the majority of princes, he did not understand such work, or cared little about it. But if princes realised the importance of appreciating the value of men of genius on account of the fame which they may leave behind, neither they nor their ministers would be so indifferent. It is indeed clear that whoever cumbers himself with cheap and unskilful artists obtains but a short life for the works and for his own fame, and besides this he does an injury to the public and to the century in which he is born, since posterity will conclude that had the age possessed better masters the prince would have employed them in preference to the unskilful ones. Thus when Eugenius IV. was made Pope in 1431, and learned that the Florentines were employing Lorenzo Ghiberti to make the doors of S. Giovanni, it occurred to him that he also would

[1] Foppa.
[2] Now in the Accademia, Florence. He means the figure in the black hood on the other side.

have a bronze door for S. Pietro. But as he did not understand such matters, he left it to his ministers. Antonio Filarete,[1] then a youth, and Simone, Donatello's brother, had so much influence with these officials at that time that the work was allotted to them.[2] Accordingly they began it, and laboured twelve years to finish it. Although Pope Eugenius was driven from Rome, and was much harassed in the matter of councils, yet those who had the charge of S. Pietro succeeded in preventing this from hindering the work. Filarete made simple panels in bas-relief, with two upright figures in each, the Saviour and the Madonna above, and St. Peter and St. Paul below. At St. Peter's feet he made the portrait of the Pope kneeling. Under each figure is a small scene from the life of the saint above. Beneath St. Peter is his crucifixion, and beneath St. Paul the decollation; while under the Saviour and the Madonna are some of the events of their lives. On the inside, at the bottom of the door, Antonio's fancy led him to make a small bronze bas-relief containing portraits of himself, Simone and their pupils on their way to a vineyard with an ass laden with delicacies. But as they did not devote the whole of their time during the twelve years to the door, they also made some marble tombs of popes and cardinals in S. Pietro, which were pulled down on the construction of the new church. After this, Antonio was invited to Milan by Duke Francesco Sforza, then gonfalonier of the church, who had seen his work in Rome, to build with his plans the hospice of the Poor of God, which is a hospital for infirm men and women and for innocent children of illegitimate birth.[3] The men's quarters in this place, which is cruciform, are 160 braccia each arm, as also are those of the women. The breadth is 16 braccia, and in the four quadrangles formed by the arms of the crosses there are four courtyards surrounded by porticoes, loggias and apartments for the use of the master, officials, servants and ministers of the hospital, which are very convenient and useful, and on one side there is a channel in which water runs incessantly for the service of the hospital and to turn a mill, a very great convenience for the house, as may well be imagined. Between the two hospitals is a cloister, 80 braccia broad and 160 long. In the middle of this is tne church, so contrived as to serve both quarters. To make a long story short, the place is so well constructed and ordered that I do not believe

[1] Antonio Averlino, called il Filarete; born c. 1400. Donatello's brother had no hand in it.
[2] In 1433; finished 1445. [3] Ospedale Maggiore.

its counterpart can be found in all Europe. According to what
Filarete himself writes, the first stone of this edifice was laid
with a solemn procession of all the clergy of Milan, in the presence
of the Duke Francesco Sforza, the Signora Bianca Maria and
all their children, the Marquis of Mantua, the ambassador of
King Alfonso of Aragon, and many other lords. On the founda-
tion stone, and also on the medallions, were written the following
words: "*Franciscus Sfortia Dux IV qui amissum per praeces-
sorum obitum urbis imperium recuperavit hoc munus Christi
pauperibus dedit fundavitque MCCCCLVII die XII April.*" The
scenes in the portico were afterwards painted by Maestro
Vincenzio di Zoppa, a Lombard, as no better master was to be
found in those parts. The principal church of Bergamo, again,
was the work of Antonio, and he carried it out with no less
diligence and judgment than he had displayed in the hospital.
While these works were in progress he wrote a book, an occupa-
tion in which he also took delight, divided into three parts. In
the first he deals with the measurements of all buildings, and
of everything that is needed by anyone who wishes to build.
In the second he treats of the method of building, and how a
city may be made beautiful and commodious. In the third he
introduces new forms of buildings, combining ancient and
modern things. The whole work is divided into twenty-four
books, illustrated with diagrams by his own hand. Although
it contains some good things, it is probably the most ridiculous
and silly book that was ever produced. He dedicated it in 1464
to Piero de' Cosimo de' Medici the Magnificent, and it is now
among the possessions of Duke Cosimo.[1] As he gave himself so
much pains, it might have been of some advantage if he had
supplied information about the masters of his day and their
works, but as the book contains few or none, and those scattered
promiscuously through the work where there was least call for
them, he has, as I have said, taken all this trouble only to prove
his ignorance and lack of judgment in sitting down to do a thing
of which he knew nothing.

But enough of Filarete; it is time that I should turn to Simone,
Donato's brother, who, after doing the door, made the bronze
tomb of Pope Martin.[2] He also made some casts which went to
France, and many other things the location of which is not
known. In the church of the Ermini, next to the mills of Florence,
he made a crucifix of life-size, to be carried in procession, the

[1] The MS. is in the Bibl. Magliabechiana.
[2] Martin V., who died 1431. For Simone, see note to page 311 above.

material being cork, for the sake of lightness. In S. Felicita he made a St. Mary Magdalene in penitence, of clay, 3½ braccia high, and beautifully proportioned, showing the muscles in such a way as to prove his thorough knowledge of anatomy. In the Servites he did for the company of the Annunciation a marble slab for a tomb, introducing a grey and white marble figure, like a painting, as I have described Duccio to have done in the Duomo at Siena, a much-admired work. At Prato he made a bronze grille for the chapel of the Girdle. At Forli he made a Madonna with two angels in bas-relief over the door of the Canonicate. For M. Giovanni di Riolo he did the chapel of the Trinity in S. Francesco in half-relief, and at Rimini he did the chapel of St. Sigismund in the church of S. Francesco for Sigismondo Malatesta, containing many elephants carved in marble, the device of that lord.[1] To M. Bartolommeo Scamisci, a canon of the Pieve of Arezzo, he sent a Madonna and Child made of terra cotta, with angels in half-relief, beautifully executed. This is now in the Pieve against a column. For the baptistery of the Vescovado of Arezzo he did a Christ baptised by St. John in some scenes in bas-relief. At Florence he made the marble tomb of M. Orlando de' Medici in the church of the Nunziata.[2] At length, at the age of fifty-five, he rendered his soul to the Lord who gave it. Not long after, Filarete, who had returned from Rome, died at the age of sixty-nine, and was buried in the Minerva, where he had caused Giovanni Foccora, a painter of some repute, to make the portrait of Pope Eugenius, whilst he was staying in his service at Rome. The portrait of Antonio by his own hand may be found at the beginning of his book on building. His pupils were Varrone and Niccolo, Florentines,[3] who made the marble statue for Pope Pius II. near Pontemolle, when he brought the head of St. Andrew to Rome, and it was by that Pope's orders that Tigoli was practically rebuilt by them. In S. Pietro they made the marble ornamentation above the columns of the chapel in which the head of St. Andrew is preserved. Near this chapel is the tomb of Pope Pius by the hand of Pasquino da Montepulciano, a pupil of Filarete and of Bernardo Ciuffagni, who made a marble tomb in S. Francesco at Rimini for Gismondo Malatesti,[4] introducing his portrait, and he did some other things, it is said, at Lucca and Mantua.

[1] This work is by Agostino di Duccio.
[2] The work of Bernardo Rossellino.
[3] i.e. Beltrame and Niccolo Baroncelli.
[4] In 1447.

GIULIANO DA MAIANO, Sculptor and Architect of Florence
(1432–1490)

No slight error is committed by those fathers who do not allow the dispositions of their children to have free play during their childhood, and who do not permit them to practise to the fullest extent the things which are most to their taste. By endeavouring to divert their attention to things for which they have no heart, they run the risk of preventing them from excelling in anything, for it is almost always the case that those who do not like their work will never make much progress at it. On the other hand, those who follow the instincts of Nature usually become distinguished and famous in the arts to which they devote themselves. This was especially the case with Giuliano da Maiano. His father had long resided on the hill of Fiesole, in the part called Maiano, where he worked as a stone-cutter. He came at length to Florence, where he set up a shop of prepared stones, keeping it supplied with such things as are often required by builders at short notice. Whilst he was at Florence the birth of Giuliano occurred, and as, after a time, the father thought that the child displayed good parts, he proposed to make him a notary, judging by his own experience that stone-cutting was too laborious and not very profitable. However, this project was never realised, for though Giuliano went to a grammar school for a while he had no head for it and made no progress there. Very often he played truant, and showed that the bent of his mind was towards sculpture, although he began as a carpenter and studied design. He is said to have made the benches of the sacristy of the Nunziata in conjunction with Giusto and Minore, masters of marquetry, and also those of the choir, next to the chapel, as well as many other things in the abbey of Fiesole and in S. Marco. Acquiring a reputation by these things, he was invited to Pisa, where he made the seat in the Duomo beside the high altar, at the place where the priest, the deacon and the sub-deacon sit when Mass is sung. On the back he inlaid in coloured and shaded wood the three prophets which are to be seen there. In this work he employed Guido del Servellino and Maestro Domenico di Mariotto, Pisan carpenters, and taught them the art so well that they afterwards did the greater part of that choir in intaglio and carved work, which was finished in our own day, but in a much better style, by

Battista del Cervelliera, a Pisan, and a really ingenious and clever man. But to return to Giuliano. He did the chests of the sacristy of S. Maria del Fiore, which were considered wonderful at that time as specimens of inlaid work. Thus Giuliano pursued his inlaid work and also devoted himself to sculpture and architecture. Meanwhile Filippo di ser Brunellesco died, and Giuliano was appointed by the wardens in his place.[1] He incrusted with black and white marble the friezes beneath the vaulting and about the round windows. At the sides he made the marble pilasters, above which Baccio d'Agnolo afterwards placed the architrave, frieze and cornice, as will be said hereafter. It is true, if we may believe the evidence of some designs by his hand which are in our book, that he wished to make another disposition of frieze, cornice and gallery with a pediment on each of the eight sides of the cupola, but he had no time to put this in hand because, while the work was being postponed from day to day, he died. Before this happened he went to Naples, and at Poggio Reale he acted as architect of the magnificent palace there, with the beautiful fountains and aqueducts in the courtyard, for King Alfonso. In the city also he designed many fountains with beautiful and ingenious inventions for the houses of nobles and for the piazzas. He further caused the palace of Poggio Reale to be painted throughout by Piero del Donzello and Polito, his brother. In sculpture he made some bas-reliefs for King Alfonso, then Duke of Calabria, in the great hall of the castle of Naples, over a door both inside and out, and also the door of the castle in marble, of the Corinthian order, with a countless number of figures. To this work he gave the form of a triumphal arch, on which the acts and some of the victories of the king are carved in marble. Giuliano also made the decoration of the Capuan gate, introducing many varied and beautiful trophies. On this account he deserved the affection which the king entertained for him, who, by remunerating him liberally for his labours, provided for his descendants. As Giuliano had taught his nephew,[2] Benedetto, the art of marquetry, architecture and the manipulation of marble, Benedetto remained in Florence, devoting himself to marquetry, because that brought him better returns than the other arts had done, when Giuliano was summoned to Rome by M. Antonio Rosello of Arezzo, the secretary of Pope Paul II., for the service of that Pope. Proceeding thither, he designed the loggias of Travertine

[1] Brunelleschi died nineteen years before Giuliano's appointment in 1465.
[2] Brother.

marble in the first courtyard of the palace of S. Pietro,[1] with three rows of columns, the first on the ground-level where the lead[2] and other offices are, the second above for the datary and other prelates, and the third and last containing the apartments which communicate with the courtyard of S. Pietro, adorned by him with gilded ceilings and other ornaments. Under his direction also were made the marble loggias where the Pope gives his benediction, a very great work as may be seen to-day. But his most stupendous work was the palace which he made for that Pope, together with the church of S. Marco at Rome, where he introduced a countless number of Travertine stones, said to have been taken from quarries near the arch of Constantine, and buttressed up with part of the spoils of the Coliseum, which is now in ruins, perhaps owing to this very act.[3] By the same Pope Giuliano was sent to the Madonna of Loreto, where he restored and greatly enlarged the body of the church, which was originally small and built upon pillars in the rough style, but he did not go higher than the string course. Here he brought his nephew Benedetto, who, as will be said, afterwards vaulted the cupola. When Giuliano was obliged later to return to Naples to finish the works begun there, King Alfonso assigned to him a gate near the castle, which was to contain more than eighty figures to be made by Benedetto in Florence. This was cut short by the king's death, though some remains still exist at Florence in the Misericordia, and some others were beside the mills in our day, but I do not know what has become of them. Before the king died, Giuliano expired at Naples, aged seventy years, and was honoured with rich obsequies, for the king dressed fifty men in brown to follow him to the grave, and afterwards ordered that a marble tomb should be made for him. Polito followed in his footsteps and completed the canals for the waters of Poggio Reale. Benedetto devoted himself to sculpture, and, as I shall have occasion to say, surpassed his uncle Giuliano in excellence, competing in his youth with a sculptor who worked in clay named Modanino da Modena, who made a Pieta for Alfonso with a quantity of very vivacious figures in full relief in coloured clay, placed by the king in the church of Monte Oliveto, Naples, a most celebrated monastery there. This work contains the portrait of the king kneeling, and is indeed

[1] Begun in 1482, but not by Giuliano, who was never in Rome.
[2] i.e. for sealing documents, lead being used for this in the papal chancery.
[3] Done in 1455.

more than life-like, for which cause he rewarded Modanino most richly. But on the king's death Polito and Benedetto returned to Florence, where soon afterwards Polito followed Giuliano to his last home. The sculptures and paintings of these men were executed about the year of grace 1447.

PIERO DELLA FRANCESCA of the Borgo a S. Sepolcro, Painter (?1416–1492)

THOSE are indeed unfortunate who, after most arduous studies to the end that they may assist others and leave a reputation behind them, are not allowed, either through sickness or death, to complete the works which they have begun. And it very often happens in cases where they have almost brought their works to completion, that they suffer from the presumption of those who endeavour to cover their own ass's hide with the honoured skin of the lion. And although Time, which is called the father of Truth, sooner or later brings the truth to light, yet they are for some time defrauded of the honour due to their labours. This was the case with Piero della Francesca of the Borgo a S. Sepolcro. A consummate arithmetician, geometrician and per-spectivist, the blindness which came upon him in his old age and the termination of his life, prevented him from displaying the results of his labours and the numerous books written by him, which are still preserved in his native Borgo. The man who should have done his utmost to increase Piero's glory and reputation, who had learned from him everything which he knew, impiously and malignantly sought to annul his teacher's fame, and usurp the honour due to him, publishing under his own name of Frà Luca dal Borgo all the results of the labours of that good old man, who, besides his knowledge mentioned above, was also an excellent painter. Born in Borgo a S. Sepolcro, not then a city as it now is, and called della Francesca after his mother, for she had been left pregnant of him at the death of her husband, Piero was reared by her and assisted to attain to the rank which his good fortune procured for him. In his youth Piero studied mathematics, but although at the age of fifteen he was already on the road to being a painter, he did not relin-quish the study of the other, but made marvellous progress in both. He was accordingly sent for by Guidobaldo Feltro, the

old Duke of Urbino,[1] for whom he made many beautiful pictures of small figures, most of which have come to grief during the numerous wars from which that State has suffered. However, some of his writings on geometry and perspective are still preserved there, and in these he proves himself not inferior to anyone of his own day, or perhaps of all time. All his works give evidence of his skill, being full of perspectives, especially a vase represented so as to show its front and back, its sides, its bottom and its mouth. This is certainly a marvellous work, as he has carefully represented every detail, foreshortening all the curves with much grace. He acquired such a reputation at that court that he wished to make himself known in other places. Accordingly he went to Pesaro and Ancona. Thence, while very busy, he was invited to Ferrara by Duke Borso, and in the palace there [2] painted many rooms, afterwards destroyed by the old Duke Ercole in order to modernise the palace. Thus nothing of Piero's has been left in the city except a chapel in S. Agostino painted in fresco, and even that has suffered from the damp. Being afterwards invited to Rome by Pope Nicholas V., Piero did two scenes in the upper chambers of the palace in competition with Bramante of Milan.[3] These were also destroyed by Pope Julius II. in order that Raphael of Urbino might paint the Imprisonment of Peter, the Miracle of the Corporale at Bolsena, together with some other things which Bramantino,[4] an excellent artist of his day, had painted.

As I cannot devote a separate section to the life and works of this man, for his things have been destroyed so that it is not worth while, I will take this opportunity to write a notice of him. In the works which he made and which were pulled down there were, as I have heard them described, some fine heads from life, so well executed that but for the gift of speech they seemed alive. A goodly number of these heads have been preserved, because Raphael caused them to be copied, as they all represented great personalities. Among them were Niccolo Fortebraccio; Charles VII., King of France; Antonio Colonna, Prince of Salerno; Francesco Carmignuola; Giovanni Vitellesco; Bessarione, the cardinal; Francesco Spinola; Battista da Caneto. All these portriats were given to Giovio by Guilio Romano, the pupil and heir of Raphael, and were deposited by Giovio in

[1] He was not born until 1472; Vasari probably means the famous Duke Federigo of Montefeltro.
[2] i.e. Palazzo Schifanoia, which was raised a story in 1469.
[3] 1444–1514.
[4] Bartolommeo Suardi, ?1470/80–c. 1536.

his museum at Como. At Milan, over the door of S. Sepolcro, I have seen a dead Christ foreshortened by the same hand,[1] the whole painting being no more than a braccia in height, but showing the whole length with ease and judgment, though the task seems impossible. That city contains other of his works, in the house of the young Marquis Ostanesia, where the chambers and loggias are executed by him with great skill and power in foreshortening the figures. Outside the Versellina gate, near the castle, he painted in the stables, now demolished, servants grooming horses, among them being one which is so well done and so full of life that another horse, taking it for the reality, kicked it repeatedly with its hoofs.

But to return to Piero della Francesca. Having finished his work at Rome, he returned to the Borgo, his mother being dead. Inside the middle door of the Pieve there he did two saints in fresco which are considered very fine. In the convent of the friars of St. Augustine he painted the picture of the high altar,[2] a much-admired work, and in fresco he made Our Lady of Mercy in a company, or as some say a confraternity. In the palace of the Conservadori he made a Resurrection of Christ, which is considered to be the best of all his works in that city. At S. Maria of Loreto he began to paint the vaulting of the sacristy in conjunction with Dominico of Venice, but fearing the plague they left it incomplete.[3] It was afterwards finished by Luca da Cortona, Piero's pupil, as will be related in the proper place. From Loreto Piero proceeded to Arezzo, where he painted the chapel of the high altar in S. Francesco for Luigi Bacci, citizen of Arezzo,[4] the vaulting of which had been already begun by Lorenzo di Bicci. This work contains stories of the cross, from the time when the sons of Adam, when burying their father, sow the seed of the tree under his tongue, to the exaltation of the cross by the Emperor Heraclius, who, carrying it on his shoulders, enters Jerusalem bare-headed and bare-footed. The work contains many fine ideas and praiseworthy attitudes, as, for example, the dresses of the women of the Queen of Sheba, executed in a smooth and novel manner, many portraits antique in style and full of life, a divinely measured row of Corinthian columns, a serf leaning on his spade awaiting the commands of St. Helena, while the three crosses are being dug up, all of which cannot be

[1] Now inside. [2] Commissioned in 1454.
[3] There was plague between 1447 and 1452. "Domenico" was probably Domenico Veneziano.
[4] 1452–66.

improved upon. Very excellent also is the dead man who is raised on touching the cross, as well as the joy depicted in the face of St. Helena, who kneels to adore, and the amazement of the bystanders. But the most remarkable indication of his resource, judgment and art is his painting of an angel foreshortened, with its head downwards, which appears suddenly by night to carry the sign of victory to Constantine, as he is sleeping in a tent guarded by a chamberlain, and by some other armed men, obscured by the darkness of the night. The heavenly visitor illuminates with his own light the tent, the armed men and all the surroundings very admirably. In this work Piero shows how important it is to imitate reality and to draw from the things themselves. His success in this has led the moderns to follow him and thereby attain to that high level from which we now view things. In this same history, in a battle, he has admirably expressed fear, animosity, skill, force and all other emotions produced in a fight, as well as the accidents, with a great heap of wounded, of the fallen, and the dead. He deserves great praise for having imitated the lustre on the arms in this work, and also for having made a group of horses in foreshortening on the other wall, which contains the flight and drowning of Maxentius, most marvellously executed. It must be considered a work of surpassing excellence for those days. In the same scene he represented a man half-clothed and half-naked, like a Saracen, riding barebacked, very remarkable for its display of anatomy, a thing little known then, For this work he deserved the large reward he received from Luigi Bacci, whom he drew there with Charles and his other brothers, and many Aretines, distinguished men of letters of the day, assisting at the beheading of a king, and he also merited the love and reverence of that city which was afterwards accorded to him, having rendered it so illustrious by his talents. In the Vescovado of the same city he made a St. Mary Magdalene in fresco,[1] beside the sacristy door, and in the company of the Nunziata he made a banner for carrying in procession. At the head of a cloister in S. Maria delle Grazie fuor della terra he made a St. Donato shown seated, in perspective, in his pontificals, surrounded by infants, and a St. Vincent in S. Bernardo for the monks of Monte Oliveto, in a niche high up in the wall, a work much admired by artists. At Sargiano, a place of the bare-footed friars of St. Francis outside Arezzo, he painted in a chapel a beautiful Christ praying in the Garden at night. In Perugia also he did many things which may still be

[1] In 1468.

seen there. In the church of the nuns of S. Antonio at Padua, he painted on a panel in tempera the Virgin and Child, St. Francis, St. Elizabeth, St. John the Baptist and St. Anthony of Padua.[1] Above this he made a fine Annunciation, with an angel which really seems to have come from heaven, and, what is more, an admirable perspective of diminishing columns. In the predella are scenes in small figures of St. Anthony raising a boy, St. Elizabeth saving a child which has fallen into a well, and St. Francis receiving the stigmata. At the altar of St. Joseph in S. Ciriaco at Ancona he painted a fine representation of the marriage of the Virgin.

Piero was, as I have said, a diligent student of his art who assiduously practised perspective, and had a thorough acquaintance with Euclid, so that he understood better than anyone else all the curves in regular bodies, and we owe to him the fullest light that has been thrown on the subject. It happened thus: Luca dal Borgo, a Franciscan friar, who wrote of regular bodies in geometry, was his pupil; and when Piero came to his old age and died, after having written many books, the same master Luca took upon himself to have them printed as his own, since they came into his hands on his master's death. Piero was in the habit of making clay models, covering them with soft cloth with a number of folds in order to copy them and turn them to account. Among his pupils was Lorentino d'Angelo of Arezzo, who in imitation of his style did many paintings in Arezzo, finishing those which Piero left incomplete when death surprised him. Near the St. Donato which Piero made in the Madonna delle Grazie, Lorentino painted in fresco some scenes from the life of that saint, and other works in many other parts of the city, and a quantity of things in the country districts both because he never rested and to assist his family, which was then very poor. In this same church delle Grazie he painted the scene where Pope Sixtus IV., between the cardinal of Mantua and the Cardinal Piccolomini, afterwards Pope Pius III., grants an indulgence to that place. In this scene Lorentino introduced the portraits of Tommaso Marzi, Piero, Traditi Donato Rosselli and Giuliano Nardi, kneeling, all citizens of Arezzo and wardens of the church. In the hall of the palace of the priors he also made portraits from life of Galeotto, cardinal of Pietramala, the Bishop Guglielmino degli Ubertini, M. Angelo Albergotti, doctor of laws, and many other works which are scattered about the city. It is said that one carnival-tide Lorentino's children begged him to kill

[1] Now in the Pinacoteca, Perugia.

a pig, as is the custom of the country; but as he had not the means to buy one, they asked him, "As you have no money, how will papa manage it?" To this he answered, "Some saint will help us." When he had repeated this several times, but did not buy the pig, they lost all hope, the season being past, until one day a rustic came from the Pieve a Quarto who wanted a picture of St. Martin to fulfil a vow, but had nothing else with which to pay except his pig, worth 5 lire. Finding Lorentino, he told him that he wanted a picture of St. Martin, but had nothing to give except the pig. A bargain was struck, Lorentino painted his saint and the rustic brought him the pig, and thus the saint provided a pig for the poor children of the painter. Another pupil, Piero da Castel della Pieve did an arch above S. Agostino and a St. Urban for the nuns of St. Catherine at Arezzo, which has been recently pulled down to rebuild the church. Another pupil was Luca Signorelli of Cortona, who did him more credit than all the others. Piero Borghese, whose paintings were executed about 1458, was rendered blind at sixty by a catarrh, and lived thus until the eighty-sixth year of his life. He left a fine property in the Borgo, and some houses which he had built himself. These were burned and destroyed by factions in the year 1536. He was buried by his fellow-citizens in great state in the principal church, then in the hands of the monks of Camaldoli, and now the Vescovado. The majority of Piero's books are in the library of Federigo II., Duke of Urbino, and their many excellencies have earned him the well-deserved reputation of being the best geometrician of his day.

Frà Giovanni of Fiesole, of the Order of Friars Preachers, Painter

(1387–1455)

Frà Giovanni Angelico of Fiesole, known in the world as Guido, was no less excellent as a painter and illuminator than as a monk of the highest character, and in both capacities he deserves to be most honourably remembered. Although he might easily have led a secular life and gained what he liked at art beyond what he possessed, for he showed great skill while still quite young, yet, being naturally quiet and modest, he entered the order of Friars Preachers [1] chiefly for the sake of

[1] In 1407.

his soul and for his peace of mind. For although it is possible
for men of all conditions to serve God, yet some think that they
can win salvation more easily in a monastery than in the world.
Although this course is well enough for good men, yet it leads
to a wretched and unhappy existence for those who become
monks for other ends. There are some choir books illuminated by
Frà Giovanni in his convent of S. Marco at Florence of indescrib-
able beauty, and others like them in S. Domenico at Fiesole,
executed with extraordinary diligence. It is true that in doing
these he was assisted by an elder brother who was also an
illuminator, and well skilled in painting. One of the first works
in painting executed by this good Father was a panel in the
Certosa of Florence, placed in the principal chapel of the Cardinal
degli Acciaiuoli, representing a Madonna and Child, with lovely
angels playing and singing at her feet. Beside her are St. Lau-
rence, St. Mary Magdalene, St. Zanobius and St. Benedict. The
predella contains incidents from the lives of these saints in small
figures, executed with extraordinary finish. On the screen of the
chapel are two other pictures by his hand, the one a Coronation
of the Virgin, the other a Madonna and two saints, beautifully
executed in ultramarine blue. On the screen of S. Maria Novella
he afterwards painted in fresco, beside the door opposite the
choir, St. Dominic, St. Catherine of Siena and St. Peter Martyr,
as well as some small scenes in the chapel of the Coronation of
the Virgin. He made an Annunciation on canvas for the small
doors of the old organ, now in the convent opposite the door of
the dormitory, low down between one cloister and the other.
This friar, on account of his great qualities, was much esteemed
by Cosimo de' Medici, who, after he had built the church and
convent of S. Marco, employed him to paint the Passion of Christ
on a wall of the chapter-house. On one side are all the saints
who have founded or been the heads of religious orders, sorrowful
and weeping at the foot of the cross, the other side being occupied
by St. Mark the Evangelist, the Mother of God, who has fainted
on seeing the Saviour of the world crucified, the Maries who are
supporting her, and SS. Cosimo and Damian, the former said
to be a portrait of his friend, Nanni d'Antonio di Banco, the
sculptor. Beneath this work, in a frieze above the dado, he made
a tree, at the foot of which is St. Dominic; and in some medallions
which are about the branches are all the popes, cardinals,
bishops, saints and masters of theology who had been members
of the order of the Friars Preachers up to that time. In this
work he introduced many portraits, the friars helping him by

sending for them to different places. They include St. Dominic, who is in the middle and holding the branches of the cross, the French Pope Innocent V., the Blessed Ugo, the first cardinal of the order, the Blessed Paolo, the Florence patriarch, St. Anthony, Archbishop of Florence, Giordano the German, the second general of the order, the Blessed Niccolo, the Blessed Remigio of Florence, Boninsegno, martyr of Florence, all these being on the right-hand; on the left are Benedict IX. of Treviso, Giandomenico the cardinal, a Florentine, Pietro da Palude, Patriarch of Jerusalem, Alberto Magno the German, the Blessed Raimondo da Catalogna, third general of the order, the Blessed Chiaro of Florence, provincial of Rome, St. Vincenzio di Valenza, and the Blessed Bernardo of Florence, all the heads being wonderfully graceful and very beautiful. In the first cloister, above some lunettes, he afterwards did many fine figures in fresco, with a St.Dominic at the foot of the cross which has been much admired. In the dormitory, besides many other things in the cells and on the walls, he made a scene from the New Testament of indescribable beauty. But especially beautiful and marvellous is the picture of the high altar of the church. The Madonna inspires devotion in the beholder by her simplicity, and the saints standing are like her. The predella contains incidents in the martyrdom of SS. Cosmo and Damian and the others, all most wonderfully done, so that it would be hard to imagine a work executed with more diligence or containing more delicate and better devised figures.[1] In S. Domenico at Fiesole he painted the picture of the high altar, but because it was thought to be damaged it has been retouched by other masters and spoiled. The predella and the ciborium of the Sacrament, however, have been better preserved, and the innumerable figures contained in the heavenly glory are so fine that they appear really to be from Paradise, and one can never tire of looking at them.[2] In a chapel of the same church there is an Annunciation by his hand, the face being so devout, delicate and well made that it is not like the work of a man, but a product of Paradise. In the landscape are Adam and Eve, who led to the Incarnation of the Redeemer through the Virgin. The predella also contains some very charming little scenes.[3] But among all the works of Frà Giovanni, he surpassed himself and displayed the full extent of his powers and knowledge of

[1] The main part of the altar-piece, which was painted probably c. 1438, is in the Museo S. Marco. It was much repainted by Lorenzo di Credi in 1501. The predella is now in the National Gallery. [2] In the Prado.

[3] A picture in the Madrid Gallery may probably be identified as the one here described.

art in a panel in the same church next to the entrance door on the left side, containing Christ crowning Our Lady in the middle of a choir of angels and a multitude of saints, so numerous, so well executed and so varied in action and gesture that it is an unspeakable delight to regard them, for it appears that the spirits of the blessed in heaven cannot be otherwise than these, or to put it better, they could not if they were corporeal, for all the saints there are not only full of life with their sweet and delicate ways, but the entire colouring appears to be the work of a saint or an angel like themselves.[1] Right well did this holy friar deserve the name by which he was always known, Frà Giovanni *Angelico*. In the predella the scenes of Our Lady and of St. Dominic are divine of their kind, and I can truthfully say that for me they never lose their freshness, and I never tire of seeing them. In the Chapel of the Nunziata of Florence, erected by Piero di Cosimo de' Medici, he painted the doors of the presses, where the plate is kept, with small figures executed with great finish.[2] This friar did so many things which are in private houses in Florence that I am lost in astonishment that one man, even in so many years, could have done such a quantity of things, and so well. The Very Rev. Don Vincenzo Borghini, master of the Innocenti, has a lovely small Madonna by his hand, and Bartolommeo Gondi, as zealous a patron of the arts as any other nobleman, has a large picture, a small one and a cross by the same hand. The paintings in the tympanum over the door of S. Domenico are also his, and so is a picture in the sacristy of S. Trinità representing a Deposition from the Cross, finished carefully so that it may be counted among his best works.[3] At S. Francesco outside the S. Miniato gate is an Annunciation, and in S. Maria Novella, besides the things already spoken of, he painted the paschal taper and some reliquaries with small scenes, which are placed upon the altar on great occasions. In the Badia in the same city he made a St. Benedict commanding silence, over the door of the cloister. For the linen-drapers he made a picture which is in the office of their art,[4] and in Cortona he did a small arch over the door of the church of his order, as well as the picture of the high altar.[5] At Orvieto he began some prophets on the vaulting of the chapel of Our Lady in the Duomo,[6] which were finished by Luca da Cortona. For the company of the Temple at Florence he made

[1] Now in the Louvre.
[2] Now in the Museo S. Marco, *c.* 1450.
[3] Museo S. Marco.
[4] Museo S. Marco, painted 1433.
[5] In 1414.
[6] Begun in 1447.

a dead Christ on a panel, and in the church of the monks of the Angeli he made a Paradise and a Hell of small figures, displaying great observation in his representations of the beauty, the blessedness and rejoicing of the good, and the damned prepared for the pains of hell, with various expressions of sadness, their sin and worthlessness depicted in their faces. The blessed enter Paradise by the door joyfully dancing, while the damned are dragged by demons to everlasting pains.[1] This work is on the right side of the church as one goes towards the high altar, where the priest is stationed when Mass is sung. For the nuns of S. Piero Martire, who now occupy the monastery of S. Felice in the piazza, which belonged to the monks of Camaldoli, he made a panel containing Our Lady, St. John the Baptist, St. Dominic, St. Thomas and St. Peter Martyr, in somewhat small figures.[2] A panel by his hand may still be seen on the screen of S. Maria Nuova.[3] By these numerous works the fame of Frà Giovanni was spread abroad through all Italy, so that Pope Nicholas V. sent for him to Rome, and employed him to decorate the chapel of the palace where the Pope hears Mass. Here he painted a Deposition from the Cross and some stories of St. Laurence of great beauty, and he also illuminated some books very beautifully.[4] In the Minerva he made the picture of the high altar, and an Annunciation now fixed to the wall beside the principal chapel. For the same Pope he did the chapel of the Sacrament in the palace. This was afterwards destroyed by Pope Paul III. in order to put his stairs there. In this work, which was excellent in his distinctive style, he did some incidents from the life of Jesus Christ in fresco, introducing many portraits from life of noteworthy persons of the day. These would probably have been lost also had not Giovio saved them for his museum. They comprise Pope Nicholas V., the Emperor Frederick, who came to Italy at that time, Frà Antonino, afterwards Archbishop of Florence, il Biondo of Forli, and Ferdinand of Aragon. And because Frà Giovanni appeared to the Pope to be a person of most holy life, quiet and modest, as indeed he was, he wished to appoint him to the Archbishopric of Florence, then vacant. When the friar learned this he besought His Holiness to appoint another, because he did not feel himself fit to be a ruler of men, saying that his order possessed a friar who was kind to the poor,

[1] Both works now in the Museo S. Marco.
[2] Museo S. Marco.
[3] Uffizi Gallery.
[4] He went to Rome in 1445. The payments for the St. Laurence frescoes extend from 1445 to 1450.

very learned, capable of ruling, and God-fearing, far better
suited for that dignity than himself. The Pope recognised that
he spoke no more than the truth and granted the favour freely.
In this way Frà Antonino of the order of the Preachers became
Archbishop of Florence.[1] He was a truly distinguished man, both
for his holiness and his learning, fully deserving his canonisation
in our own day by Adrian VI. It was a good action of Frà
Giovanni and a most rare thing to grant such a dignity and so
great a charge, when offered to him by the pontiff, to a man whom
his clear judgment and sincerity recognised as being much better
fitted for it than himself. The monks of our own day might well
learn from the example of this holy man not to undertake
burdens which they cannot worthily sustain, but to yield them
to more capable men. To return to Frà Giovanni. Would God it
could be said that all the monks spent their time as this truly
religious friar did, for he devoted his life entirely to the service
of God and the benefit of the world and his neighbours. What
more can or should be desired than to win the heavenly kingdom
by holy living, and eternal renown on earth by masterly work?
It is certain that a surpassing and extraordinary talent like that
of Frà Giovanni cannot and ought not to be granted to any man
who is not of a most holy life, because those who devote them-
selves to ecclesiastical and holy things ought to be ecclesiastics
and holy men, for it is seen that, whenever such things are
produced by men of little belief who do not highly value religion,
they frequently excite dishonourable appetites and lascivious
desires, so that the work is blamed for what is disreputable,
while praise is accorded to its artistic qualities. But I do not
wish to be misunderstood to call an awkward, clumsy thing
devout, and a fine and good work lascivious, as some do when
they see figures of women and youths rather more beautiful and
ornate than usual, condemning them immediately as lascivious
without perceiving that they are most wrongfully condemning
the good judgment of the painter, who considers that the saints,
as celestial beings, must be as much superior to mortal nature
in beauty as heavenly loveliness surpasses that of the earth.
What is worse than this, they display the foulness and corrupt-
ness of their own minds in finding evil and wicked ideas in
those things in which, if they had been true lovers of right, as
they would like in their blind zeal to be thought, they would
perceive the longing for heaven and the desire to make them

[1] Antonio Forciglione (who became St. Antoninus) was consecrated Arch-
bishop in 1448.

acceptable to the Creator of all things, from whose most perfect and beautiful nature all perfection and beauty are derived. What might be expected of such men if they happened to find themselves in the presence of living beauties, with their lascivious ways, soft words, movements full of grace and ravishing eyes, when the mere counterfeit and shadow of beauty moves them so much? However, I would not let it be understood that I approve of the all but nude figures which are painted in churches, because they prove that the artist has not entertained a proper respect for the place. Wherefore, whenever an artist wishes to display his skill he ought to do so with a full regard for the circumstances, the persons, the time and the place.

Frà Giovanni was a simple and most holy man in his habits, and it is a sign of his goodness that one morning, when Pope Nicholas V. wished him to dine with him, he excused himself from eating flesh without the permission of his prior, not thinking of the papal authority. He avoided all worldly intrigues, living in purity and holiness, and was as benign to the poor as I believe Heaven must now be to him. He was always busy with his paintings, but would never do any but holy subjects. He might have become rich, but he cared nothing about it, for he used to say that true riches consist in being contented with little. He might have ruled many but would not, saying that there was less trouble and error in obeying others. He could have obtained high rank in his order and in the world but he did not esteem it, saying that he wished for no other dignity than to escape hell and win Paradise. In truth, not only the religious, but all men ought to seek that dignity, which is only to be found in good and in virtuous living. He was most gentle and temperate, living chastely, removed from the cares of the world. He would often say that whoever practised art needed a quiet life and freedom from care, and that he who occupies himself with the things of Christ ought always to be with Christ. He was never seen in anger among the friars, which seems to me an extraordinary thing and almost impossible to believe; his habit was to smile and reprove his friends. To those who wished works of him he would gently say that they must first obtain the consent of the prior, and after that he would not fail. I cannot bestow too much praise on this holy father, who was so humble and modest in all his works and conversation, so facile and devout in his painting, the saints by his hand being more like those blessed beings than those of any other. He never retouched or repaired any of his pictures, always leaving them in the condition in which they were

first seen, believing, so he said, that this was the will of God. Some say that Frà Giovanni never took up his brush without first making a prayer. He never made a crucifix when the tears did not course down his cheeks, while the goodness of his sincere and great soul in religion may be seen in the faces and attitudes of his figures. He died in 1455 at the age of sixty-eight, and left as his pupils Benozzo of Florence, who closely imitated his style, and Zanobi Strozzi, who made panels and paintings for all Florence, for the houses of citizens, and notably a picture now placed in the transept of S. Maria Novella beside that of Frà Giovanni, and one in S. Benedetto, a monastery of the monks of Camaldoli outside the Pinti gate, now destroyed. This painting is at present in the monastery of the Angeli in the little church of S. Michele, before one enters the principal church, on the right-hand going towards the altar, fixed to the wall. He also made a picture for the Chapel of the Nasi in S. Lucia and another in S. Romeo. In the wardrobe of the duke are the portraits of Giovanni di Bicci de' Medici and that of Bartolommeo Valori in the same picture by the same artist. Other pupils of Frà Giovanni were Gentile da Fabriano and Domenico di Michelino, who made the picture at the altar of St. Zanobius in S. Apollinare at Florence, and many other paintings. Frà Giovanni was buried by the friars in the Minerva at Rome by the side entry near the sacristy, in a round marble tomb, with his effigy above it. On the marble is carved this epitaph:

Non mihi sit laudi, quod eram velut alter Apelles,
Sed quod lucra tuis omnia, Christe, dabam:
Altera nam terris opera extant, altera caelo.
Urbs me Joannem flos tulit Etruriae.

In S. Maria del Fiore there are two large books divinely illuminated by Frà Giovanni held in great veneration; they are richly ornamented, and are only seen on great occasions.

There lived at the same time as Frà Giovanni a celebrated and famous illuminator named Attavante of Florence, whose cognomen I have never heard. Among other things he illuminated a Silius Italicus, now in S. Giovanni e Paolo at Venice. I will describe some particulars of this work, both because they are worthy of note by artists, and because, so far as I am aware, no other work of his is known. Indeed, I should not have known of this myself had not the Very Rev. M. Cosimo Bartoli, nobleman of Florence, told me about it, out of the affection which he bears for the arts, in order that the talents of Attavante should not be practically buried. In this book, the figure of Silius wears

a helmet incrusted with gold, surrounded with a laurel crown, a blue cuirass plated with gold in the antique style, his right hand holds a book and his left a short sword. Over the cuirass he wears a red cloak, fastened in front by a brooch, and hanging from his shoulders is a gold fringe; the lining of the cloak is of varied colours and embroidered with gold rosettes. His shoes are yellow, and he is resting on his right foot, in a niche. The next figure in the book, representing Scipio Africanus, wears a yellow cuirass, the girdle and sleeves of which are blue and all embroidered with gold. On his head is a helmet, with two wings and a fish as a crest. He is a youth of blonde complexion and remarkable beauty, and proudly raises his right hand brandishing a naked sword, while he holds his sheath, which is red and embroidered with gold, in his left. His shoes are simple, of green colour, and the cloak blue, the lining being red with a border of gold. It is buckled under the chin, leaving the front open, and falling gracefully behind. This youth, who is placed in a niche of mixed green and grey, with blue shoes embroidered with gold, regards with indescribable fierceness the Hannibal on the opposite page. Hannibal is represented as a man of about thirty-six. His brow is wrinkled like that of an angry man, and he also fixedly regards Scipio. On his head is a yellow helmet, with a green and yellow dragon for a crest, and wreathed by a serpent. He rests on one foot, and raises his right hand, in which he holds the shaft of an ancient javelin. His cuirass is blue, and the trappings partly blue and partly yellow, the sleeves alternately red and blue, and the shoes yellow. The cloak is red and yellow, gathered at the shoulder and lined with green. The left hand rests on his sword, and he stands in a niche of alternate yellow and white. On the opposite page is a portrait of Pope Nicholas V., in a striped mantle of violet and red, all embroidered with gold. He is in full profile without a beard, and he looks towards the beginning of the work opposite to him, to which he points with an air of wonderment. The niche is green, white and red. In the border are some half-figures, introduced into ovals and circles, and other like things, with a number of small birds and cherubs so well made that nothing better could be desired. Near these are similar representations of Hanno the Carthaginian, Hasdrubal, Lelius, Massinissa, C. Salinator, Nero, Sempronius, M. Marcellus, Q. Fabius, the other Scipio, and Vibius. At the end of the book there is a Mars in an antique chariot drawn by two red horses. On his head is a helmet of red and gold with two wings, on his left arm a shield which he holds

before him, and in his right hand a naked sword. He rests on one foot only, holding the other up. His cuirass is antique, and of red and gold, while his shoes and stockings are the same. The cloak is blue above and green beneath embroidered with gold. The chariot is covered with red cloth embroidered with gold, surrounded by a band of ermine; he is placed in a green and flowery country, amid boulders and rocks, countries and cities being visible in the distance, in the midst of a blue sky, all most excellent. On the other side is a Neptune, a youth clothed in a long flowing embroidered robe, with an earth-green girdle. His complexion is very pale. In his right hand he holds a small trident, and lifts his robe with his left. He rests with both his feet in the car, which is covered with red, embroidered with gold and bordered with sable. This car has four wheels like that of Mars, but is drawn by four dolphins. There are also three sea-nymphs, two boys, and innumerable fish, all done in a water-colour like the earth, bathed in a delightful air. Here also we may see Carthage in despair, a tall and dishevelled woman clothed in green, her open garb showing her vest lined with red cloth embroidered with gold. Through an opening in this is seen another thin vest, with violet and white stripes. The sleeves are red and gold, with certain swellings and folds made by the upper vest. She stretches out her left hand to Rome, who is opposite, as if to say, "What is your will? I will answer you." In her right hand is a naked sword, as if she were infuriated. Her shoes are blue, while she stands on a rock in the middle of the sea, surrounded by air of marvellous purity. Rome is a young woman of the highest imaginable beauty, her dishevelled tresses falling with infinite grace, clothed all in red, embroidered only at the feet. The lining of the vest is yellow, and the under-vest, seen through an opening, is violet and white. Her shoes are green; in her right hand she holds a sceptre, in her left a globe. She also stands upon a rock in the middle of an inconceivably beautiful air. But although I have done my utmost to show with what skill these figures were produced by Attavante, I have only been able to give a feeble idea of their beauty; no more perfect illuminations of that time can be seen, displaying such judgment and design, and, above all, the colours are laid on with incomparable delicacy.

Leon Battista Alberti, Architect of Florence
(1404–1472)

LETTERS are of the greatest use to all those artists who delight in them, but especially to sculptors, painters and architects, by paving a way for their inventions, while without them no one can have a perfect judgment, however great his natural ability. Who does not know that in choosing sites for buildings it is necessary to consider philosophically the severity of pestilential winds, the unhealthiness of the air, the smell and exhalations of impure and unhealthy waters? Who does not know that it is necessary when a work is to be begun to ascertain, unaided, by mature reflection, what to avoid and what to adopt, without being obliged to have recourse to the theories of others, which, when unilluminated by practice, are usually of little assistance. But when theory and practice are united in one person, the ideal condition is attained, because art is enriched and perfected by knowledge, the opinions and writings of learned artists having more weight and more credit than the words or works of those who have nothing more to recommend them beyond what they have produced, whether it be done well or ill. The truth of these remarks is illustrated by Leon Battista Alberti, who, having studied the Latin tongue and practised architecture, perspective and painting, has left works to which modern artists can add nothing, although numbers of them have surpassed him in practical skill. His writings possess such force that is it commonly supposed that he surpassed all those who were actually his superiors in art. Thus it is clear from experience that, with respect to fame and name, writings enjoy the greatest power and vitality, for books easily penetrate everywhere and inspire confidence if they are true and lie not. It is no marvel, then, if the famous Leon Battista is better known by his writings than by the works of his hands. He was born in Florence [1] of the most noble family of the Alberti, spoken of elsewhere, and he endeavoured not only to explore the world and measure antiquities, but also paid much more attention to writing than to his other work, following his inclination. He was an excellent mathematician and geometrician, and wrote a Latin work on architecture in ten books, published by him in 1485. It may be read to-day in the translation by the Rev. M. Cosimo Bartoli, provost of S. Giovanni in Florence. He wrote three books on

[1] He was born at Venice.

painting, which have been translated into Tuscan by M. Ludovico Domenichi. He wrote a treatise on traction and on measuring elevations, the *Libri della Vita Civile*, and some erotic works in prose and verse, while he was the first to employ the Latin prosody for verses in the vulgar tongue, as may be seen in this letter of his:

> Questa per estrema miserabile pistola mando
> A te che spregi miseramente noi.

Leon Battista happened to arrive in Rome at the time when Nicholas V.[1] by his manner of building had turned the city upside down, and by the offices of his close friend, Biondo da Forli, he became intimate with the Pope, who had hitherto been advised in architectural matters by Bernardo Rossellino, sculptor and architect of Florence, as will be said in the life of his brother Antonio. This man having begun to restore the Pope's palace and to do some things in S. Maria Maggiore in conformity with the Pope's wishes, always previously took the advice of Leon Battista. Thus the Pope, by following the advice of one of them and the execution of the other, carried out many useful and praiseworthy things, such as the rebuilding of the ruined acqueduct of the Virgin, making the fountain on the piazza de' Trevi [2] with the marble ornamentation which is still there, containing the arms of that pontiff and of the Roman people. After this Leon went to Sigismondo Malatesti, lord of Rimini, and designed for him the church of S. Francesco, and especially its marble façade, as well as an arcade of large arches on the south side and the tombs for illustrious men of the city.[3] In short, he so transformed the building that from being quite an ordinary work it became one of the most famous temples in Italy. The interior contains six fine chapels. One of them dedicated to St. Jerome is very ornate, many relics from Jerusalem being preserved there. In the same church are the tombs of Sigismondo and his wife, richly constructed of marble in the year 1450, and above one is the effigy of that lord, and in another part of the work is the portrait of Leon Battista. In the year following, 1457, in which John Gutemberg, a German, discovered the most useful art of printing books, Leon Battista likewise made a discovery for representing landscapes and for diminishing and enlarging figures by means of an instrument, all good inventions, useful to art. It happened that when Giovanni di Paolo Rucellai wished to build the façade of S. Maria Novella in marble at his own

[1] 1447-55. [2] In 1453. [3] 1447-55.

cost, he consulted Leon Battista, his close friend, who not only gave him advice, but the design, so that he decided to execute the work as a memorial of himself. Accordingly it was begun and finished in 1477, to the general satisfaction, the whole work giving pleasure, but especially the door, upon which Leon Battista clearly bestowed more than ordinary pains. For Cosimo Rucellai he made the design of the palace which he erected in the street called la Vigna, and that of the loggia opposite. In this he formed his arches over the narrow columns on the forward face, but as he wished to continue these and not make a single arch, he found he had too much space in every direction. Accordingly he was obliged to make brackets on the inside. When he came to the vaulting of the interior he found that to give it the sixth of a half-circle would result in cramped and awkward appearance, and so he decided to form small arches from one bracket to another. This lack of judgment and design proves that practice is necessary as well as theory, because the judgment can never be perfected unless knowledge is put into practice. It is said that he also made the design for the house and garden of these same Rucellai in the via della Scala, a work of great judgment and very convenient, for beside many other things he introduced two loggias, one facing south and another west, both very beautiful, and erected upon columns without arches.[1] This method is the true one, and was observed by the ancients, because the architraves which are laid upon the capitals of the columns make things level, whereas a square thing such as arches are, which turn, cannot rest upon a round column, without throwing the corners out; the true method of construction therefore requires that the architraves shall be placed upon the columns, and that when arches are made they should be borne by pilasters and not by columns. For the same Rucellai, and in the same style, Leon Battista made a chapel in S. Brancazio,[2] which is borne upon large architraves laid upon two columns and two pilasters made in the wall of the church, a difficult but safe method, so that this is one of the best works of our architect. In the middle of the chapel is a fine marble tomb of an elongated oval form, like the sepulchre of Christ at Jerusalem, as an inscription indicates. At this same time, Ludovico Gonzago, Marquis of Mantua, wished to make the tribune and principal chapel in the Nunziata of the Servites at Florence, from designs by Leon Battista. Accordingly he pulled down an old square

[1] Now Palazzo Strozzi; Alberti's authorship is denied.
[2] *Rectius* S. Pancrazio; in 1467.

chapel there of no great size, painted in the old style, and made the beautiful and difficult tribune in the shape of a round temple, surrounded by nine chapels forming an arc and constructed like niches.[1] The arches of the chapel being borne by the pilasters in front, the stone ornamentation of the arches inclining towards the wall, tends to lean backward in order to meet the wall, thus turning away from the tribune. Accordingly, when the arches of the chapels are looked at from the side, they have an ugly appearance, as they fall backwards, although the measurements are correct and the method of construction difficult. Indeed, it would have been better had Leon Battista avoided this method, because, besides being awkward to carry out, it cannot be done successfully, being ugly as a whole and in the details. Thus we see that, though the great front arch is very fine when looked at from the outside at the entrance of the tribune, it is extremely ugly on the inside, because it has to be turned in conformity with the round chapel, and this gives it the appearance of falling backwards. Possibly Leon Battista would not have done this if he had possessed practical knowledge and experience in addition to his learning and theories, for any other man would have avoided such difficulties, and striven rather to render the building as graceful and beautiful as possible. In other respects this work is entirely beautiful, ingenious and difficult, and the courage of Leon Battista must have been great to make the vaulting of the tribune in such a manner in that age. Being invited to Mantua afterwards by the same Marquis Ludovico, Leon Battista made the model of the church of S. Andrea [2] and some other things for him, and on the road from Mantua to Padua some churches built in his style may be seen. Salvestro [3] Fancelli carried out the designs and models of Leon Battista. He was an architect and sculptor of Florence of some ability, and executed for Leon Battista all the works which he had done in Florence with extraordinary judgment and diligence. Those at Mantua were done by one Luca,[4] a Florentine, who subsequently came to live in the city and died there. According to Filarete he left his name to the family of the Luchi, which still flourishes there. Leon Battista was not a little fortunate, therefore, in having friends who understood him, knew his methods and were willing to serve him, for as architects cannot always be at their work, a faithful and loving executor is a great boon to them, as I know very well by my own experience.

[1] In 1476. [2] Building 1472–94. [3] Luca Fancelli.
[4] The same Luca Fancelli.

In painting Leon Battista produced no great or remarkable work, his things being small without great perfection. This is not remarkable, because he paid more attention to his studies than to design. Yet he was able to show his meaning in his drawings, as we see by some sheets of his in our book, containing a drawing of the Ponte S. Agnolo, and of the roof made there from his design for the loggia, as a shelter from the sun in summer and from the wind and the rain in winter. This work was given to him by Pope Nicholas V., who intended to make many similar ones all over Rome, had not death interposed. Another work of Leon Battista on the side of the ponte alla Carraia at Florence, in a small chapel of Our Lady, is a small altar-slab containing three scenes with perspectives, much better described by his pen than they were painted by his brush. In Florence also there is a portrait of himself in the house of Palla Rucellai, done with a mirror, and a picture of somewhat large figures in chiaroscuro. He further painted a Venice in perspective, and S. Marco, but the figures were done by other masters, and this is one of his best paintings. He was a person of the most courteous and praise-worthy manners, a friend of distinguished men, generous and kind to all. He lived honourably like a nobleman all his days, and after having attained a somewhat advanced age, he passed quietly and contentedly to a better life, leaving an honoured name behind him.

Lazzaro Vasari, Painter of Arezzo
(1399 – ? 1452)

Great is the satisfaction of those who find that some of their ancestors and relations have been distinguished and famous in some profession, whether it be arms, letters, painting or any other noble exercise. Those men also who find that honourable mention has been made of their predecessors by historians have at least a stimulus to virtue, and a bridle to restrain them from doing anything unworthy of a family which boasts illustrious and distinguished names. The full extent of this pleasure, of which I have just spoken, I experienced myself when I found that among my predecessors Lazzaro Vasari had been a famous painter in his day, not only in his own country but in all Tuscany. This was certainly not without cause, as I could clearly demon-strate, were it permissible to speak freely of him, as I have done

of the others. But lest I might be thought to praise him exces-
sively, being of his blood, I will pass over in silence his merits
and those of his family, contenting myself by relating only what
I cannot and must not omit, if I would speak the truth on which
all history depends. Lazzaro Vasari, then, painter of Arezzo,
was a close friend of Pietro della Francesca of Borgo a San
Sepolcro, and while the latter was engaged at Arezzo they
always worked together, as has been said. As is frequently the
case, this friendship proved to be of great assistance to both of
them, because whereas Lazzaro was in the habit of making small
figures only for some things, as was then the custom, the influence
of Piero induced him to undertake works of more importance.
His first work in fresco was a St. Vincent in S. Domenico at
Arezzo, in the second chapel on the left-hand as one enters the
church, and at the saint's feet he painted himself and his son
Giorgio in rich clothing of the time, kneeling to recommend
themselves to the saint, the youth having accidentally wounded
his face with a knife. Although there is no inscription on this
work, yet some old records of our family and the Vasari arms
on the picture are sufficient evidence that this is true. Doubtless
there was some record of it in the convent, but I am not surprised
that none can now be found, seeing how much the papers and
other possessions of the monastery have suffered from the
soldiery. Lazzaro's style was so like that of Pietro Borghese that
very little difference could be perceived between them.

Now it was the custom in those days to paint various things
upon the armour of horses, more particularly the devices of
their riders, and in this work Lazzaro was a skilled artist, it
being a peculiarity of his to paint with much grace small figures
which were well suited for such ornamentation. For Niccolo
Piccinino, his soldiers and captains, he did many such things,
full of scenes and devices which were highly valued, and brought
him so much profit that he was able to fetch to Arezzo nearly
all his brothers, who were living at Cortona, engaged in the
manufacture of earthen vessels. In like manner he brought Luca
Signorelli, his sister's son, from Cortona, who, being a clever
youth, associated with Pietro Borghese and learned the art of
painting, in which he made great progress, as will be said here-
after. Thus Lazzaro, by means of continuous application to his
art, became more excellent every day, as we see by some very
good designs by his hand in our book. He greatly delighted to
represent certain natural effects, and could do so excellently,
such as weeping, laughing, shouting, fear, trembling, and such

things, his pictures being full of such inventions, as may be seen in a small chapel painted in fresco by him in S. Gimignano at Arezzo, containing a crucifix, Our Lady, St. John, and the Magdalene at the foot of the cross, who are weeping in various attitudes, and are so life-like that they brought him great renown among his fellow-citizens. He painted on cloth, for the company of St. Anthony in that city, a processional banner representing Christ stripped and bound to the column with such realism that He appears to be trembling, and with contracted shoulders bears with wonderful humility and patience the blows given him by two Jews, one of whom, stepping backward, is using both his hands, turning his back towards Christ in a most cruel manner, the other, being in profile and about to rise on the tips of his toes, is stretching the whip with his hands and grinding his teeth in indescribable rage. In order to represent the nude, Lazzaro painted these two men with their clothes torn, contenting himself with covering their shameful parts. This work has endured on the cloth, astonishing to relate, to this very day, and on account of its beauty and excellence it was copied for the men of the company by the French prior,[1] as will be related in the proper place. Lazzaro also worked at Perugia in the church of the Servites in a chapel next to the sacristy, doing some stories of Our Lady and a crucifix. In the Pieve of Montepulciano, he did a predella of small figures, and in S. Francesco at Castiglione of Arezzo a panel in tempera, as well as many things which it would take too much space to tell of, and notably a quantity of chests for private houses. Among the old armour in the Parte Guelfa at Florence some excellent caparisons of his may still be seen. For the company of St. Sebastian he painted a banner representing that saint at the column, with angels crowning him, but this is now completely ruined by time.

In Lazzaro's day there was a young Aretine named Fabiano Sassoli who was very skilful in making stained glass, as is shown by his works in the Vescovado, Badia, Pieve, and other places in that city, but he was not clever in design, and was far from attaining to the excellence achieved in this department by Parri Spinelli. As he was well acquainted with the method of baking the glass and of joining the pieces, he was anxious to make some work which should form a good picture, and accordingly he asked Lazzaro to prepare him two sheets for two windows for the Madonna delle Grazie. Having obtained this favour from his friend Lazzaro, who was an obliging artist, he made the windows

[1] William of Marseilles, known in Italy as Guglielmo di Marciglia.

so well and so beautifully that they will bear comparison with any. One represents a lovely Madonna, and the other, which is far superior, a Resurrection of Christ, with an armed man foreshortened in front of the sepulchre. It is a marvel, seeing that the window and consequently the picture are so small, how the figures appear to be so large. There are many other things which I could tell of Lazzaro, who was a fine draughtsman, as may be seen by some sheets in our book, but I refrain, because I think it better to do so.

Lazzaro was an amiable man, and very quick in argument, and although much addicted to pleasures, yet he never strayed from the path of virtue. He lived seventy-two years, and left a son Giorgio, who devoted all his time to antique earthenware vessels of Arezzo. In the time of M. Gentile Urbinato, bishop of Arezzo, he discovered the old method of colouring earthenware vessels in red and black, which had been employed by the old Aretines until the days of the King Porsena. As he was an industrious person he made great vases a braccia and a half high, which may still be seen in his house. It is said that one day, as he was looking for vases in a place where he thought that the ancients had worked, he found in a clay-field at the ponte alla Calciarella, in a place of the same name, at a depth of three braccia, three arches of ancient ovens, and about them a quantity of fragments and of broken vessels with four whole ones. These he presented to Lorenzo the Magnificent when on a visit to Arezzo, having been presented by the bishop, a matter which gave rise to the subsequent relations between him and that most illustrious house. Giorgio worked beautifully in relief, as may be seen by some heads in his house. He had five sons, who all practised the same art, and of their number Lazzaro and Bernardo were good artists, the latter dying at Rome when quite young. It is certain that if death had not carried him off so soon, he would have brought added renown to his country by the genius which exhibited itself so early in him. Lazzaro died an old man in 1452, and Giorgio, his son, in 1484, at the age of sixty-eight, both being buried in the Pieve of Arezzo at the foot of their chapel of St. Giorgio, where the following verses were subsequently attached in honour of Lazzaro:

> Aretii exultet tellus clarissima: namque est
> Rebus in augustis, in tenuique labor
> Via operum istius partes cognoscere possis:
> Myrmecides taceat: Callicrates sileat.

Finally, the last Giorgio Vasari, the writer of the present work,

having received the principal chapel of the Pieve as a gift from his fellow-citizens, the wardens and canons, as has been related in the Life of Piero Laurati, and being grateful for the benefices which he acknowledges that he owes in great part to his ancestors, has brought the chapel to its present form and erected a new tomb in the middle of the choir behind the altar, placing in it the bones of Lazzaro and Giorgio and of all the other members of the family, both male and female, thus making a new tomb for all the descendants of the house of Vasari. The body of his mother, who died at Florence in 1557 and was buried in S. Croce, he has caused to be placed in that tomb, in conformity with her wish, with her husband Antonio, his father, who died of the plague in 1527. In the predella beneath the picture of that altar there are portraits by the said Giorgio of Lazzaro, Giorgio the elder, his grandfather, Antonio, his father, and M. Maddalena de' Tacci, his mother. And this is the end of the Life of Lazzaro Vasari, painter, of Arezzo.

ANTONELLO DA MESSINA, Painter
(?1431-1499)

WHEN I consider the various benefits and advantages conferred upon the art of painting by many masters who have followed this second style, I cannot but call them truly industrious and excellent in considering their works, since their chief preoccupation was to bring painting to greater perfection without a thought of any inconvenience, expense or their own particular interests. Thus they continued to work on panels and canvas with no other colour but tempera, a method introduced by Cimabue in 1250 while he was with the Greeks, and afterwards followed by Giotto and the others of whom we have spoken up to this point, who all adopted the same methods. However, it was recognised that works executed in tempera lacked something in smoothness and vivacity, which if achieved would have produced more grace in the design, more beauty in the colouring and greater facility in blending the colours, as they had always been accustomed to treat their works with the point of the brush only. But although many had endeavoured to find some such means, yet they had never discovered a good method, though they used liquid varnish and mixed other colours with the tempera. Among those who practised these experiments in vain were Alesso Baldovinetto, Pesello, and many

others, none of whom succeeded in producing works of the
beauty and excellence to which they aspired. Even if they
had found what they sought, they lacked the means of making
the figures in a picture pose like those which are made on a wall,
or the method of washing them without the colours running, or
to resist all accidents while the work was in progress. Artists
had frequently met to discuss these things without the con-
ferences yielding any fruit. The same lofty purpose animated
the minds of many men who devoted themselves to painting
outside Italy, in France, Spain, Germany and other countries.
While matters were at this stage, it happened that there was at
work in Flanders a man named Giovanni da Bruggia,[1] of great
reputation in those parts as a skilful painter. He set himself to
test divers sorts of colours, being fond of alchemy, making oils
for the preparation of varnishes as well as other things pleasing
to his inquiring mind. Having upon one occasion devoted the
utmost pains in painting a picture, which he had finished with
great care, he varnished it and put it in the sun to dry, as was
then customary. Whether the heat was excessive, or the wood
badly joined or ill-seasoned, the picture unfortunately split at
the joints. When Giovanni perceived the harm that the heat
of the sun had done, he determined to find a means whereby he
should be spared such an annoyance in the future. Accordingly,
rejecting at once the varnish and tempera, it occurred to him
that he might succeed in discovering a kind of varnish which
would dry in the shade without the aid of the sun. After making
a number of experiments and many mixtures, he discovered
that linseed oil and the oil of nuts dried more quickly than any
which he had tried. By boiling these with other ingredients, he
obtained the varnish which he and every other painter had so
long desired. Numerous experiments showed him that by mixing
colours with these oils he gave them a quality of great strength,
and that when they were dry they were not only proof against
water, but the colours were so strong that they were quite
lustrous without any varnish, and, what was even more remark-
able, they blended far better than the tempera. Enchanted with
this discovery, as well he might be, Giovanni began a large
number of works, filling the whole country with them, to the
infinite delight of the people and immense profit to himself, and
as his experience grew greater every day, he kept attacking
larger and better things. In a short while the fame of his inven-
tion spread not only throughout Flanders, but as far as Italy

[1] Jan van Eyck. He improved but did not invent the oil process.

and many other parts of the world, kindling artists with the utmost desire to know by what means he produced such perfect works. And the artists, who saw his works and were unable to say how they were produced, were compelled to admire him and lavish praises upon him, while he became an object of their virtuous envy, especially as for a long time he refused to permit anyone to see him at work, declining to impart his secret to a single fellow-creature. But having become old, he at length disclosed it to Ruggiero da Bruggia,[1] his pupil, who told his own pupil Ausse [2] and others, who are mentioned in works dealing with this method of painting in oils. But in spite of all, and although the merchants sent works of the kind all over the world to princes and great personages to their great advantage, the method did not get beyond Flanders. And although such paintings possessed that pungent smell imparted by the mixing of the colours and the oil, especially when fresh, whereby it would seem easy to detect the secret, yet after a lapse of many years none had been able to do so. But an oil-painting of Giovanni, having many figures, being sent to Alfonso I., King of Naples, by some Florentines trading in Flanders, which was highly valued by the king for the beauty of the figures and the new method of its colouring, the artists who were in the kingdom all came to see it and were loud in its praises. Now there was one Antonello da Messina, a person of good and quick intelligence, and very ready and skilful in his profession, who had studied design at Rome, and had gone first to Palermo, working there for many years, and finally to his native Messina, where his works confirmed his reputation there of being a painter of the highest excellence. He happened on one occasion to make a voyage of business from Sicily to Naples, and learned how King Alfonso had received this picture of Giovanni da Bruggia from Flanders, which was painted in oil so that it might be washed, would resist all accidents, and possessed every quality. When he had once seen the picture, the brightness of the colouring and the unity and beauty of the painting made such an impression upon him that he laid aside every other care and design and set out for Flanders. Arrived at Bruges, he became very friendly with Giovanni, presenting him with a number of designs made in the Italian style, and with other things. And thus by observation and because Giovanni being now an old man was willing that Antonello should see the method of colouring in oil, he did not leave the country until he had thoroughly mastered this method,

[1] Rogier van der Weyden. [2] Hans Memlinc.

as he so earnestly desired to do. When Giovanni died, not long after, Antonello left Flanders to revisit his native country and to give Italy the benefit of this beautiful and useful secret.[1] After remaining a few months at Messina he went to Venice, where he resolved to spend the remainder of his days, for he was greatly addicted to women and pleasure, and had found the means of gratifying his tastes. Accordingly he set to work and made many oil-paintings there in the way he had learnt in Flanders, which are scattered about in the houses of the nobles of that city, being much valued for the novelty of that work. He also did many which were sent to various places. Having at length established a reputation and a name, he was employed to paint a picture for S. Cassano, a parish in that city, upon which he devoted all his skill without counting the time. When it was completed it was highly praised and valued for the novelty of the colouring and the beauty of the figures, for it was well designed. When this new secret which he had brought to that city from Flanders was fully appreciated, he was greatly favoured and caressed by the magnificent nobles there as long as his life lasted.

Among the painters of repute in Venice at that time was Maestro Domenico. This man, on Antonello's arrival in the city, welcomed him as warmly as he would have done a dear friend. Antonello, who did not wish to be surpassed in courtesy, taught him the secret and method of oil-painting. No courtesy or act of friendship could possibly have given him greater satisfaction, and with good reason, as by means of this secret he came to be much honoured in his country, as may easily be conceived. Decidedly men are entirely in the wrong who think that, if they are avaricious even over things that cost them nothing, they will be well served by others for their beautiful eyes, as the saying goes. The courtesies of Maestro Domenico won from Antonello that which he had acquired with much toil and labour, and which he probably would not have imparted to any other for a great sum of money. But as I shall speak of Maestro Domenico in another place and his work at Florence (for he was most liberal with the gift which he had received from others), I return to Antonello, who made a number of pictures and portraits for many Venetian noblemen after the S. Cassano picture. M. Bernardo Vecchietti of Florence has a fine St. Francis and St. Dominic in the same picture by his hand. After the Signoria had commissioned him to make some scenes in the

[1] The dates do not fit. Jan van Eyck died 1440 and Antonello was born in 1431.

palace, which they had refused to give to Francesco di Mon-
signore of Verona, although he had been greatly favoured by
the Duke of Mantua, he fell sick of pleurisy and died at the age
of forty-nine, without having even begun the work. He received
a sumptuous funeral from the artists because of his gift of the
new method of colouring to art, as this epitaph testifies:

D. O. M.

Antonius pictor, praecipuum Messanae suae et Siciliae totius
ornamentum, hac humo contegitur. Non solum suis picturis, in quibus
singulare artificium et venustas fuit, sed et quod coloribus oleo
miscendis splendorem et perpetuitatem primus italicae picturae
contulit summo semper artificium studio celebratus.

The death of Antonello caused great sorrow to his friends,
and especially to Andrea Riccio, a sculptor, who made the two
marble statues of Adam and Eve which adorn the courtyard of
the ducal palace at Venice, and are much admired.[1] Such, then,
was the end of Antonello, to whom our artists are not less
indebted for having brought the method of painting in oils to
Italy, than to Giovanni da Bruggia for having discovered the
method in Flanders, as both of them benefited and enriched
their art. This invention has made possible those excellent
artists who have subsequently been able to make their figures
like living beings. The discovery is the more marvellous because
no writer has ever informed us that it was practised by
the ancients. If we could feel sure that this method was not
known by them, our age would have surpassed theirs in this
particular. But just as it is impossible to say anything which
has not been already uttered, it is probably equally impossible
to do anything which has not previously been done, and so I
must leave the matter. Thus, while I am bound to accord the
highest praise to those who add something to their art beyond
their designs, I will pass on to write about the others.

ALESSO BALDOVINETTI, Painter of Florence
(1427–1499)

THE noble art of painting exercises such a fascination that
many worthy men have abandoned professions in which they
might have become rich and, being drawn to this profession

[1] Vasari has here confused Andrea Riccio of Padua with Antonio Riccio
of Verona, the real author of the statues.

by inclination and against the wishes of their parents, have followed their natural bent and devoted themselves to painting, sculpture or some similar exercise. To tell the truth, those who value riches at their true worth and no more make virtue the end of their actions and acquire other treasure than silver and gold, and they need never fear that anything will in a moment deprive them of their earthly riches, so blindly valued by men at more than their worth. This was recognised by Alesso Baldovinetti, who of his own accord abandoned commerce, in which his family had always been engaged and in which they had acquired riches and lived as noble citizens, through their honest toil, and devoted himself to painting, in which he was particularly successful in counterfeiting natural objects, as may be seen by his works. While still a child he began to design, though it was against his father's wish, who would rather he had devoted himself to commerce, and he soon made such progress that his father was content to allow him to follow his natural inclination. His first work in fresco was the front part of the chapel of St. Giles in S. Maria Nuova, which was much admired at that time, for it contained among other things a St. Giles which was considered a very fine figure. He also did the principal picture as well as the chapel of the S. Trinità in fresco [1] for M. Gherardo and M. Bongianni Gianfigliazzi, rich and considerable Florentine nobles, painting some scenes from the Old Testament, which Alesso sketched in fresco and afterwards finished *a secco*, tempering the colours with the yolk of eggs mixed with liquid varnish made in the fire. He thought that this tempera would protect his paintings from the damp, but such was its strength that in many places where it was laid on too thickly it became incrusted, and thus he was mistaken in thinking that he had lighted upon a valuable discovery. He painted a number of portraits, and in the chapel where he painted the Queen of Sheba coming to hear the wisdom of Solomon he introduced Lorenzo de' Medici the Magnificent, the father of Pope Leo X., and Lorenzo dalla Volpaia, an excellent master clockmaker and distinguished astrologer. It was he who made for this same Lorenzo de' Medici the magnificent clock, now in the palace of Duke Cosimo, in which the wheels of the planets are in continual motion; this is rare, and it was the first work of its kind. In another scene opposite to this Alesso introduced portraits of Luigi Giucciardini the elder, Luca Pitti, Diotisalvi Neroni, Giuliano de' Medici, the father

[1] Finished in 1497.

of Pope Clement VII., and, beside the stone pilaster, Gherardo Gianfigliazzi the elder and M. Bongianni, knight, wearing a blue vest with a collar round his neck, and Jacopo and Giovanni of the same family. Beside these are Filippo Strozzi the elder, and M. Paolo the astrologer from Pozzo Toscanelli. In the vaulting are the four patriarchs, and the altar-piece is a Trinity with St. John Gualbert and another saint kneeling.[1] All these portraits may be readily recognised, because they resemble those which may be seen in other works, and especially in the houses of their descendants, whether in gesso or in painting. Alesso spent much time over these things, because he was very patient and liked to work at his ease. He designed very well, as a mule drawn from life in our book shows, the hair of the animal being represented with much grace and patience. He was most diligent, striving to imitate all the small details which Mother Nature knows how to make. His style was somewhat dry and crude, especially in drapery. He was very fond of drawing landscapes, copying them from Nature, exactly as they existed. Thus his paintings contain rivers, bridges, rocks, grass, fruits, roads, fields, cities, castles, sand, and an endless list of other things. On the wall in the courtyard behind the Nunziata at Florence, where the Annunciation itself is painted, he did a scene in fresco, retouched a secco, representing the Nativity [2] with such pains and so carefully finished that it would be possible to count the straws of the roof, and the knots in them. He also represented there the ruins of a house, the mouldering stones corroded and worn by the rain and snow, while an ivy root covers a part of the wall. His laborious patience may be noted in the colouring of the leaves, the face being of one shade and the back of another, precisely as in nature. In addition to the shepherds he made a snake or adder crawling along the wall, very naturally. It is said that he took great pains to discover the true method of mosaic, but that he never succeeded in finding anything really valuable. At length he came across a German, who was going to Rome for the indulgences. He gave this man lodging, and from him he learned all the methods and rules of the art, so that he subsequently set to work boldly at S. Giovanni above the bronze doors, making the angels who are holding the head of Christ, on the inside in the arches.[3] His good methods becoming recognised by means of this work, the

[1] The altar-piece now in the Accademia, Florence. The work in the chapel was allotted in 1471 and appraised in 1497. It was destroyed in 1760, with the exception of portions of the vaulting.
[2] 1460-2. [3] In 1482.

consuls of the art of the merchants employed him to clean and repair the entire vaulting of that church, which had been done, as I have related, by Andrea Tafi, because it was coming to pieces in many places, and needed repairing. Alesso did this with ardour and diligence, making use of a wooden scaffolding constructed for him by Il Cecca, who was the best architect of the day. Alesso taught the art of mosaic to Domenico Ghirlandaio, who afterwards painted his portrait [1] beside his own in the Chapel of the Tornabuoni in S. Maria Novella in the scene where Joachim is driven from the Temple, as a clean-shaven old man with a cap on his head. Alesso lived eighty years, and when old age began to creep upon him he went into the hospital of S. Paolo, wishing to attend to the studies of his profession with a quiet mind, as is frequently done. It was perhaps because he wished to be received there more willingly and to be better treated (though it might have been merely fortuitous) that he caused a huge chest to be brought into his apartment, creating the impression that it contained a great sum of money. On this account the master and the other servants, who knew that he had left to the hospital all that he possessed, paid him the greatest possible attentions. However, when he died, the chest was found to contain nothing but designs, pencil drawings of portraits, and a small book of instructions for making the stones of mosaic, the stucco, and the methods of working it. If report speak true, it was no wonder that he left no money, because he was so liberal that all that he possessed belonged as much to his friends as to himself.

Among his pupils was Il Graffioni, a Florentine, who did a God the Father with some angels in fresco over the door of the Innocenti which is still there. It is said that one day Lorenzo de' Medici was talking with Il Graffioni, who was a wild fellow, and said, "I want all the stone corners on the inside of the cupola done in mosaic and stucco," to which Il Graffioni replied, "You have not the men to do it." Lorenzo retorted, "We have so much money that we shall manage it," to which Il Graffioni immediately rejoined, "Ah, Lorenzo, money does not make masters, though masters make money." He was a curious and eccentric person, never sitting down to a meal unless the table was covered with his own drawing-paper, and never sleeping in any other bed but a chest full of straw without sheets. But to return to Alesso: his art and his life came to an end in 1448, and he was honourably buried by his relations and fellow-citizens.

[1] The portrait is that of his own father, Tommaso.

Vellano da Padova,[1] Sculptor
(1430 – c. 1498)

CAREFUL imitation may be carried so far that when it is done by a man who takes pleasure in his work, none but a discerning eye can discover any difference between the original and the copy, and it rarely happens that a studious pupil does not acquire, at least in large part, the style of his master. Vellano da Padova applied himself with such zeal to imitate the style of Donato in sculpture, especially in bronzes, that in Padua he was left as heir of Donatello's ability, as his works in the Santo show, for to all but those thoroughly acquainted with the matter they appear to be Donato's own, and those who are not better informed are continually being deceived. This man, being inflamed by hearing the praises bestowed upon Donato the Florentine sculptor, who was then at work in Padua, and by the desire to win the benefits acquired by good artists through the excellence of their works, joined himself to Donato to learn sculpture, and made such progress that with the aid of this great master he at length succeeded in attaining his purpose. Thus even before Donato left Padua, after finishing his work there, Vellano had advanced in the art to such an extent that good expectations were entertained of him, while his master considered him to be of such promise that he left to him all the materials, the designs and the models for his works in bronze about the choir of the Santo in that city. Accordingly, after Donato had gone, as I have said, the entire work was publicly entrusted to Vellano in his native place, to his great honour. He therefore made all the bronze bas-reliefs on the outside of the choir of the Santo, where among other things is Samson breaking the column and pulling down the temple of the Philistines, showing the falling pieces, together with the death of that great throng, with a great variety in the attitudes, some perishing by the ruins, and some by fear, all marvellously expressed by Vellano. The same place possesses wax and other models of these things, as well as bronze candelabra prepared by the same artist with great judgment and invention. So far as can be seen, he was most anxious to attain to the level of Donatello, but he did not succeed, as he aspired too high in a most difficult art. Being very fond of architecture also, and

[1] Bartolommeo Bellano.

above the common level of excellence in that profession, Vellano went to Rome in the time of Pope Paul the Venetian, in 1464, for whom Giuliano da Maiano was acting as architect in the building of the Vatican. Vellano also was employed on many things, making the arms of that Pope which may be seen there with his name upon them. To him also is due a great part of the ornament of the palace of S. Marco for the same Pope, whose head, by Vellano's hand, is at the top of the stairs. For the same place Vellano designed a marvellous courtyard with a convenient and pleasant flight of steps. But all these things remained unfinished on account of the Pope's death. During the time that Vellano was staying at Rome he made a quantity of small things in marble and bronze for the same Pope and for others, but I have not been able to trace them. In Perugia he made a bronze statue of more than life-size, representing the Pope seated, in his pontificals.[1] At the base he put his name and the year in which it was made. The figure stands outside the door of S. Lorenzo, the cathedral of that city, in a niche made of several kinds of stone carved and very carefully finished. He also made many medals, some of which may still be seen, notably those of the Pope and of his two secretaries, Antonio Rosello of Arezzo and Battista Platina. After these things Vellano returned to Padua with a great reputation, being valued not only in his own country, but in all Lombardy and the March of Treviso, both by reason of the lack of excellent artists in those parts, and because he was very skilful in founding metals. Vellano had become old when the Venetian Signoria, having decided to erect a bronze equestrian statue to Bartolommeo da Bergamo, allotted the horse to Andrea del Verrochio of Florence and the figure to Vellano. On hearing this Andrea, who thought that the entire work was to be his, fell into such a rage, knowing himself, with good cause, to be a far better master than Vellano, that he broke to atoms the model of the horse which he had already made, and departed for Florence. Being afterwards recalled by the Signoria, who gave the entire work to him, he returned and completed it. Vellano was so offended at this that he left Venice without a word or a sign and returned to Padua, where he passed the remainder of his days in honour, resting content with the works which he had made, and with the affection and honour accorded to him by his own people. He died at the age of ninety-two, and was buried in the Santo with that honour which his ability deserved,

[1] Set up in 1467; melted down by the French in 1798.

for he had both added lustre to himself and to his country. His portrait was sent to me from Padua by some friends of mine, who had it, as they informed me, from the learned and Rev. Cardinal Bembo, who was a distinguished patron of the fine arts and of all the rarer virtues and gifts of the mind and body, excelling all the other men of our age.

END OF VOL. I

EVERYMAN'S LIBRARY was founded in 1906, and the series stands without rival today as the world's most comprehensive low-priced collection of books of classic measure. It was conceived as a library covering the whole field of English literature, including translations of the ancient classics and outstanding foreign works; a series to make widely available those great books which appeal to every kind of reader, and which in essence form the basis of western culture. The aim and scope of the series was crystallized in the title Everyman's Library, justified by world sales totalling (by 1963) some forty-six millions.

There were, of course, already in being in 1906 other popular series of reprints, but none on the scale proposed for Everyman. One hundred and fifty-five volumes were published in three batches in the Library's first year; they comprised a balanced selection from many branches of literature and set the standard on which the Library has been built up. By the outbreak of the First World War the Library was moving towards its 750th volume; and, in spite of the interruptions of two world wars, the aim of the founder-publisher, a library of a thousand volumes, was achieved by the jubilee in 1956, with Aristotle's *Metaphysics*, translated by John Warrington.

In March 1953 a fresh development of the Library began: new volumes and all new issues of established volumes in Everyman's Library were now made in a larger size. The larger volumes have new title-pages, bindings and wrappers, and the text pages have generous margins. Four hundred and twenty-two volumes in this improved format had been issued by 1960. In that year new pictorial wrappers appeared and they have provided the volumes with a surprisingly contemporary 'look'.

Editorially the Library is under constant survey; volumes are examined and brought up to date, with new introductions, annotations and additional matter; often a completely new translation or a newly edited text is substituted when transferring an old volume to the new format. New editions of Demosthenes' *Public Orations*, Harvey's *The Circulation of the Blood and Other Writings*, Aristotle's *Ethics* and Professor T. M. Raysor's reorganization of Coleridge's *Shakespearean Criticism* are examples of this type of revision.

The new larger volumes are in keeping with the original 'home-library' plan but are also in a suitable size for the shelves

of all institutional libraries, more so since many important works in Everyman's Library are unobtainable in any other edition. This development entails no break in the continuity of the Library; and fresh titles and verified editions are being constantly added.

A Classified Annotated Catalogue of the library is available free, the annotations giving the year of birth and death of the author, the date of first publication of the work and in many instances descriptive notes on the contents of the last revised Everyman's Library edition. Also available is A. J. Hoppé's *The Reader's Guide to Everyman's Library*, revised and reissued in 1962 as an Everyman Paperback. It gives in one alphabetical sequence references and cross-references of a comprehensive kind, including all authors and all works, even works included in anthologies, and a factual annotation of each work. Running to more than 400 pages, and referring to 1,260 authors, it is virtually a guide to all books of classic standing in the English language.

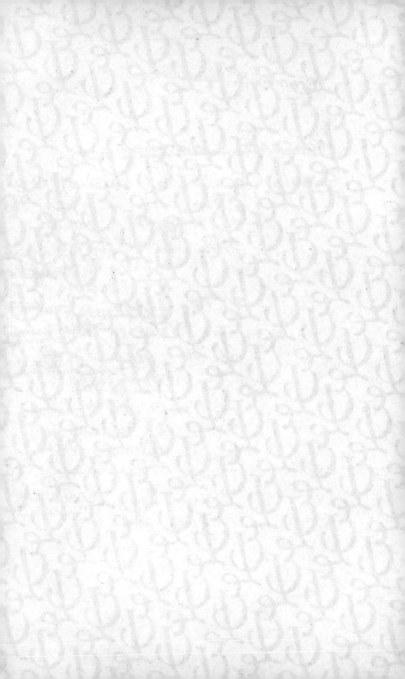

PORTRAITS. FIND SELF PORT.

Giotto (p. 66 68) Christ. of ?
 p. 71 - port. in life of Job
 p. 74. port. of pope
 p. 72 portraits of ?
 Men - ? Self Po
 at Naples
 p. 76 Self Port at
 Giotto ?
 p. 76 ? of ? ca
 ? ?
 p. 77 Signo Malatesta
 in Rimini in
 ? Blessd
 Micheline
 82 Pupil Puccis - Self
 Port.